The
Book of Video
Photography

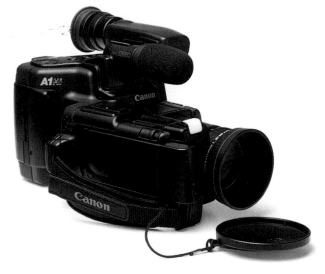

KNOPF
75
YEARS·OF·PUBLISHING

The Book of Video Photography

A

Handbook for the
Amateur
Movie-Maker

DAVID CHESHIRE

A DORLING KINDERSLEY BOOK

First published in US in 1990 by Alfred Knopf,
201 East 50th Street, New York, NY 10022

First published in Great Britain in 1990
by Dorling Kindersley Limited,
9 Henrietta Street, London WC2E 8PS

Edited and designed by
CARROLL & BROWN LIMITED

Editor: Phil Wilkinson
Art Editor: Bob Gordon

Library of Congress Cataloging-in-Publication Data
Cheshire, David
 The book of video photography: a handbook for the amateur
movie-maker / David Cheshire. — 1st American ed.
 p. cm.
 Published simultaneously under title: The complete book of
video photography.
 Includes index.
 ISBN 0–394–68744–8
 1. Electronic cameras. 2. Cinematography. 3. Motion
pictures— Production and direction. I. Title.
TR882.044 1990
778.59 ––dc20 90–53110
 CIP

Typeset by MS Filmsetting Limited, Frome, Somerset
Reproduced by Mendip Graphics, Bath, Avon,
and Colourscan, Singapore
Printed and bound in Italy by Graphicom

PREFACE

*'Now that we can photograph our loved-ones, not only in
stillness, but as they move, as they act, as they make familiar
gestures, as they speak – Death ceases to be absolute.'*

A recent Sony catalogue? A Kodak, Nikon, or Panasonic advert? Or perhaps
even something more than usually dotty from the Jehovah's Witnesses? *NO:
"La Poste de Paris"* (1896), written ecstatically by a man who had just seen
Lumiere's *Cinematographe* for the first time.

In the intervening century, the recording of images and sound has invaded
every corner of our consciousness: the brutal realities of war and so-called
"peace", along with every fantasy from "2001" to Marilyn Monroe or Donald
Duck. But in the final resort, for most of the people most of the time, it is the
record of our own lives, or our perception of them (which is usually a quite
different thing), and our feelings about our "loved ones" that have dominated
that impulse to freeze the transient; even to anesthetize that nineteenth-
century Frenchman's quite correct apprehensions concerning mortality.

Arguably, no medium has yet been so successful at sustaining this illusion
of the conquest of time as the modern video recording system. With high-
fidelity stereo sound, high-resolution images (certain to be very much higher
and wider soon), and complete automation in even the very lowest light,
"video" has now come close to fulfilling that long-dead Frenchman's dream –
though he would not have believed his eyes, let alone his ears.

The great thing about the sophistication of modern equipment is that it
enables you, alone, as an amateur, to do very complex things in both sound
and vision; or just forget the complexities and let the machine do the
calculations for you. This is where the historical context becomes fascinating,
and four quotations from great film-makers of the past are inspiring when
filming the baby on the lawn, even if the cast is smaller than *"Ben Hur"* –

"The real work was thinking, just thinking"

CHARLES CHAPLIN

"The first quality of a director is to *see*"

MICHELANGELO ANTONIONI

"The only technique worth having is the technique
you invent yourself"

JEAN COCTEAU

"The camera is an eye in the head of a poet"

ORSON WELLES

Though all these quite different geniuses were at that time writing about
celluloid, their remarks apply as aptly to video – and indeed to painting! All
three require a combination of art and technical expertise, instinct and
practicality, and, in the case of video, a good ear as well as a good eye. Above
all, video "work" – if it honestly can be so described – is enjoyable, affordable,
watchable, and, effectively, everlasting. In all respects except, alas, the last,
our Frenchman of 1896 was *dead right*.

CONTENTS

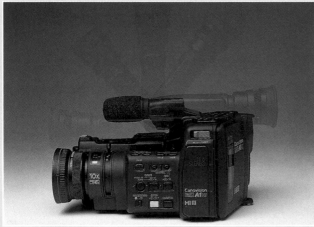

INTRODUCTION

INTRODUCTION

The story and the place of video in the history of image-making is, in its own bizarre way, as astonishing as the political revolutions that have recently transformed Europe. Since the late nineteenth century, celluloid films (first 35 mm then other, smaller gauges) had held the entire field to themselves. In the case of 35 mm and 16 mm, each still has its very distinct place alongside video recording. But whether in the private or the professional field (and in this book we shall be taking a look at both), they are increasingly fighting for space and a *raison-d'être*. It remains a battle between the old chemistry and the new physics.

The rise and rise of video

Both film and video methods have been used in various different guises by all amateur and professional movie-makers over the last twenty years or so; and each medium has its own advantages and drawbacks: film is obviously more tactile to handle in editing (after all, you can physically *touch* the cut) – but then again you can, at a price, transfer video onto film to edit it . . . The debate rages wherever movies are made, anywhere in the world. But the fact is that video *does* look quite different from film (sharper, for a start); and it *does* have a different "feel" on the screen. But for a given price, and home viewing, in terms of both capital and production costs, modern amateur video equipment (if indeed S-VHS or Hi-8 can any longer be called amateur) now offers far more scope and flexibility than film. The astonishing features of modern video, which are outlined in the following pages, are upgraded almost by the hour: as the size of the gear shrinks, the capacities expand, and even editing at home with a relatively simple set-up can produce outstandingly professional results, without the expense of film printing, and with the possibility of indefinite copying without physical damage. This is especially true of the new high-resolution formats, which are virtually broadcast-quality, in both stereo Hi-Fi and high-resolution vision. In the end, this all un-questionably makes video not only the "fun" medium of the present and the future, but – for the amateur – the matchless first choice.

So our advice is: think carefully, and buy equipment that suits your needs, now and in the near future, and your budget. And above all enjoy yourself making good (or even bad!) video movies.

The evolution of television

It was the development of the telegraph in the USA around 1830 that made communication by electricity practical. The dynamically inventive climate of the 19th century also saw the birth of photography (around 1839), the telephone (1876), radio (1877), and the cinema (1895). It was expected by many that electricity would somehow provide the means to transmit live moving pictures.

The first attempts were with still pictures. In 1843 the English physicist Alexander Bain designed an electro-

The work of Baird
John Logie Baird (left) invented the mechanical scanning technique that produced the first television images. The pictures were poor in quality, as the example (right) shows. But Baird's work was innovative enough to excite the interest of the public.

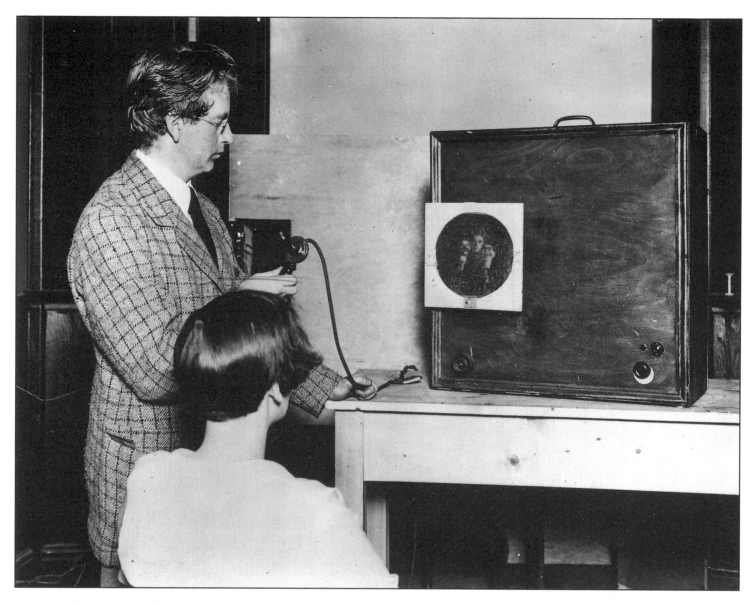

mechanical device that could transmit an image of metal printing-type over telegraph lines and reproduce it in facsimile at the other end. In this device the principles of scanning the image, of converting it to electrical pulses, and of reproducing it instantaneously were all established. These principles are all fundamental to today's television.

Light into electricity

Just as photography depends on the interaction of light and chemicals (light from the subject is recorded on film coated with chemicals that are sensitive to the light), television requires the interaction of light and electricity. In 1873 it was discovered that the metal selenium (later to be used in photographic light meters) increased its conductivity when exposed to light. This brought the possibility of television a quantum-leap closer.

A rapid scanning device was now required that would dissect an image into a sufficient number of lines to make a recognizable image at a rate of 12 or more pictures per second – enough to give the impression of continuous movement. An obscure German inventor, Paul Nipkow, designed a device for this purpose in 1884 as part of his "electric telescope". His invention was a large disk perforated with holes in a single spiral turn close to the rim. With one full rotation, the disk was able to scan completely a small rectangular aperture. In spite of the revolutionary nature of the disk, Nipkow's electric telescope was never developed – the reaction of its primitive selenium cell was too slow, and there was no way at the time to amplify the tiny current produced.

In 1907 thermionic valve amplification was invented. With this new method of amplifying the current, interest in the transmission of moving pictures was renewed,

Baird and his "Televisor"
The image of Baird's assistant with two dolls is clearly visible on the screen of Televisor. Baird himself is directing the subject's movements by telephone.

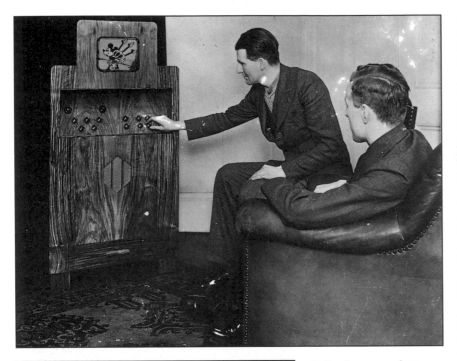

and experiments continued in the USA, Japan, Russia, Germany, and Hungary. But it is a Scot, John Logie Baird, who is credited with the first public demonstration of television using the Nipkow disk.

It took place in London's famous Selfridge's department store in October 1925. His apparatus was rather like the Heath Robinson cartoons of the time – ingenious but crude. But he handled his publicity well. Public interest was excited and pressure was brought on the reluctant British Broadcasting Corporation to allow Baird his first regular broadcast with their facilities on December 30, 1929. By the end of 1932 about 10,000 of his "Televisor" receivers had been sold.

The cathode ray tube

But Baird's mechanical scanning techniques were simply not adaptable to the speeds required for high-resolution pictures. Sadly, Baird persisted in advocating his mechanical scanning system, ignoring crucial developments in electronic scanning. These were to stem from the cathode ray oscilloscope tube, which was developed by Karl F. Braun in 1897, following much earlier work by Julius Plucker, William Crooks, and Ambrose Fleming. Much more like the modern television receiver, it consists of an evacuated glass tube containing negative and positive electrodes. When a high electric tension (around 10,000 volts) is placed between them, a stream of electrodes (the cathode ray itself) flows from the negative towards the positive electrode and beyond, to create a fluorescent glow at the far end of the tube. The ray can be focused to a tight spot and deflected by magnetic coils.

Scientists both in Russia and England saw the potential of this device for television scanning in the 1900s. They each designed scanning systems. But vacuum technology was not yet far enough advanced for them to realise their schemes.

The breakthrough came with the work of Vladimir Zworykin in the USA. In 1923 he patented a practical camera tube, the Iconoscope, and led research with the large facilities of the Radio Corporation of America in New York. The research team developed a systematic approach to the questions of line and frame standards and synchronization. The proposed radio frequency was increased to accommodate all the detail that the high-definition pictures would contain. By 1933 the Iconoscope was fully developed and soon the number of scanning lines was increased from 240 to 343, and interlaced scanning was introduced to effectively double the scan rate and eliminate screen flicker.

In the UK, Baird continued to try to refine his system to give higher definition. But serious competition came from the EMI company. Part-owned by the American corporation RCA, they had access to Zworykin's camera and were progressing even faster than the Americans. In conjunction with the Marconi company, they gained the radio expertise in 1934 to transmit 405 interlaced lines at 25 pictures per second. This became the standard for VHF transmissions on the BBC and continued until as late as 1985, although it had been superseded by the 625-line UHF standard for color in 1969.

Cathode ray receiver
This early television receiver used a cathode ray tube to produce the image. The result was a far better picture than that from Baird's mechanical scanning device. Even so, the screen size was still very small.

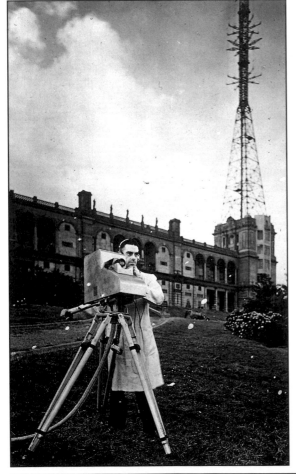

Transmitter
This 1930s television camera has been set up outside the British transmitter at Alexandra Palace. The image of the transmitter's antennae became famous from many newsreel broadcasts.

How many lines?
French television cameras of the 1950s were used to create pictures with over 800 scanning lines, which gave surprisingly high definition for this early date.

In the studio
A corner of a television studio of the early 1950s shows a group of people waiting to take part in a show featuring sponsored television weddings. This was one of the most popular American programs of the decade.

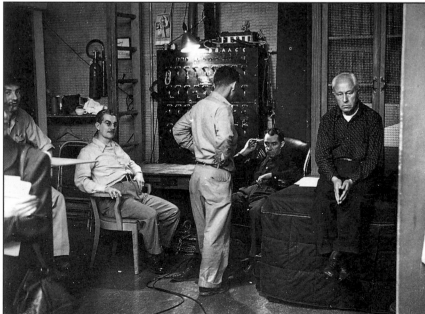

Baird's equipment imposed severe restrictions on broadcasting. To begin with, there was no camera as such. The television studio would be in total darkness, save for a dazzling spot of light from a spinning Nipkow disk that scanned the performer. The reflected light was picked up by a bank of selenium cells and produced the signal. Actors had to move forward for a close-up, guided by assistants crawling on the ground. Dance routines were performed within a five foot square! But films could be scanned for broadcast fairly satisfactorily, using a German-designed cathode ray tube. So for large "live" studio scenes, Baird used an "intermediate film process". The program was recorded on 35 mm cine film. This was fed directly into a tank to be developed and washed before being scanned for transmission one minute later while still wet.

In 1934 the UK government set up a committee of enquiry that recommended a full public service for the BBC. A minimum of 240 lines was specified, and this just fell within the capability of Baird's equipment. The world's first "high-definition" television service began on November 2, 1936, with the Baird and Marconi-EMI systems broadcasting in turn. By the end of January 1937 the Marconi-EMI system was declared the outright

winner, and Baird's system was dropped. But initially the new service had a short life. On September 1, 1939, with war against Germany imminent, the transmitters were closed down. They could have guided enemy bombers to London.

Post-war television and the rise of video

In 1939 regular transmissions began in the USA. The NBC, a subsidiary of RCA, broadcast using 441 scanning lines. The first broadcast was of the opening of the New York World's Fair, when F D Roosevelt became the first president to appear on the small screen. Rival broadcasters were Philco, who had developed a 605 line standard, and CBS, later to become the biggest broadcaster in the USA. The Federal Communications commission, seeking a federal standard for television systems, established the National Television Systems Committee (NTSC), who opted for a compromise of 525 lines at 30 pictures per second, to begin on July 1, 1941. On December 7 of that year, the Japanese attacked the US fleet in Pearl Harbor, bringing the country into World War II and virtually halting the development of television in the US.

In Germany, broadcasting began in 1935. It continued during the war, essentially as a support to the armed forces, and during the occupation of France, the Germans made use of the powerful transmitter on the Eiffel Tower. At 985 ft (300 m) it was the tallest mast in Europe, producing signals that could be picked up in England and monitored by British Intelligence. Broadcasting from Berlin came to an end in November 1943, when allied bombs hit the transmitter.

Meanwhile, television engineers applied their skills to the development of Radar. This new technology brought benefits to peace-time television. After the war, television proliferated. For example, the BBC's network of transmitters made television accessible to 80 percent of the population by June 1953, when the coronation of Queen Elizabeth II attracted an audience of some 20 million viewers. This meant an average of eight people crowding around each small screen.

Britain's first commercial television service, Independent Television (ITV) opened in September 1955. People wanting to watch ITV needed a new antenna for the higher frequencies, plus a new tuner or signal converter. The receivers on which people watched these broadcasts of the 1950s were more compact than their predecessors. Their tubes were shorter and had rectangular screens. Picture steadiness was improved by making synchronization less dependent on the signal when disturbed by radio noise.

The second BBC channel was launched in 1964 with 625-line resolution, which most of Europe had already adopted, and a shift in transmission to the ultra-high-frequency (UHF) band to prepare for the coming of color television in 1967–68. In America, different color systems had been developed by RCA and CBS, and the standard chosen by the NTSC was in use from 1953. In order to make color transmission compatible with black-

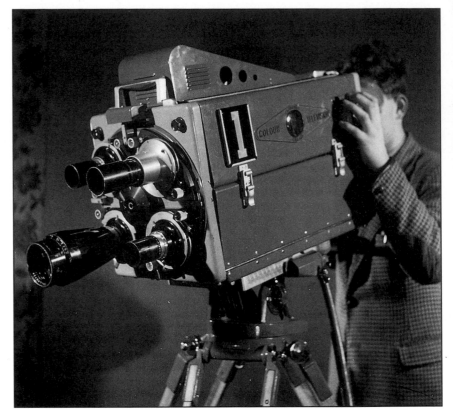

and-white receivers and to avoid the wide waveband needed to transmit red, green, and blue pictures in rapid sequence or simultaneously, a system was adopted in which low-resolution color was encoded in the monochrome signal. RCA achieved this by using a *shadow mask*, allowing three electron beams to hit their correct spot on the screen without overlap. The NTSC system was not without its problems, which earned it the nickname "Never Twice the Same Color". Britain adopted a German variant of the system, PAL, which gave good color stability, while France developed SECAM, with a memory system to improve the color.

Meanwhile, camera tubes gradually increased in sensitivity and fidelity, giving greater scope to broadcasters and, potentially, greater entertainment value to television. EMI's Super Emitron tube of 1937 was ten times more sensitive than the early Iconoscope. By 1946, RCA had developed the three-inch Image Orthicon tube, one hundred times more sensitive.

Color television required further advances in tube technology. Between two and four tubes were needed in each camera, so they had to be still smaller, RCA led the way with their one-inch Vidicon tube of 1950. The Dutch company Philips produced an improved version, the Plumbicon. By 1973, the Japanese had produced tubes capable of resolutions of 1,000 lines or more.

But a complete departure from the cathode ray tube was to herald a new direction in camera design. An integrated circuit imaging chip, or charge-coupled device (CCD), is used in today's camcorders, and has

Color camera
This is one of the first color television cameras. Its lens turret carries four different focal lengths. The camera's large size meant that movement was very restricted and coverage of all but the most straightforward subjects had to be done with several cameras at different positions.

achieved such high image quality that it will remain the focus for future developments in video imaging. In domestic camcorders a single chip produces the full color signal. In professional cameras there are often three chips, dividing the red, green, and blue signals.

As tubes have developed, television cameras have become more maneuverable and, recently, even portable. The first cameras had fixed lenses. These were replaced with a rotating turret that contained a selection of lenses with different focal lengths. In live transmissions, it was necessary to cut to another camera while the lens was being changed. Zoom lenses, although they had been available since 1949, only replaced the turret system when the introduction of color revealed the different color rendition provided by individual lenses. The first zoom had a focal length ratio of 2:1. In 1990, zooms of 45:1 are being used.

Video recording

Baird had been able to make direct recordings of his 30-line pictures as early as 1928. The signals were recorded on wax phonograph disks like those used for sound recordings. But when image definition improved, the only available method was to point a cine camera at a monitor screen.

Sound recording on magnetic tape and wire had been developed in Germany during World War II. There were problems in adapting this for video because the highest video frequencies required a tape travel speed hundreds of times faster than for audio. In addition, the range of frequencies – about 16 octaves – had to be reproduced from a system limited to about 8 octaves. At the lowest frequencies the signal would be drowned out with amplifier noise; at the highest frequencies the tape would become demagnetized.

The problems were solved in the USA by Ampex Corporation. In their Quadruplex system, a two-inch-wide tape traveling at 15 inches per second was scanned across its width by a rapidly rotating drum with four recording heads. The flexible tape was curved around the drum by a vacuum former to keep head contact, and each head recorded 16 lines of picture. The sound was recorded separately on a track along the edge of the tape. The system needed precision engineering and sophisticated electronics to make it work, but it began to revolutionize television production.

At first, editing was only possible by meticulous physical splicing of the tape. This method was superseded by copying between synchronized machines. Advances in tape materials have made smaller tape formats possible and helical scanning has allowed one whole field of picture to be recorded with each traverse of the recording head. This in turn has simplified the electronics.

The first domestic video recorder, the Philips N1500, dated from 1972. The 1970s also saw the arrival of the VHS and Betamax systems from Japan. Since then VHS and its derivatives have taken by far the greatest share of the market. The Sony 8 mm format, introduced in 1983 remains a serious contender.

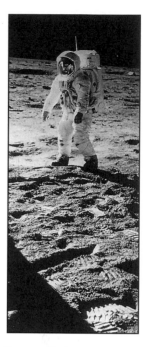

One small step
Television came to dominate the world in a unique way. In the 1960s, pictures were even sent back from the moon.

Video arrives
Philips was one of the first manufacturers to produce a portable video camera. It did not contain the recording mechanism and so had to be used in conjunction with a video recorder. It was equipment like this which opened many people's eyes to the potential of video.

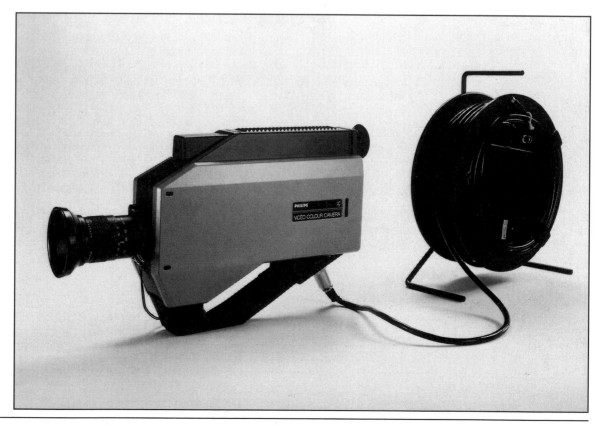

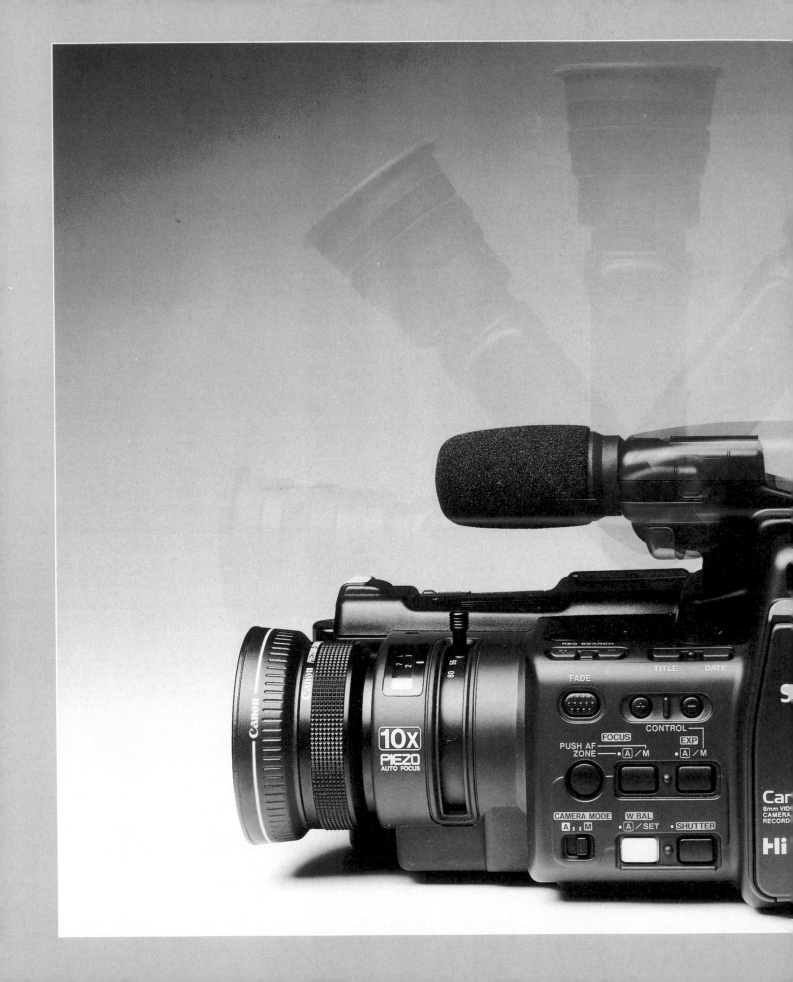

GETTING STARTED IN VIDEO

HOW VIDEO WORKS

The central principle of all video equipment is that a focused image must be converted into an electrical signal which can be transmitted either by cable or by a radio frequency. When the signal is received, it can be reassembled on a screen as a visible image. All visible images may be thought of as variations of light and shade. In order that they can be converted into electrical signals, they must be broken down into a very large number of dots, ranging from black through gray to pure white, which are in turn arranged as a series of slightly slanted horizontal lines on the screen – 625 in Europe, and 525 in the USA and Japan. In order to convey the effect of motion, each of these lined "pictures" must last no more than 1/25 sec (1/30 sec in USA), but in practice even this very brief duration would appear to flicker when viewed, so each picture of action is scanned *twice* by the tube by a series of interlaced lines which, when combined, produce a complete picture. Thus the "field frequency" of each system is double the picture frequency – i.e. 50 Hz in Europe and 60 Hz in the USA and Japan. (This corresponds to the frequency of the power supplies in these countries.)

To convert the focused image into an electrical signal modern camcorders use a charge-coupled device (CCD). This is a chip which varies in its electrical conductivity according to the amount of light falling on it. The camcorder lens focuses light from the image on the CCD, and the varying electric current caused by the varying light intensity creates an electrically coded version of the image. To make up the whole picture field, the chip is scanned by a microscopic network of lines, both vertical and horizontal.

Seeing in color

The information our eyes receive from the outside world is of two kinds: brightness and wavelength. The brightness of the object tells us how much light is falling upon it, whereas the wavelength of the light that we observe is conveyed to us as color. Violet is the shortest visible wavelength, and red the longest, with all the other visible colors spaced out in between, as in a rainbow.

It is possible, however, to produce any of the colors in the spectrum by the combination of just three of its components, which are strategically placed midway and at either end of the rainbow: red, green, and blue (R,G,B). These are the primary colors, and if they are combined on projection they will form a perfect white at the center, while around them will be found all the other colors that the eye can see. In video, the tint of a particular color is referred to as a *hue*, and this hue is modified by its degree of brightness (or *luminance*) in the direction of either white or black. The luminance therefore also affects the degree to which the color is light or deep, and this is known as the degree of *saturation* of that color. In other words, red+green+blue give us hue. Hue+luminance give us the correctly saturated color at the correct degree of brightness. This is all we need in order to see an object at the right color.

Color in the camera

A black and white camera need only concern itself with the luminance (known as Y) of the multitude of points that it scans across a given scene, whereas a color camera has to analyse each point of the image not only for luminance, but also for hue – the color, or *chroma*. This means *four* separate sources of information: red, green, blue, and luminance. In turn, the transmission system will have to communicate all this to the receiver, which will have to recombine it into an image.

Traditional video cameras coped with color in various ways. Some had a tube for each of the four sources; others made do with three tubes; or they had a single tube with a filter to allow the colors to be scanned alternately. In a CCD camcorder, a single microchip is sensitive to light and color across its surface.

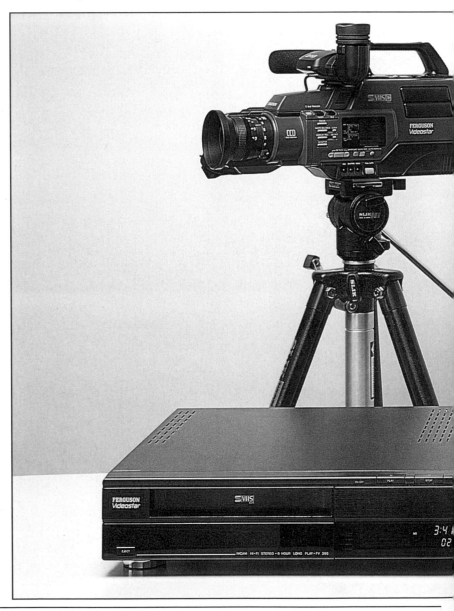

Encoding for color

"Encoding" is the term used to describe the process by which the color information in the camera (chroma) is added to the luminance information in such a way that it subsequently can be decoded and displayed on the receiver. If each of the four components red, green, blue, and yellow (R,G,B,Y) were allotted the same amount of room in the available bandwidth, the bandwidth would have to be enormously large. However, the problem can be solved by a form of electronic "algebra". The luminance signal (γ) is subtracted from both the blue and the red signals, giving B-γ and R-γ. These two signals are modulated on to a subcarrier, which operates at a frequency of 4.43 MHz (in Europe) or 3.58 MHz (in the USA).

Each line scan transmitted contains a very brief but very accurately phased "burst" of the subcarrier, and this is placed immediately after the line sync pulse, which has instructed the receiver to begin a new line scan. The algebra can now be decoded in such a way that green too can be derived: since we know the values of red, blue, and the total luminance, green must be the missing factor: $G = \gamma - (R + B)$.

This is necessarily a very schematic description of a very sophisticated process. In practice, the three color systems in use at the present time (NTSC, PAL, and SECAM) use different methods for encoding and decoding their colors. They are completely incompatible, though converters do exist, and certain manufacturers offer receivers and semi-professional recorders that are switchable between international standards for playback only (see p. 202).

The three fundamentals
A color television receiver or monitor, a camcorder (which is capable of replay as well as recording), and a VCR (so that you can record off-air as well as edit from the camcorder onto full-size tape) are the three basic pieces of equipment you need. With such a set-up, you can create quite sophisticated videos.

THE TELEVISION SET

TV receivers are changing almost beyond recognition. Screens are getting larger, and picture definition and sound quality are improving. Apart from everyday considerations such as the size and color scheme of your room, there are certain factors you should consider when buying a TV set. They involve screen size, technical requirements such as connections and sound decoding, the position of the equipment in your room, and the cost. Many of these priorities are a matter of personal choice, so the following information is intended to give signposts rather than hard and fast rules.

Screen size

Buy the largest screen you can afford that also offers the other features that you require. The old complaints about poor quality from large screens are no longer valid, and teletext is particularly improved by larger screen size, especially with the faster teletext retrieval now offered on the better models.

Some non-projection TVs now go up to giant screen sizes of 36 ins (95 cm) across the diagonal. Although many people will feel that such a set is simply too large for their homes, a large 26 ins (65-66 cm) set could be the answer. If you prefer a smaller image, you should remember that the more people who are watching at any one time, the larger the screen must be if they are all to enjoy the picture.

Sockets, inputs, and outputs

As a general rule, go for a television that has as many input and output jack sockets on the back as possible. Naturally, there will be a power source input and a radio frequency (RF) input for the antenna. These are the basic requirements, but, as television becomes more sophisticated and flexible, the jack sockets multiply. On a NICAM TV, which gives you high-quality digital stereo, there will be left and right channel audio outputs for connection to your stereo system for even better results. Also, in Europe, look for one (or preferably two) 21-pin SCART sockets, so that you can connect the set up to one or two VCRs, camcorders, or computers. This effectively makes your television into a monitor as well, since the incoming and outgoing signals do not have to pass through the set's RF decoding circuitry, and therefore remain purer. In addition, for the same reason, look for video in/out BNC sockets, with audio sockets to match. Finally, Super-VHS cameras require a separate socket to get the full benefit of Super-VHS quality on playback.

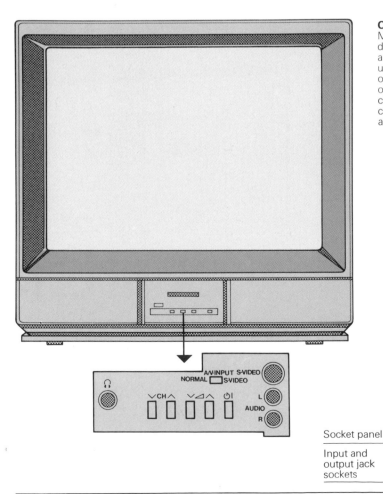

Controls
Most modern televisions are designed to be operated by a remote-control unit. The unit duplicates the functions of the buttons on the front of the set. These include channels, brightness, contrast, color, volume, and, if applicable, teletext.

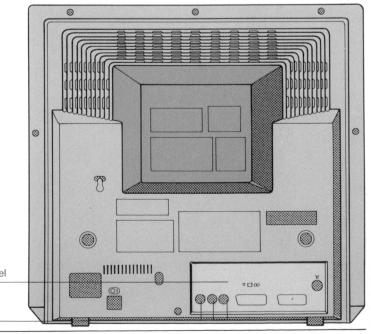

Connections
The more input and output jack sockets, the better. Audio and video channels may be separate or combined – in a SCART 21–pin socket, for example. But the more versatile the options, the greater the receiver's capabilities.

Socket panel

Input and output jack sockets

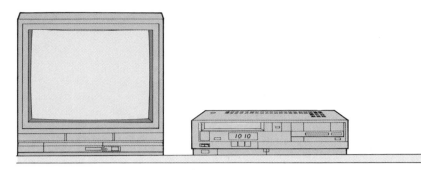

immense sophistication of infrared remote controls for both appliances (often on the same control pad, with baffling results), a lot of viewers spend their time grovelling on the floor in front of the VCR for a tape or a dimly-lit button. This is bad enough when you are trying to insert a cassette or reprogram the VCR; when editing, the situation becomes intolerable – you need constant access to the controls.

Perhaps the best solution is to place the VCR next to the TV. With the TV at waist height for easy viewing, you will be able to operate both the appliances easily while looking at the picture. If possible, and if the set is equipped for NICAM/Stereo, you also should place the TV between your speakers. In this way you will be able to appreciate fully the sound quality of programs and films.

Reception

No matter how sophisticated your TV, the quality of the image you see depends utterly on the input quality. In the TV jargon "Rubbish in; rubbish out". A good signal is especially important now that stereo sound is becoming the norm. So buy a good antenna and have it correctly installed (see p. 22).

Positioning the equipment
Placing the television and VCR at the same level, on a shelf at waist height, is the most comfortable option both for viewing and for operating the controls.

Most modern TVs will soon provide all these inputs and outputs, and it is to be hoped that manufacturers will standardize plugs and systems in the process. Although they sound complicated, these interconnections will put your televison at the heart of a total video system, which is where it belongs. Be prepared to buy a range of adaptor leads to connect different equipment.

Placing the TV

Many manufacturers seem to have decided, for the sake of tidiness and the eyeline of the TV, that the best place for a VCR is beneath the receiver. As a result, despite the

The tube
The cathode ray tube is at the heart of the television receiver. It consists of three electron "guns" (one for each of the three primary colors), a shadow mask to separate the colors, and a screen coated with phosphor strips that glow when the different colored beams hit them.

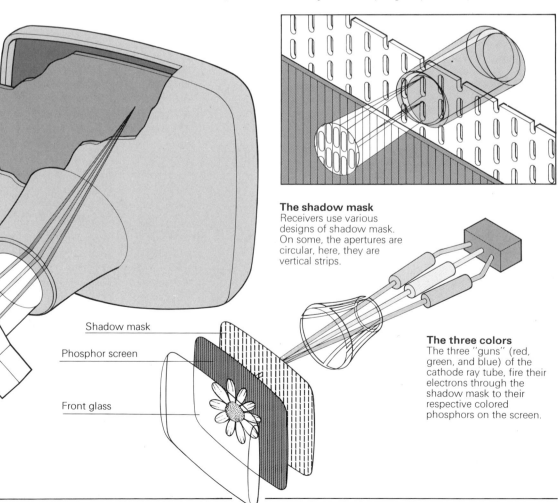

The shadow mask
Receivers use various designs of shadow mask. On some, the apertures are circular, here, they are vertical strips.

Shadow mask

Phosphor screen

Front glass

The three colors
The three "guns" (red, green, and blue) of the cathode ray tube, fire their electrons through the shadow mask to their respective colored phosphors on the screen.

GETTING THE BEST PICTURE

Assuming that you have found the receiver that suits your present and future needs (including the variety of ways in which it can fit into the rest of your audio-visual system), the next stage is to instal it so that it will give the best results that it can deliver. You should begin with the most fundamental and most frequently overlooked item – the aerial or antenna.

Reception

With regular television (cable and satellite have different problems), recepeption quality can vary from country to country, and even from house to house in the same street. One large building can reflect visual echoes (known as "ghosting"); other forms of interference can create "snow" in darker areas of the image. The list of possible causes for poor reception is virtually endless, but the remedies are simple. Employ a properly qualified installer to put a large antenna on the roof (not in the attic, unless you live next to the transmitter), and make sure that the incoming signal is free of extraneous visual or sonic noise.

If you live in a remote valley or a complex of high-rise buildings you may need some form of booster near the antenna. Do not even consider an indoor antenna – they are a simple way of throwing money down the drain. There is no point in wasting expensive television equipment on an unsatisfactory signal.

European televisions use 75 ohm co-axial cable as an input for UHF broadcasts, whereas in the USA and some other countries VHF broadcasts are received via 300 ohm unbalanced inputs. UHF is much more refined than VHF, though more directional, and is therefore more suited to Europe, where there is a rather restricted number of transmitters in operation.

The incoming signal, whether VHF or UHF, interacts with the dipoles on the antenna to produce a very small electric current. This is amplified and decoded by the television set. The dimensions of the antenna are directly related to the wavelength of the signal you intend to receive and the elements of the antenna are set at right-angles to the transmitter, and may be aligned vertically or, more commonly, horizontally, to match the polarity of the transmitted signal.

In poor reception areas it is worth trying an antenna with more elements, especially for UHF wavelengths. This will increase its directionality and give a better signal – so long as the antenna is aligned correctly with the transmitter. If the distance from the antenna to the receiver is long, another way of improving the signal is to use a "low-loss" cable. This will minimize the inevitable weakening of the signal that occurs in the cable and depletes the image quality. The conductor in low-loss cable is simply thicker than that in standard cable. The UHF signal that feeds into the co-axial 75 ohm cable in Europe should not have too long a run. If you live in the basement of a tall building and a long run is unavoidable, you may need to have a booster (effectively a pre-amplifier) in the roof, to help the signal down.

The same problems do not apply so urgently to 300 ohm flat-feed cables for VHF. But in the USA, where there are transmitters all over the place, aligning the antenna is more of a problem. An electrically movable antenna is the answer. There can be a similar problem with satellite dishes, where several "footprints" may overlap a particular geographical area.

In Europe, different satellite broadcasters often use different systems. You may therefore need more than one dish to receive all the stations.

The test card
Test cards, of which this is an example, are invaluable for setting up a television. This one shows the correct linearity, with vertical and horizontal borders, as well as the range of white/black contrast and horizontal resolution. These are the essential considerations for black and white.

Contrast too light

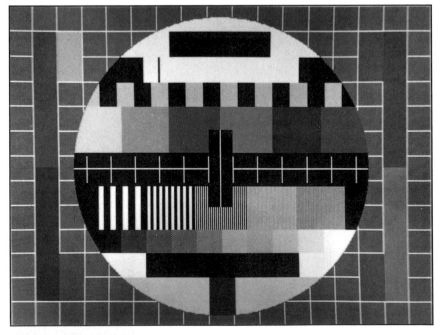

Picture of correct contrast

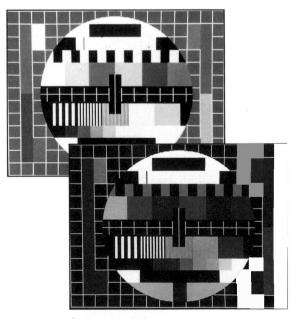

Contrast too dark

Power supply

You can view a video picture on either a TV receiver or a monitor. TV receivers, which we normally use in the home, can decode the radio-frequency input before it is converted into red, green, blue, luminance, and audio signals. Monitors have no sound supply or frequency tuner. They are used simply to look at the video signal from a camera or VCR. While ordinary home receivers run off the main power supply at 240 V or 110 V, video monitors can run off this supply or, in some cases, off DC via a 12 V converter. So-called receiver-monitors have the best of both worlds. They can either take the radio frequency signal (RF) and decode it, or accept direct uncoded RGB and audio input, with greatly superior quality. They also have many extra input and output jack sockets, for excellent reasons.

Tuning in

The RF signal from the antenna is first of all routed through the VCR tuner. Each channel on the VCR is tuned to a broadcast channel. But the entire RF input is passed immediately on to the television via its RF input

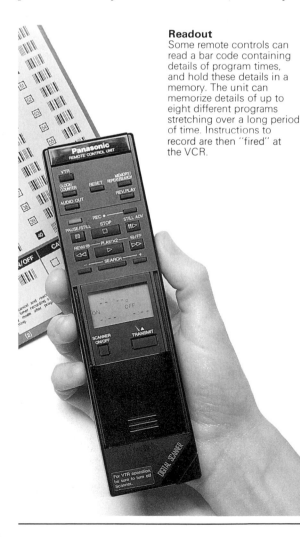

Readout
Some remote controls can read a bar code containing details of program times, and hold these details in a memory. The unit can memorize details of up to eight different programs stretching over a long period of time. Instructions to record are then "fired" at the VCR.

jack socket. On the TV the RF input from the video has to be assigned its own channel, so that you can view the VCR output on the television screen. The TV will thus be able to receive channels from the "air" or from the recorder.

You therefore need to do three tuning jobs, tuning the VCR and television to the separate channels, and tuning the VCR to the channel you have assigned it on the television. These jobs vary according to the models and should be fully explained in the manuals that come with the equipment.

The key-pad

The push-button remote-control unit or key-pad has virtually taken over the functions of the buttons of the television and VCR, although these controls will still be found, usually behind a flimsy lid on the front of the television. The functions that can be controlled from the keypad naturally include brightness, contrast, channel selection, volume, and all the other everyday items. But increasingly, a range of other facilities is available, from alarm functions to digital picture-in-picture special effects. Many of these are of limited use, but it is essential to understand the basic key functions.

Video set-up

When first using your television, only three video controls need concern you: color saturation, contrast, and brightness. The latter two controls are sometimes confused – the brightness control is usually marked with a sun symbol, while contrast generally has a half-moon design. Cheaper televisions sometimes have no brightness control. Some sets, particularly in the USA, also have a control for hue, which influences color balance and is useful where reception (as in America) is erratic.

To begin with, turn down the color control until you have a black-and-white image; then manipulate the brightness and contrast controls until you are happy with the combination. When you are satisfied with the tonality and black-and-white range of your monochrome image, gradually turn up the color until it looks natural in the lighting conditions in which you would normally be viewing. Try to light the room from behind the set – even modern sets are easily outshone by the light of the sun.

Controls for all
The remote-control unit pictured above controls both VCR and television from the single handset. The unit pictured below controls a camera. This is particularly useful in editing, or if you want to include yourself in the picture.

VIDEO TAPE

Tape is the recording medium used by both audio and video recorders. It is a very thin material (traditionally polyester), which is coated on one side with a layer of oxide that can be magnetized by the recording heads in the camcorder or VCR. The oxide is most commonly iron, but some tapes use chromium dioxide or cobalt-doped metal; there are also metal-evaporated tapes. These last types are designed to give considerably better frequency response, with a consequent improvement in picture quality and recording density.

The oxide is covered by a highly polished topcoat that protects the recording heads and the magnetic oxide; this also improves head contact. There is also often a carbon backing to reduce static as the tape passes across the head guides.

The amount of recorded information that can be packed on to the tape depends on two main factors: the speed of the tape as it moves across the record and replay heads; and the width of the tape-head gap. The faster the effective "writing speed" of the tape, and the narrower the gap, the more information can be absorbed for subsequent replay. In practice, the effective writing speed works out at about 6 meters per second for domestic video machines, more on professional models.

It is impractical to actually have the tape playing at this sort of speed. Consequently, all the early types of video recording, and most of the later ones, have attempted to achieve a high writing speed without an excessive actual tape speed. This has meant that the tape heads themselves must move in relation to the tape.

True video recording really began with the invention by Ampex of the Quadruplex (Quad) recorder in 1956.

This used a 2-inch tape which travelled at 15 inches per second. Four recording heads spun across this tape at very high speeds. The video signal was thus laid down at a writing speed that was adequate for the bandwidth of black and white television.

Quad has now largely been replaced by helical scanning. This is simply another way of moving the heads in relation to the tape movement. Instead of spinning the heads at right-angles to the direction of travel of the tape, they spin horizontally, but at a slight angle to the tape. This creates a series of diagonal, very closely spaced video tracks running across the tape. Because the tracks run at a very shallow angle each individual track is much longer than in Quad recording – in fact each track contains one field (half a frame) of video. These tracks occupy the bulk of the tape, but there is space for a narrow audio band on one outside edge, as well as for a control track on the other edge.

The other major development has been the gradual reduction of tape widths as technology has allowed more and more information to be stored in less and less space. The earliest video recorders were black and white and used either 1 inch or $\frac{1}{2}$ inch wide tape. They also used reel-to-reel tapes. With color came the first cassettes and the first domestic video machines. Sony introduced their $\frac{3}{4}$-inch U-Matic system in 1970, and this has been refined since to a high professional standard. In fact it is the only cassette to have survived from the early years of video. It now exists as Low-Band and the better-quality High-Band, which is acceptable for broadcasting.

The most important innovations were the introduction of Sony's Betamax format in 1975, shortly followed

Tape technology
Modern tape formulations have dramatically raised the resolution and sensitivity of recordings. In particular, metal-evaporated tape, with its greatly enhanced data capacity, has meant that smaller tapes can run for much longer. In addition, sound can be encoded electronically in the video layers of the tape to give superb digital stereo. This diagram shows the way in which a typical standard video tape is manufactured in layers.

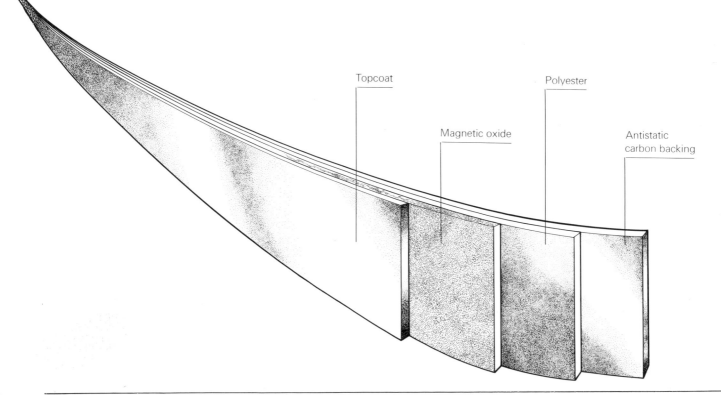

Topcoat

Magnetic oxide

Polyester

Antistatic carbon backing

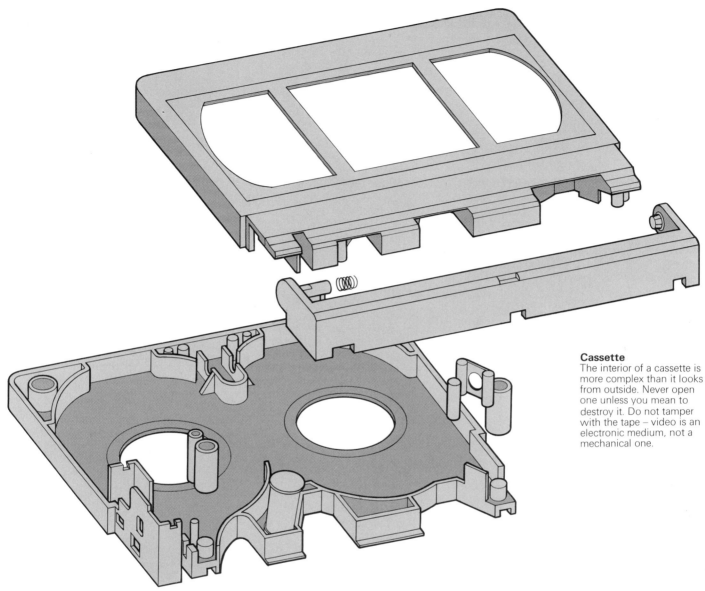

Cassette
The interior of a cassette is more complex than it looks from outside. Never open one unless you mean to destroy it. Do not tamper with the tape – video is an electronic medium, not a mechanical one.

by JVC's Home Video System (VHS). VHS has stood the test of time well. In addition to the standard cassettes, which are still very widely used, compact VHS (VHS-C) and Super VHS (S-VHS) cassettes are available. Compact VHS cassettes are simply shorter VHS tapes in a smaller cassette. This makes them highly portable, but limits the running time to 45 minutes at standard speed. Most camcorders that are designed for use with this tape therefore offer a slower, long-play speed, to extend the playing time. S-VHS employs a higher-specification tape to eliminate video problems such as flickering colors in areas of the subject that have a finely striped pattern. Betamax has fared less well. It is obsolete as a domestic format. The high-quality Beta SP runs costly metal tape at high speeds.

Another important recent format is Video 8, which uses tapes only 8 mm wide. This tape format offers quality as good as standard VHS, and Video 8 has the advantage over VHS-C of a running time of 90 minutes

at standard speed, or three hours at long-play settings. Another advantage is that the format encodes the video and audio signals together, which means that the audio signals can benefit from the high writing speed traditionally reserved for the video tracks. The format has a slight drawback in that few VCRs are available that accept its tapes; there are also few prerecorded Video 8 tapes available. This means that your tapes have to be played back via the camcorder, which you connect to the television as you would your VCR.

As well as the tracks containing the audio and video information, video tape contains a control track. This provides a field sync pulse, which controls the video image along with another sync pulse – the line sync – which is contained within the video information itself. The field sync pulse is normally laid down along one edge of the tape. A separate stationary record/replay head monitors the pulses on the tape and adjusts the speed accordingly.

FORMATS

In a field that changes as rapidly as video, one of the major concerns is to choose the right format of equipment. In the past formats have come and gone with alarming speed, with the result that many prospective purchasers are frightened of ending up with equipment that will be almost immediately obsolete. Fortunately, although there are many changes ahead, several video formats have established themselves as leaders in domestic video.

VHS

The most widespread format for prerecorded tapes is VHS, or Video Home System, which was introduced by JVC in 1976. It uses a tape cassette that contains two reels for the tape, and employs helical scanning. The standard tape speed is 0.92 inches per second (2.339 cm per second). This gives very good definition because of the fast-spinning record/replay heads; these move across the tape at 1800 rpm in the USA (1500 rpm in Europe), so that over 16 ft (5 m) of tape can effectively

pass under the heads every second. The sound is recorded on a separate audio track through a stationary audio head. This means that the format has a tendency to produce hiss on the soundtrack. Some manufacturers have tried to overcome this by including noise reduction systems of the type often found on audio recorders. The fact remains, however, that sound quality is the major weakness of standard VHS equipment.

The standard speed gives a maximum of four hours' recording or replay in Europe. In the USA and Japan a range of different speeds is available, giving up to 6 hours of programming on a single tape. Naturally there is some loss of quality at the slower speeds, and some manufacturers include a second pair of heads, with a narrower head gap, for use in slow-speed recording and playback. The popularity of the format means that a wide variety of VCRs is available for use with VHS tapes, from basic models to those with ultra-sophisticated timing and playback facilities. However, not all these features are as useful as they seem (see p. 28).

VHS
This format, developed originally by JVC in Japan, has now become the standard half-inch domestic format. It runs for up to four hours, or eight hours in the long-play mode. The most recent developments, with high-grade tape formulae and "Super-VHS" recording, give almost broadcast-quality results.

A variety of camcorders has also been produced for the VHS format. Many of these appear rather large and bulky compared with those of the smaller formats – the size of the cassette makes a large machine necessary. But this may not be such a drawback as it seems. Large camcorders are actually easier to hold steady than smaller models.

VHS-C

Manufacturers have overcome the problem of the bulk of the standard VHS cassette by producing a compact VHS cassette. This format, known as VHS-C, uses tapes that play for 30 minutes at standard speed. The camcorders have similar advantages and disadvantages to their standard VHS counterparts, except that they are much more compact. You can play back VHS-C cassettes in a standard VHS VCR by means of a special adaptor. This is the size of a standard VHS cassette. You insert the VHS-C tape into the adaptor, put the adaptor into the VCR, and the tape path is altered to make playback possible.

Super VHS

This format uses tapes and cassettes of the same size as standard VHS. But by upgrading the tape and modifying the recording and playback equipment, the manufacturers have provided higher quality. This results in excellent picture quality, but it is vital to have S-VHS equipment – you cannot play back the tapes on standard VCRs. The tapes offer a longer running time than VHS-C and are capable of excellent sound quality with the right playback equipment. Not surprisingly, the tapes cost more than their standard VHS counterparts. There are also Super VHS-C tapes, offering a combination of high quality and compact size.

Video 8 and Hi-8

The smallest of the currently available tape formats, Video 8 uses 8 mm tape in cassettes roughly the same size as audio cassettes. The high quality metallic tapes mean that quality is not sacrificed, however – results are at least as good as standard VHS. What is more, camcorders can be very compact and sound is excellent when good quality audio equipment is used to play back the tapes. This is because the sound is recorded at the same high writing speed as the picture information. This leads to one drawback – the sound and picture cannot be erased and dubbed separately during editing. The lack of compatible VCRs is another disadvantage. Hi-8 is a high-resolution version of this format, offering even better quality pictures and superb sound.

Betamax

You may still come across Betamax video equipment. This was a format introduced by Sony which is now obsolete. If you have a Betamax VCR and are thinking of making your own recordings, you therefore will have to change format, since Betamax camcorders are no longer manufactured today.

VHS-C (above)
A compact alternative is the VHS-C cassette. It runs for a maximum of 30 minutes at normal speed, but needs an adaptor if it is to be played back on a domestic VCR. The advantage of this arrangement over Video-8 is that replay is first-generation.

Video-8 (below)
These small cassettes have astonishing capacity, running for up to 90 minutes at standard speed. For editing, the recording can be transferred to a VHS machine, although some 8 mm recorders are available.

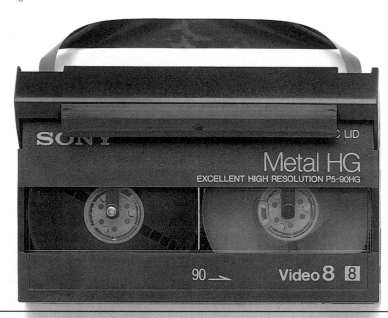

CHOOSING A VCR

In many ways choosing a VCR is no different from choosing any other consumer item: you get what you pay for, and you should beware of paying for facilities that may be beyond your needs. Cheaper VCRs can give excellent pictures, and if that is all you require, a simple model should be enough for you. If you require the best sound quality, however, and the potential to edit tapes, you will have to pay more.

Picture quality

This is the most important factor when choosing any VCR. Almost all modern VCRs will return pictures of acceptable quality – with around 240 lines horizontal resolution – if you use good tape. The difference between the most costly and the cheapest models only becomes apparent when you are copying or editing – especially when you are making several "generations" of copies. Look for the specifications on the tracking control. On a modern VCR this should be digitally regulated, and will apply not only to the normal and long-play modes, but also to such special effects as freeze-frame and shuttle search. Such a tracking control is essential for picture stability in all these modes of replay, and it is more convenient if the machine carries out the process for you, rather than leaving you to fiddle around for yourself. Some VCRs also have variable sharpness, but this is a luxury that should not really be necessary.

Sound

There is far more variation in sound quality than in vision replay performance. In VHS, the most popular format, you will find models offering stereo, and true hi-fi encoded sound. In Europe, you will find also VCRs with ability to decode NICAM stereo signals to give superb CD-quality sound.

The inputs and outputs on the back of the VCR will also affect the quality of the sound you can produce. You should have separate audio-video in-and-out phono sockets, as well as a SCART terminal for connection either to another VCR or a suitably-matched TV. With these connections, you can position your television and VCR between the speakers of your audio system, and have cinema-quality sound. In addition, the sound signal now being transmitted contains a very low bass component. This requires an extra-low-frequency speaker at the back of the room. The output of this so-called "woofer" is routed through the TV receiver rather than the VCR.

Another facility, available on more expensive models, is that they can be used, in long-play mode, as purely audio recorders. They offer up to 8 hours of recording time per tape in matchless CD-quality digital stereo. This gives the possibility of recording all Beethoven's symphonies on a single tape with a signal-to-noise ratio and frequency response as good, if not better, than CD.

The timer

This is a feature that can be vastly over-sophisticated. The multiple programs that are available on some models are too powerful for most normal use. The proliferation of control buttons that come with the more excessive modern timers is often counterproductive – especially when you are in a hurry. So examine the timer controls carefully before buying and decide how easy they are to use. Several have LCD readouts on the keypad; others use barcodes to read program information; another type offers an on-screen display so that you can keep tabs on the programming as you go. Features like this can be worthwhile if you find that they make the timer easier to use. But avoid spending extra money on 12-program timers that you will never use. By contrast, the simple "one-touch" recording system found on some models is easy to use and has much to recommend it.

High-tech video

If your ambitions stretch a little further than simple recording and playback, you might be interested in a recorder that takes S-VHS. For this you will need an S-socket; the decoder is incorporated in the VCR. Such a machine will play normal VHS tapes but the picture quality is vastly superior, with about 400 lines horizontal resolution as opposed to the usual 240.

Such VCRs are excellent, but need to be used with high-quality evaporated-metal tapes to realize their full potential. These cost three times as much as the older ferric or chrome types. In addition, it is essential to have a television receiver of comparable quality to the VCR if you are to get the full advantage of the picture quality. For movie-making, you will need a camcorder to match of the same quality, too.

Editing connections

When choosing a VCR, you should bear in mind that you may want to use it as an editing machine. This is an area where the great variation in VCR specification means that some machines are much better than others. Some give you exact control over the freeze-frame, with beautiful forward-and-reverse operation at varying speeds. At the same time, the recorder may allow you to control the input machine, which may be a camcorder linked to the VCR through a remote-edit connection. This is an invaluable feature for editing.

Other, more modestly priced VCRs, simply do not have the sockets and facilities needed for editing. If you are intrerested in editing – or think you might become interested in it – look carefully at the editing facilities on the machines you are considering, and make sure the VCR you choose is compatible with your camcorder and any other equipment you have.

Super-VHS

This format, also known as S-VHS, has a bandwidth much broader than standard VHS, giving a resolution of 400 lines, as opposed to the 260 lines of the standard format. The result is a picture of near-broadcast quality, though you must have an S-jack socket on the VCR, which in turn must be S-VHS compatible. So, too, must the television if you are to obtain the full benefit of the format.

CAMCORDERS

Early video cameras worked by using a lens to gather light from the image, which was then passed to a pick-up tube. This created a small electrical current that varied with the intensity of the light. The current was then passed to a separate portable VCR, which contained the tape on to which the picture was recorded. This cumbersome set-up meant that the camera operator had to carry two bulky pieces of equipment. A radical change came about when equipment manufacturers managed to combine both items in one unit – the camcorder.

Early camcorders still used pick-up tubes. But they were abandoned when a chip called a charge-coupled device (CCD) was adopted instead. A CCD is more reliable than a tube, more sensitive, and more compact.

The decreasing size of video tape has led to camcorders that are in some cases little bigger than conventional 35 mm still cameras. Such camcorders are highly portable and very unobtrusive. But they are also less easy to

hold steady than their larger counterparts. Generally, the larger models are designed to be carried on the shoulder, with the viewfinder at the side, meaning that they can be held firmly against the side of your head. Smaller camcorders usually have a rear viewfinder and are designed to be held in front of the face. While this is a good position for a still camera, it is not always ideal when you want to move around during a shot.

The other major trend has been towards greater automation and electronic sophistication. Automatic exposure, autofocus, and motorized zoom lenses are now the norm. Such features make camcorders beguilingly easy to use, but they can also make them less versatile. Experienced video makers often want to override the camera's automatic settings or perform a zoom manually, and many machines do not allow you to do this. You will also have to consider which format you want, and how versatile your chosen camcorder is when it

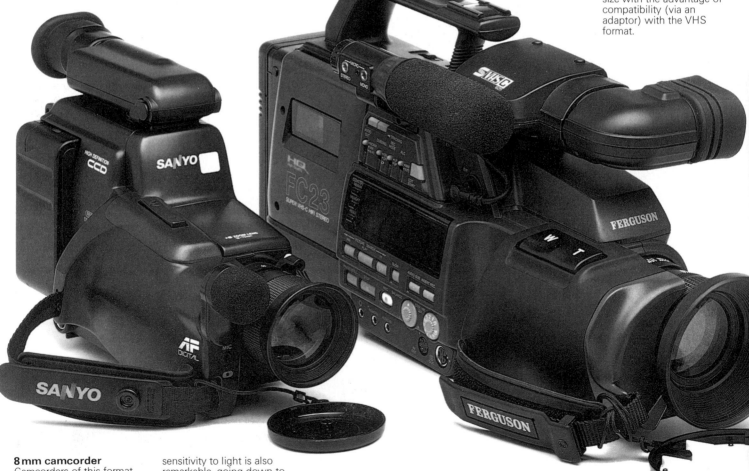

VHS-C camcorder
Camcorders like this offer the convenience of small size with the advantage of compatibility (via an adaptor) with the VHS format.

8 mm camcorder
Camcorders of this format have outstanding sound and, because they use metal-evaporated tape, very fine image quality. The sensitivity to light is also remarkable, going down to 5 lux. Unfortunately, tapes have to be transferred to VHS for editing and most domestic uses.

comes to connecting other equipment – does it allow you to connect an external microphone, for example, and how flexible is it when it comes to editing? You should also familiarize yourself with the range of facilities available on current models. When you have limited your choice to two or three models, go to a reputable dealer and ask to try them all. It will probably be factors that are difficult to detect from the printed specification – such as how easy you find it to hold the camera steady or exactly what you can include in the frame with the zoom lens – that will finally sway your choice.

Lightweight camcorder
This Sony Video-8 camcorder is currently the smallest and lightest high-quality camcorder on the market. It weighs just over 2 lb (1 kg).

VHS camcorder
This full-scale VHS camcorder has enough facilities for the most demanding operator – including ''trick'' editing effects and titling. When plugged into the main electricity supply, it can run for 3 or 4 hours – or twice that in long-play mode. A tripod is therefore useful for this heavy camcorder.

WHAT A CAMCORDER CAN DO

A video camcorder is a complex piece of equipment, but its basic elements can be divided into three main areas: the optical components (the zoom lens and its controls), the electronics (the components that control the video signal itself), and the motor and controls of the recorder. In addition there are components controlling the sound, and a power supply for the entire machine, which usually comes from a rechargeable battery.

The lens

A zoom lens is normally fitted as standard. This type of lens allows you to vary the focal length, and therefore also the angle of view, so that you can magnify distant subjects or pull back to include a broader, closer scene. If you are used to still photography, you will find that the angles of view of the different focal lengths do not correspond to those of 35 mm cameras. What is more, these angles of view vary from one camcorder to another, because of the different sizes of the camcorder chips. The cardinal rule is therefore to try any zoom lens before you buy, so that you can see for yourself exactly what its capabilities are. (For more information on zoom lenses, see p. 38.)

Various controls are linked to the lens. An exposure meter monitors the available light. The camera then adjusts the iris in the lens to allow the optimum amount of light through. The ability to override this automatic exposure system manually is desirable, since automatic cameras can be misled in certain lighting conditions, such as backlighting (see p. 42). Even if the camcorder does not allow actual manual setting of the iris, a backlight control may be available to adjust the iris by a fixed amount (usually 1.5 stops) when you encounter a backlit subject.

The focusing of the lens is also usually controlled automatically. Again it is useful to be able to focus manually in some situations. In particular, some auto-focus systems are misled by reflective surfaces, or focus only on a subject if it is in the center of the screen. So look for the ability to focus the lens manually, or for a design that allows you to focus on subjects even if they are not in the middle of the frame.

Many zooms have a macro setting. This allows you to focus much more closely than the normal closest focusing distance of the lens. You can produce, therefore, quite dramatic shots of small subjects, such as insects.

The simplest feature of the lens is also one of the most important – the lens cap. This protects the vulnerable surface of the front glass element; it also provides some protection for the electronic components inside the camcorder. You should remove the lens cap only when you are about to start shooting. On most models, the lens cap is attached to the camcorder by a length of cord or plastic, so that it is always ready to be put back on the lens. Otherwise, it is easy to lose the lens cap.

The electronics

You will be aware of how well the camcorder's electronic circuits are recording the picture via the viewfinder. At present, all but one viewfinder gives a black and white image. This is adequate for judging exposure and framing, but color has to be assessed on a monitor or on playback. This has led some manufacturers to produce miniature, clip-on monitors that attach to the side of the camcorder itself. These provide a useful half-way house between a proper monitor and a color viewfinder, although their color rendition is not always very good.

The most important color control is the white balance, which sets the camcorder's circuits for either indoor or outdoor lighting. Most models can do this automatically; some also give you a manual option (see p. 50).

There may also be a low light control. This boosts the video signal electronically in poor lighting conditions. This can be useful when you need to shoot in low light and there is no way of adding artificial illumination. But, unfortunately, the boosting of the signal also results in increased video "noise".

The fade control enables you to end a shot with a gradual fade to black or white. This can be useful, especially when you are not planning to edit your coverage later.

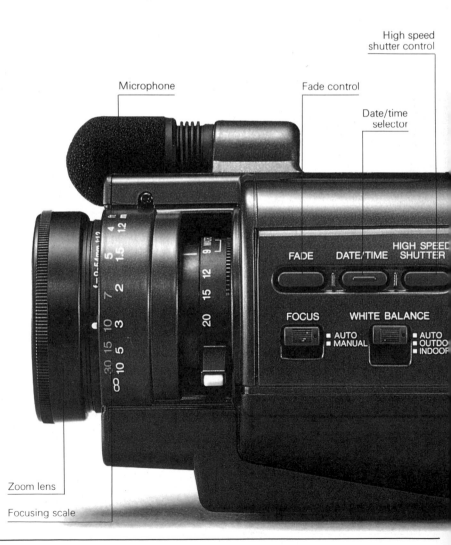

Microphone

Fade control

High speed shutter control

Date/time selector

FADE DATE/TIME HIGH SPEED SHUTTER

FOCUS WHITE BALANCE

AUTO / MANUAL

AUTO / OUTDOOR / INDOOR

Zoom lens

Focusing scale

Tape-transport controls

Since the camcorder contains the basic components of a VCR, it has, as you would expect, a set of buttons that controls the movement of the tape on playback – play, stop, rewind, and fast-forward. These often are hidden beneath a sliding panel at the back of the camcorder, to protect them while the machine is being used for recording.

Another useful tape-transport control is the record-review button. This allows you to make a quick check of your last shot by replaying the last section of the tape that has been recorded. It saves a great deal of time winding back to where you want to start replaying, and, since it is not always easy winding back to exactly the right point, it helps you save on batteries, too.

More modern machines also have "logic-control". This means, for example, that you can go straight from fast-forward to play without the camcorder having to stop in between. This is clearly useful when you are operating the machine in a hurry.

Inputs and outputs

Like most pieces of electronic equipment, a camcorder has various input and output sockets for the connection of other items. The most prominent of these jacks are usually those used for playing back and monitoring recordings. There may be more than one socket for this purpose – one for connection to a television receiver, another for linking and camcorder to a VCR. There also may be sockets for connecting S-VHS equipment.

In addition, you also may be able to connect the camcorder to an alternative power supply via a DC input, which can be useful if you want to use a car battery or the main domestic supply via an adaptor.

Finally, there may be jack sockets for sound. You may be able to connect an additional microsphone, or to monitor the sound through a pair of headphones.

Because the actual number of socket types is vast, and varies according to manufacturer and country of origin, you will probably need some adaptor leads. These may be expensive, but be sure to get them right.

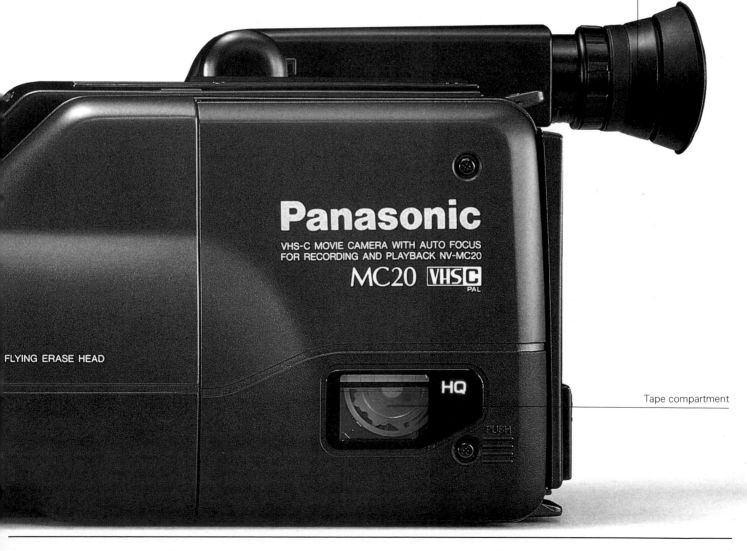

Electronic viewfinder

Tape compartment

Panasonic
VHS-C MOVIE CAMERA WITH AUTO FOCUS
FOR RECORDING AND PLAYBACK NV-MC20
MC20 VHSC PAL

FLYING ERASE HEAD

HQ

PUSH

ADVANCED CAMCORDER FEATURES

Most of the features described on the previous pages are common to all current camcorders in one form or another. But some of today's camcorders offer additional features that can make video-making easier, or enable you to shoot in a range of difficult conditions. You have to decide whether you will need any or all of these extra features. If you are undecided, it is a good idea to rent one or two different machines before paying out the considerable extra expense that a higher specification camcorder will entail.

"Super" format

Rather than buying a standard VHS machine, you should consider buying one that allows you to use S-VHS cassettes, or a Video 8 machine. Both of these will deliver high quality pictures and sound, and will probably come with a host of additional recording features that you will find useful. Remember, though, that the rest of your equipment will have to be up to standard if you are to take full advantage of the quality offered by these formats.

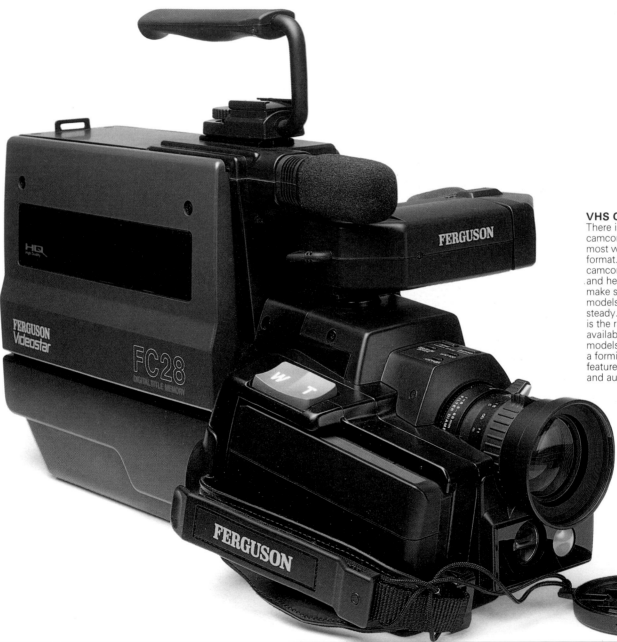

VHS Camcorder
There is a good choice of camcorders for this, the most widespread domestic format. Most VHS camcorders are quite large and heavy, but this can make shoulder-mounting models easier to hold steady. Another advantage is the range of features available. Even quite basic models, like this one, offer a formidable array of features, such as insert edit and audio dub.

High-speed shutters

One camcorder feature that is often neglected is the high-speed electronic "shutter". Some designs are adjustable, allowing you to select different speeds, rather as you might on a still camera. High shutter speeds are useful for cutting down the blur when you are recording fast action. They are also used in conjunction with the iris on the lens as a way of controlling exposure. Some camcorders offer a choice of 1/250, 1/500, or 1/1,000 sec shutter speeds.

Enhanced autofocus

Look out for improvements in autofocus systems. Early video autofocus mechanisms often were misled – especially by "difficult" subjects such as glass and water. But more and more manufacturers have improved their autofocus to get over these problems (see p. 40).

Editing facilities

If you are new to video, you may feel that simply shooting is enough for you and that editing is something to leave to the professionals. But you will soon find that you want to improve the tapes you have made after you have shot them. It is therefore worth planning ahead and buying a camcorder that has a few features that you will find invaluable when editing.

Look for "flying" erase heads that will give smooth transitions when you are joining different parts of a recording together – your dealer should be able to advise on this. Another feature that helps transitions from shot to shot is the ability to fade in and fade out. An audio dub control is also useful as it allows you to add extra sound to your tapes and is essential if you want to add a commentary or background music to your finished tapes. Hi-fi stereo is advisable for this.

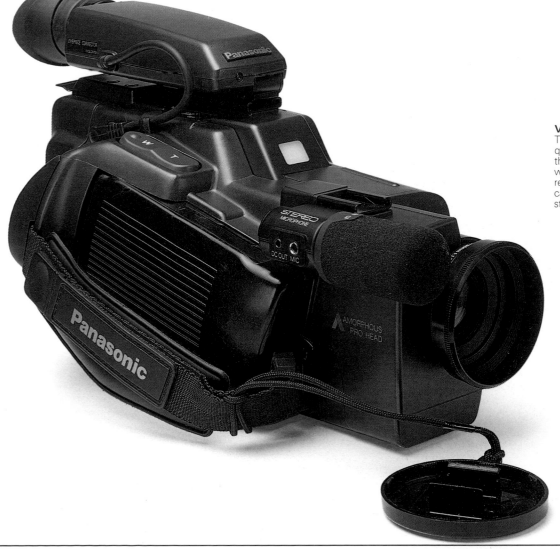

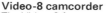

Video-8 camcorder
The Video-8 format uses quarter-inch, rather than the usual half-inch, tape, with a corresponding reduction in the size of the camera. It also gives superb stereo sound.

ADVANCED CAMCORDER FEATURES

Adding titles

Some machines include their own character generator, so that you can add text to your tapes. This seems an attractive option, but you will find that the range of effects is rather limited and your efforts will lack the polish of professional television titles. So, although a character generator may have limited use, you might find it more satisfying to create your titles in other ways (see p. 168).

Versatile lenses

Pay particular attention to the lenses on the camcorders you are considering. The standard zooms on many camcorders are somewhat limiting. The zoom range itself may be too restricted for your requirements. Many machines feature a $6 \times$ zoom, whereas if you intend to make movies in areas where you are likely to be a long way away from the subject – for example in sports or wildlife – it may be worth investing in a longer range. A

$10 \times$ or even a $12 \times$ zoom may be the answer.

A yet more flexible solution is to go for a camera that accepts interchangeable lenses. Only machines aimed at the top of the market offer this facility, but it is worth considering. For some models special adaptors are produced, which allow you to attach interchangeable lenses from 35 mm still cameras. So if you already have a still camera system, this could be a good way of extending the versatility of your video system.

A word of warning

Do not be so beguiled by the potential of the latest camcorders that you ignore the rest of your equipment. No camcorder will realize its potential unless it is matched with playback equipment of comparable quality. What is more, fairly simple extra equipment, such as a firm camera stand or tripod (see p. 56), can improve your results more than a host of features that distract you from such basics as planning your shots, framing them effectively, and keeping the camera steady.

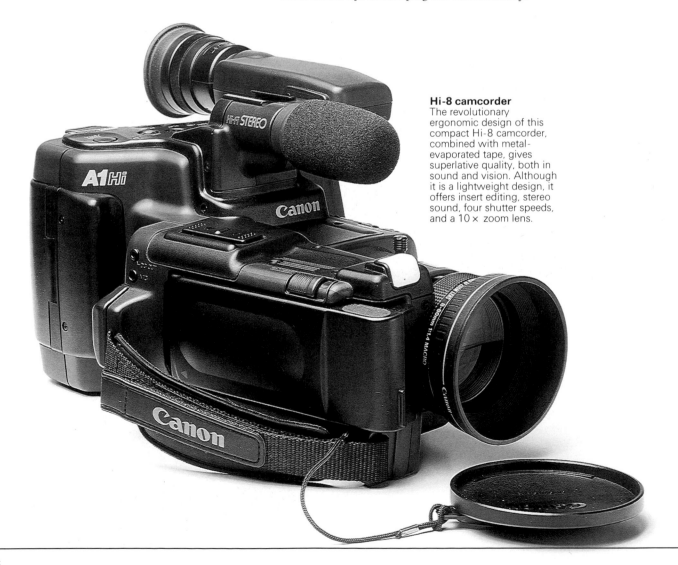

Hi-8 camcorder
The revolutionary ergonomic design of this compact Hi-8 camcorder, combined with metal-evaporated tape, gives superlative quality, both in sound and vision. Although it is a lightweight design, it offers insert editing, stereo sound, four shutter speeds, and a 10 × zoom lens.

Operating the camcorder

When you have worked out which of these many features you want, try to arrange to test the camcorder of your choice. Begin by looking at the various switch settings on the camcorder – especially the white balance, and any switches that allow you to select manual or automatic focus and exposure. To start with, it may be best to set these to "automatic".

Next put in a fully charged battery. When you switch on the camcorder's power control, any LCD displays should start to function. The next stage is to press the eject button to open the tape compartment, and load a blank cassette.

Most camcorders have a monitor control. Pressing this allows you to point the camcorder at the subject and rehearse any shots you want to record. You will be able to see an image in the viewfinder, but the tape will not move. This allows you to check exposure, focus, and zoom settings. When you are satisfied, press the record and start buttons to begin recording.

Regular VHS camcorder
A full-size VHS camcorder has the great advantage that every conceivable feature can be built-in. There is a penalty in terms of weight, but the camcorder is easier to hold steady than a lightweight model. There is the added bonus of a longer running-time – up to four hours on AC – for lengthy takes.

THE LENS

We first experience a lens when we open our eyes. The flexible lens inside the human eye focuses the incoming rays of light so that they form an inverted image on the retina at the back of the eye, in the same way that a magnifying glass (the simplest form of lens) will focus the sun on a piece of paper. The distance between the lens and the "target" (in the case of a video camera, a video tube or CCD chip) where the light will be focused is the focal length of the lens.

Focal lengths are measured in millimeters. As the focal length varies, so will the magnifying strength of the lens and the size of the image at the focal plane. The longer the focal length the narrower the angle of view, and vice versa. A lens of long focal length (a telephoto) enlarges the image while giving a narrower angle of view. The opposite is true of a lens with a shorter focal length – a wider angle of view is delivered to the "target". Some lenses have a single fixed focal length: these are known as prime lenses. Other lenses, including those most often found on camcorders, have a variable focal length and are called zoom lenses.

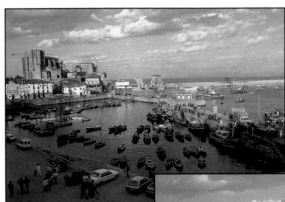

Wide-angle image
With the lens at its widest focal-length setting, a broad view of the subject can be seen. This is useful for panoramic landscapes – and for interior shots where you want to include the whole of the room in the frame.

Telephoto image
Zooming in to the telephoto end of the lens allows you to select details. It also creates the effect of compressed perspective, making distant objects seem much closer than at the wide-angle setting.

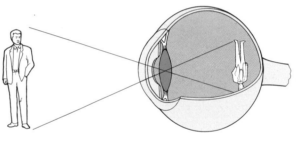

The human eye
In the eye, the image arrives at the retina inverted and the retina is round. But it has some qualities in common with television, particularly its red, green, and blue "rods", which resemble the colored phosphors that make the TV image.

Controlling the light
Like the human eye, video cameras work best in certain lighting conditions, so both zoom and prime lenses need some means of controlling the amount of light falling on the image-plane. This they do (again as in the human eye) by an adjustable iris, which opens and closes to regulate the intensity of light travelling through. The iris controls the effective aperture of the lens, and the range of different aperture sizes allowed by the iris is shown by so-called f-numbers or f-stops. These numbers are a mathematical expression of the relationship between the aperture size and the focal length of the lens. The wider the aperture, the smaller the f-number; the narrower the aperture, the higher the f-number. So in dark conditions you might use an aperture of f1.2, while in brilliant sunlight on snow, the lens might be stopped down to a tiny f22 to reduce the light. A lens with a large maximum aperture (and a small f-number) is known as a "fast" lens, since it can gather more light during any given time of exposure than a "slower" lens. Aperture has other important effects, for example on focus (see p. 40), where it affects depth of field.

The effect of aperture on exposure

Wide aperture
In dark conditions, the lens aperture must be opened up wide – just as the pupil of the eye dilates to take in more light. But in normal conditions, too wide an aperture may result in an over-exposed shot.

f1.4

Medium aperture
When the aperture of the lens is accurately matched to the lighting conditions of the subject, exactly the right amount of light is allowed onto the film, and the shot will be correctly exposed.

f11

Small aperture
In bright conditions, the lens aperture must be "stopped down" – just as the pupil of the eye contracts to take in less light. But in normal conditions, too small an aperture may result in an under-exposed shot.

f22

Prime lenses

In the early days of photography prime lenses were the norm. Nowadays in video, zooms are more common, but prime lenses are still valuable if they can be attached to a camera with an interchangeable lens mount. This is particularly true for telephoto lenses. Here the effective magnification of the image is much greater than on, say, a 35 mm still camera. A very powerful 1,000 mm lens on a still camera would become the equivalent of a 6,000 mm lens when fitted to a camcorder – a true telescope, in fact. There are no such advantages with wide-angle prime lenses. Here it is best to use screw-on adaptors.

Zooms

A zoom lens is a lens that has a variable focal length, and therefore a variable angle of view. It contains a dozen or more glass elements, which fall into three groups: a prime lens group at the rear, which does not normally move; the zooming group, which can be moved in and out to vary the focal length; and the focusing group, which rotates to adjust the focus.

The zoom lenses on almost all modern home video camcorders can be electrically driven. Zooming is usually controlled by a rocker switch controlled by the first fingers of the right hand. Better models allow you to vary the speed of the zoom, but manual zooming is often more flexible and more sensitive, so look for a model that allows the motorized zoom to be overridden. It is worth rehearsing really smooth manual zooming.

Choosing a zoom lens

Consider your real needs when selecting a zoom lens. The most important factors to bear in mind are: the zoom range and ratio; the maximum aperture of the lens; the bulk, weight, and balance of the lens; and whether the zoom is motorized and, if so, whether the speed can be varied or the motor overridden. Variable speed is a useful but often costly option.

The zoom ratio is the multiplication factor between the wide-angle and telephoto limits of the zoom. For example, if the zoom goes from 10 mm to 100 mm, it has a zoom ratio of $10 \times$. More common ratios are $8 \times$ or $6 \times$. A high zoom ratio does not necessarily mean a better lens. You have to look at the lens's performance at the settings at which you are most likely to use it. In fact, zoom lenses are usually most stretched at the so-called wide-angle end, precisely the range of focal lengths used for indoor and family shots. You are more likely to use the telephoto end for action, wildlife, and landscape work. So match the zoom to the sort of filming you are most likely to be doing. Remember that long telephotos are of dubious use unless well supported, and that they are usually heavier, longer, and have slower maximum apertures than shorter lenses.

Another point that should influence your choice is the fact that cameras have different-sized "target" areas. Current camcorders have $\frac{1}{2}$ in or $\frac{2}{3}$ in diameter chips. For a $\frac{1}{2}$ in chip, 9 mm is quite a wide-angle video zoom; with a $\frac{2}{3}$ in chip you would need a focal length of 12 mm to produce an image of the same size. What really

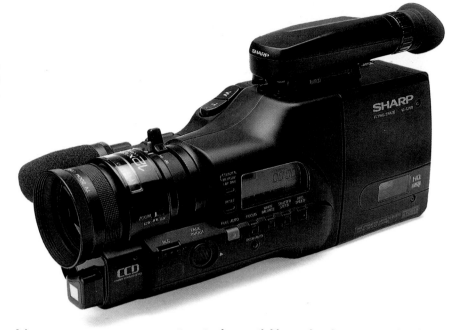

A long zoom
The zoom lens has now almost entirely replaced prime lenses where camcorders are concerned. This model has a zoom ratio of 12 ×. Its focal lengths range from 8 mm at the wide-angle end, to 96 mm at the telephoto end. The long telephoto settings are useful for subjects like wildlife and sports, but the camcorder needs firm support at these focal lengths.

matters is the available angle of view, not the focal length of the lens in millimeters. The simplest way of judging this without a calculator is to try the competition at their widest settings, side by side, in the store, and compare the angle of view for yourself.

Using a zoom

The most important rule when using a zoom is not to overuse it while actually recording. It is best to think of the zoom as a convenient way of carrying a sackful of different prime lenses and to set the focal length before each shot. Only use the moving zoom in vision when you have a specific reason or when you are aiming for an especially dramatic effect. For drama, you can use a manual zoom for extra speed, provided that you prefocus before zooming in. Otherwise, there is nothing more tiring to watch than a series of zoomed shots – especially if pans or tilts are being carried out at the same time. Worse still are half-zooms, when viewers are not really sure where the shot will end up. So choose the shot, rapidly select the framing with the zoom, hold the subject, and have the confidence not to zoom around. A well executed zoom, carefully placed amid more static shots, is too valuable an effect to squander.

When you are preparing to zoom in, preview the end of the shot for focus and composition before actually shooting. If you do not do this, the autofocus may not be able to cope without visibly "hunting" for the end-subject as you go in. Conversely, when preparing to zoom out, make sure you have a satisfactory point of arrival to aim for, so that you can use to good advantage the dramatic revelation in the zoom-out. In both cases, always have a brief hold at the beginning and end of each zoom. This will be invaluable in editing.

FOCUS AND FOCUSING

Once the light from your subject has passed through the camera lens, its rays converge to form an inverted image on the chip or tube at the focal plane. If the lens is either too near or too far from the focal plane, the image will be blurred. So you can alter the distance from the focal plane by twisting the focusing ring in or out, either manually or electrically.

Most of the lenses on modern cameras will have autofocus, but it is often best to work the lens manually, to give more precise control. For this reason, an auto-focus lens with manual override is preferable. There is no real problem at the wide-angle end of the zoom range, because the short focal length gives more latitude in focusing. But at the telephoto end you have to focus precisely, and when zooming in it is best, if there is time, to pre-focus.

Even with purely static manual shots, it is best to zoom in first, focus the lens, and zoom out again before actually recording the shot. This will ensure maximum sharpness because the telephoto end of the zoom is so much more accurate for focusing.

Autofocus
There have been several varieties of autofocus used over the past few years. The most durable have been infrared (IR) and various through-the-lens (TTL) systems that

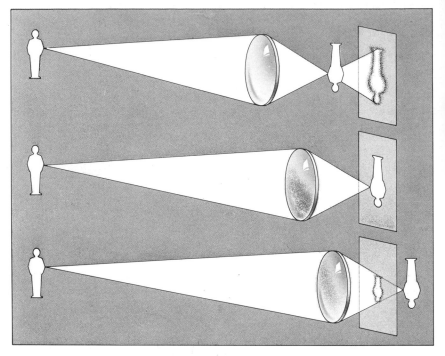

Point the camera
Set up the camera at the required distance and frame your subject in the viewfinder.

Zoom in
Zoom to the telephoto end of the lens. It is a good idea to zoom manually while focusing as this will help to conserve the batteries.

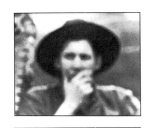

Focus on the subject
In the case of a person, focus on the subject's eyes. For more complex shots, choose a point one third of the way into the range which you wish to be in focus.

Zoom out
When sharply focused, zoom back out to the required focal length for the shot. The increased depth of field will guarantee accurate focus throughout the shot and during a subsequent zoom-in.

attempt to identify the area of maximum contrast. Optical TTL systems have been most popular, because of technical problems with IR, and these systems come in two main forms: one uses the camera's CCD itself and the other has a separate chip, but with both, the aim is to get the greatest degree of contrast at the focal plane.

There are several problems with autofocus systems for video work. One is with moving subjects, when the autofocus system often does not know which subject to choose and "hunts" between two parts of the picture. A similar thing can happen with scenes such as a river shot through the sharply defined branches of a tree – the tree, and not the river, will be selected. Many systems also have problems with shooting through glass or water, or when the main subject is not in the center of the frame. You may also have difficulties with optical TTL autofocus in low-light or low-contrast situations. Manual override is the best way of overcoming this.

Recent autofocus systems provide good ways around some of the difficulties. Sometimes you can select an area of the subject and then "freeze" the point of focus during subsequent movement. Some cameras allow you visibly to alter the metering area by moving a white square in the viewfinder. Others have sophisticated memories that stay with the main subject wherever it moves; and a new "piezo" system gives good results through glass, and allows autofocus in the macro mode. These developments are impressive, but manual override is still invaluable in many situations.

Aperture and focus
The prime function of the lens aperture is to regulate the amount of light entering the lens. But it also has an effect on the range of distances that appear to be in focus at a

Eyepiece adjustment control
Adjustable eyepieces are calibrated in "diopters". On most cameras, they vary from plus or minus two to three diopters.

given focal length. This range of distances is known as the depth of field.

Whatever the aperture, there will be an area behind and in front of the main point of focus that is also adequately sharp. The depth of this area will be greater with a small aperture, and shallower if the aperture is a large one.

On video cameras you can only alter the aperture by using the back-light control to open the iris by about $1\frac{1}{2}$ stops when shooting into the light. More sophisticated models have variable manual override. You can also change the depth of field by changing focal length: the longer the focal length, the shallower the depth of field. Making the depth of field shalllower can be especially useful if you want to throw unwanted areas of the foreground or background out of focus.

The Piezo system

In the piezo system, the sensor chip is mounted on a wafer of quartz crystal which physically bends when an electric current is applied to it. The crystal vibrates about 12 times per second in the image plane, and its output is maximized to reflect the best point of focus on the chip itself. The resulting signals are compared and passed to the lens control. The system is said to work well through glass, and to reduce "hunting" by minimizing the need for the lens to move back and forth.

The effect of aperture on depth of field

Wide aperture
The wider the aperture, the shallower the depth of field. At a lens setting of f1.4, the small girl is the only part of the scene in sharp focus. The trees on either side of her are out of focus.

f1.4

Small aperture
The smaller the aperture, the greater the the depth of field. With the diaphragm stopped down to f22, both the girl and the two trees are within the depth of field and are therefore in sharp focus.

f22

The effect of focal length on depth of field

Telephoto position
The longer the focal length of the lens, the shallower the depth of field. In this shot, taken with the zoom lens in the telephoto position, only the subject and one of the columns are in sharp focus.

75 mm

Wide-angle position
The shorter the focal length of the lens, the greater the depth of field. In this shot, taken with the zoom lens in the wide-angle position, the subject and all the columns are in sharp focus.

10 mm

LIGHT AND EXPOSURE

Light comes from both natural and artifical sources, which vary both in their intensity and quality. The most obvious, and in many ways the most important of these is the sheer quantity of light. The amount of light will affect the brightness of the subject, and may even determine whether or not you can record certain subjects at all.

Light intensity is measured in foot-candles or their metric equivalent, lux (lumens per square meter). The amount of light depends on the power of the source and its distance. The relationship between these two factors follows the inverse square law, so that doubling the distance of the subject from the light source produces illumination of a quarter of the previous brightness. You do not have to worry about this law when shooting in sunlight, because the sun is so distant. But it becomes very important when you are using interior lighting.

Apart from brightness, the other aspects of lighting that are important for video are contrast, direction, and color balance. For a satisfactory result these all need to be considered, though, fortunately, modern cameras will do much of the considering for you.

Brightness

The eye can see in a tremendous range of lighting conditions – from bright sunlight to darkened rooms. Many manufacturers claim that their cameras can perform well in light below 10 lux, which is too dark to read in. But, although an image may be recorded in these conditions, it may be grainy and have poor color rendition.

There is a medium area of soft daylight with not too much difference between highlights and shadows within which any camera performs best. The camera's exposure system is designed to allow this level of light to fall on the tube or chip at any one time. The main mechanism for achieving this is the iris (see page 38), which opens and closes as the camera's light meter measures the light entering the camera. Below a certain level of brightness, when the iris is wide open, the sensitivity of the tube or chip may be increased by an automatic gain control. At this point you will probably see some deterioration in color fidelity and graininess. If there is inadequate illumination to record a picture, a warning light usually flashes in the viewfinder.

Contrast

High-contrast lighting is very dramatic, but much of the light we enjoy is too contrasty for the quite narrow tolerances of film and video. Indoors, artificial lighting is usually the solution (see page 88). Outdoors, the most flattering view of a person or place can often only be achieved by shooting towards the sun. But the sun is too strong, and with a normal automatic exposure setting you may end up with a dark main subject. The answer is to open up the iris by about one-and-a-half stops so that the subject, rather than the brilliant background, is exposed correctly. You can normally do this with a backlight control (BLC) switch on the camera. The result is visible in the viewfinder. Alternatively, you can leave the shot uncorrected, and go for a silhouette effect.

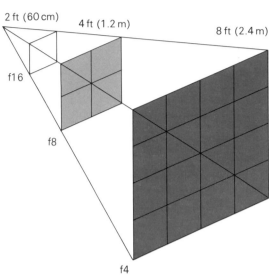

Inverse-square law
Light from any given source decreases in intensity as the square of the subject's distance from the lamp. This is important when you are using artificial lights indoors, especially if you are setting the exposure manually.

Noise
This can appear on the screen in the form of bars – especially in still-frame or fast-forward replay.

Lag
In poor light, highlights, like these candles, can produce streaks when you pan the camera. Many modern camcorders, with their CCD chips, have overcome this problem.

Graduated neutral density filter
By reducing the exposure in the top half of the picture, the sky was darkened to create an overcast, stormy scene.

A highlight reading will be under-exposed.

A shadow reading will be over-exposed.

An "average" reading over-exposes the central figure.

Stop down to give the correct exposure.

An "average" reading under-exposes your subject's face.

Open up to give the correct exposure.

Taking an average reading

In any scene the range of reflected light that you would find by metering different areas is astonishingly large. The small picture inset at the top left shows the result when a meter reading was taken from the bright area of sky (f16); the other small picture shows the result when the reading came from the dark shadow areas at the bottom of the scene (f2). The first is under-exposed and the second is over-exposed. The main picture was shot at f8 – an average of the two individual readings.

Contre-jour and silhouette

Shooting into the light is sometimes referred to as *contre-jour*. It produces a "backlit" subject. If you want to retain some detail in the shadow areas facing the camera but still want to catch the high contrast glitter ,of the highlights or the sun streaming over your subject's shoulder, take a reflected light reading but use the camera's back-light control. If you want to shoot in pure silhouette, meter the reflected light directly.

Contre-jour

Silhouette

If you have a camera with full manual override, you can try diferent settings in the viewfinder until you are satisfied with the result. Other cameras have a selective exposure lock. This enables you to zoom in on your main subject, open up the iris and lock it at the required f-stop, and zoom out again to shoot. More commonly on non-professional equipment, the exposure meter is center-weighted, so that a bright sky around a central subject does not fool the camera so drastically. Other selective metering systems are available that attempt to reduce metering errors in different ways.

High-speed shutters

More and more cameras are being equipped with shutters that scan the target faster than the normal 1/50 sec. Because these high speeds let in less light, the iris is opened up to compensate, giving reduced depth of field (see page 41) if required. Such shutters also sharpen fast action shots, especially when replayed in freeze-frame or slow-motion modes. Very high speeds need good light, but are useful in fields such as sports coaching, or when using the new technology that allows you to print hard copies from single frozen video frames.

Metering systems
Camcorders measure light from the subject through the lens, but the light is sampled and assessed in a variety of ways. In some cases (top), the overall intensity of light is measured by the meter. In other systems (middle), the image is analysed as a composite mosaic, so that contrast differences are reduced. Some systems (bottom), "weight" the reading so that the skylight is given less importance than light from the lower and central areas of the subject.

AUTOMATIC EXPOSURE

Modern camcorders do the work of setting the exposure for you, adjusting the iris to the best setting for the level of light read by the photosensitive meter (see p. 43). In many situations, the automatic exposure settings provided by the camcorder are perfectly adequate. If the lighting is even, or corresponds to the pattern which the light meter is programmed to cope with, then you need do little more than point the camera and begin recording.

But not all subjects are ideal for automatic exposure. For example, if there is a lot of contrast in the subject, the meter may respond to the part of the frame in which you are least interested. This may happen when you are recording a figure in front of a window. The landscape outside is recorded perfectly, but the figure comes out too dark. In a similar way in a landscape shot, a bright sky might dominate the exposure setting at the expense of the land beneath or a building in front – which is fine if your main point of interest is the clouds, less convenient if you want to show what is happening on the ground.

In situations like these, manual exposure comes into its own. It is invaluable when combined with an exposure lock, which allows you to keep your manual setting while you are recording.

The simplest form of manual exposure override is a button which you press when your subject is lit from behind. This alters the exposure by a fixed amount to compensate for the poorly lit main subject. Another simple, but more extreme, form of exposure compensation is the gain control. This is useful in providing extra exposure in low light, but is likely to give a grainier picture. Such a deterioration in picture quality is hardly desirable unless you want to use the extra grain to give a different visual atmosphere.

More sophisticated camcorder designs allow full manual control of the iris. This is much more flexible, and is the form of control preferred by most experienced movie makers. It offers the additional advantage that by gradually reducing the image to an overexposed white you can create a manual picture fade. Most camcorders of this sophistication also have a fade button, but this will probably fade both sound and picture, and do so at a set speed, so the manual fade may be useful if you want more control.

Shooting the sky
There are times when the sky is as important as the land. Dramatic sky shots like this are possible with a wide-angle attachment, but exposure may be a problem. You can try using a graduated neutral-density filter to darken the sky and enhance the contrast in the clouds, though not all clouds are in the same class as those above the New Mexico desert.

COLOR TEMPERATURE

Even by the reddish light of a campfire the human eye can tell green from red or identify the color of someone's eyes. Equally, by the very blue light of an overcast sky, we see a white wall as white, even though the actual light being reflected from it is blue. Video cameras do not work in this way. They are technically more accurate than the eye (the people around the campfire would all look red; the white wall would look blue), but effectively less flexible. The camera therefore has to be set to match the color of the incoming illumination. That color, which usually falls between the blue and the red ends of the spectrum, can be assigned a "color temperature" in degrees Kelvin.

The color temperature of light outdoors varies according to the time of day, the weather, the latitude, the altitude, and the position of the subject. For instance, if direct sunlight at noon is assigned the central color temperature of 5,500 degrees Kelvin, then both dawn and sunset, with their reddish hue, rate only about 2,000 on the Kelvin scale, whereas the very blue light from a shaded snow-drift under a blue sky may be as high as 14,000. This variation happens simply because of the way in which the sun's rays are refracted by the atmosphere at low or high angles.

This is a problem for the conventional film photographer, who has to use colored filters to make the required corrections and cannot view the results until later. With video it is easier. You can adjust electronically for different lighting conditions and, if you have a portable monitor or color viewfinder, check the color balance before and during shooting.

In each case, there is no hard-and-fast rule about what is "normal" color. You simply have to go for the effect you find best. There is nothing arbitrary about this: you will be guided by your personal taste, and it is a very important way of putting your own stamp on the finished tape.

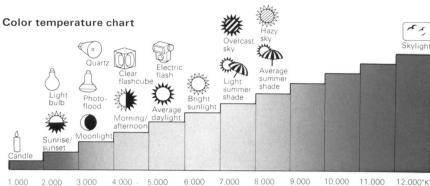

Color temperature chart

1,000 2,000 3,000 4,000 5,000 6,000 7,000 8,000 9,000 10,000 11,000 12,000°K

Candle · Sunrise/sunset · Light bulb · Photoflood · Moonlight · Quartz · Clear flashcube · Morning/afternoon · Average daylight · Electric flash · Bright sunlight · Light summer shade · Average summer shade · Overcast sky · Hazy sky · Skylight

Mixed lighting
The picture on the right provides a good illustration of the different color temperatures of different light sources. The light from the early night sky has given the scene a blue cast. The electric lights inside the house, however, have a much lower color temperature, hence their warm, red-yellow light.

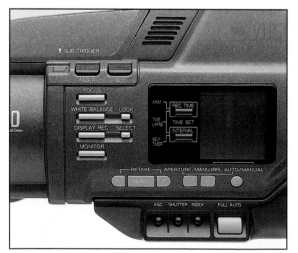

White balance
The automatic white balance can be overridden manually using a control on the side of the camcorder. You zoom in to a white subject as a reference, and lock the white balance control.

Sunlight
The large picture was shot in sunlight, with the camera's white balance correctly set. The small picture shows the same shot with the white balance set for indoor lighting: it is unnaturally blue.

Lamplight
The large picture was shot in lamplight with the white balance correctly set. The small picture shows the same shot with the white balance set for sunlight: it is unnaturally yellow.

Contrasting colors
When the sun is setting in the Mediterranean, it is a little after noon in New Mexico. The two times and places are marked by contrasting colors from opposite ends of the spectrum – deep, warm orange in the Mediterranean and icy blue in the desert.

Time of day

The color temperature of light varies enormously through the course of the day and will have a profound effect on the atmosphere, the color and the relief of your film. The changes in the color of the light can be turned to great advantage, and you should make a habit of using the prevailing light, not fighting it. However, if you do need to, you can use any of the color correction filters.

Changing color temperature
At sunrise, the color temperature of the light is likely to be about 2-3,000°K – a warm pink or yellow, according to the strength of the sun. The color temperature rises during the day, reaching a peak at noon and in the early afternoon. Towards evening it falls again, often producing a rich red color cast at sunset.

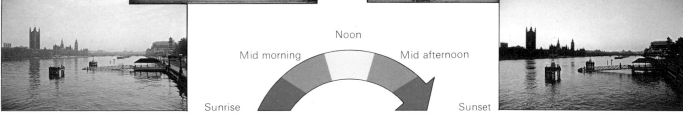

Noon

Mid morning Mid afternoon

Sunrise Sunset

THE VIEWFINDER

You can see everything that goes onto the tape in the viewfinder. But before you start to film you must make sure that the viewfinder is correctly aligned for your eyes, that it is properly plugged in if it is a separable model, and that the power/record mode is correctly set on the camera so the image comes through clearly enough for you to see.

The viewfinder itself may be molded into the camera body or, more commonly, hinged, so that you can turn it to view from a variety of different angles – even the side. You can also move this type of viewfinder backward and forward to accommodate your eye position. Many viewfinders have built-in diopter correction lenses, which mean that eye glasses do not have to be worn while using the camera. When you look at the screen in the viewfinder, the effective optical distance of the image from your eye is about 3 ft (1 m). There are also magnifying "sports finders" for some cameras, which allow you to hold the camera overhead or at a distance from your eyes when shooting fast action.

The greatest limitation of the first generation of viewfinders is that they show the image in black and white. Very small color monitors are now available. These can be attached to the bracket of the camcorder so that you can monitor color while shooting. These are fun to use, and handy as a rough guide when you are shooting on location. But their image quality is not quite good enough for reference when shooting in difficult lighting situations, such as mixed lighting or high-contrast conditions. Ironically these are precisely the times when a color monitor is most needed.

As well as the image of the subject, most viewfinders contain a range of lights or symbols giving information about many of the camera's functions. There will be an indicator to show that the camera is running, together with displays concerning color, focus, and exposure. On

Viewfinder adjustment
One great advantage of the video viewfinder is that it can be rotated in any direction. Some models even have a viewfinder that can be flipped from right to left. These adjustments mean that you can operate the camcorder from ground level, or even from directly overhead.

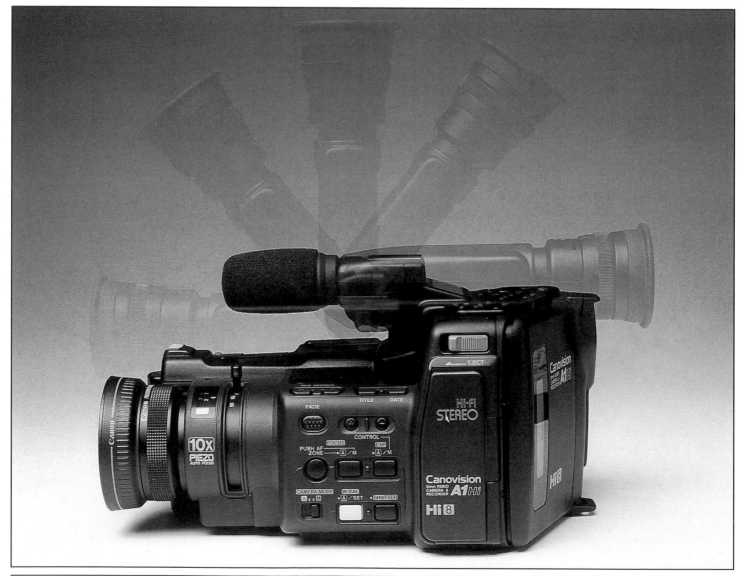

more sophisticated models, titling and in-camera effects may be shown.

One of the main problems that you face when starting to use a video camera is deciding whether or not you are actually recording. This is usually clear enough to anyone in front of the camera, because a red light on the camera body flashes during recording. There is usually some sort of indication (such as flashing arrows) in the viewfinder to show that the camera is running, but this can be difficult to see. With modern silent camcorders it is all too easy to record when you think that the tape is not running, and vice versa. Rehearse at length and in private to prevent the embarrassment of recording when you did not mean to, or the disappointment of missing a vital shot.

Manual overrides

There are three areas – exposure, focus, and color correction – where it is often useful to be able to override the automatic settings made by the camera. Exposure can be overriden by the BLC (see p. 42) or on professional equipment by a manual iris control. Focus can be overridden in a variety of ways, according to the system employed (see p. 40). Color can also be corrected manually, but there is a built-in contradiction here, because of the black-and-white viewfinder image. In all these cases, the act of taking control by means of one of the override buttons is signaled in the viewfinder or by an LCD display on the side of the camera.

With all this additional information in the viewfinder, there can be a danger that the image itself is obscured, or at any rate given less prominence than it needs. As a result, the viewfinder and its displays can be really valuable only if you understand the extra visual input so well that you can concentrate on the actual image.

The whole question of automation versus manual operation is most difficult in the area of color. This is where personal taste is most apparent and least predictable. It is much easier to agree on what constitutes "bad exposure" or "incorrect focus" than on "poor color rendition". Not only do peoples' tastes vary when it comes to color, but so, to a remarkable extent, does their eyesight. So a small monitor to check the color is an enormous help.

Using a monitor is easy enough when the camera is static on a tripod at an event such as a wedding or a school play though more difficult when you are moving around with the camera.

Tape mode

Most viewfinders display a message or some arrows to show when the tape is running. There may also be a counter to identify the position of the recording on the tape, or the "lap-time" duration of the shot. This information is helpful in several ways: it tells you whether you are actually recording (not always obvious in noisy surroundings with a quiet camera); it enables you to pace the sequence and to review the very end of the previous shot if you have been in "Pause" mode between shots, and it tells you when you are about to run out of tape.

Clip-on monitor
With a black-and-white viewfinder you have to resort to a monitor to assess the color balance of the image. One solution to this problem is a small flat-screen LCD color monitor, which you can attach to the lighting bracket.

COLOR CORRECTION

If you use a standard "daylight" setting in ordinary indoor lighting, the image on tape will look yellow or even red. All the camera is doing is failing to compensate for the change in ambient light in the way that our eyes do. Fortunately, the camera can compensate with ease, so that everything looks as though it was shot under the same lighting conditions whether indoors or out.

There are two extremes of color balance that need to be controlled both inside and out. These are the drift of the ambient light away from white toward either red or blue. Indoor light (known as "tungsten" light, after the filament of the usual indoor bulb) is very yellow; it can be nearly red when light from low-wattage bulbs is recorded on tape. Outdoors, normal daylight is bluish, the most blue light coming from an overcast sky at midday. In most cases, the ideal is to reproduce a neutral skintone that at the same time reflects the particular quality of the ambient light. For example, you will probably not want to "correct" a romantic candlelit close-up so that the subject's face is ashen white; nor would you want to change a golden dawn to a frosty white sky.

Correcting in the camera

Video cameras can now do the whole job of color correction automatically. The most basic cameras have a switch that enables you to choose between settings for daylight and tungsten. Some also have a setting in between that is designed for fluorescent lights. The latter setting is of limited value, since fluorescent tubes have a very wide range of color. Their so-called "discontinuous spectrum" often comes out on tape as bright green!

More recent cameras have improved on the simple two-way switch. They have a white balance setting that can accommodate any light conditions. In a room with mixed lighting and a white wall, you can de-focus the camera to give a diffused image, point it at the white wall, press a button, and the white balance will lock onto that particular ambient light until you reset it. Some cameras achieve the same result with a translucent white lens cap. With this type attach the lens cap, point camera at the light source, and the balance is then set.

A similar, but far more sophisticated and flexible system is used on most current camcorders. There is a translucent white window on the front of the camcorder; the ambient light is permanently monitored through this window and the balance adjusted to match. With this system, for example, you could track from a sunlit courtyard to a torchlit tent without manually compensating for the change in color temperature. The main danger to avoid is accidentally covering the white window with your fingers.

Manual override

On a camera that only allows you to set "daylight" or "tungsten", problems can occur with mixed lighting. This is quite common. A room that contains a tungsten table lamp and a window beyond through which sunlight can enter is an example of a subject with mixed lighting. Some models allow you to override the settings to accommodate this, but you will need a color monitor to view the results. Color viewfinders, which will soon be available, will make this problem easier to overcome, provided that they are of good enough quality to show the color just as it will appear on tape.

Finally, bear in mind that color is a personal choice. You may not want every subject you shoot to look as if it was illuminated by light of the same color temperature. Daylight may be warm or chilly, for example; indoors can be bleak or welcoming. You may well want your video image to reflect these differences, in which case you may have to override the automatic settings to get the result you want.

Noon light
The colors of this shot of the gorge, 3000 ft (1000 m) below the scene opposite, are quite different in character, but equally natural.

Dawn light
What *is* natural daylight? This telephoto dawn shot of the Grand Canyon, filled with blueish ultra-violet light, has an utterly different palette from the noonday shot opposite. Electronic "correction" would have ruined the effect, sometimes, whether in sunlight or tungsten lamplight, it is best to accept the ambient tonality and make the most of it.

POWER, BATTERIES AND CHARGERS

Whereas film relies on purely chemical reactions, tape works electrically. Tape can run at different speeds, can be used for both sound and video (sometimes on the same channel), and can be erased. For all these things it needs electricity. Electrical power comes either in high-voltage form as 110 V or 240 V Alternating Current (AC), or as Direct Current (DC), which can vary according to the appliance from around 12 V to 1.5 V.

Domestic VCRs run directly off the mains (AC) and should be set according to the local power supply. This is simple enough, usually involving a switch on the rear of the recorder. It will almost certainly be preset on purchase to either 110 V or 240 V AC.

Portable VCRs and camcorders may be run off rechargeable Nickel Cadmium (NiCad) batteries, or from the mains via a transformer. This normally doubles as the battery charger, meaning that there are no extra wires to trip over. Recharging times depend on the model and the temperature, but a typical time is one hour.

Adaptors are also available to run a camcorder directly from a car's 12 V DC battery, using the cigarette lighter socket as a power outlet. Alternatively, the adaptor can be used to charge a battery. It is usually advisable to keep the car's engine ticking over when using the adaptor in this way. Not all adaptors are suitable for all cars. Compatibility depends both on polarity (whether there is negative or positive earth), and the car's DC voltage (12 V or 24 V). Read both car and camcorder manuals before buying.

Most of the time, for the sake of convenience, you probably will be relying on batteries. Only one will be supplied with your camcorder, and it is worth buying at least one spare, so you always have a fresh one ready.

The usable running time of a rechargeable battery pack varies according to the outside temperature (the warmer the better, within reason) and the demands made upon it. Electrical motor functions, such as record and pause, zooming, autofocus, rewind, and replay, will drain a battery much more rapidly than the process of recording images on tape. When the power is beginning to run low a warning signal will flash in the viewfinder. Change the battery at once, or plug into a wall outlet using the AC adaptor. Most adaptors cannot be used for recharging and running the camera at the same time – another good reason for a spare battery pack.

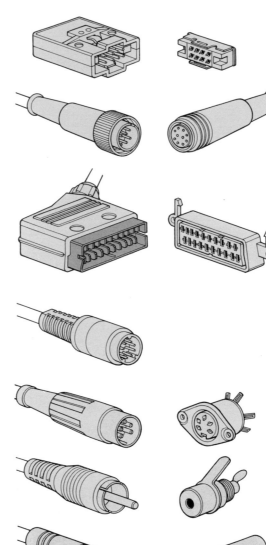

Eight-pin
This composite plug is a standard connector between VCRs and monitors. It carries all video and audio in and out connections.

Ten-pin
Multi-pin plugs like this are often used to connect some cameras to VCRs. They lock with a screw thread. They incorporate all the necessary functions in one cord.

SCART
These European multi-pin plugs can deal with all the inputs and outputs for both audio and video connections between TV receivers and VCRs. They have some pins which are not always connected, to enable the use of S-VHS.

DIN plugs
These circular plugs are used for a variety of different connections. Five-pin DIN plugs are often used for audio connections, and also for video on some machines. Four-pin plugs are used for connections between camcorders, TV receivers, and VCRs in the S-VHS format.

RCA/Phono
Standard hi-fi connectors, these plugs carry one channel only, through thin coaxial cord.

Jack/Quarter-inch phono
These are used for headphones and other audio connections. Smaller versions are used on some VCRs, to connect the audio input from a monitor.

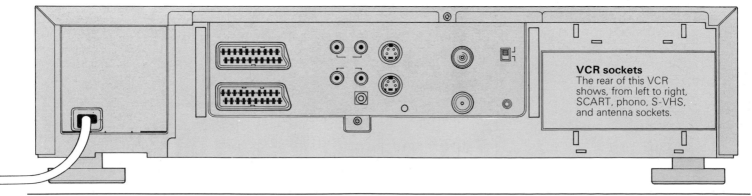

VCR sockets
The rear of this VCR shows, from left to right, SCART, phono, S-VHS, and antenna sockets.

UHF
This is the standard European socket and plug for antenna connections. It is used for RF connections between a VCR and receiver. It has no screw thread.

F and E
This connector, also for coaxial cord, has a screw thread. It has largely been replaced by the BNC connector.

BNC
Commonly used for video in and out sockets, these connectors have sturdy bayonet fittings.

F-pin
Another connector for coaxial cord, this plug has a screw mount.

300-ohm twin feeder
This cord and connector, with a resistance of 300 ohms, is standard for receivers in the USA and Japan, where the main broadcast channels are in the VHF range.

Converter
Converters like this enable you to connect a 75 ohm coaxial feed to a 300 ohm twin feed.

Power supply hints and tips
Store battery packs in a cool dry place, and avoid long exposure to high temperatures, which will increase battery discharge and shorten battery life.

Extend battery life by fully discharging batteries before a period of long storage.

Carry out full charging at normal room temperature – charging takes longer at lower temperatures, and may be incomplete at temperatures above about 35°C.

Don't leave batteries attached to the camcorder when it is not in use; a small discharge may continue, flattening the battery just when you need it in a hurry.

Avoid repeated recharging of batteries without complete discharge.

Do not drop the unit or subject it to extreme vibration.

If you are working in very cold conditions – for example when skiing – keep a battery warm in an inside pocket for maximum efficiency. If the camcorder gets very cold and is then taken into a warm room, condensation may occur and a "dew" warning should flash in the viewfinder. The camcorder will stop automatically, and you should switch off at once and give it ample time to warm up before re-use.

The battery and charger will both become quite warm when charging. This is quite normal.

Connectors
The variety of standards and functions involved in video has led to many different designs of connectors being used. Even if all your equipment is compatible, you may have to use different types of plugs and sockets for video, audio, antenna, and headphone connections. The illustrations on this page show most of the connectors you are likely to come across.

BASIC
CAMERA
TECHNIQUE

STEADYING THE CAMERA

If you want to make a movie, which other people will enjoy watching, you should aim to keep the camera as steady as possible. The kind of shakiness produced by careless hand-held camerawork is unsettling to watch, and it should only be used to achieve special effects such as "earthquakes" and "explosions" or the view seen by a running fugitive or a staggering drunk (see *The moving camera*, p. 72). The most "natural" look comes from a steady camera: the TV screen then acts like a pane of clear glass through which we watch the action. If the movement of the camera becomes too erratic, this illusion is destroyed and we become excessively aware of the recording process itself.

The only certain way of guaranteeing that the camera is stable is to use a tripod. But there is a great deal you can do to improve your hand-holding technique.

Hand-holding the camera

There are many occasions – when you need to be able to move quickly or when space is restricted – where it clearly makes more sense to hand-hold the camera than to use a tripod. Modern cameras are extremely portable, and you should exploit this to the full.

When hand-holding the camera, move in close and use the widest angle you can justify. The picture will appear steadier and you will also have a greater depth of field. Remember that the longer the focal length the more your movements will be exaggerated by the lens. So, unless you have no choice, avoid sustained hand-held telephoto shots. If you want your subject to be larger, move nearer rather than zooming in.

The hand-held camera really comes into its own when following a moving subject (see p. 72). Aim to move in a smooth glide, keeping your steps short to minimize up-and-down motion. Practice keeping both eyes open so that you can see and avoid any obstacles in your path.

Camera supports

The balance of the camera is as important as its weight, especially with larger cameras. Aluminum body harnesses are available, which support the camera and leave the camera operator's hands free.

Low level viewing

Use the advantages of the rotatable viewfinder for very low ground shots. You cannot do this with the human eye.

How to hand-hold the camera

Almost all cameras are designed for right-handed people. Therefore, brace the camera by pressing it up against your eye with your right hand, keeping your right elbow pressed tightly against your side. Keep your feet slightly apart and stay literally on your toes. Use a wall, a tree, the corner of a building, a car roof, the back of a chair, or even another person to lean on whenever you can.

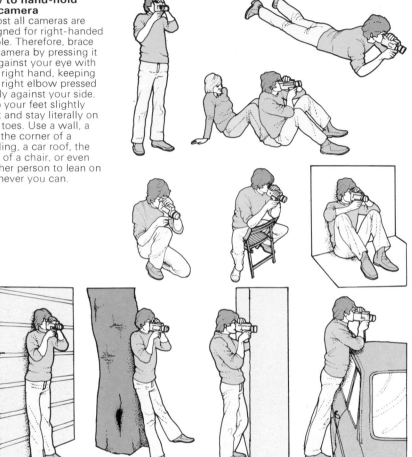

Stabilizing the camera

The stability of the image is in some ways the moviemaker's first priority. Although a small camera might seem easy to hold, oddly enough the weight of the camera is in inverse proportion to its steadiness. A heavy camera, resting on your shoulder, may seem unwieldy, but will in practice be very stable. The light new cameras coming on to the market can, by comparison, be very shaky, especially at the "long" end of the zoom.

Shoulder-mounting camera

Tripods

There are many movie techniques and subjects for which a tripod is essential – for example, titling, time-lapse, remote-control, telephoto wildlife shots, architecture, landscapes, and macro recording. As a general rule, though, you should *always* use a tripod if you know that you will be shooting from a fixed position. Steadiness is the perfect example of invisible technique. You should therefore beware of intercutting between tripod work and shots which were obviously hand-held: the difference will be very noticeable.

Tripods come in various sizes and in various degrees of sturdiness. They have collapsible legs made of metal or wood which can be adjusted so that the tripod can be properly leveled on uneven ground. The legs may have rubber or spiked tips to give a grip on different surfaces.

The most important thing you will want from a tripod is steadiness, both in the legs and in the head. Therefore, go for the sturdiest model you can afford. The lighter and cheaper tripods are adequate for static shots but tend to move with the camera when you pan or tilt.

Setting up the tripod

Begin by setting up the tripod at the right height. Then attach the camera to it. Check the view and make certain that the camera is absolutely upright, especially when the shot contains strong vertical or horizontal lines. Some tripods have a built-in bubble level for this purpose. If yours does not, it is worth buying a small one and laying it on top of the camera to check the leveling. Remember that if you intend to pan or tilt, the camera must be level at the start *and* at the end of the movement.

On a slippery floor, the legs of the tripod are sometimes held in place by a *spider* or a *spreader*. However, standing the tripod on a blanket or taping around the legs can be just as effective as a way of keeping it steady.

The pan head

The camera is mounted onto the tripod by means of a *pan head*. This moves from side to side for panning, and up and down for tilting. Ball and socket heads, which move in every direction, though ideal for still photography, are unsuitable for video work because the camera cannot be kept vertical when panning.

It is vital that the pan head should not only be very steady but that it should move as smoothly as possible. You should be able to pan the camera using only the slightest pressure; the movement should be perfectly even, without sticking or jumping; and it should stop when you do, without any backlash or overshooting.

The cheaper, lightweight tripods usually have *friction* heads which rely on the resistance between their moving parts to damp the movement. They are usually adequate for the smaller camcorders, but they tend to "stick" at the beginning of a pan or tilt.

Although they are more expensive, *fluid* heads give the best results for normal work. They are hydraulically damped and give a perfectly smooth movement.

Geared heads are large, expensive and very accurate. They are used chiefly in professional movie work for supporting heavy cameras.

Various types of tripod

Basic tripod (above)
This simple aluminum tripod has twist-grip telescopic legs.

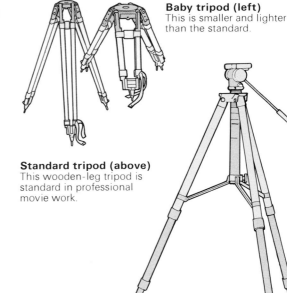

Baby tripod (left)
This is smaller and lighter than the standard.

Standard tripod (above)
This wooden-leg tripod is standard in professional movie work.

Cullmann tripod (above)
This tripod has quick-set clamps on the legs and will go very low.

"High hat" (above)
This is used for difficult or floor-level shots.

Tripod on wheels (above)
This can be used just like a proper tracking dolly. It will also keep level, provided that the floor is level too.

Securing the tripod legs

Spider
This device stops the tripod legs from slipping.

Improvising with tape
Wrap tape or a length of string around the legs.

Using a blanket base
A rug or blanket prevents the legs from slipping.

Various types of pan head

Friction head (left)
A single handle allows the camera to be moved both horizontally for a pan and vertically for a tilt.

Fluid head (right)
This head produces very smooth pans and tilts. The movement is damped by a heavily viscous fluid.

THE BASIC SHOTS

It is customary when discussing video to divide shots into three main categories: *long shot*, *mid shot* and *close-up*. Although the division is a somewhat arbitrary one, the terms are usually used in connection with the human figure. In all cases, what is crucial is the amount of the subject in the frame. For example, a long shot usually includes a subject's feet; a mid shot usually extends below the waist; and a close-up does not include the hands. These three basic shots relate broadly to three different degrees of concentration: they narrow an audience's attention from the overall scene, through a group of people, to the single individual. The shots can be further divided into sub-categories such as "big close-up", "medium close-up" or "extreme long shot".

The three basic shots
Camera shots are conventionally divided into three categories: close-up, mid shot and long shot. They produce quite different effects, since each shot has its own specific characteristics.

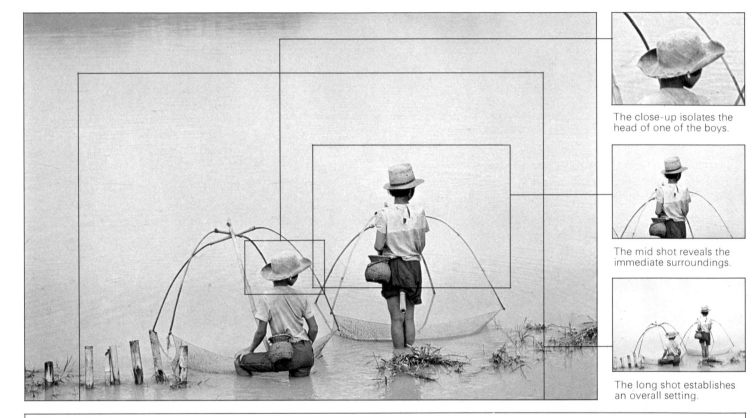

The close-up isolates the head of one of the boys.

The mid shot reveals the immediate surroundings.

The long shot establishes an overall setting.

Cutting height
When framing your shot, remember that to include only half your subject's feet, their hands by their side, or their hands gesturing, is very irritating for an audience to watch. For this reason, a convention called "cutting height" has developed. You will find that if you cut the human figure at one of the points shown right you will get a more attractive composition. The cutting heights are usually regarded as being just below the armpits, below the chest, below the waist, below the crotch and below the knees.

Cutting heights

Close-up
The best cutting height for a close-up is just below the armpits (above). This will balance the composition.

Mid shot
The cutting height for a mid shot is below the waist. This makes it a "body" shot since the face does not dominate.

Long shot
A long shot should include your subject's entire body (above). It makes for bad composition to cut them off at the ankles (below).

The characteristics of the shots

The *long shot* is the most basic of all movie shots, and in most situations, if you have time for only one shot, this is the one it should be. It includes everything of importance in a given scene and can be used purely for conveying information – as an "establishing" or "master" shot. Alternatively, it can be used creatively, in direct and dramatic contrast to surrounding mid shots and close-ups. A long shot shows your subject's relation to nature, to their environment or to a group of other people.

The *mid shot* is the prime shot-size for establishing the interplay of character. It reveals enough detail of a character's face for us to be involved in what they are saying or thinking but not so much that we are *only* interested in that one person. Two or more people can be in shot at once, and all their reactions will be perfectly visible; you can then intercut close-ups as well.

A *close-up* concentrates exclusively on one person's face, or on any one detail of a scene. It can therefore give an insight into the interior life of the subject. The close-up is the most "compelling" shot, since it forces an audience's attention onto one single person.

Long shot (above)
The two girls cycling towards the camera are seen in long shot.

Mid shot (left)
This mid shot isolates the nun but shows her against a background of trees and a white fence.

Close-up (right)
The close-up of this girl shows her at close-range. It is basically a facial shot in which she dominates the frame.

Extreme close-up

Also known as a *big close-up*, this shot should not be used casually. It produces a "shock" effect by filling the screen with a single image, and is often used to focus an audience's attention onto a character's eyes or hands. Remember, however, that a face looks distorted if the camera is too close.

Extreme long shot

This is the shot to use if you want a panoramic view of a city or a landscape. In this way, it can act as a huge "master shot", establishing the location in which the action will take place. Very long shots can also be used to set a tiny human figure against a vast landscape, conveying a sense of dramatic isolation.

Extreme close-up (left)
In this shot, the subject's eyes and nose fill the frame. A blink of the eyelid at this range would appear to be a powerfully dramatic gesture.

Extreme long shot (right)
The lone figure in this shot gives a sense of scale to the ruined Armenian church, as well as emphasizing its precariousness.

CHOOSING THE RIGHT SHOT

Movement in the frame

In still photography, composition is of primary importance because the image does not move. In video work, however, the movement itself is part of the composition, so when choosing a camera position you should make the most of whatever action you can expect to see in the frame. Bear in mind that with a moving subject the composition at the beginning of the shot may be less important than the middle or the end. When you select a spot from which to shoot, try to anticipate how things will develop during the course of the shot. Relate the movement of the subject in the frame to: its own movement; that of the camera; that of the zoom; and the changing background.

Remember that the focal length of the lens and the distance between the camera and the subject will affect the degree of movement in the frame (see p. 38).

Matching different shots

Because each type of shot has its own characteristics, you must constantly be aware of the effect you are creating when juxtaposing one shot with another. Cutting from a long shot to a mid shot will *concentrate* the audience's attention onto a smaller area of interest. But following a close-up with a mid shot often *reduces* the tension or intensity in a scene by opening out the shot and allowing other elements into the frame. Be careful when cutting shots from chosen positions and from different angles that your subjects are looking in the same direction (see opposite), that they are moving in the same direction (see p. 68) and that they are in the correct part of the frame (see p. 71).

When cutting from, say, a mid shot to a close-up of the same subject, you should try to match the lighting, the height and also the expression of the two shots.

You should also bear in mind that the difference in size and angle between two shots should always be large enough to be decisive but not so large as to jolt the eye.

Subtle facial expressions should really be close-ups, not long shots.

Long shot to mid shot
A "cut-in" from a long shot to a mid shot will focus the attention of the audience on your subject. From being merely a figure in front of a building, the man reading the magazine (right) suddenly fills the frame.

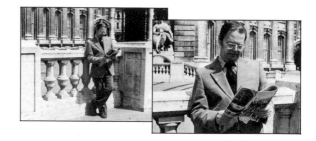

Mid shot to close-up
A "cut-in" from a mid shot to a close-up concentrates the attention still further. The background becomes scarcely visible and the girl's head and shoulders fill the frame.

Image size

Unlike the theater, where the distance between the audience and the actors remains fixed, a video camera is able to move closer to and further away from the subject – either by zooming or by tracking in and out. This means that as a filmmaker you can control the viewpoint of the audience.

When choosing your shot, bear in mind that if you are very close to the subject, every action he or she makes will seem exaggerated. On the other hand, if you are a long way away, only large gestures will be visible.

Matching close-ups

If you are filming a couple talking to each other by intercutting separate close-ups of them, be certain that you match up the size of the shots. If they are different, the relative size of the faces will affect the way the audience "sees" the relationship.

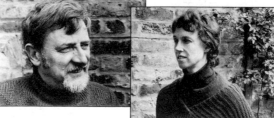

Woman dominant
If the close-ups of the woman are consistently larger than the close-ups of the man, she will tend to appear the more dominant of the couple. If this is the effect you want, then the technique can be used to great advantage.

Man dominant
The reverse is true if the close-ups of the man are larger than those of the woman: he will appear as the more powerful character. Be careful when intercutting close-ups to match up the "eyelines" (see right).

Eyeline

The *eyeline* of your subject is generally taken to be the direction in which he or she is looking – although it is a term whose meaning can vary according to the context in which it is used (see p. 88).

When filming a single subject, the closer the eyeline is to the camera lens, the more intense will be his or her gaze – and therefore the stronger the shot. For this reason, when cutting from a mid shot to a close-up, the increased intensity produced by the close-up should be matched by a narrowing of the angle between the camera and the subject's eyeline (see right).

Filming a person looking straight into the camera will allow the audience to "enter" the subject's mind. But if one subject in a dialogue is looking straight at the camera, however, then the camera becomes their interlocutor. In this case, the camera is as it were "inside" the head of the other person in the conversation.

When shooting a group of people by cutting from a master shot to close-ups and vice-versa, it is vital that your subjects are seen to be looking in the same direction in the close-ups as they are when we see them all together in the mid shot. The eyeline close-ups should be carefully matched to the overall geography of the scene.

In a dialogue, the eyes of each person are normally recorded slightly "off camera". One of the two will look left of the camera; the other right. This way, when the close-ups are intercut, the respective positions of the two people are maintained and the audience happily accepts that they are in fact talking to one another (see p. 76).

Narrowing the eyeline on a cut-in
When cutting from a mid shot to a close-up, narrow the angle of the subject's eyeline as shown.

Subject facing camera
A close-up of someone looking straight into the camera is one of the strongest shots available since the subject's gaze is directed straight at the audience. It is a shot often used with a voice-over soliloquy which represents what the subject is supposed to be thinking.

Incorrect

Correct

Matching close-ups to the master shot
Be careful that your subjects are looking in the same direction in close-ups as they are in the master shot – or they will appear to have moved and continuity will be lost.

Correct

Incorrect

Correct

Incorrect

Correct

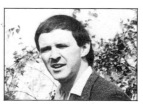

Incorrect

THE "LANGUAGE" OF MOVIES

Reference is often made to the "language" of movies, because with movies, as with language, the whole is greater than the sum of its parts. To take a melodramatic example, if you follow a shot of a woman crying with a shot of an empty baby carriage, you have created a whole that is more complex and more potent than the two shots together. Video can leap from one shot to the next with the fluency of a dream so as to bypass our literal interpretation of images thereby striking directly at our imagination. For instance, when you watch an effective suspense film, you are often unaware as to what exactly causes unease or discomfort. In other words, watching a movie does not require any standard of literacy. However, the more movies you watch and the more carefully you look at them, the greater will be your understanding of the techniques involved. You will begin to see *how* sequences are assembled.

Superimposed on our instinctive understanding of film language are a number of conventions that have evolved with the movies. These devices, usually known as the "grammar" of film (see p. 70), are concerned with such things as changes of direction, intercutting and transitions in time. We now accept these conventions so automatically that they pass unnoticed, and as a result they have often been mistaken for rules.

Because film "language" has so many variables, there is no doubt that the "rules" of film should only be discarded for good reasons and by someone who knows how to break them to telling effect. You have only to see one really incoherent (or "illiterate") movie to appreciate the value of film grammar. Imagine a page on which each word has a different size and color, could be moved across the page, zoomed in and out, have its own distinctive sound, and have a variable duration: these effects are the fundamentals of filmmaking. And unless all these elements are first understood in isolation, you will never combine them successfully in your videos.

The place of editing

The best way to improve your videos is to edit them. Some videos can be "edited in the camera", but to shoot a video that really needs no editing requires a flawless technique and a mastery of cutting that only comes with years of experience. Unfortunately, and perhaps inevitably, this is how most people *begin* to make movies.

The results can be a little discouraging, for without editing you cannot juxtapose images, build a sequence, discard rubbish, tighten loose shots, intercut parallel actions, or indeed give any shape to the video beyond that of the original event. On the other hand, editing your footage can be a very exciting and creative activity.

There are, of course, tapes that may not need editing (such as a simple record taken for private consumption only). But even there, a knowledge of how a sequence is built will make all the difference to the shooting technique. Such knowledge can only be gained by editing, and many of the shooting techniques that follow in this book pre-suppose that you *are* going to edit.

1 ⏱ **2 sec Gavino looks around at his friends**

2 ⏱ **12 sec The friends walk away**

Gavino's friends: "Remember: study vocabulary, learn the meaning of words"

The parade ground
As Gavino watches his friends walk off, there is an abrupt cut to a shot of the commanding officer addressing his men. Gavino is among then (shot 7).

Officer: "The flag ... All of you must know the meaning of the flag ..."

3 ⏱ **5.5 sec Gavino stares after him**

4 ⏱ **15.5 sec The commanding officer**

5 ⏱ **10.5 sec The parade ground**

but not the significance of the flag, symbol of our mother country"

You can forget your mother's name, your father's name, your brother's names ...

6 ⏱ **4 sec Raising the flag**

7 ⏱ **8 sec Gavino**

"Padre Padrone" (1977)
This sequence from the Taviani brothers' film, *Padre Padrone* ("My Father, My master") illustrates the freedom with which film can cross time and space. The hero, Gavino, is an illiterate Sardinian peasant who has enlisted into the army to ecape from the tyranny of his father. But on the parade ground in Turin, with the commanding officer's patriotic words hammering through his head, his new-found obsession with learning to read merges with his memories of his sadistic father – his master.

8a ⏱ 42.5 sec Raising the flag

8b Close-up of flag

8c Close-up of flag

The flag
From Gavino watching the flag being raised, there is a cut to a seemingly continuous shot of the flag itself. The camera zooms into a close-up of what at first appears to be the same flag. But this is a subtle transition to shot 8d. At the same time, Gavino's voice-over as he begins to recite words merges with the commanding officer's tirade on the Italian flag.

Gavino voice-over: "Banner ... bank ... band ..."

"Bandit ... bondage ... baritine ... Bantu ..."

"State ... stagnant ... staff ... stall ... stalagmite ... starred ... statue ..."

Gavino as a boy
Leaving the *red* of the flag – a political statement in itself – the camera tilts down and pans around to the sheep and fields of Gavino's childhood. A boy appears in the frame and the camera cuts in to show him loading his barrow – for Gavino, it is a memory that is also a premonition of return to his Sardinian farm.

8d Sardinian landscape

9a ⏱ 9 sec Boy in fields

9b Boy in fields

"Station ... generation ... infant ... boy ... baby ... benumbed ... bloodsucker ... blistered ... blockhead ... savage ... wild ..."

10a ⏱ 17 sec Close-up of flag

10b Close-up of flag

11a ⏱ 17 sec Close-up of flag

The flag again
In shot 10a the camera again returns to the flag. Gavino's incantation of words (he is learning to read) has moved from "pastoral ... pasture ... pasteurization ..." to "languid ... horrid ... filthy ...", and finally the camera tilts down from the flag onto his father striding through the landscape.

"Mountainous ... bucolic ... idyllic ... Arcadian ... pastoral ... pasture ... pasteurization ...

"Deportation ... separation ... rejection ... masturbation ...

"Languid ... horrid ... filthy ... father ..."

11b Gavino's father

Resolution
Finally, the logic becomes clear: for Gavino the flag symbolizes the paternalism of Italy itself – "father ... patriarch ... godfather ... master ..." This is both a political and a personal vision of his past, expressed through the color of the flag, the flashbacks of his father and the alliteration of the voice-over on the sound track. It also provides the title of the movie itself.

"Patriarch ... godfather ... master ... Father Eternal ... patron ..."

11c Gavino's father

12 ⏱ 46 sec Gavino studying

MAKING
A
MOVIE

HOW TO SHOOT FOR LATER EDITING

The most important aspect of your movie is structure. This involves not only the form of each individual shot, but the relationship of the shot to its neighbors and to the flow of the movie as a whole. The process of editing is vital in placing each shot in its final context, but the search for a coherent structure means that you also have to consider every aspect of each shot – its size, color, pace, duration, and sound. Therefore you have to plan for editing, and this means that in addition to the main action, which can often be covered in one long take, you must shoot cutaways – shots of things that are relevant to the main action but not covered by the master shot, and which can be inserted into the movie at the editing stage.

Cutaways can sometimes be shot at a different time, or even in a different place to the main shot. They can sometimes suggest themselves to you in an almost subliminal way. A flashing glance, the touch of a hand, a leaf blowing in the wind – subjects such as these might make effective cutaways in the right context. The beauty of video tape is that it is cheap, compared to film, and you can afford to record a multitude of images that relate only marginally to the main subject. You may often find that such impressions turn out to be useful when you come to edit, even if at the time they seem irrelevant.

A static subject
A simple sequence of someone sitting in a chair knitting does not seem to offer much opportunity for variety. But by thinking about the different inserts and cutaways you might want later, you can inject a lot of variety at the shooting stage. Take shots from different angles, move away to take longer shots of the person in context, and zoom in for big close-ups of the hands at work. And do not forget telling details, such as the balls of wool at her feet. This range of shots will give you ample material when you come to edit your tape.

A moving subject
In a movie about a subject like a motorcyclist, it is easy to get carried away with the shots of the bike and rider in motion. Even here, remember to try different angles, like the low shot and the shot over the rider's shoulder. Shots of the rider maintaining the bike or polishing it can give a quieter context to the more dynamic sections of the tape.

The narrative sequence

But your basic aim when shooting is still the effective telling of a story, whether real or imaginary, and you must be sure that the narrative flow is maintained. If you are shooting a long sequence such as a birthday party, you will want to have several long takes with continuous sound. You will then need to insert a variety of close-ups. These might be of inanimate objects, such as a row of birthday cards or a fizzing glass of champagne; or of people, in which case you could take mute shots of guests smiling – or possibly sleeping off the champagne in a corner.

Later on, when you come to edit your tape, you can slip cutaways like these over the long soundtrack by insert editing, or use them to abbreviate the whole sequence by including them between shots that were taken some time apart. Another method of abbreviation is to use the fade control on the camera. You can fade down, in both sound and vision, and then fade up again at a later stage in the event. Or you can defocus, and focus again for the next shot, blurring the loss of continuity. A "whip-pan" has the same effect, in editing.

Contrast and continuity

When you know that you will be editing your tape later on, try to bear in mind the relative shot-sizes. To give a variety of "flavors", and for ease of intercutting, make sure that the framing covers the whole range of shots from very wide-angle to big close-up, or even macro (see p. 58). Likewise, you should vary the pace of the shots from rapid to stationary, so that you can orchestrate the final product in as varied a way as possible. But you should not overdo this sort of effect: your overriding concern should be for continuity rather than contrast: the cutaways should be the salt and pepper rather than the main course.

THE "LINE"

One of the greatest problems in filmmaking is that of maintaining a clear geography while changing the position of the camera in between shots. It is all too easy accidentally to juxtapose two shots in which the same person is seen to be facing or moving in opposite directions (a "reverse cut"). To prevent the confusion which this causes, there is a convention known as the "line": it is an imaginary line composed partly of the subject's eyeline, partly of the direction in which he or she is moving, and partly of the "line of interest" that stretches between two or more people. Both eyeline and direction will be confused if the camera positions for two consecutive shots are on opposite sides of the line.

Crossing the line

It would be an intolerable restriction if, having chosen to shoot from one side of the line, you were stuck on that side for the duration of the sequence. Some of the most common ways of "crossing the line" are shown in the illustrations below.

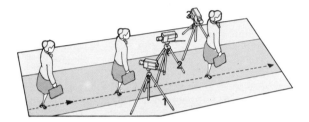

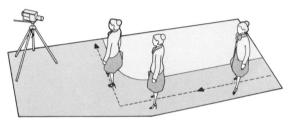

How to cross the line
One way of crossing the line (far left) is to get on the line itself. If the camera is placed exactly on the line, you can use the "dead-ahead" shot as a transition between the shots on either side of the line. Another method (left) is to let the line cross the camera on a turn. If the subject changes direction, so does the line. If you set up the camera so that the change of direction is seen on the screen, the new line will be clearly established.

Entering a doorway

As the girl in our scene walks up the path, she approaches a door. You are now faced with the problem of how to film her opening the door and entering the house. Unless you are going to settle for just one shot of her disappearing into the house, you will need a minimum of two camera positions – one outdoors and one indoors. The camera positions must be carefully thought out in relation to the "line" if continuity is to be maintained when you cut from the first shot to the second. In this case, the line may be taken to be the direction of the girl's movement (below). If the camera outside the house (position 1) pans to show her walking from right to left, then the camera inside the house must be set up on the same side of the line (position 2) or the girl will be seen walking from left to right and she will appear to have changed direction.

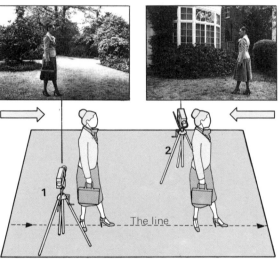

The "reverse cut"
In the example shown here, the "line" is the direction in which the girl is walking. The direction of any movement on film is what the eye sees first, and it should therefore be consistent. The stills show what happens if two camera positions are selected on either side of the line. Camera 1 shows the girl walking from left to right; camera 2 shows her walking from right to left. If the two shots are juxtaposed, then they will produce a "reverse cut" and the girl will appear to walk in the opposite direction.

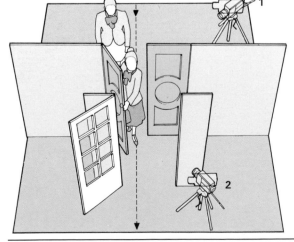

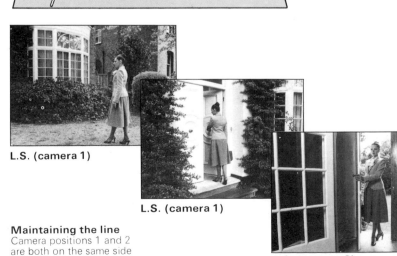

L.S. (camera 1)

L.S. (camera 1)

L.S. (camera 2)

Maintaining the line
Camera positions 1 and 2 are both on the same side of the line.

Situations in which more than two people are being filmed can cause difficulties if the position of each person in relation to the others is to be clearly maintained while you cut from shot to shot on the screen. For this reason try to plan sequences of this kind before you begin shooting. In the case of a group of people, there will be several lines of interest, several eyelines and, if any of the subjects move, several lines of movement. How do you decide where the "line" which dictates the camera positioning runs? The answer is to make a choice of one of the many lines — it may be the dominant dramatic axis of the scene — and stick to it as far as possible.

In the example illustrated here, a group of four people are sitting around a table eating a meal. The number of possible "lines" are shown right. The easiest solution is to select one of the outer lines, say the one between B and C, and remain outside it — that is, outside the whole circle. The two camera positions will allow you to cover all four subjects.

Inserts and cutaways

When you are working in unplanned situations, you should try as far as possible to "cover" yourself by getting plenty of reaction shots of your subjects as they listen and respond to one another. This will give you much more freedom when you come to the editing stage, and will enable you to get around difficult problems of continuity. Because the constant direction of eyeline is so important in maintaining a sense of geography (see p. 61), especially when intercutting close-ups from different camera positions, try to get a close-up shot of each person in the scene looking right, looking left and looking straight ahead. You can then insert these (see p. 74) as linking shots when you edit the movie.

Camera position 1
From this camera angle it is possible to get three of the four people in shot—C, D and A—although you will not be able to get a close-up of C's face. The line passes between B and C.

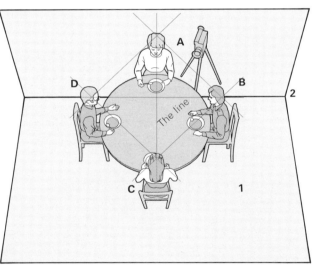

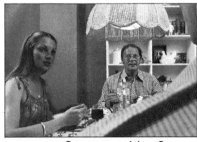

Camera position 2
The camera has now moved around the table, although it is still on the same side of the line between B and C. From the new position, you will get a shot that includes D, A and B.

Tracking around the table

While "two-shots" and "three-shots" tend to provide their own geography — since we recognize the relative positions of the people around the table — close-ups are very easy to confuse, and after three close-ups in a row an audience will no longer be clear about who is positioned where. In situations where you cannot plan the sequence shot for shot, the easiest way of establishing the geography is to hand-hold the camera and track around the table *before* cutting or zooming in to a close-up. That way, the change of position is actually visible.

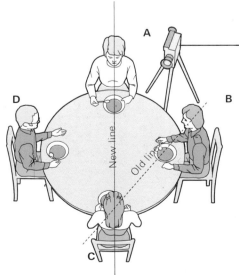

Close-up of C
By crossing the old B to C line and establishing a new one between A and C, you can move around the table and get a full close-up of C's face.

Tracking around the table
In situations when you cannot plan the sequence shot for shot, the easiest way of establishing the geography is to hand-hold the camera and track around the table *before* cutting or zooming in to a close-up. That way, the change of position is actually visible.

CREATING A SEQUENCE

All movies tell a story. No matter how impressionistic the treatment, the shots which you put together in any completed video will be in a fixed sequence; and that sequence is a statement which the viewer will interpret as a narrative. Unless you make it clear that what is being seen is a flashback or a dream, your audience will assume that the first shot occurred before the second shot, the second before the third, and so on. Indeed, our minds are so geared towards narrative and to recognizing cause and effect that movies can easily generate misconceptions: if two quite unrelated images succeed one another, an audience will tend to create an imaginary link between them.

The story-telling aspect of video is as important for home movies or for documentary reportage as for drama. Say, for example, that you want to make a short tape of your small daughter having a bath and going to bed. During the half hour this takes, you might be recording for about 15 minutes. After editing, this might be reduced to about 5 minutes.

Immediately, you come up against the following problems: you have to intercut various shots of the same person, using different camera angles and shot-sizes, without producing any ugly "jump cuts"; you have to maintain geography as the child moves from one room to the next; and you have to use "cutaways", "inserts" and close-ups in order to telescope the time-scale on the viewing screen.

The art of the filmmaker is to take shots filmed at different times, from different angles and sometimes in different places, and to put them together to create a satisfying account of an event, or a place, or a mood. If the basic shots are thought of as the *vocabulary* of video, then the business of putting the shots together to create a logical, coherent sequence may be considered to be the *grammar* of video. It is what makes movies work. The techniques outlined in the following pages provide the visual punctuation marks without which no video would make sense. They are not rules, but guidelines.

Abbreviations
There is a common convention for describing the basic shots in movie photography (see p. 58). The terms used are always abbreviated in the following way:

B.C.U. Big close-up

C.U. Close-up

M.C.U. Medium close-up

M.S. Mid shot

M.L.S. Medium long shot

L.S. Long shot

E.L.S. Extreme long shot

Shooting a simple narrative

Whatever the scene you are shooting, your job will be the same: you must record it so that all the shots can be assembled at the editing stage into one sequence of unbroken action. Some of the things you will have to consider will be: the *size* of the subjects in the frame; their *position* in the frame; the direction of their *eyeline* and their movement; and *continuity* of action. The example we have chosen to illustrate here is very simple. A girl is seen walking up a path, opening the door of a house and going in. The picture below shows the scene in plan and also some of the key camera positions which you might use. In the following pages, we discuss some of the ways in which you might record this scene and explain how to avoid the most commonly made errors.

Camera position 4
The camera is now inside the house. You might set it up on the same side of the "line" as position 3 or on the opposite side (see p. 75).

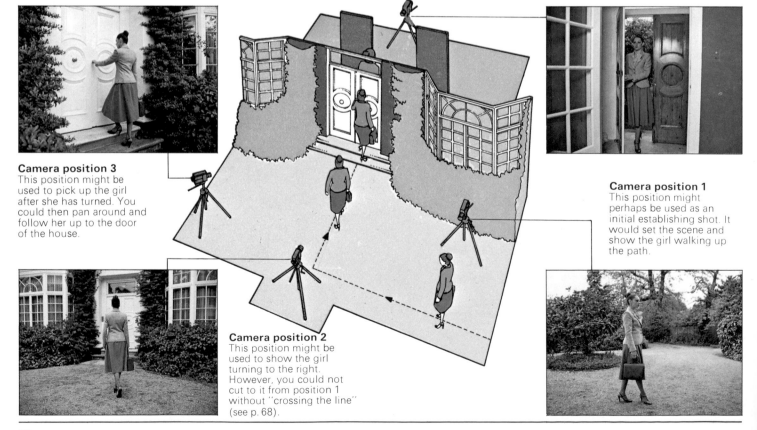

Camera position 3
This position might be used to pick up the girl after she has turned. You could then pan around and follow her up to the door of the house.

Camera position 1
This position might perhaps be used as an initial establishing shot. It would set the scene and show the girl walking up the path.

Camera position 2
This position might be used to show the girl turning to the right. However, you could not cut to it from position 1 without "crossing the line" (see p. 68).

Image size

One way of opening the sequence would be to set up the camera in position 1 (see below) and begin with a long shot of the girl walking up to the house. This will establish the scene. You might then decide to pan around and follow her until cutting to another position when she turns. But it would probably help the sequence if, once the scene has been set, you cut in to a closer shot of the girl. This will guarantee that the audience's attention is firmly centered on her.

When making a cut of this kind, it is crucial that the difference in the size of each shot is right – or the effect will be either indecisive or shocking (see right). The usual technique is to use a mid shot in between the long shot and the close-up. You could shoot the whole scene from camera position 1, using the zoom lens to close in. But, in practice, it would be better to move the camera as well. Position 2 will vary the angle and give you a better mid shot; and for the close-up you could either pan around or track just in front of her to position 3.

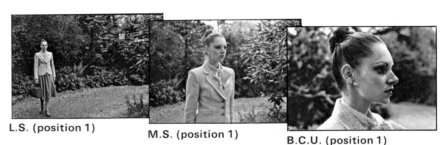

An "indecisive" cut
When cutting from a long shot to a mid shot, the difference in image size must be decisive. If the size of the girl does not change sufficiently, as shown here, you will get an unpleasant effect like that of a "jump cut" (see p. 77).

A "shock" cut
If, on the other hand, you cut directly from a long shot to a big close-up, you will produce a shock effect which may be inappropriate. For this reason, the usual compromise is to record a mid shot.

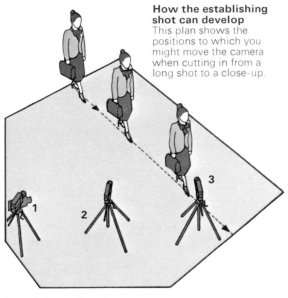

How the establishing shot can develop
This plan shows the positions to which you might move the camera when cutting in from a long shot to a close-up.

L.S. (position 1) M.S. (position 1) B.C.U. (position 1)

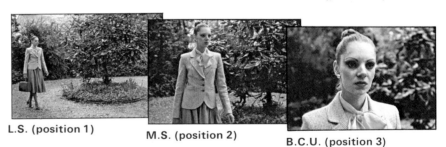

L.S. (position 1) M.S. (position 2) B.C.U. (position 3)

Position in the frame

When cutting from one shot to another – say, from a long shot to a mid shot – the subject should occupy the same position in the frame. If your subject is on the left of the picture in the long shot then he or she should also appear on the left in the mid shot. This way the shots will juxtapose well and the audience will recognize instantly that the subject is the same person. If this rule is not obeyed and a subject formerly on the left of the screen suddenly appears in close-up on the right, there will be an awkward and distracting jolt.

Matching the position of the subject
In both the examples shown here, the position of the girl in the frame has changed from one shot to the next. Both the subject and the background appear to jump suddenly over to the right.

THE MOVING CAMERA

Moving the camera horizontally across the floor is known as *tracking*; moving it up or down in the air is known as a *crane shot*. It is *during* these movements that the video camera really comes into its own. No other recording medium except film has this capacity to re-create three-dimensional objects on a flat screen. As the camera moves, perspective changes and a building, a person, or a sculpture takes on body and mass. This is video at its most dynamic and magical.

Tracking a stationary subject

A tracking shot is the best way of recording three-dimensional subjects which can be properly revealed only if the camera moves around them. Moreover, a track conveys a sense of exploration and a clear geography which cannot be achieved by a series of static shots from varying angles. Choose your speed carefully and rehearse the track before you start shooting.

In the case of people in a static dialogue, a tracking shot is normally dramatically motivated by the interplay of character. It is a visual metaphor for some aspect of the relationship and a clear manipulation of the point of view by the filmmaker: it should be used sparingly.

Tracking a moving subject

A tracking shot is an excellent way of keeping a moving subject in reasonable close-up. As the subject moves, so does the camera – and the distance between the two remains the same. The only other way of doing this is to use a telephoto lens and shoot from a long distance, but this will not have the force or impact of a tracked close-up. The subject can be anything from a person walking or running to someone in a moving car, or even a horse race. The speed can be slow and relaxed, or frenetic.

Tracking a moving subject is one of the most difficult of all shots. Hand-held tracking needs a good deal of coordination and practice (see p. 56) and so, if the situation allows, use some form of "dolly" to steady the camera. If you have a chance to plan the shot and rehearse it, do so. Decide whether you want to be in front, behind or beside your subject, and what distance you want to maintain. Outdoors, check for different light levels (see p. 42) and indoors set up your lights to give an even, consistent illumination (see p. 88).

The "subjective" track

A tracking shot in which the view seen by the camera represents the view seen by a character on the tape is known as a *subjective track*. Imagine, for instance, a scene in which a man walks up to a door and opens it. As he walks through, the tape cuts to a shot which represents what he sees. The camera is set up in the position in which we last see him; it then tracks as if it were the subject himself. If he stops, the track must stop. If he starts to run, the track must gather speed. If he looks to one side, so must the camera. We see the world as if through his eyes. In this situation, a steady camera is not essential. In fact, the slight wobble produced by a normal hand-held shot will convincingly suggest the subject's movement, especially if the man is supposed to be running, drunk, ill or deranged.

Stationary subject
Tracking around a stationary subject is a way of exploring it and giving it a sense of depth, since perspective alters with the movement of the camera.

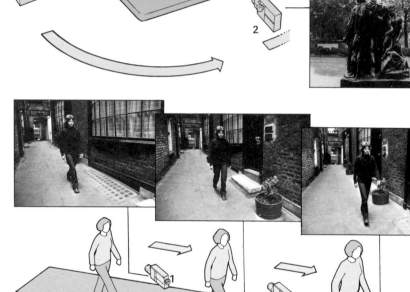

Moving subject
Tracking with a moving subject enables you to keep it in close-up throughout the shot.

Subjective track
Camera position 1 is a shot of the subject walking down a street. We then cut to a tracking shot (positions 2 and 3) in which the camera's point of view becomes that of the subject.

How to track

A track may be made from a professional "dolly", a car or a wheelchair; or it may be simply hand-held. In each case, the big problem is keeping the camera steady. The powerful effect of a tracking shot will be spoiled if it is so wobbly that it draws attention to the filmmaking process rather than to the subject of the movie.

If you decide to hand-hold the shot, try to move as smoothly and evenly as you can. You may find it worth hiring one of the stabilizing systems specially designed for hand-held tracking shots.

Where possible, it is best to use some sort of "dolly". A professional dolly is simply a wheeled platform on which the camera is mounted. The camera-operator sits or stands on the dolly, and the entire unit is propelled on rubber wheels or tracks by a motor or by a second person. However, it is possible to improvise your own dolly using a wheelchair, a supermarket cart or even a baby carriage. But for tracking along a road, a car is by far the best. If the road surface is poor, try letting some air out of the tires to damp down the bouncing movement of the car. If you are shooting through the windscreen, make sure it is clean.

Wheelchair dolly
Use long wooden planks as improvised rails.

Professional dolly
Both camera and operator sit on a special cart.

Start and end marks
Because focusing is often critical in close-ups, marks are sometimes made on the floor so that both the subject and the camera-operator can be in exactly the right spot at the start and end of the track. Either make your marks with chalk, or use pieces of gaffer tape.

Tracking speed

The speed of the track is governed by the focal length of the lens, the subject-to-camera distance and the angle at which objects move past the camera. It can therefore only be judged by the camera-operator during a rehearsal. As a general rule, the wider the angle of the lens, the faster you need to track to achieve a given speed on the screen. And the closer the subject is to the camera, the slower you must track. If the camera is pointing straight ahead, the track will appear slower than if you pan around so that you are looking to the left or right of the direction in which you are traveling.

Looking to one side
The camera pans so that it points sideways.

Looking straight ahead
The camera points in the direction of the track.

Crane shots

A *crane shot* is a vertical track. The camera is either raised up into the air or lowered to the ground during the shot – thereby dramatically varying the height and the angle-of-view of the shot. Because this effect is outside our everyday experience, the crane shot can never be bland or neutral: it is probably the most spectacular shot in video.

Simple crane shot
The framing varies with the height of the camera.

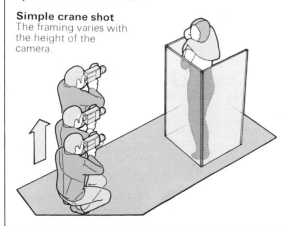

How to perform a crane shot

By hand-holding the camera and rising gradually from your knees to a standing position, you can perform a simple crane shot, but you must be very steady. It is possible to hire a large hydraulic platform designed for maintaining street lights, but they are expensive. Improvise by making use of escalators, elevators, fork-lift trucks or see-saws.

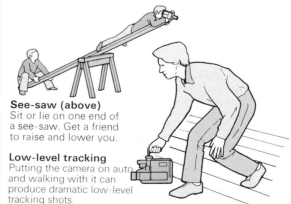

See-saw (above)
Sit or lie on one end of a see-saw. Get a friend to raise and lower you.

Low-level tracking
Putting the camera on auto and walking with it can produce dramatic low-level tracking shots.

EXPANDING THE ACTION

The simplest way of recording an event on video is to set up the camera in one place and cover the whole scene from that one position. This is known as a *master shot*. It is the most theatrical of all video techniques: the action takes place in front of a static camera, which acts as a passive observer. The pace of the sequence is determined by the actors or the events themselves.

However, the unique feature of movie photography is that it allows the filmmaker to manipulate the action, to create his or her own pace, and to expand the image of reality which we finally see on the screen. For this reason, the master-shot system is very rarely used on its own. What sometimes happens is that the scene is acted out several times, each time being filmed from a different camera position – one of which will be the master shot. The sequence is then built up at the editing stage by inserting close-ups and different angles into the master shot. This system allows you plenty of flexibility when editing and guarantees a certain inherent continuity. An alternative is to plot out the sequence, break the whole scene down into separate shots and shoot each one as a new set-up.

The master shot
A master shot is a record of the whole scene shot from one camera position in an extended "single take". However, it will look very static on the screen. To make the sequence visually more interesting, the master shot can be intercut with different angles, close-ups, inserts, cutaways or reaction shots.

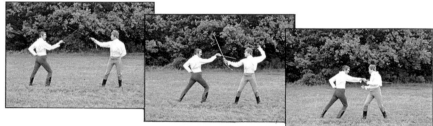

Inserts

An *insert* is a shot of part of the scene covered by the master shot. It is usually shot from a different camera angle and is intercut into the master shot to provide visual variety and to concentrate the audience's attention on a small portion of the scene. Inserts are therefore most often used to emphasize a significant detail. They can also be used as a bridge between two separate master shots. Be very careful when using inserts, especially if you are recording them at a different time: any continuity discrepancies will be instantly visible. Take great care that the camera does not accidentally cross the line, and that you match up eyelines if cutting in to close-ups.

Using inserts
In this sequence of a pistol duel, two inserts have been intercut with the master shot to provide close-ups of the protagonists.

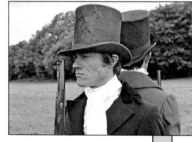

An insert shot from camera position 2

An insert shot from camera position 3

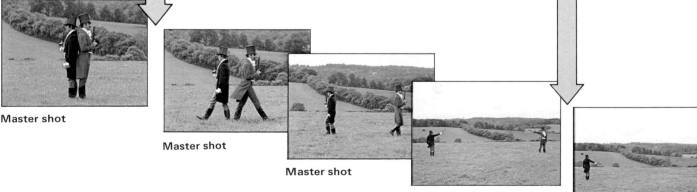

Master shot

Master shot

Master shot

Master shot

Master shot

Cutaways

A *cutaway* is a shot of something not covered by the master shot. It is inserted into the main scene because it has some relevance to it, and to provide some kind of visual or dramatic enrichment of the central action. It might be simply a shot of something or somebody offscreen to which the main characters are referring. Or it may well be something at a distance – in either time or in space. Or it may be an image that is quite imaginary, inserted as a metaphorical comment on the action or on one of the characters. One of the most frequent, and unsatisfactory, uses of the cutaway is as a means of disguising an accidental reverse cut or a break in continuity (see p. 190).

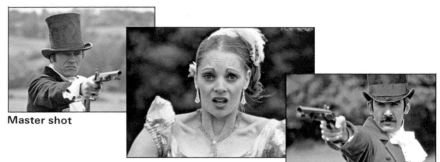

Master shot

Cutaway

Master shot

Using cutaways
By intercutting cutaways into the main action, it is possible to introduce an extra dimension to the scene. In the examples illustrated here, shots of the anxious girl, the pistols being taken from their box and a close-up of one of the guns have all been inserted into the master shot.

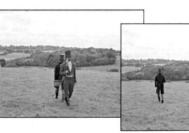

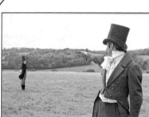

Reaction shots

As its name implies, a *reaction shot* is the silent response of one or many people to another person or event. Reaction shots are recorded in the light of the main shot – and thus *after* it, unless you are using two cameras. Eyelines must be compatible, and in a dialogue you must judge carefully how you wish to balance the angle and the image-size of the respective faces, since this will affect their impact on the screen (see p. 60). In a confrontation, always position each face on the opposite side of the frame, or else your subjects will seem to be back-to-back.

Good reaction shots are surprisingly difficult to produce, since actors tend to overplay an isolated close-up. The best solution is to restage the whole scene from the new camera position. Alternatively, you can get your reaction shots from the listener or audience during some other comparable moment in the action.

Master shot

Reaction shot

Master shot

PARALLEL ACTION

Cinematic devices such as inserts, cutaways and re-action shots (see p. 74–5) are all, in their own way, examples of "simultaneous" filming. In other words, the inserted shots are not so much consecutive with the master shots on either side of them as "parallel": they are another way of looking at the same scene. Video can create this simultaneity very easily. Indeed, the double vision is often extended to the point where two quite separate scenes are intercut. This technique is known as *parallel action*. Parallel action may be thought of as any related scene which is not occurring in the same place as the central action but which may be intercut with the master shot. In such a case, the two scenes are parallel in time – even if one of the two is a flashback to the past or a glimpse of the future. An intercut sequence of parallel action may therefore be a memory, a fantasy or a purely symbolic exploration of the main thread of narrative. There is no limit to the degree of intercutting, provided that direction and pace are maintained.

When to use parallel action

The technique of parallel action has been conventionally used to build up tension in a sequence since the beginning of movie photography. For instance, a blazing Western heroine staked by Indians has for decades been intercut with shots of the cavalry racing across the plain. She looks left; they charge right. So familiar are we with the conventions of movie language that we supply the implicit link between the two parallel shots.

Parallel action is not, however, confined to building up tension in thrillers and chase sequences. It applies to any movie which attempts to do more than tell a two-dimensional tale. For instance, the reaction shots in a four-way conversation may tell a quite different story from the master shots. In this case the parallel action can be used to create another psychological or emotional dimension to the scene. The effectiveness of the technique depends on the skill and subtlety with which the parallel shots are intercut at the editing stage.

Intercutting for suspense
In this sequence, shots of the unsuspecting woman in the bedroom are intercut with shots of the murderer climbing the stairs. The feeling of increasing suspense is heightened by the dramatic lighting and by the contrast between extreme close-ups and wide-angle long shots.

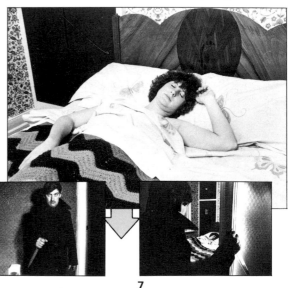

Bridging time and space
In this example of parallel action, shots of a burglar breaking into a house are juxtaposed with shots of the policeman. The audience will supply the connection between the two scenes of action.

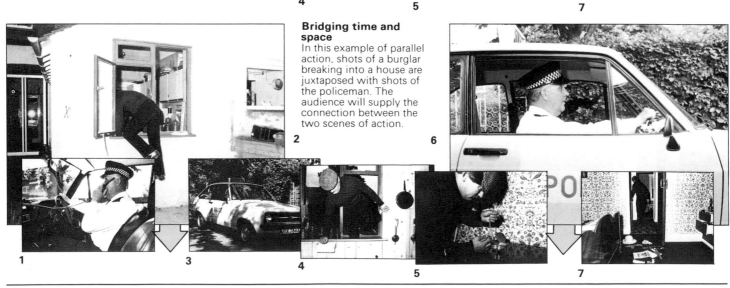

MANIPULATING TIME AND SPACE

Video allows you to distort time and space. You can compress a week of real time into a minute of screen time, or flash from one place to another, making "here" seem like "there". You can thus create a screen reality which need have no similarity to your actual settings – it will have its own time-scale and its own geography. Fades, dissolves, wipes, whip pans, cutaways and jump cuts are some of the conventional tools of movie language which enable you to manipulate time and space.

Optical effects

A shot may be faded in or faded out. A *fade-out* to black is used to close a scene; a *fade-in* to open it. If a fade-out is followed by a fade-in, the audience will accept that time has passed or the location has changed.

A *dissolve* is a fade-out overlapped with a fade-in of equal duration. It is a transition shot, but is not as final as a fade-out. It is used to create a smooth visual flow between shots.

Editing techniques

Inserts, *cutaways* and *reaction shots* (see p.74–5) are all used to compress action when you wish to disguise the fact that the time-span is being shortened. Perhaps the most familiar use of these is the cutaway of the crowd in a TV football game which enables the match to be condensed into, say, twenty-five minutes without any apparent discontinuity in the action. Cutaways may also be used to *expand* action. By overshooting a scene, you can, for example, stretch the last five seconds before a bomb goes off to thirty seconds on the screen.

A *jump cut* is a cut achieved by editing a length of footage from a single continuous shot and joining the two remaining ends together again. On screen it may be glaringly abrupt or virtually invisible. Jump cuts are often used in documentaries to compress an interview without using cutaways.

Fade-out

Master shot **Cutaway** **Master shot**

Long shot **Edited-out zoom-in** **Jump cut to mid shot**

Wipes and dissolves

Certain studio special effects are useful when you want to manipulate time and space. One is the wipe, in which the new image occupies an ever-increasing area of the screen and is separated from the old image by a hard line. Another technique is the dissolve, in which a new image is faded up as the old image is faded down. Both of these effects need to be carried out at the editing stage, and usually require some form of editing controller or special effects generator, as well as a camcorder and VCR. What the editing controller or special effects generator can do is to synchronize two incoming video signals. These can then be mixed together in the proportions required to create a dissolve or wipe. Square or circular wipes (in which the new picture expands to fill the screen) are also possible.

Dissolve

THE ASSEMBLED SEQUENCE

This sequence illustrates how the various elements outlined in the preceding pages – shot size, pace, camera movement, composition – create their effect by working not separately but in unison. Claude Chabrol's *Le Boucher* ("The Butcher", 1968), from which these frames are taken, is an example of discreet but highly refined technique. In this sequence, the schoolteacher – Chabrol's wife, Stephane Audran – is on a picnic with her pupils. We already know that there is a murderer at large. There is an atmosphere of apprehension, reinforced by the brooding music and relentless, slow tracking shots.

1 ⏱ 8 sec The school picnic

Establishing shot
In this long opening shot, we see that the children are literally on the cliff edge. This helps to emphasize the potential dangers of their position. The camera broods on the scene. There are distant children's voices on the sound track.

2a ⏱ 14 sec The teacher

2b The schoolchildren

2c The little girl in blue

Pan and tilt
This lengthy (14 sec) top shot focuses our attention from the group onto the little girl in blue. We do not know yet why, and this again contributes to the tension of the scene. The children's voices are mixed with increasingly menacing music.

Close-up of girl
From the long pan and tilt, Chabrol cuts to this shot which is a more intimate (and faster) close-up. It shows one of the shoolgirls preparing to eat a roll.

3 ⏱ 2 sec The girl opens her roll

4 ⏱ 2 sec She is just about to begin eating

Eye-level shot
The camera moves down and around and we are now right on the girl's eye level – although she is not yet in big close-up. The meaning of her question is still unclear and there is still no clue as to why the camera has selected her.

Girl: "Is it raining?"

Mid shot of teacher
This shot, in which we cross-cut to the teacher again is still quite lengthy (5 sec), thereby underlining the growing suspense. The use of mid shots here means that the big close-ups can be saved for later, more dramatic moments.

5 ⏱ 5 sec The teacher

Big close-up of blood
This is the moment when the tension is released. From now on the sequence accelerates and deals with large close-ups. The "rain" is blood, and it drips onto the little girl's roll.

Teacher: "Of course not. The sky is clear"

6 ⏱ 3 sec Extreme close-up of blood dripping onto the roll

Girl: "It's red"

Reaction shot
In a short close-up, the teacher looks around quickly to the little girl. It is the pace of the movement rather than the speed of the shot which accelerates the drama.

7 ⏱ **1.5 sec The teacher turns**

Shock cut
Chabrol cuts back to the girl in another very fast, shocking shot. The blood which previously fell on the roll has now dripped onto the girl's face.

8 ⏱ **1 sec The blood hits the girl**

9a ⏱ **6 sec Mid shot of boy**

9b The camera tracks backwards to a big close-up of the teacher staring up

Track out
Using a track – which must surely have been hand-held – Chabrol links the children's world by retreating from a mid shot of the frightened boy to a big close-up of the teacher standing and looking upwards. We then cut to her eyeline.

Boy: "It's blood"

10a ⏱ **6 sec Zoom-in**

10b Zoom-in

Subjective shot
This is the teacher's view. The blood is revealed to be dripping from a hand hanging over a cliff-top and outstretched against the blue sky. This is the point at which the music reaches a climax.

Zoom-in
This shot is a perfect example of a subjective zoom-in. The hand grows larger and larger in the frame, thus conveying the horrified narrowing of the teacher's attention on one object – the bleeding hand.

10c Zoom-in

LIGHTING

NATURAL LIGHTING CONDITIONS

The natural lighting conditions produced by the changing weather will dictate the mood of your sequence even more forcefully than the time of day. It is difficult to make a funeral look anything other than festive if the sun is shining brightly; and a wedding in heavy, gray drizzle is perhaps better not recorded at all.

If you are attempting to establish a particular atmosphere, work in weather that most closely resembles that mood, even if you have to wait a very long time.

Wet weather

It is always best to try and *use* the prevailing light and weather conditions that Fate provides. If it is raining, then show the puddles and umbrellas, the people running for cover, the water dripping from leaves, and so on. Your subsequent shot of a rainbow – if you are lucky – will then make sense chronologically as well as aesthetically. Always keep the camera dry: cover it with a plastic bag or stand under an umbrella. A plain glass or ultraviolet filter will keep raindrops off the lens itself, but remember that the drops are more visible at the wide angle than at the telephoto end of the lens.

After rain (above)
The light in this shot has a soft, pastel quality. It was taken in the early evening after a rainstorm.

Rainbow (far left)
This shot of a rainbow was taken during a summer storm.

Rainstorm (left)
The feeling of a sudden downpour is perfectly conveyed in this muted shot, taken through a rain-soaked window pane.

Shooting a sunset

Sunsets are particularly dramatic when shot using the "time-lapse" technique (see p. 152); they also make spectacular background scenery. Remember, however, that the light will be very red and will give an almost "raspberry" color cast to the overall scene. If this is the effect you want, however, you can exaggerate it by using red or orange colored filters.

Getting the right exposure will be your biggest problem when shooting sunsets, since, when the sun is still high in the sky, its presence tends to overwhelm the meter. One solution is to use your zoom lens to take a spot reading of the clouds near the sun, then lock the aperture and zoom out again for the shot. Alternatively, zoom to your wide-angle setting and, stretching your left hand as far forward as you can, try to mask the sun alone from the lens. This will give you an average reading of the cloud area.

Late sunset (below)
The sun has now sunk below the horizon. For the purposes of calculating the exposure, it may now be safely ignored: it will no longer be bright enough to mislead the meter.

Early sunset (above)
The sun is still above the horizon. If the camera is "locked-off" for a long exposure with the sun in shot, the tube may be permanently damaged.

Skyscape
Sometimes a shot of the sky is the best way to set the scene or define the atmosphere. After all, the sky is where the weather originates, and cloud patterns can form dramatic subjects in their own right. Automatic exposure systems make shooting the sky quite straightforward in many cases, but you may have a problem with contrast – a brightly lit sky may expose correctly, leaving the ground rather dark.

LOW LIGHT

Modern cameras and lenses allow you to record in conditions that only a few years ago would have been considered impossible. Most camcorders can operate at light levels of 10 lux or less – about the equivalent of candle-light.

Low light has no special intrinsic virtue. But low light capability means that you can fully exploit natural light without tampering with it. You can shoot a barbecue by the glow of the campfire, a street scene by the light of the shop windows, or a rock concert by the stage lighting. Video cameras and receivers can only cope satisfactorily with a limited range of contrast. If a subject has very bright highlights and very deep shadows, it is said to have "high contrast", or a high "contrast ratio". As the camera can be adjusted for either the highlights or the shadows, but not both, the result will be either burnt-out highlights or blocked-up shadows. With a low-contrast subject, the camera can easily encompass the range of contrast, but the image is flat and undramatic.

To compensate for excessive contrast, use either a reflector to fill in the shadows; or a portable quartz sun-gun with blue filter; or a large gauze screen between the sun and the subject.

The only way of correcting low contrast is to supplement the available light with large quantities of tightly focused spotlights (with blue filters). In professional work, these would often be arc lamps, which can even simulate sunshine. The volume of light, and therefore power, required for such an effect is so large that it may be more advisable to wait for another day. In all these attempts to manipulate light the intention is not merely to improve the appearance of a scene, but also to create, and sustain, a mood – perhaps over several days of shooting.

Indoor lighting is just as variable in its range of contrast as daylight, if not more so: the pools of light that are created by table lamps or spotlights may give just enough illumination in their immediate area, but the spaces in between will be black on your tape. The over-all level of light in a domestic setting can be raised easily and cheaply by replacing the bulbs with higher-wattage units or with photofloods. In addition, to reduce the contrast, and to raise the over-all level of illumination still further, it is good practice to place one or two photofloods *without* shades behind the camera. These will bounce light off the walls and ceiling and will help the exposure in the shadow areas. These simple procedures require no investment in lighting equipment except for the bulbs, and the original effect of the room lighting will, generally speaking, be preserved. If you are seeking a natural effect, and do not wish to intrude on the scene with glaring spotlights, this solution is certainly preferable to the use of a battery light on or behind the camera.

Firelight
This shot was recorded entirely by the light given off from the bonfire. A wide aperture was set on the lens. Remember that depth of field is very shallow at wide apertures, so focusing is critical.

Stage lighting
This shot of Mick Jagger was recorded using the stage lighting. Stage lighting, which often comes from above or behind the performer can produce strong, attractive back-lighting, but – unless it is an effect you desire – beware of the lights flaring into the camera lens.

Using a fast lens
When filming *Barry Lyndon*, Stanley Kubrick often used an unusually fast f0.7 lens. He was thus able to achieve marvellously naturalistic shots and can be said to have been responsible for the first feature film ever shot by candle power.

Interior lighting
The vast dark interior space of the church of Hagia Sophia, Istanbul stretched the capabilities of the camera to their utmost.

LIGHTS AND ACCESSORIES

The function of any artificial lighting is to raise the level of illumination to the point where you get an acceptable exposure. This level will, of course, vary with the lens setting, and with the color, texture and angle of the subject, but the principal factors involved are the design and output of the light source that you are using and its distance from the subject.

Video lighting comes in every conceivable shape and size – from tiny "movie lights" which slot onto the camera to large professional units. The important thing to remember about artificial lighting is that *you* control it completely: the range of effects that can be obtained is limited only by your time, money and imagination.

The factors you should bear in mind when choosing a lighting system are primarily output and flexibility; can you vary both the intensity and the quality – the "softness" or "hardness" – of the light?

High output, long life and portability have made quartz lights very popular, especially for newsreel and documentary work and in other areas where mobility or one-person operation is important.

Quartz lights

Also known as *tungsten-halogen* or *quartz-iodine*, these lamps now dominate the moviemaking scene. They are smaller, lighter and more efficient than tungsten lights. They consist of a metal tungsten filament inside a small quartz glass tube filled with a halogen gas – usually iodine. The presence of the iodine guarantees that the bulb does not darken and that the light output and color temperature remain constant. Most quartz lamps last as long as 250 hours and have a color temperature rating of 3,200°K. Outputs vary from 150 to 350 watts for battery lights and from 200 to 10,000 watts for main power supply use. The quartz bulb itself should never be touched with a bare hand, even when unlit, as acid from the skin can cause premature failure of the bulb. Always handle the bulb with a small piece of tissue paper.

Movielights are designed to be attached to the top of a camera and are either designed to be plugged into the main electrical supply or to be powered by a battery. Sometimes they can be swiveled upwards so that the light is "bounced" off the ceiling. This is a big advantage because the light produced by a movielight tends to be hard, uneven and devoid of any relief.

Hand-held battery lights are often used professionally in night-shooting. They are usually known as *sunguns*, since they can also be used as a "filler" for facial shadows on dull days. When using a hand-held sungun, take care that it does not wobble while shooting because the motion will be visible on the screen.

Quartz bulbs set in open reflectors are probably the most common quartz lights. They are available in a wide range of wattages, usually from 200 to 2,000 but also as high as 10,000 watts. On many models the light may be focused by moving the quartz bulb to and fro. Nowadays, many of the better lamps are made with fiberglass housings to reduce transmission of the bulbs' heat.

Basic quartz lighting kits usually consist of three lights, each of which might be 1,000 watts. They are often equipped with "barndoors" and stands.

Quartz bulbs
The tungsten filament is set in a quartz glass bulb filled with halogen gases.

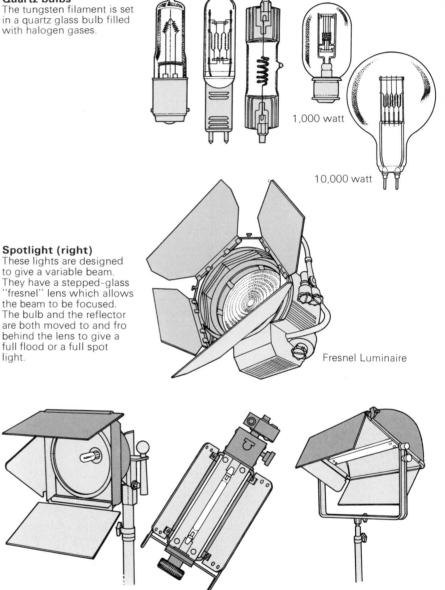

1,000 watt

10,000 watt

Spotlight (right)
These lights are designed to give a variable beam. They have a stepped-glass "fresnel" lens which allows the beam to be focused. The bulb and the reflector are both moved to and fro behind the lens to give a full flood or a full spot light.

Fresnel Luminaire

Quartz reflector lamp
This lamp takes interchangeable bulbs of 500, 750 or 1,000 watts. The light-beam can be focused by moving the bulb backwards and forwards in the reflector. If the light is on a very tall stand, a system of chains enables you to do this by remote control. At full flood position the angle of the beam is 67°; at full spot it is 5°. A range of accessories such as barn-doors, filters, scrims and alternative reflector dishes are all available.

Quartz "Tota-Light"
This rectangular reflector lamp uses double-ended quartz bulbs ranging in output from 300 to 1,000 watts. It gives an exceptionally broad, even beam of light, ideal for "bouncing" off walls or ceilings. The angle of illumination can be adjusted by altering the position of the reflector doors. The lamp is rugged, very compact and extremely light (it weighs only 20 oz.). Reflector screens, "umbrellas" and filters are all available.

Quartz softlight
This lamp is designed to take two double-ended quartz bulbs, usually 750 watts each. The bulbs face inwards, towards the reflector surface. This means that no direct light hits your subject. All the light is "bounced" off the lamp's textured reflector surface. As a result, although the light is still bright, it is much "softer" than unreflected light. It is ideal for producing delicate lighting, especially if you are only using one light.

The most important lighting accessory is the *stand*. It should be as strong as possible without being too heavy, and can be stabilized by draping a sandbag or water bag over the legs. Alternatively, use a *clamp* to attach the light to a door or a curtain rail, for example. The best kind is the "alligator clamp" or "gaffer grip".

Most of the other lighting accessories available are designed to control the quality, rather than the placing of the light (see below). Some of them – *barndoors*, spunglass *diffusers* and *filters* – are virtually essential. Many can be home-made: for instance, a large sheet of white polystyrene provides an excellent reflector for producing soft, diffused light. Large diffusers can also be improvised: simply hang up an ordinary white bed sheet and project light through it to soften it.

Sungun

Sunguns are small, lightweight quartz units. They usually range in output from, say, 150 to 350 watts and are powered by battery packs. Their chief advantage is their portability, and for this reason they are often used in newsreel work or in situations where heavy lighting equipment is not practical. However, the light they produce tends to be very hard if used directly.

Lighting stands
The best stands are made of lightweight alloy and are telescopic. Ideally they should extend to about 6 or 7 ft (1.8 m to 2.1 m) and have wide, robust legs. They are also available in a "boom" form so that overhead lighting can be provided without the stand being visible in the shot.

Alligator clamp
A spring-loaded clamp like this is ideal for securing fairly lightweight lamps such as medium-sized quartz lights.

Barndoors
These are hinged metal flaps which fit onto the front of the lamp. By adjusting their position, you can limit the light area as you wish.

Snoot
Sometimes called a "nose", this is an open-ended cylindrical funnel which fits over the front of the lamp and gives a narrow, concentrated circle of light.

Diffuser
A sheet of material such as frosted plexiglass, spun glass or even tracing paper placed in front of a lamp will soften the light and allow you to control its "flavor".

Umbrella
These umbrellas open up to reveal a highly reflective surface on the inside. They soften the light and produce relatively shadowless illumination.

Filters
Glass or gelatin filters allow you to change the color of the light.

Reflector design

A lamp without any kind of reflector will radiate light in every direction. By placing the lamp within a reflector, you can control the light and direct it where you want it. A *parabolic* reflector produces a hard light and is most commonly used with tungsten lamps. A *softlight* reflector has a shield in front of the bulb and so produces a diffused light. A *spotlight* enables you to vary the light beam. In each case, the light will be softer if the reflector surface is matted or dimpled rather than highly polished.

Parabolic reflector
This produces a concentrated beam of hard light.

Softlight reflector
This produces a broad beam of soft light.

Spotlight
This produces a variable beam of light.

BUILDING A LIGHTING SET-UP

Creative control of lighting is as important as proper control of the camera. You can vary the height, angle, intensity and diffusion of each of the lights in your set-up, and every change will affect the look and feel of your video. By positioning the lights where you want them you can produce a glossy, glittering image or a diffused, naturalistic effect; you can either allow yourself maximum flexibility for unpredictable locations (such as a party) or you can build a carefully structured and elaborately theatrical set-up for actors who can be guaranteed to be in the right spot at the right time. The techniques illustrated in the following pages can be adapted to any situation you wish. They can all be achieved using simple, inexpensive equipment.

Lighting for portraits

The human face is the most basic ingredient of any video, and an understanding of the ways in which it can be lit will help you to light other, more complex subjects. You are aiming to emphasize the best features of the face without producing excessive distortion. Although you are quite free to experiment with lights as you wish, most filmmakers agree that the best of way of lighting for portraits is to use a *key light*, a *filler* and a *back light*.

When positioning each of these lights, remember that there are two main factors involved: the quality of the light (that is, its "hardness" or "softness") and the direction from which it strikes the subject.

Lighting direction
The direction of the predominant light source has a great effect on the shape and appearance of a face. Here, a strong spotlight has been used at different angles to show how the degree of modeling and the amount of detail change.

4 Sidelight

The effect ranges from complete silhouette when the light is directed at a white background behind the girl's head, through to a harshly lit face without any modeling when the light is shone straight at the girl from just above the camera. None of the lights, on their own, are very flattering.

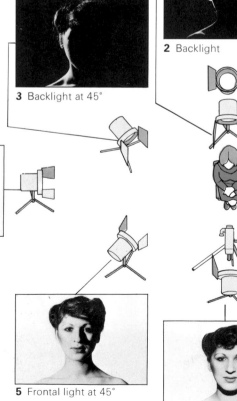

1 Silhouette

2 Backlight

3 Backlight at 45°

5 Frontal light at 45°

6 Frontal light

Positioning the key light

The key light is the basis of all facial lighting. For this reason it is sometimes called the "main" or "source" light. Because it is the strongest light it is the one which gives modeling to the face and is almost always placed off to one side of the camera. It is very important to set up the keylight correctly in relation to your subject's "eyeline". The eyeline is an imaginary line projecting out from the face at an angle of 90°, at the level of the eyes. Unless your subject is actually facing the camera, the key light should in general be as close as possible to the eyeline, or else you will get unpleasant shadows from the nose. There is an arc of about 20° on either side of the eyeline within which you can move the key light to adjust the modeling without running into trouble, but beyond this point you are likely to have an unflattering image.

Horizontal angle
The key light is usually placed within an angle of 20° on either side of the subject's eyeline.

The height of the key light is also important. If it is too low, the effect is grotesque: the eyebrows, cheekbones and chin are all unnaturally exaggerated. This may be fine for shooting a horror story, but not for a normal portrait. If the key light is too high, the eyes are invisible and heavy shadows distort the features. The best position for most subjects is found to be at an angle of about 40° above the subject's eyeline. This is hardly surprising since that is the position of most sunlight. It therefore produces a balance of highlights and shadow areas on the face to which we are accustomed and which we find "natural".

Vertical angle
Place the key light about 40° above the subject's eyeline.

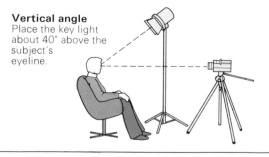

Key light only

The *key light* should be set up first and the others built around it. It provides the main bulk of the illumination, and therefore largely determines the exposure. When you have chosen the direction of the key light, you can then adjust the output and the degree of diffusion. If you decide to reduce the intensity of the light by moving it away from your subject, remember to increase its height so that the angle between it and the eyeline remains the same. The key light is normally a spotlight or variable-focus flood. It is not usual to diffuse it, but if it is the only light you have it should certainly be softened. No key light should ever be placed directly behind the camera. Check the result in the viewfinder or monitor.

Key light
This is the most important light in any set-up. It is often placed at an angle of 45° to the camera.

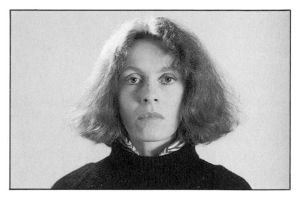

Adding a "filler" light

A *filler* light is added to the set-up to light some of the shadow areas thrown by the key light. It should be bright enough to relieve these shadows but not so bright as to fill them completely. The ratio between key light and filler light, called the *lighting ratio*, determines the degree of contrast and drama in the shot. In a classical set-up it would be about 2:1, the filler light adding perhaps one stop extra illumination. Always use a soft, diffused light for the filler. If your subject is looking straight at the camera, set it up on the opposite side of the key light. But if your subject's eyeline is off to the side, place the filler somewhere in the arc *between* the camera and the key light. Turn the key light back on and move the filler until the combined effect is just right.

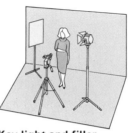

Key light and filler
The filler is set closer to the camera and lower down than the key light. It reveals detail in the shadow areas.

Adding a back light

When the key light and filler light have been set, switch them off and add a *back light*. This light, which is usually a spot or variable-focus flood, is sometimes known as a "separation light". Its purpose is to rim-light your subject's hair and shoulders in order to "separate" the figure from the background and to give it greater mass and form. The back light should be just to one side of the line of sight, and on quite a high stand – at an elevation of about 50° from your subject's head. Use a "French flag" (see p. 85) to make certain that the light is not shining directly onto the camera lens, or you will get severe flare. Check too that the lighting stand is not so near that it is accidentally visible in the shot.

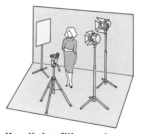

Key light, filler and back light
The back light shines from behind the subject and produces highlights around the shoulders and hair.

Lighting the background

The chances are that your subject will now be either set against a dark background that may mislead the camera's meter or against a light background that contains unwanted, confusing shadows. By setting up a *background light*, you can control this. A floodlight, focused onto the backdrop, is usually placed off to one side of the shot – the same side as the key light. This will soften the shadows cast by your subject and add a sense of depth to the scene. You can add a "cukaloris" (see p. 85) in front of the lamp if you want to break up the shadows still further. Alternatively, a light can be placed behind your subject or behind a stage prop so that it cannot be seen by the camera. But beware of this making the background too light and upsetting the overall balance.

The completed set-up
By adding a background light, the area behind the subject can be lit. In some situations this will produce a feeling of depth to the shot.

LIGHTING AND THE IMAGE

Lighting is the key to all creative movie photography. Once you have got sufficient light to record an image, you can vary the lighting to achieve the mood or atmosphere you want. The shots on these two pages come from Ken Russell's film, *Mahler*. They illustrate how different forms of lighting can be used for various effects in movie photography.

Silhouette

Shooting against the light is one of the most exciting ways to film; and pure silhouette, with its total absence of modeling or relief, can be used to create strong, abstract images. In this scene, Ken Russell uses a shot of Mahler in silhouette to bridge a gap of time and space. The sequence begins with Mahler in a railway car, silhouetted against the passing scenery. Suddenly the film cuts to a shot of him in exactly the same pose, but this time silhouetted against a blue lake. We realize that we have flashed back to a memory in his past.

1a ⏱ **2 sec In the train**

Shape and silhouette
A sudden cut between the train and the lake is linked by the shape of this distinctive silhouette.

1b ⏱ **3 sec In the train**

2a ⏱ **2 sec Mahler beside the lake**

2b ⏱ **3 sec He begins to speak**

2c ⏱ **5 sec The camera zooms out**

Light and reflection

A simple and effective way of enlivening any shot is to use whatever reflections you can. Light reflected off water, glass, metal or a wet street will emphasize any highlights in the composition and produce an attractive, high-contrast glitter. For the dramatic shot of Mahler shown right, Ken Russell devised an ingenious camera set-up which involved shooting through two windows and catching the reflections of the mountains in the first.

Reflections in glass
This shot comprises three elements. The camera is set up outside the lake-side hut in which Mahler stands. We see him through one window. It is this window in which the mountains across the lake are reflected. The patch of light behind Mahler's head is the view out of a second window on the other side of the hut.

Natural lighting

Try to take advantage of the variety offered by the changing light – for example, the soft, shadowless light on an overcast day, or the dramatic skies of a heavy thunderstorm. The scene shown here is set on the lake, outside the hut in which Mahler composed his music. The whole sequence is shot in late-afternoon sunlight. This creates warm, golden colors and strong contrasts between areas of light and dark.

Afternoon sunlight
The atmosphere of the idyllic setting is enhanced by the use of rich, golden sunlight.

1a ⏱ 5 sec The hut on the lake

1b ⏱ 3 sec Mahler and his wife

1c ⏱ 5 sec Mahler and his wife

Artificial lighting

In indoor scenes, it may not be possible to shoot without using some form of artificial lighting. However, with careful planning and careful positioning of the lights, these shots can be very effective and need not look at all "unnatural". The sequence illustrated here is a perfect example. It begins with Mahler's wife standing in front of a window. The scene is lit by light from outside, and she is seen in silhouette. She then turns towards the camera and walks into the center of the room, where the children are in bed. This shot appears to be lit by a candle on the bedside table. In fact, the effect of candlelight is being simulated by a strong spotlight which is shining onto the wall behind the table.

1a ⏱ 6 sec Mahler's wife

1b ⏱ 6 sec She turns towards the camera

1c ⏱ 4 sec With the children

Candlelight
The light cast by the candle is in fact a spotlight. It is switched off when Mahler's wife bends over and blows out the candle.

1d ⏱ 8 sec She bends over the child

1e ⏱ 1 sec She blows out the candle

LIGHTING FOR DRAMATIC EFFECT

The classic lighting set-up of key light, filler and back light can be used to produce a glamorous, stylized effect. It is done by using a strong back light, to give an exaggerated halo around the hair and shoulders, and by establishing a high ratio between the back light and the filler. This kind of lighting is artificial and does not aim at naturalism, but at drama, glamor and glitter. At its best it can be beautifully polished and convincing. As a style of lighting, it was very popular in the Hollywood of the thirties, especially used with diffusion filters. This was partly because a brightly lit set was essential for the very slow filmstocks and camera lenses which were then all that was available to moviemakers, and partly a striving for romantic effect.

The "Hollywood" look
This shot of Marlene Dietrich as she appeared in Sternberg's *The Blue Angel* (1930) is a perfect illustration of the classical Hollywood lighting technique. The filtering, the high-key – high-contrast lighting and the powerful back light all contribute to the impression of artificially exaggerated glamor.

How to build a high-key lighting set-up
Set a powerful key light off to one side of the camera to provide the bulk of the illumination. Use a spot or a variable-focus lamp with a narrow beam. Add a filler to light up the shadow areas. Keep the ratio between the key and filler light fairly high for dramatic effect. Finally, add a strong back light to emphasize the highlights in your subject's hair.

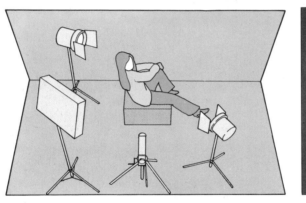

Lighting for melodrama
The best way to light for melodrama is to break all the rules. Instead of striving to achieve a "perfect" set-up in which all the lights are balanced and the result is an evenly lit subject with no heavy shadows, break up your shot into sharply contrasting areas of light and dark. This will create a strong sense of drama and tension. Use strong spotlights or adapt your open-reflector lamps by fitting "snoots" (see p. 85) so that you cast narrow beams of hard light across the scene. Above all, vary the *angle* of the lighting: a harsh light shone onto your subject's face from well below the eyeline will produce a very sinister effect, and is a technique used in countless horror movies.

Dramatic lighting
This frame enlargement is taken from *Citizen Kane* (1941). The two reporters, whose faces are never clearly seen, are rimlit by concentrated shafts of light across an almost totally dark projection-room. This is a case where the composition and the highly stylized lighting both generate a powerful sense of drama.

How to build a lighting set-up for melodrama
Use hard lights, preferably highly focused spots. Set the key light low down so that it shines up towards your subject's face at a sharp angle. If you wish, lighten the shadows slightly with a filler, set high up on the opposite side. Use a strong back light to emphasize one side of the face and throw stark, dramatic shadows onto the background.

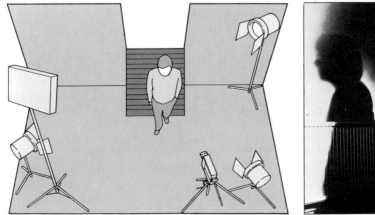

LIGHTING FOR REALISM

Outdoors, in natural lighting, we normally see things in soft sunlight or in the diffused light from a cloudy–bright sky. It is this light which we generally feel to be the most "realistic" and attractive. It casts few shadows and no pronounced, exaggerated highlights.

Because modern video equipment no longer requires the brightly lit indoor sets it once did, it is now possible to shoot scenes using low key, realistic lighting. This kind of modern naturalistic filmmaking was pioneered by European directors and cameramen in the fifties and sixties; it has now spread to Hollywood, with all the gains in realism that you might expect. It is also a "look" that any amateur can achieve with simple equipment.

Soft, misty light
Antonioni's film, *The Red Desert* (1964), from which this shot was taken, was among those European movies of the sixties which were breaking away from the traditions of artificial studio lighting. This shot of Marcello Mastroianni achieves its muted, atmospheric effect from the soft light, the misty gray sky and the muted colors and forms.

Using natural light
Both these shots are taken from *The Duellists* (1977). They both take advantage of natural lighting conditions. In the shot on the left, the couple are lit entirely by the light streaming through the bedroom window. No filler has been used, though the camera has some diffusion.
The shot on the right has the characteristically soft, shadowless light from a gray, autumn sky.

Lighting for naturalism

If you want your artificial lighting set-up to look as realistic as possible, you should aim to achieve the same soft overall light that you would get outdoors on an average day. The key to this is to use large, diffused light sources. Avoid hard lighting of any kind, keep the ratio between the key and filler light low and be careful not to overdo the backlighting. If you have a window in your shot it is a good idea to use the natural light coming through it to predominate as a back light for your subject. Unless you are using specially designed "soft-lights" (see p. 84), soften the illumination by either bouncing the light off a wall or ceiling, or by projecting the lamps through some form of diffusing material.

How to build a lighting set-up for realism
Diffuse any hard lights to produce a soft overall illumination. If you use a back light, keep it subdued.

Bounced and diffused light

All soft, relatively shadowless illumination comes from a diffused, broad light source. In other words, no direct light from the bulb must hit the subject. Lights which normally give a hard light can be easily adapted to produce soft light. The easiest method is to direct them away from your subject, towards a wall or ceiling, so that all the light is *bounced* or reflected. You can use a sheet of white polystyrene for the same purpose. Beware of colored surfaces since they will reflect colored light. Alternatively, you can *diffuse* a hard light by shining it through a sheet of tracing paper or spun glass. This will broaden the light and soften any shadows that it casts.

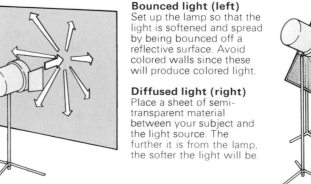

Bounced light (left)
Set up the lamp so that the light is softened and spread by being bounced off a reflective surface. Avoid colored walls since these will produce colored light.

Diffused light (right)
Place a sheet of semi-transparent material between your subject and the light source. The further it is from the lamp, the softer the light will be.

SPECIAL EFFECT LIGHTING

Fireworks
With the ability of recent camcorders to perform in very low light levels, the patterns made by fireworks against a dark sky can provide spectacular video subjects. This example captures some of the excitement of a rock concert with fireworks and laser displays. A tripod is essential to avoid blurring the trails of light.

Laser beams
This shot of rock musician Jean-Michel Jarre captures the drama of his performance and the laser show that accompanied it. With hi-fi sound and the excellent picture quality now available, such subjects make good material for video movies.

SOUND

THE BASICS OF SOUND

Sound is the succession of pressure waves in the air caused by any vibrating object – a violin string, the human vocal chords or the diaphragm of a loudspeaker, for example. Air molecules move backwards and forwards until they meet the ear drum, which vibrates in response to these waves to produce the sensation of sound. Although the air molecules move to and fro, not up and down, sound is described as traveling in *waves*, which helps to describe the frequency of sound.

Frequency

A sound's *pitch* is determined by its frequency, or the number of times per second a complete wave passes a static reference point. The unit of frequency is the *Hertz* (*Hz*) (one cycle per second). The human ear can hear a range from about 16 Hz (a low rumble) to about 16,000 Hz (a bat-like squeak).

Flute				
Oboe				
Clarinet				
Trumpet				
French horn				
Trombone				
Bass clarinet				
100 Hz	500	1,000	1,500	2,000

Volume

The human ear hears each doubling of sound intensity as a small single-step increase in a similar way as the camera sees each additional stop of exposure as a doubling of the amount of light reaching the chip. This unit of sound intensity is measured in *decibels* (*dB*). As a guide, 120 dB is referred to as the threshold of pain.

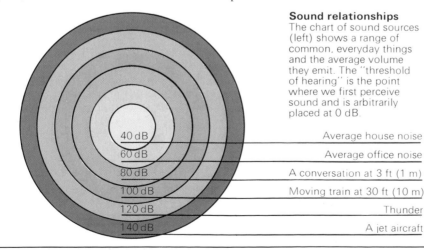

Sound relationships
The chart of sound sources (left) shows a range of common, everyday things and the average volume they emit. The "threshold of hearing" is the point where we first perceive sound and is arbitrarily placed at 0 dB.

40 dB	Average house noise
60 dB	Average office noise
80 dB	A conversation at 3 ft (1 m)
100 dB	Moving train at 30 ft (10 m)
120 dB	Thunder
140 dB	A jet aircraft

Sound waves
The tuning fork (above) produces a series of pressure waves that radiate in all directions.

Frequency
The selection of musical instruments indicated by the chart on the left all have a different range of frequencies. Those illustrated make up only a small part of the range of frequencies audible to someone with good hearing.

Frequency response

All sounds contain complex resonances that extend way up into the upper reaches of hearing, and it is these that give a piano note, for example, a quite different sound from the same note played on a violin. This is why the breadth of "frequency response" of any recording system is so important. "High-fidelity" is the sound equivalent of "high definition" in television.

Each piece of equipment in the recording system, from the microphone to the actual tape, has its own particular frequency response characteristics. To exploit the full potential of all your equipment, it therefore has to be of a consistent standard – there is no point in buying an expensive sound recorder and microphone if you then use the cheapest tapes you can find. Similarly, playback equipment must also be capable of the required frequency response if you are to get the full advantage. This is where recent hi-fi VCRs are so effective.

The recording medium

The first step in translating sound waves into a sound track is the *microphone*, which converts the vibrations in the air into electricity. This can be done in a number of ways, and each microphone design produces its own pattern of frequency response, sensitivity and directional characteristics.

Magnetic sound

The microphone signal is amplified and passed on to a magnetic recording head. A length of tape coated with oxide particles runs past the head, and is magnetized in response to the strength of the microphone signal. When the tape is replayed the original signals are reproduced.

The sound quality can be affected by the type of audio tape you use. The traditional tape coating is iron oxide – tapes of this type are usually labelled "normal" or "regular" on the packaging. But there are also "Ferric" tapes, chromium dioxide (CrO_2) tapes, and so-called "metal" tapes. These give better sound reproduction than regular tapes, provided that they are used with equipment of sufficient quality, and the bias and equalization settings on the tape recorder are correctly set. The same differences in tape quality apply to the sound produced on video tape itself.

Recording speed

The fidelity of any sound system is judged largely by its capacity to produce a full and balanced range of frequencies. In particular, the very highest notes require a large number of oxide particles to pass the recording head in a given second if they are to be properly rendered. The higher the tape speed, the better the frequency response. Reel-to-reel recorders are set to run at 15 ips (inches per second) for professional music recording; $7\frac{1}{2}$ ips for speech and normal music recording; $3\frac{3}{4}$ ips, which is barely adequate for speech, but not music; and $1\frac{7}{8}$ ips, usable only for dictation. Cassettes also run at $1\frac{7}{8}$ ips but can be fitted with Dolby noise-reduction circuitry, which gives remarkably good results even with demanding music. Modern cassette recorders can also use new kinds of oxide tapes (FeCr and CrO_2), which go a long way towards overcoming the disadvantages of the narrow tape width and slow speed.

Any judgment of sound quality is subjective, and someone used to listening to good stereo is more likely to notice the difference.

Noise reduction

One of the most useful features on a cassette recorder is noise reduction. There are several systems, but they are all designed to eliminate the hiss that results on cassette tape that runs at low speeds. They do this by electronically filtering out some of the higher frequencies on the tape, and as a result you may also lose some of the recorded frequencies on playback. But this is a small price to pay for a marked increase in sound quality.

Various noise-reduction systems are available. The most common are those that use the Dolby systems B and C. They are operated by a small button on the recorder, and can be used both while recording and when you are playing back the tape.

Stereo

The fact that we have two ears allows us to hear which direction a sound is coming from, so that we effectively hear in "three dimensions". By using two loudspeakers and dividing up the sound into a left and a right channel, stereo mimics this spatial quality, giving a realism that was impossible with traditional mono sound and a single loudspeaker.

Hi-fi enthusiasts have been able to enjoy the benefits of stereo for decades; stereo sound is now also available on video. Many viewers find stereo worthwhile for the playing back of pre-recorded movies alone. But the combination of a hi-fi stereo camcorder and VCR can give an added realism to your own movies too.

Sound on video

The sound available to the movie maker is of three kinds: *actual sound* (either "synchronized" or "wildtrack"), *effect sound* and *added sound*.

Actual sound

The video maker is fortunate in that the camcorder has its own built-in microphone, so that sound can be recorded as the action is filmed. This type of sound, which happens and is recorded at the same time as the pictures, is known as synchronized sound.

Instant synchronized sound gives video a great advantage over the traditional home cine film system, which was usually silent. It is undoubtedly one of the features that has made video so popular for the domestic user. But the potential of the medium for adding sound from other sources at the editing stage is also very great.

A "wildtrack" is a recording made at the original location but independent of the camcorder. This track might be played intact as a background to a sequence.

Effect sound

Sound effects recorded at the time of the action, such as the sound of breaking glass or footsteps, have a distressing habit of sounding thin and inadequate and even faked. On the other hand, genuinely faked sound effects can sound surprisingly real and are often better than the actual thing.

Added sound

Sound has been a part of films since they first began, but the video maker has the advantage that he or she, not the piano accompanist, can call the tune. Sound from a number of different sources can be put on tape. These sources could include your own spoken commentary on the events, together with appropriate background music. This composite tape could then be recorded onto the video tape itself, to give a complete interpretation of the subject, with synchronized sound, wildtrack, commentary, and music all complementing the pictures at different points in the movie.

Editing such a complex soundtrack is a slow, painstaking business. But sound can give such scope for you to interpret your subject in your own personal way that it is worthwhile persevering. The results can be truly professional.

MICROPHONES

The function of the microphone is to convert the physical motion of the air molecules (see p. 98) into an electrical impulse, and the construction of the microphone has a direct bearing on this – and hence on the quality of the sound produced at the other end of the system. There are four basic microphone designs: crystal carbon, ribbon, moving coil and condenser – all of which work on slightly different principles. In the cheaper, less efficient range, the crystal and carbon types give relatively poor results. Ribbon, moving coil and condenser microphones can all be excellent, as can the cheaper variant of the condenser type, the electret.

From the point of view of the ordinary user, the most important thing to know about the microphone is its *directional characteristics*. Not all microphones respond equally to sounds from all sides, and the most convenient way to classify them is in terms of their *directional response*. There are three principal types: omnidirectional, cardioid and shotgun.

Advanced modern camcorders have directional on-board stereo microphones for hi-fi sound. They can be monitored through small earpieces.

Omnidirectional

This type of microphone theoretically covers an arc of 360° with equal response, and therefore receives a broad, unselective sound. It is ideal for recording unfocused atmospheric sound – at a party, for example – but it is a poor instrument for rejecting unwanted sound, such as camera noise. It is unfortunate that this type of microphone is so often supplied by manufacturers of camcorders.

Cardioid

Cardioid microphones are so-called because of the heart-shape of their response patterns. They are much more sensitive to a sound source dead ahead than behind or to one side. This characteristic is particularly useful if the microphone is to be mounted on top of the camera, since the camera noise will be behind the microphone, and the sound balance will automatically match the subject in the shot rather than some sound source the camera cannot see. It is equally suitable for recording an "atmosphere" track, but it needs more careful placement than the omnidirectional microphone – perhaps up high on a boom, "overlooking" the sound source.

Shotgun

Shotgun microphones are even more directional versions of the cardioid, with an area of sensitivity of about 40°, and are sometimes known as "supercardioids". Their limited area of sensitivity means that all sounds coming from the sides are registered only faintly. This type of microphone is particularly useful when you cannot move in close to the sound source – because the sound recordist might be seen by a camera fitted with a wide-angle lens, for example. Shotgun microphones tend to be on the expensive side and their sound quality is not always as good as the omnidirectional or cardioid types when used close to the sound source.

Personal microphone

Radio microphone

Omnidirectional microphone
The omnidirectional (or nondirectional) microphone is the ideal tool for recording a general, nonspecific sound, the type that is needed for an "atmosphere" sound track. It is not often used attached to a boom because of the general need for a more specific pick-up response pattern.

Cardioid microphone
This type of microphone is probably the most generally useful design. Although the exact response pattern varies from type to type, its ability to reject unwanted noise from the sides and back makes it a good, all-purpose microphone, and especially useful when it is camera-mounted as camera noise will not be registered.

Shotgun microphone
This type of microphone is also known as a supercardioid or ultradirectional microphone because of its very narrow sound acceptance angle compared to other types. It is believed by some that only sound in a narrow strip in front of the microphone is picked up, but this is not so as it has an acceptance angle of approximately 40°.

Personal microphone

These tiny and unobtrusive personal microphones can be either clipped to clothing or hung around the neck. The microphone cable is channeled down a sleeve or trouser leg out of sight of the camera. You must take care that clothing does not rub against the microphone as it will be recorded as a "rustling" sound or could possibly muffle the sound altogether. These microphones are particularly useful in noisy surroundings as they can be positioned very close to the mouth.

Radio microphone

Radio microphones are now offered as accessories by many manufacturers, and they are extensively used in professional filming. They consist of a microphone, a short-range transmitter and a receiver on the camera or recorder, and they operate on the FM (frequency modulation) waveband. They allow a moving subject greater freedom since there is no lead to get in the way.

Positioning the microphone

In all films that strive after realism there is a convention that the microphone is never seen. On the other hand, in a documentary the reporter often brandishes a hand-held microphone to advertise the actual process of recording. Deciding where to place the microphone depends on the type you are using and on the acoustics of the surroundings. In the following discussion of how to use and position the microphone for the best results, it is assumed that you will not want it to be visible.

Making use of acoustics

Even in the open air, sound travels to the microphone from the subject by a devious route. In a "live" acoustic, such as a bathroom or gymnasium, the hard surfaces reflect the sound to and fro many times before it dies, and the high frequencies in particular may become muddled as they reverberate round the room. In a "dead" acoustic, such as a room thickly carpeted and with curtains or tapestries, the sound dies quickly, with little reverberance or echo. A dead acoustic always helps the clarity of music or speech, but clarity is not everything, and for music you may decide you want an attractive touch of echo. Either way, your choice of acoustic has a great effect on microphone placement. In general, if you want to reduce the effects of excessive reverberation, move the microphone nearer the sound source – it will then be louder in relation to the reflected sounds. You can also deaden the acoustic by drawing the curtains or throwing down a carpet. Conversely, moving the microphone further away from the sound source will "open up" the sound, giving it more spaciousness at the expense of detail. The proximity of the microphone to the walls will also have an effect on your recording. To get the most out of your chosen acoustic, experiment with different positions.

A "live" acoustic
An empty room and hard sufaces reflect the sound.

A "dead" acoustic
Furnishings tend to absorb sound.

Microphone impedance

Impedance is the total resistance offered by the electrical system, and is measured in ohms (Ω). Microphones are usually grouped as high, medium or low impedance, and they should be connected to a socket of equivalent impedance on the recorder or the video camera. Your dealer will advise you if you are in any doubt if you take along the specification sheet. As a rule, microphones of high impedance are of low quality and those of low impedance are high quality.

One person talking
When recording a single sound source, a cardioid or omnidirectional microphone should be positioned in front of the camera to minimize the camera noise.

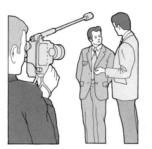

A conversation
If using two microphones proves impossible, then a single cardioid or shotgun microphone can be used instead.

A crowd
When recording the generalized noise generated by a crowd, the broad response patterns of the omnidirectional and cardioid microphones can equally be used.

Recording one person talking

If you do not have a personal microphone, you will probably be using either a cardioid or omnidirectional microphone. The cardioid should be between two and four feet from the sound source (depending on the ambient noise), and the omnidirectional type slightly closer. Both types must be *in front of the camera*, just out of frame, in order to minimize camera noise being picked up by the microphone. Even when using an omnidirectional microphone, which is really unsuited to the job, it must be placed on the axis of the subject's "eyeline" in order to record the best sound, though it may be above or below head height. Always check that the microphone is well clear of the camera's field-of-view or it will be visible in the shot. If it proves difficult to position the microphone close enough to the sound source to obtain a good recording level with the cardioid or omnidirectional types, consider using a shotgun microphone placed further from the subject.

Recording a conversation

A conversation between two or more people can be recorded in a number of ways. Ideally, it requires two microphones. If you only have one, you could place an omnidirectional microphone between them, but it would probably be in shot. If a cardioid or shotgun microphone is used it must either be mounted on the camera or else skilfully operated by a sound recordist to follow the course of the conversation. At the same time the recordist has to keep a sharp eye on the movement of the camera to avoid getting into shot and to make sure that he or she is covering a sound appropriate to the image. The recordist can also balance the different voice levels. This, however, is quite a complicated technique, and for most simple filming the on-camera position should produce fairly acceptable results.

Recording a crowd

Since an overall effect is called for here, a well-edited "wildtrack" recorded on audio tape may give a better sound track than a sync recording. Either an omnidirectional or cardioid microphone may be used to equal effect, especially when combined with a recorder hung over the shoulder. For specific "spot-effects" of someone speaking, the wildtrack can be overlaid with sync effects shot on a video camera.

Recording music

Filming music is a very broad topic and the problems of microphone placement can only be talked about in general terms here. There is one golden rule – *always monitor the sound before shooting and adjust the microphone position accordingly*. Decide whether you want a live acoustic or a dead one; one microphone or several; one master track or one track for each instrument. Most important is to thoroughly familiarize yourself with the music beforehand; have the players rehearse the loudest notes so the recordist knows when to expect them. Finally, be aware that music is the most testing of all subjects for your microphone so use the best one possible.

MONITORING THE SOUND

In any sound recording the incoming signal must be matched to the capacity of the magnetic tape receiving it. Too little signal, and the sound becomes degraded by the "hissy" noise inherent in the magnetic oxide material; too much signal, and the tape becomes overloaded, resulting in an "out-of-focus" sound, especially noticeable on high notes. Sound input is monitored automatically on video cameras. But if you are using a separate audio tape recorder it can be monitored manually with the aid of a calibrated *VU meter* (see above right). The needle of the meter should remain solidly in the middle of the white area, and just nudge the red section when the loudest noise is recorded. When the needle enters the red section of the scale the recording is becoming overloaded. Outdoors, use a wind shield.

Automatic gain control

Automatic sound monitoring, known as *automatic gain control* (*AGC*), approximates an average sound level, and this system works best in conditions of steady ambient sound. However, problems arise whenever there is a sudden lull, as the amplifier in the camera pulls up the sound level to maintain an average level, and surges of background noise appear in every pause. Despite this disadvantage, AGC can give better, more consistent sound recordings than manual sound monitoring in one-person operation, and it also leaves you with more time to think about the shooting.

Recording sound

For the average home-movie-maker only a limited knowledge of microphone construction is necessary. The most important thing to bear in mind about most types of microphones purchased with the averagely priced video camera is their lack of sensitivity. To test the sensitivity of your particular microphone, shoot a test tape with the microphone at varying distances from the sound source and note where its performance is best.

Sound meters
Both the VU meter (left) and the frequency peak indicator (right) are manual systems for measuring the amount of signal entering the recording medium.

Headphones

Earphones

Ear plug

Sound monitoring
Monitoring the sound coming into the recording system through headphones, earphones or an ear plug has many advantages. It tells you immediately if the microphone is properly connected and properly positioned. Another important aspect of monitoring is that you only hear the sound picked up by the microphone. Without these aids you might hear a car start up and immediately try to filter the noise out, although the microphone may not have responded to it. Above all, monitoring helps you to balance the various recorded sounds.

Unless you are shooting an interview or documentary you will not want the microphone to be visible in the shot, and yet it must be close enough to the sound source to give a good recording level. To overcome this problem without purchasing a better quality microphone (see p. 100–101), a boom or long pole can be used to suspend the microphone over the sound source. To avoid having to buy a boom, use a lighting stand.

Microphone positions
The illustrations below are only a few of the many ways you can position the microphone.

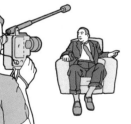

On the camera
Mounting a directional microphone on the camera (left) is the most convenient method of one-person shooting and sound recording.

On a small stand
A small microphone stand (left) is a great help. If you do not want the microphone to appear in shot, adjust the central column until the height is right. The disadvantage with this system is that the microphone cannot follow a moving sound source.

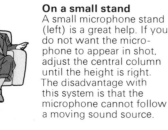

On a boom
A lightweight boom or pole (left) allows you to get the microphone above the sound source.

Hand-held
If you are shooting an documentary (right) you may not mind if the microphone is in the shot.

On a table stand
Like the small floor stand, the table stand (left) is low enough not to be in shot unless a wide-angle lens is in use.

Out of sight
Props can be used to hide the microphone, but make sure they do not muffle the sound.

MANIPULATING THE SOUND

Sound filters

All microphones add their own coloration to a sound, and this continues at all points in the chain of recording and reproduction. To rectify this distortion, "sound filters" are used in a process known as equalization. These filters are termed either "active" or "passive".

Active filters

These filters can actually be used to boost one portion of the frequency range as well as to lower it. Most of us know these filters as the bass and treble controls on domestic hi-fi amplifiers. Active filters are also used to lift the mid-range, which has the effect of adding "presence" to the sound. At their most complex, active filters can provide a separate control for each octave and these permit very fine control of the recorded sound.

Passive filters

These filters merely reduce the signal at one end or the other of the scale of frequencies. Their most familiar forms are as the "rumble" filter (or bass-cut) and the "scratch" filter (which removes high frequencies) found on hi-fi amplifiers. Passive filters are principally used to correct mechanical faults in disk reproduction.

Equalizers

In a professional recording studio, each input channel would have its own filter, or equalizer, so that each instrument could be correctly balanced. The non-professional user would be more likely to have only one equalizer circuit to work with, and this would be placed between the mixer and the recorder. However, it might be better to delay the process of equalizing the sound until the dubbing stage. Sound, once removed, can never be properly replaced, and except in the case of a serious distortion (rumbling traffic noise, for example) you should try to leave the sound as it is first recorded.

Echo and reverberation

Echo (also known as reverb) can be added to any sound track. It is used to brighten a dead acoustic, to glamorize a wobbly top note, and to conceal clumsy sound edits. This effect can be generated in three ways. An *echo chamber* is a small, soundproof room with hard walls and floor containing a speaker and microphone. The sound is fed in through the speaker and is altered by the acoustic qualities of the room, so that by the time it reaches the microphone it will have acquired a new resonance. Alternatively, a *reverberation plate* can be used. This is a large steel sheet fitted with two "transducers" (devices for transferring energy from one form to another), one of which vibrates the sheet while the other picks up the reverberant sound. The third method involves creating an echo by using the feedback from any tape recorder that possesses three heads and a sound-on-sound control (see p. 104). The idea is that the recorded sound is returned from the playback head to the recording head, where it is added back to the master track. This method is not recommended for use where a natural sound is required, but it can produce a useful science fiction or horror movie electronic warble.

Noise-reduction adapter
The most effective method of improving sound quality is to use the Dolby noise-reduction unit each time the sound track is re-recorded, as most "hiss" and other high-frequency noise is picked up at these points. Decoding the signal takes place when the film is projected.

Frequency equalizer
A frequency equalizer is very useful when dubbing the sound onto the final master track. Slider controls on the equalizer (above) are used to boost or cut a specific range of frequencies. The equalizer can be thought of as a tone control that splits the frequencies in the audible range into very fine divisions, each of which is controlled by its own slider.

Compressors

Compressors are extensively used to boost the apparent loudness of amplified rock music while preventing any overloading of the recording medium. They are rarely used for classical music.

Noise-reduction systems

Any tape recording contains a degree of "hiss", which cannot be heard if a strong signal is present on top. If, however, the signal is weak, as in a quiet passage of music, or if the equipment is poor, tape noise can build up to an unacceptable level. All noise-reduction systems aim to improve the signal-to-noise ratio and thereby reduce tape "hiss". The most commonly used is the Dolby system, which is known as Dolby B in its amateur form. The principle is that, on recording, the higher frequencies are boosted, to a greater or lesser extent, depending on the volume at the time. On playback, the reverse process occurs and the boosted frequencies are returned to normal. Since the tape "hiss" has not been boosted it is lost in the decoding process. Dolby systems are invaluable for cassette decks, where tape noise is particularly evident, but Dolby tapes require Dolby equipment for proper reproduction.

Stereo recording

Stereo recording depends on the information from two separate microphones being fed to two separate speakers through two entirely separate chains of amplification and reproduction. The effect produced of spaciousness comes from the fact that our ears are given all the information they need to establish the direction of the sound. It is absolutely vital for all stereo recordings to be played back into speakers that are correctly *in phase*. As the cone of a speaker moves in and out, the air is alternately pressurized and depressurized. If the positive and negative terminals on the projector (or amplifier) outputs are not connected to their appropriate counter-parts on the speakers, the left and right speakers will be moving the air in exactly opposite directions at any given time. When this happens the speakers are said to be *out of phase*, and the effect is to destroy the stereo image, as well as resulting in a severe loss of bass response and possible damage to the amplifier.

Duo-track and multi-track

A two-track recorder need not necessarily be used to record a stereo track. It can also be used to record two tracks that will later be mixed down into one composite mono track. For example, one track might carry a piano and the other a vocalist. It is known as a *duo-track*.

Professional recording studios have extended this system of recording with the use of eight-track and sixteen-track recorders using $\frac{1}{2}$ in. (13 mm) tape. These professional *multi-track* recorders record each channel separately and without mixing them. These tracks can then be subsequently mixed, juggled and manipulated in a wide variety of ways without affecting the original recording in a procedure called *post-balancing*. The main use for these machines is in the recording of rock music, where many of the effects are electronic.

SOUND RECORDERS

For practical purposes, only a portable sound recorder that can be comfortably carried in one hand will normally be used to record additional "wildtrack" sound on location. A recorder suitable for video sound can be a simple cassette or a professional reel-to-reel recorder, depending on budget. Unless you are aiming at the very highest quality, satisfactory sound results can be achieved with a recorder costing less than an average priced camcorder.

How sound recorders work

Magnetic sound recorders work on the principle of the interaction between electrical currents and magnetic fields. The microphone converts sound (from a human voice, disk or any other sound source) into an electrical current, the strength of which fluctuates depending on the intensity of the original sound. After amplification the signal passes over a *recording head*, which produces a magnetic field that also varies in accordance with the strength of the sound input. As the tape passes the recording head (an electromagnet), the magnet changes the orientation of the oxides or metal on the tape. To play the recorded sound, the tape must pass over the *playback head*, which is another electromagnet. On some machines the recording and playback heads are combined. When the rearranged oxide particles on the tape enter the magnetic field of the playback head a current is induced, which is again amplified and sent to the speakers or headphones.

Reel-to-reel recorders

A reel-to-reel recorder offers optimum flexibility. A wide choice of tape speeds, which have a direct bearing on sound quality, is standard – on many machines ranging from 15 ips to $1\frac{7}{8}$ ips. If you are building up several different soundtracks to create one "master" soundtrack, a certain amount of re-recording will be required. At each stage, some loss of sound fidelity is to be expected – so it is important that the original recording is as good as you can make it. The $\frac{1}{4}$ in. (6 mm) tape and higher tape speed on reel-to-reel recorders actually allows more room for the recorded signal than on a cassette.

Unfortunately, many reel-to-reel recorders are too heavy for comfortable use on location and are really designed for indoor recording. Also, many of these machines need to be connected to the main power supply. But good-quality, battery-operated reel-to-reel machines are available.

The principle of sound recording

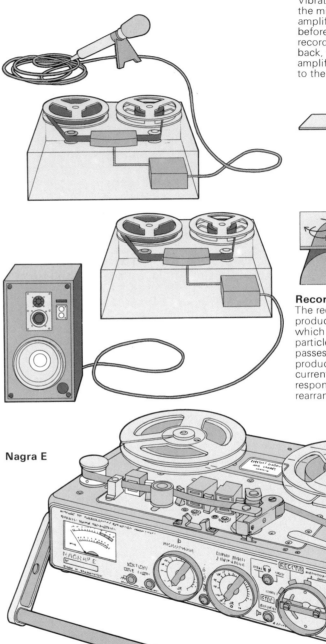

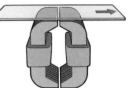

How sound is recorded
Vibrations are picked up by the microphone and amplified by the recorder before being sent to the recording head. On playback, the signal is again amplified before being sent to the speaker.

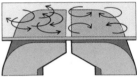

Recording and playback
The recording head produces a magnetic field, which rearranges the oxide particles on the tape as it passes. The playback head produces an electrical current, which varies in response to these rearranged oxide particles.

Nagra E

Nagra SN

Reel-to-reel recorders
These range greatly in size. The SN measures only $5\frac{3}{4} \times 4 \times 1$ in. ($147 \times 100 \times 25$ mm) and has a recording time of 30 minutes.

Cassette recorders

The major advantage cassette recorders have over reel-to-reel recorders is portability. Their light, compact construction is a great asset in the field, and if necessary a cassette recorder can easily be carried by the camera operator, removing the need for a sound recordist. With better quality cassette machines this lightness is not at the expense of robustness. When shooting, the action is frequently tightly scripted and time spent rethreading a reel-to-reel recorder could mean that unrepeatable sound is lost. With a cassette recorder, loading a fresh tape takes only a few seconds and there is less chance that any action will not be covered by the sound track.

Since the introduction of Dolby noise-reduction circuitry, the main drawbacks of cassette recorders – their slow tape speed (only $1\frac{7}{8}$ ips) and high "noise" level – have largely been overcome. Despite the tiny size of the recording area on cassette tapes, modern tape designs are steadily reducing the lead in quality that the $\frac{1}{4}$ in. reel-to-reel tapes have enjoyed in the past. If using small, "uncritical" speakers, the difference in sound quality between the two systems is difficult to detect.

From the filmmaker's point of view, the drawback with using cassettes comes in editing the tape. If recording a wildtrack, editing is essential and the narrow tape width means that cutting and splicing can only be done electronically. You need to pre-mix the track (a mixer is vital for this) and dub it to the tape on video.

Which system for edited soundtracks?

If you wish to edit together sound effects, music and perhaps commentary before transferring them to the video tape, then it is preferable to use a reel-to-reel recorder. The $\frac{1}{4}$ in. tape of the reel-to-reel is more flexible than the cassette tape, and it can be edited easily. A stereo recorder, with two tracks running in each direction, gives you the option of using combinations of different types of "added sound". If your recorder has a *sound-on-sound superimposition* facility (able to record one sound on top of another without erasing the original), then music and commentary, for example, can be locked together in a fixed relationship. When recording this type of sound track it is vital that the recorder has an accurate *digital counter*. Unless you know how much of a particular sound you have recorded, combining it with the images might be hit-and-miss.

Building sound on tape

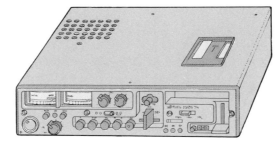

Commentary
Music and commentary
Commentary
Music and commentary
Effects replace commentary
Music and commentary
Effects

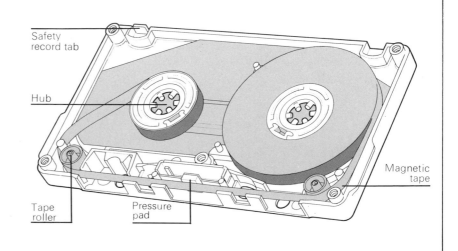

Uher
This cassette recorder offers Dolby noise-reduction, plus 2-track stereo recording in addition to a third pulse-reference track. Quality is very high.

How cassettes work

The cassette consists of a thin plastic container housing the magnetic tape, which runs between two hubs. When the tape finishes it cannot come loose because it is attached to the hubs by a length of leader tape. This is because the cassette is designed as a sealed unit and the tape is not thick enough to allow it to be handled, as would be necessary for rethreading. A series of rollers and guides hold the tape in contact with the driving rollers, and recording and playback heads of the cassette machine. It is vital that the "bias" of the tape matches the characteristics of your machine. CrO_2 tapes for example, require special switching on the recorder to correct replay and correct recording.

Safety record tab

Hub

Tape roller

Pressure pad

Magnetic tape

STEREO AND HI-FI SOUND

Originally the VHS format allowed only for a single mono linear soundtrack, running along the top of the tape. The writing speed of the soundtrack was limited to the actual running speed of the tape. Beneath the soundtrack, the video image was helically scanned at a far greater writing speed, which meant that, although the pictures could be of an acceptable quality, the sound lagged far behind.

This problem led the manufacturers of early VHS recorders to build in noise-reduction systems like those found on audio tape machines, to reduce tape hiss and increase the frequency response. Such noise-reduction is still the norm on cheaper VCRs, but more advanced models offer different ways of improving the sound. You can therefore find VCRs offering stereo sound, others sold as "hi-fi", and yet more sophisticated models with NICAM digital sound. These three types, often confused by the public, are quite distinct.

Stereo

Stereo is produced on the VHS format by providing two linear tracks, one for the left-hand channel and one for the right, in a similar way to audio tape. The tracks run at the same speed of the single mono soundtrack that is otherwise provided on VHS, so there are the same problems of tape hiss and distortion. Nevertheless, the sound is far better than that from a single mono track, especially when a noise-reduction system such as Dolby, is in use.

Stereo television sets are available, but these will not necessarily give stereo sound from broadcast programs. Broadcasts in your area may not yet be in stereo (look at your local program listings), but even if they are, a stereo television may not be able to decode them. So a better solution could be a NICAM receiver (see below). But stereo televisions can be useful for coupling to a stereo satellite receiver or for viewing stereo video cassettes – especially items such as pre-recorded feature films.

Hi-fi

Unlike straightforward stereo, a true hi-fi signal is encoded on to a deep layer of the helically-scanned video track itself. This gives a fast writing speed and consequently an excellent signal-to-noise ratio – there is virtually no hiss. The linear track remains running along the top of the tape and can be used for editing purposes. It is also possible to use hi-fi VCRs for purely audio recording, with spectacular results and a playing time of up to eight hours per tape.

NICAM

This word is an abbreviation of "near instantaneously companded audio multiplex". In a NICAM recorder, the transmitted signal for a given program can be encoded with digital stereo sound of matchless quality. It also allows for a sub-carrier signal that drives a very low-frequency "woofer" loudspeaker that can be placed at the back of the room to give surround sound of the sort you would expect in a good cinema. This low-resonant speaker, like the rest of the sound apparatus, should be connected through your hi-fi audio system for the best results. Some televisions are capable of providing good enough sound to take full advantage of NICAM, but these receivers are costly.

With the dawn of stereo broadcasting, a television that can decode broadcasts transmitted with NICAM sound is an attractive, if costly, proposition. To provide acceptable stereo sound, such a receiver would need to be equipped with sockets for connecting external loudspeakers. Such loudspeakers will give a much more convincing sound than twin loudspeakers fitted inside the receiver itself.

There is a way around the cost of this type of set-up if you already have a NICAM-equipped VCR and a hi-fi audio system. You can use the VCR to receive the broadcasts. The picture can then be routed to your television set, while the sound should be passed to the amplifier in your hi-fi system (see opposite). This way, you do not have to double up on speakers and NICAM-receiving equipment and, with everything in the right position you can benefit from excellent sound.

Super-sound

The latest generation of tapes produces even better sound when played back on the right equipment. They have expanded the horizons of the amateur video maker in a revolutionary way. Super-VHS (S-VHS) has not only brought visual resolution of near-broadcast quality (around 400 lines), but also delivers massively-improved stereo hi-fi sound.

Working with a metal-evaporated tape exactly half the width of VHS tape, Sony have managed to produce even better sound on their Hi-8 format. They have done this by passing the sound through an FM signal on to the tape, which now runs at normal speed for up to 90 minutes. This is an extraordinary achievement in a cassette that is slightly smaller than an audio cassette. At present the range of cameras is restricted, and playback is more likely to be carried out via the camera than a VCR, but these are small sacrifices to make for the combination of portability and quality that this format provides.

Audio equipment

Hi-fi VCRs and the recent high-quality formats such as S-VHS and Hi-8 offer superb sound reproduction. It therefore makes sense to do what you can to realise this potential when you are playing back your tapes. Unfortunately, the majority of television receivers are not capable of really high-quality sound reproduction, although some hi-fi receivers are available. An effective compromise is to play back the sound from your VCR through the domestic hi-fi system. With the television placed between the two loud-speakers, you will be able to achieve an excellent, almost cinematic combination of sound and vision.

The amplifier

In order to do this, your amplifier will have to have a spare input to take the audio connection from the VCR. Most amplifiers have an auxilliary input that you can use in this way; some models even have a special video

channel that is actually designed for the connection of a VCR. If you do not have a spare input, or if you already use it for an additional piece of equipment such as an extra audio tape deck, special compact switching units are available that allow you to connect extra items.

Apart from the number of inputs, the qualities that you should look out for in an amplifier for video sound are similar to those you need in a regular hi-fi amplifier. Look for a good signal-to-noise ratio and a wide frequency response (see p. 98). If you are going to be listening in a large room, you will need an amplifier with more power than one that is adequate for an average living room.

As with video, beware of being tempted by equipment that gives you more features than you actually need. An array of tone controls may look impressive, and it may occasionally be useful if you are not entirely happy with the quality of your recorded sound. But the more circuitry the amplifier has, the greater the possibility that the signal will become distorted – this is why some very high quality amplifiers do not have tone controls at all.

Loudspeakers
The final link in the audio chain, loudspeakers are very important. Make sure you have a pair that are capable of handling the power output from your amplifier; on the whole a more powerful amplifier will need larger loudspeakers, but you should check the manufacturer's specification to make sure that the equipment matches. You should look for loudspeakers of solid construction, with strong wooden cabinets. Good loudspeakers are usually heavy.

Hi-fi enthusiasts used to insist that the bigger the loudspeaker, the better the sound. But there are now some excellent small loudspeakers that are designed to give good sound without taking up too much space in a small modern living room. The drawback with small loudspeakers is that bass response is unlikely to be as good as with a larger model.

Hi-fi engineers have found a way around this problem. The provision of a separate low-frequency loudspeaker or "woofer" can greatly improve bass performance. Because bass sounds are less directional than those of higher frequencies, only a single woofer is required and it can be concealed behind furniture.

The other important factor that affects the performance of loudspeakers is their position in the room. If you are buying new equipment, this is something you should find out about before parting with your money. Some loudspeakers perform best when positioned on a stand, some distance away from the nearest wall. Others give their best results when sited next to a wall, or in a corner. In general, most loudspeakers sound best when they are at the same level as your ears. It is well worth talking to your dealer about this before you buy, since your room layout will be affected as well as your listening pleasure. If you already have a pair of loudspeakers, try them in different positions – you may be surprised at the variations in performance.

Other hi-fi equipment
The other items in a conventional hi-fi system – the record deck, tape deck, and compact disk player – do not have a direct effect on the sound coming from your VCR. But you may well use them while editing sound. You might add wildtrack sound from an audio cassette, sound effects from a vinyl disk, and music from a CD. So it is worthwhile buying the best you can afford.

The tape deck is a particularly important item in the sound-editing process. Make sure you use one that has a noise reduction system – either Dolby B or the more recent improved system, Dolby C. These systems reduce the tape hiss that can otherwise be a problem with the slow running speeds and narrow tape used in audio cassettes. The other important feature is the ability to handle as many different types of tape as possible. For more information on audio tape recorders and decks, see p. 104.

Compact disks offer the best sound quality available in domestic hi-fi. Digital encoding of the sound on the disk not only gives excellent reproduction, it makes the disks far less susceptible to the dust, dirt, and scratches that were the bane of the traditional vinyl disk. With the rise of CD video, it is also possible to use a player that will accept both regular sound-only CDs and disks that contain both sound and vision. Such players offer great flexibility, allowing you to play back everything from a feature film to a symphony, with high quality in both sound and vision. They are another example of how the audio and video media are interconnected.

Just as with picture quality the vital factor is the evidence of your own eye, so with audio you should consider the evidence of your ears above everything else. When you are buying new equipment, listen to it first.

CAPTURING YOUR SUBJECT

THE EQUIPMENT FOR THE JOB

When you are choosing equipment, you expect to start with the subject, making sure that you use a suitable tape format, camera, lighting, sound, editing techniques, and TV presentation. But most people who are interested in video already have a television, and perhaps also a VCR. So it is difficult to assemble the ideal combination for any particular video project without starting from scratch. If you are buying a television or VCR, there are certain factors you should consider (see p. 20 and p. 28). But the advice on this page is limited to choosing the right selection of your recording and lighting equipment for particular types of work.

It is most important to take the right equipment to a shoot away from home because once you have packed and arrived at your destination, you will have to use the items you have taken – you are out on your own.

Size and quantity of equipment
Do not take, or expect to use efficiently, more equipment than is appropriate for the job you have in mind. In particular, do not expect there to be a crowd of willing helpers who will provide you with a power supply or a fresh battery at some crucial moment. Go for the minimum that will do the job, but at the same time be prepared for all possible contingencies.

Zoom length
There is no point in having a huge, impressive zoom unless you have a firm tripod to support it. On the other hand, if your shooting position is going to be fixed, and if you are going to be a long way from your subject, you may find a long lens essential. So plan ahead.

Sound
Bear in mind the intended subject and the lens range that you are going to use when planning the sound. The microphone that comes with the camera is usually very wide-angled, so you will probably need an additional boom microphone. For distant subjects, you may need a "personal" or radio mike. If your camera is equipped for stereo this too will influence what microphones you choose. Outdoors, use a wind-sock to reduce the blustering noise.

Lighting
You may or may not need artificial lights, but if you do, and you are going to use mains power, make sure beforehand that the available power supply is adequate. You should also work out the cable run before you arrive for the shoot. Do not rely on hasty estimates of how much cable you will need. If you cannot actually measure the run, estimate the amount of extension leads and adaptors you will need and take double the quantity with you. If you are using a battery light or sun-gun, charge them before shooting.

Tape
Bring plenty! This is particularly important if you are using a VHS-C camcorder with 30-minute tapes, shooting at normal speed. Full-size VHS and 8 mm tapes present less of a problem in this respect.

Key
1 Camcorder
2 Connecting leads
3 Carrying strap
4 RF adaptor
 (camcorder to TV receiver)
5 Headphones for stereo
 sound monitoring
6 VHS-C cassette
7 Adaptor for regular VHS
8 Battery charger
9 Battery

Packing up
A stout case that takes the camcorder, battery pack, and accessories is vital. It provides somewhere to store your equipment, as well as protecting it when you are traveling.

Power
Flat batteries are one of the banes of camcorder users everywhere. This is a problem that is especially likely to occur when you are working away from home on a lengthy assignment. And the chances are your camcorder battery will go flat just as you are recording a vital shot. So be prepared. Take enough spare, fully charged battery packs to see you through the job in hand. You may find it worthwhile using a battery belt as a convenient way of carrying plenty of extra power around. Most come with their own charger and have enough power for several hours' recording.

Tripods and stands
In many situations a tripod is essential. When you are travelling, the temptation is to take a lightweight tripod that will be easy to carry. This is not always a good idea. A sturdy tripod, with struts to keep the legs in position and a good quality fluid head will pay dividends – both on location and at home. And with a long zoom it is the only way of keeping the camcorder steady.

Carrying cases
Finally, do not ignore the case in which you carry your equipment. Most camcorders come in stout cases with insides molded to take the equipment. Make sure your accessories are protected just as well. Keeping them in a strong, well organized case will also make them easier to find, which is important when you only have a few seconds to find what you want and capture your shot.

THE UNSCRIPTED FILM

Instead of opting for a sustained account of, say, a holiday from beginning to end, you may well prefer to select just one episode and record it rather more intensively. This has the advantage that your narrative line is automatically provided by the event itself, leaving you plenty of time to explore the character and atmosphere of the day. However, you cannot just arrive at the location and shoot at random. You will need to consider the requirements of smooth action, continuity and so on, exactly as though you were shooting a drama. At the same time, try to build into your shooting a time-structure which firmly reflects that of the day itself – this involves a number of otherwise abstract shots to establish the scene and to relate each sequence to its successor. In the example shown, you would aim to capture the sunlit atmosphere, the excitement of fishing, and some of the characters involved.

1 Long shot of stream, establishing locale

Establishing the setting
A long shot of the stream with no-one visible, followed by a macro close-up could be used as a gentle, low-key introduction.

2 Atmospheric close-up of dragonfly

3 Wide-angle establishing three-shot

4 Mid shot of one of the group

5 Two-shot cut to boys

6 Mid shot of boy fishing

7 Cutaway to close-up

Dramatizing the catch
Shots 3 to 10 progress from extreme long shot, through single shots of the fishers, into tighter close-ups ending in the capture of the fish.

8 Medium close-up of the young boy

9 Close-up of the boy

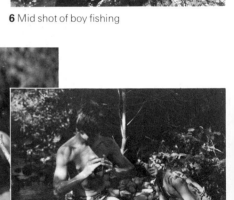

10 The fish is caught

Varying pace

By using a large number of reaction shots and cutaways, you can easily compress the events of a whole afternoon into a few minutes. But be careful to vary the cutting pace so that you do not destroy the peaceful character of the day. Also, since the catching of the minnows will be a repeated action, you can intercut two different versions of the same event. Thus, a dramatic top shot of one fish can be intercut with another.

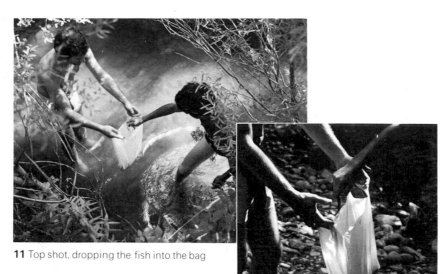

11 Top shot, dropping the fish into the bag

12 Cut to close-up of fish and bag

Line-crossing and angle

It is not quite so vital to respect line-crossing problems in this type of work, but if you are carefully following the process of one particular catch try to stay on one side of the line throughout. Alternatively, you could easily use a cutaway or a dramatic change of angle to give yourself latitude in editing. When you do go for close-ups, make sure they really fill the frame. Vary the size, angle and composition of your shots to give variety and visual excitement. While close-ups can easily be staged, both rapid action and facial close-ups should almost always be shot spontaneously for a natural effect.

13 Tighter close-up

14 Big close-up, completes capture of fish

15 Cutaway to river acts as buffer shot

16 Another top shot, last view of family

Sound track

The question of sound track may well arise in a sequence such as this. The sound of the stream, the birds, the chatter of the fishers, will all add greatly to the atmosphere you are trying to recreate. It may also be worthwhile to record a lengthy wildtrack on tape or cassette. This can be used later as a running background over which you can superimpose music or commentary.

17 Atmospheric shot of rock and river

Summary

The structure of this small example is completed as the fishers walk home, leaving one rejected minnow on a stone and ending with a fish on a plate. The passage is further helped by the shots of the bag being filled and the water rippling downstream. It is often these anonymous shots which lend a single-subject movie its principal charm and character.

18 Close-up of dinner

SPORT

Sports videos can provide some of the most exciting footage, but they are difficult to produce well. One of the greatest problems is maintaining continuity in the action. Although cuts can be made away from the action, the restrictions of shooting from one position – which is how most amateurs have to shoot – are considerable. However, there are certain techniques which can be recommended for shooting specific sports.

Team sports

To get the best coverage of the game there are certain pieces of equipment you should have. Although you will get a good impression of the game without them, the coverage will neither be as interesting nor as varied. The camera must have a reasonably long zooming range (for example, 8:1), to reduce the disadvantages of shooting from one position. Because you will frequently be working at the telephoto end of the zoom (especially in football coverage) you will also need a tripod and a good pan-head. When shooting extended activities like long matches it is best to use a full-length VHS tape or an 8 mm recorder at long-play speed. Above all, remember to carry a spare battery, fully charged.

Get permission well in advance to shoot the game and arrive with plenty of time to set up. Take adequate tapes, spare batteries and a gadget bag with the usual accessories (see p. 110). Next, decide where you want to shoot the match from. To give each team equal coverage set up near the center of the pitch, about one third of the way back into the stands. Make sure that the view is unobstructed and that you do not block the view of someone behind you (if you are directly in front of a pillar the tripod can be as high as you like without affecting anyone else). It may be necessary to buy more than one ticket to be sure of a clear view. For a more dynamic angle, but more biased coverage, set up just next to the goal of your team's opponents – this will give you very powerful shots of your team's triumphs and virtually nothing of their failures.

For indoor sports, also check the type of lighting in advance and set the color balance accordingly (see p. 50). Automatic metering systems tend to become confused as the camera pans across light and dark areas especially when you are shooting from a high angle onto a shiny floor or icerink, so take an overall exposure reading and lock the aperture at this if the camera has a manual override.

If you can use two cameras set one up in the center and the other by the goal. Both cameras *must* be on the same side of the goal since in a team game the camera positions are governed by the "line of action" (see p. 68), which passes down the middle of the pitch, running through the middle of the goals. To maintain continuity from right-to-left you can shoot from anywhere on one side of that line. Coordinate the two cameras so that they are both operating at the same points in the game. The two angles can then be intercut during editing.

Soccer
All of the action, no matter how many cameras you use, must be strung together without any jump cuts; try shooting long takes so that extensive editing is unnecessary. Use the zoom to vary shot size, but do not "trombone" in and out too much. Make sure you take plenty of cutaway shots – for example of the crowd or the trainer's bench.

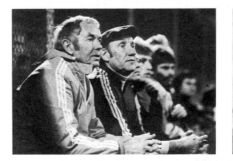

American football
You could also begin each shot by panning into the main action from the crowd or from another part of the field. This provides a built-in cutaway at the front of each shot and no editing may be needed to effect the transition. It can however become monotonous if used too frequently.

Filming tennis

In tennis there are only two positions from which you can cover all the action, and those are actually on the "line," at either end of the court (the center position cannot be used in tennis because the speed of the action creates a series of whip-pans). The fact that you are shooting from one position is less restrictive in tennis because the players change ends every two games. The height and distance from which you shoot are essentially pre-determined. The height is determined by the fact that there must be a sufficient gap between the top of the net and the service box for the bounce of the ball to be seen. The distance of the camera from the court is determined by the extent of zoom. Aim to cover the whole court on the wide-angle end of the zoom, without moving the camera. Any further away from this position and the telephoto will be restricted; any nearer and you will have to pan backwards and forwards to follow the action. Remember to take plenty of cutaways – they are just as important in tennis as in any other sport. The score board between games and sets is a very useful bridging device, as are shots of the players towelling down or changing ends. As an alternative approach, try shooting a "sports portrait" of one player and make no attempt to follow the course of the game. In this case you will want to get in close and go for the most exciting shots without regard to continuity.

Position
From the central camera position you will not only be able to cover the whole court on a wide-angle, but also, by using the zoom, you will be able to get an acceptable shot of the player at the other end of the court. You can also get a closer shot of the player at the other end.

The service
During a service, leave the zoom quite wide, or you will lose the ball. For a more dynamic view of one player, get down to ground level and shoot from the side.

Cutaways
Cutaways are vital in tennis – as in the making of any film. The scoreboard and the crowd are always useful as punctuations. You can also pan off the crowd onto the game, or vice-versa, to provide a buffer shot.

A WEDDING

Like all social ceremonies, a wedding contains certain key moments which have to be covered: the arrival of the bride and groom, the marriage ceremony, the walk up the aisle and the departure. There will also be unexpected incidents such as the fidgeting uncle or the cloudburst and these should be allowed for in the overall plan of action. Make certain that you have the minister's permission to shoot. Then go to the church before the day, if possible at the same time as the wedding will be. Take your camera and check the light. Draw up a plan of the church and mark down your proposed camera positions. Your aim throughout should be to lead the eye from the cars to the altar and back again in one smooth sweep. Never work out camera positions first and the flow of shots afterwards, or the action will appear disjointed. If it helps, write a script so that the progression of the action is clear in your mind before you get to the church on the day.

Camera positions

Find out the exact order of the service, with rough timings if possible, and think where you can put the camera for the key moments. For your main position, you must be near enough to get close-ups of the bride and groom but far enough away to get a wide-angle, with the other end of the zoom, of the whole ceremony. The greater the zooming range of the camera the greater your choice of position. Try to make the background as attractive as possible because you will not be able to move around during the service. In the quieter moments you will have to be in a good position to shoot cutaways. These are vital shots, since the main editing problem in a sequence like a wedding will be to compress the time-scale without destroying the atmosphere. If you are planning to use an off-camera microphone, you will also have to decide on the microphone positions. To record both the participants and the music, and to do justice to both, you may need two microphones.

Lighting, exposure and film

It is impossibly expensive to light even an average church, and the color temperature of unfiltered tungsten lamps is too yellow to mix with the predominant daylight inside. The size of the windows and the color of the walls will determine what exposure you use and the color balance setting. Take an average reading, prefer-ably with an incident meter. Keep in mind that on the day itself it may be four stops less bright. If so, you may not have enough light to shoot at all, even with a camera designed to perform in quite low light. Always over-estimate the amount of tape you will need. Always carry a spare battery that you have charged beforehand, and check your gadget bag before you leave to make sure you have everything you need. Remember that a wedding is a one-off event – you will not be able to reshoot if you make a mistake.

The arrival
The arrival of the bride is one of the key moments that you must catch. Starting the camera as soon as the car can be seen will give you a long, sweeping shot of the arrival. Make certain the camera position is absolutely right as the car comes to a halt. The Rolls Royce mascot gives a useful built-in cutaway to the bride getting out of the car.

Entering the church
The camera, hand-held now, tracks around the columns as the bride enters the church with her father. Try not to leave tripods or other pieces of equipment in the shot as this detracts from the final image.

The ceremony

It is often impossible to position yourself in front of the bride and groom. In such cases you might go for a high top-shot, from where you can also get close-ups. The back stairs give an unobtrusive way of moving around during the service.

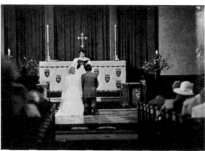

Recording inside

Many churches are quite dark inside, so you may be pushing you camera to its limits. This is why a visit to the church before the ceremony is vital. Remember that a large aperture setting will give you limited depth of field.

Close-ups

When all is said and done your video will stand or fall on capturing people's faces. Go for strong, frame-filling close-ups. It will help if you ask both sides of the families in advance who they would like to see in the video. People are easily offended if you leave them out.

The departure

The cutaways (above) of the bouquet and of the church clock will be invaluable when you come to edit your sequence together. In practice, there might be several minutes in the action which you have to bridge with a cutaway. The departure of the car provides a tidy end to the sequence at the church.

THE FAMILY RECORD

It has to be faced that "home movies" have acquired a rather unfortunate reputation over the years, largely because it is so easy to confuse what is interesting to oneself with what is interesting to others. A wobbly sustained shot of a baby crawling across the lawn may move your family to tears, but the effect on your sleepy after-dinner guests, who remember neither baby nor lawn, will be more on the lines of a yawn. There is nothing wrong with shooting a simple family record, but making movies out of the same material for *others* to watch is a far more demanding task. You will get far more pleasure from your movies if you try to give each subject form, pace, atmosphere and narrative continuity. Aim to make every tape "tell a story", even if the story is an evocation of part of your family life. Your job is to create a pattern that is both attractive and truthful to its subject and this is done partly through judicious editing (both in-camera and at the editing bench) but more especially through pre-planning.

A child grows up

There are three main ways of recording children on video. The first is to shoot at every opportunity. This is by far the easiest method, but the results are poor since each shot is separated from the ones on either side, with no continuity: it should therefore be avoided.

The second method is to choose one particular time or event and shoot it in detail, the idea being to freeze time rather than to show its passage. This gives you a chance to watch and record the child in detail, so you can build a sequence which makes sense and has atmosphere, while still retaining a strong narrative thread. Say you decide to shoot a picnic: there are certain structural elements which must be shown for the movie to have a narrative sense – the packing of the food, driving away, eating, playing and coming home. Keep an eye open, also, for any cutaways so that the time scale can be compressed without strain.

The third method is to make the passage of time itself the subject. In effect this is a "compilation movie" and will almost certainly involve more intensive editing than the single-subject approach. For example, you might decide to shoot the various stages of a child learning to read. The shooting might be spaced out over the course of a year and you might want to punctuate the final movie with some indication of the date: instead of a calendar, try intercutting the child's reading with the growth of the garden and the passing of the seasons. Show the transition from stories being read to the child, to when the child begins to read from memory.

The challenge of making any movie about children is to capture them acting unselfconsciously in front of the camera. There are several ways of making this task easier. Use a telephoto lens setting where possible so you can keep the camera at a distance. And, to get them used to the presence of the camera, shoot plenty of footage – you can always re-use the tape. But the most important thing is to *give the children something to do*. This will not only make for a more interesting film, but, with luck, their absorption in their own activity will outweigh their interest in you and your video camera.

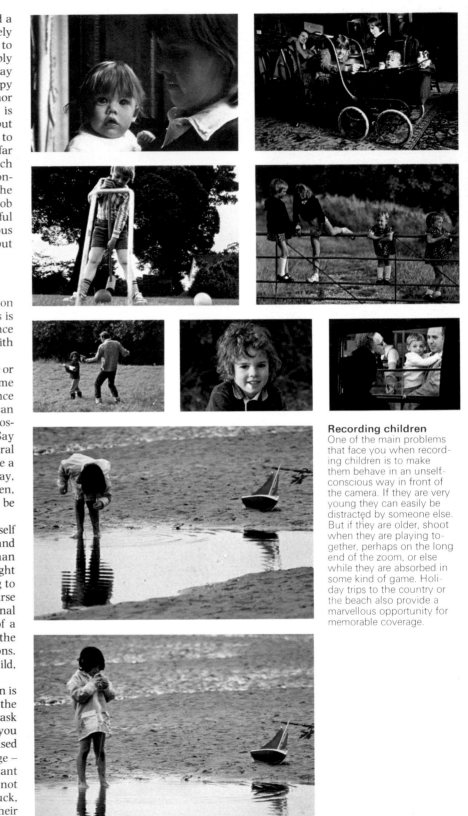

Recording children
One of the main problems that face you when recording children is to make them behave in an unselfconscious way in front of the camera. If they are very young they can easily be distracted by someone else. But if they are older, shoot when they are playing together, perhaps on the long end of the zoom, or else while they are absorbed in some kind of game. Holiday trips to the country or the beach also provide a marvellous opportunity for memorable coverage.

Choosing a theme
If you want to follow the evolution of a specific year in a child's development, you could always focus on one aspect of that growth – such as drawing or reading. For example, it would be possible to make a very attractive video of a child drawing, over which you could subsequently dub the child's voice, either describing the drawings in question, or even singing some nursery rhymes.

A children's party
Parties are marvellous locations for shooting, because the children will certainly not be distracted by the camera so long as there is cake on the table or games to play. Try to avoid using extra artificial lights, however, unless you have absolutely no choice. They are glaring and will drown the light of the candles on the cake.

BUILDINGS

A video camera is ideal for filming buildings because their three-dimensional form is really only revealed by a camera which moves across, around, up, down and eventually through them. The time of day affects the appearance of a building, especially where there is strong relief on the facade, so choose the time with care. Begin by relating the building to its surroundings, perhaps using a tracking shot, and then start to explore the building. If it has a spire, or if it is very tall, use a tilt to emphasize the height. Work with a tripod and make sure that the camera is level before shooting because the perfect verticals you are recording will reveal any inaccuracies. Use plenty of static shots in between the pans, tilts, zooms and tracks or the video will become fussy. When you shoot details in close-up make sure that it is clear where those objects stand in relation to the rest of the building. Zooms are the easiest way to do this, but they can become tedious. You may prefer to cut straight into one, or a series of, close-ups.

Establishing shots
To establish St Paul's Cathedral in its London setting, you might decide to use a long shot across the Thames, followed by a closer shot which gives an atmospheric impression of Fleet Street.

Track and tilt
This long tracking shot was only possible because of the road running around St Paul's. The camera was pointed out of the window of a smoothly moving car, which gives a dynamic, sculptural view of the building.

Track
You can cut between tracks while they are on the move as long as the movement is in the same direction as it is here.

Cutaways
Having covered the large mass of the exterior, the camera now begins to explore the details. Their location has been established in the earlier wide and medium shots.

Interiors

The challenge of shooting interiors is that of showing what you want to show without losing a grasp of the building's layout. It is a great advantage if you can follow someone so that the building is seen through their eyes. It will then be credible to use tracking shots to follow them from room to room, and to use tilts or zooms as their eyes move from one object to another. Always aim to make the whole movement through the building as orderly and smooth as possible. Decide before you enter the building where you want the film to finish – for example, when filming in a church you might decide to track down the aisle, slowly tilting up to hold on the roof. Then after a short sequence of details tilt down again to the chancel, ending with a zoom to the rose window.

Tilt
Having tracked into the church and down the aisle in previous shots, a slow tilt up to the roof was used. The camera, with a wide-angle lens, was of course mounted on a tripod.

Cutaways
Having established the overall plan and flavor of the building you can begin to explore its detail: the organ could be used as a cue for a sequence of close-ups cut to music.

Zoom
A musical climax could be constructed so that it ends with a zoom into the dome.

Final shots
Having reached the dome, the camera can now be reversed to give the view from above. The final shot is another reverse angle.

121

LANDSCAPES

It is often the most theatrical landscapes which attract the filmmaker. But even the rolling chasms, waterfalls and geysers of the American West will become tedious if you have just pointed your camera and recorded a series of repetitive long shots. Plan your shooting as though you were shooting a drama: give it a structure. You might establish your position in the landscape with a pan, then use the zoom to pick out details within the scene (you could also try a slow pan on the telephoto end of the zoom which will exaggerate the distance traveled into the landscape). Build up your video with close-up shots, juxtaposing large with small, dark with light.

Even if your landscape does not appear to have an immediate impact, it is always possible to find varied and interesting shots. As a general rule, the weakest position for the horizon is in the center of the frame – try placing it one third or two thirds of the way up. A flat landscape often derives its scale and drama from the sky, so compose your shots with the horizon low in the frame and use a wide-angle lens. Shoot in the early morning or evening, when the slanting light will bring out the full relief of the land. Make use of any changes in the weather and make the most of all cloud formations, possibly using a polarizing filter to darken a blue sky.

Landscape (left)
The slanting evening light across this Turkish landscape both emphasizes the relief and saturates the color. At noon, this field would be quite unremarkable.

Snow scene (right)
Here, too, the snaking lines of the landscape hold the composition together. But beware of the exposure problems when shooting snow scenes.

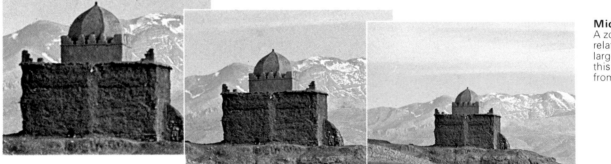

Middle Eastern Castle
A zoom can be used to relate detail to the overall large scale landscape – in this case a castle isolated from its setting.

Thirds rule
This is one practical example of the so-called "thirds rule". The horizon is always at its weakest when it bisects the screen. Here it is placed both high (left) and low (right) to emphasize earth and sky.

Evening scene
Make sure that the continuity of time of day is maintained between shots of a given landscape. Here, all three shots share the same golden evening light.

Grand Canyon (left)
One of the best ways of articulating a landscape film is to make it an account of a journey – for instance a mule-trip to the bottom of the Grand Canyon.

Clouds and horses (right)
The natural brilliance of the complementaries yellow and blue give an almost unearthly quality to this Arizona landscape.

Farm machinery
Tracking through landscape is only effective if a strong foreground is used to establish motion and scale – as in the case of this farm machinery.

Cutaways
The wide-angle shot, left, and the close-up shot, right, were used in juxta-position.

WILDLIFE

A wildlife movie, whether shot in your back-yard, local park, zoo or wildlife sanctuary, will need a lot of patience and ingenuity, but the rewards will be enormous. Aim to capture key scenes in the animal's life. For example, a video on a bird might show flying, feeding, territorial fighting, courtship, nesting and the feeding of its young. You may decide to concentrate on one of these aspects, or use them all to show the animal's life over a period of time. Whatever your subject, you must be absolutely familiar with the animal's life style. Do this by both reading about and observing the animal's habits. Get to know where it feeds and at what times, where it nests, and how sensitive it is to human presence. Even if you have chosen a spot where there are no apparent disturbances, you may find that you have to use a hide or some form of lure to get the coverage you want.

Wildlife equipment

The most important piece of equipment will be a powerful telephoto lens. So use a zoom with the longest telephoto setting you can find. A useful alternative is a camera that accepts interchangeable lenses and that takes optics designed for 35 mm still cameras. A 500 mm lens from a 35 mm camera gives very high magnification when used on a video camera. Because telephotos show up any camera shake, a solid tripod, preferably one with a good pan head, is essential. Video cameras are ideal for wildlife, as they are both silent and light-sensitive (down to 2 lux in one case). The shutters can be very high-speed. Try to use the longest tapes you can, as animals have a way of waiting until the tape has run out before they do what you want them to. To actually trigger the camera you may find that a remote control device is useful. This can be set off manually using an FM radio attachment, or it can be set off automatically using a trip-wire or photo-electric cell. Focusing is critical at long focal lengths so pre-focus and adjust the camera to give the greatest depth of field possible. This will allow for any unforeseen movements on the part of the animals. Autofocus is usually adequate with modern equipment, however. Make sure the battery supply is adequate for the long wait.

A telephoto lens
A long telephoto lens is not only useful for filling the frame: it can save your life. Even the most picturesque wild animals can be dangerous when they are accompanied by their young. Always keep the engine of your car running and reverse up to the herd.

Close-up shots
Here, the long telephoto lens has the added attraction of separating the sharply-detailed whiskers of the lioness from the dark background. For moments like this you will need patience and a lot of tape.

Filming herds
For a really sustained sequence such as a lion-hunt, or the study of a herd of impala, you will have to embark on a serious study of the animals' life style and habits. In these cases, you should get all the help you can from the game wardens and be prepared for many long waits.

Setting up for shooting

To avoid scaring the animals it may prove necessary to work in a hide. Many wildlife sanctuaries have permanent hides (built for viewing bird's nests, for instance). Alternatively, one of the best and most readily available hides is a car. For some reason, animals will accept the presence of a car, even though there are people visible inside, where they would never accept people on foot. Make sure all the windows are clean, especially the front and rear ones which cannot be rolled down. You should also consider buying a clamp attachment for the car. This can be fastened to the side door or dashboard and provides the solid support essential for telephoto settings. Animals frequently have to be lured to the hide area and the most common way of doing this is with food or water. Place the food regularly in the chosen spot until a visiting pattern is established. Three-dimensional models (like duck decoys) or tape recordings can also be used to reassure the animal.

Hides
Hides are easy to build but should be put up as quickly as possible to avoid disturbing the animals.

Using the hide
Hides are indispensable when filming birds, particularly if you want a close view of the nest. Take care not to disturb any nesting bird or it may desert its young. This particularly applies to rare species such as eagles and ospreys.

Building a hide

In inaccessible areas you may have to build yourself a hide. The most common form consists of four upright stakes hammered into the ground, with horizontal cross-pieces at the top. This box is then covered with green or brown canvas tarpaulin so that it blends with the background. One of the sides should have a hole or zipper in it for the camera lens to peep through. The front leg of the tripod may also have to poke through the canvas to get the lens close enough to the hole. Build your hide as quickly and quietly as possible, at least twenty-four hours before you plan to use it. Since your stay inside may be a long one, equip the hide with a folding canvas chair (preferably one with a back), binoculars, notebook, pens, reference books, food and drink. When it comes to recording, one trick is to take an "assistant" with you. When the assistant leaves, the animals think the hide is empty and start to behave as they would normally.

Filming in zoos
You can often get quite remarkable film sequences in an ordinary zoo. Feeding times provide a reliable action sequence with the advantage that you can predict its occurence to the minute. To avoid the bars getting into the shot, shoot with the camera parallel to the cage and use a long lens to defocus them.

TRAVEL

In the strictest sense, a "travel video" is a documentary in that the subject is the place that you are traveling to and not "you traveling". It is less personal than a holiday video and should be planned much more thoroughly. Decide on the area or town that you want to cover and do some research before you leave. Find.out about its history, famous citizens, well-known buildings and work out how these elements can best be put together in a film. Do you want a straighforward "travelog", showing the physical structure and layout of the town, its buildings and the people living there, or do you want something more specific? For example, you may choose a region famous for its food or wine. In this case you might concentrate less on the historical aspect and more on the landscape, the restaurants, the chefs, their clientèle. The final movie may well differ from your original plans, but that is part of the excitment of making a documentary. Do not forget the equipment when you make your plans. Take plenty of tapes with you, because you may not be able to buy the type you want where you are going.

Moghul palace (above)
The aim of these shots was to concentrate on the way sunlight filters through stonework onto the marble reliefs of the interior. Manual override was used to get the correct exposure.

Architectural composition
Try framing a building in an arch which is itself part of the scene. If you use a wide-angle lens keep the camera level to avoid converging verticals.

Customs and character
The experience of travel is in no way restricted to the Baedeker guide: the people, life and landscape of any place, from Damascus to Detroit, are more vivid a subject for the filmmaker than any monument could ever be. But you must be sensitive and responsive to their own culture – in the East many Muslims, especially women, may object on religious grounds to being photographed. Neither bully your subjects nor bribe them. Try to become friends, and ask their cooperation; alternatively, use the very far end of the zoom and if necessary be prepared for a quick getaway. Finally, the more you know about the local life, the better your footage will be.

THE HOLIDAY ESSAY

Before you leave, make sure that your camera is working properly and check that all the necessary equipment has been packed. Be sure to take plenty of tapes but check before you buy as some countries have restrictions on the number of tapes that can be imported. Look after your tapes both before and after exposure. If you are going to be shooting in dusty or sandy conditions pack the correct protective and cleaning equipment.

If your camera has rechargeable NiCad batteries and you are going abroad, make sure that the voltage and plugs of the country you are visiting suit your equipment. If they do not, you will need a transformer and adapter, respectively.

Another potential problem when traveling abroad is that different countries use different television standards. This may mean that you will find it impossible to play back your tapes on a local television and VCR.

There are two basic sorts of movie you can make of a holiday: the *beginning-to-end account* and the *single-subject movie*. The first attempts to cover every phase of the holiday while the other concentrates on a specific event or situation.

The beginning-to-end account

The beginning-to-end movie needs to be planned beforehand, and is therefore more time-consuming. Because the movie is meant to show the passage of time, you should take plenty of traveling and transition shots. To convey geographical locations, make the most of shots of road signs, maps, travel brochures and luggage labels. Within this framework of shots aim to show three or four episodes from the holiday that you want to record (it is unwise to show more than this in a short movie because the action will appear too disjointed).

Beginning-to-end account
In the kind of movie which attempts to convey the whole course of a holiday from beginning to end, you will need a lot of linking shots such as these: cars traveling right-to-left and left-to-right; planes taking off and landing; aerial shots; packing and unpacking; road signs passing the car; and so on. These will combine to give a sense of direction to and from the location and thereby give structure to the movie.

The single-subject movie

The single-subject movie, because it concentrates on one day or episode, allows you to develop a scene in depth. For example, you might decide to shoot "a day on the beach", retaining the original sequence of events: packing the car, driving, swimming, sunset, return. Alternatively, you could make the whole movie an atmospheric evocation of sea, sand and sun, or even a simple narrative sequence. With this kind of coverage, choose a subject that is lively, self-contained, and that will give plenty of opportunity for character to be revealed. For instance, you might record two children playing ball by the water. Tape both of them together in a two-shot and use this as the master shot. Get close-ups of them both throwing and catching the ball, from the same side of the line (see p. 68). Get cutaways of someone watching further up the beach. To end the movie see if you can find an elegant way of titling it. In this case try shooting the children writing "A day on the beach" in the sand for the opening and having this washed away by the sea for the closing title.

Single-subject movie
A typical single-subject movie might be a day on the ski slopes. You should take the obvious precautions such as protecting the camera and taking plenty of fresh batteries and tape. Keep batteries warm by putting them in an inside pocket. Get all the single shots you can as well as ones which convey the atmosphere. These elements could be either intercut or constructed into the progressive account of one single day. In all these cases you should be careful of underexposing your main subject when filming snow scenes.

Conveying mood
In this kind of movie, you are aiming to create an overall impression of a day skiing. You can therefore combine wide-angle shots of the landscape or the mountain village with crowd scenes and candid shots of the people on the ski slopes. Go for strong shots and sequences that will convey the general atmosphere of the day.

MAKING A DOCUMENTARY

Probably the most common form of the documentary is the social documentary. This umbrella term takes in a wide range of possible causes, from opposition to a new road scheme to a charitable organization wishing to raise funds. Many individuals and organizations find the short polemical movie the ideal medium for putting across a social or political viewpoint. When a television network, for instance, makes a documentary, it will go to great lengths to present an apparently rounded view of any question. Whether the resulting coverage can ever be genuinely "balanced" is arguable: after all, movies are made by people who have opinions and a moral sense. If the documentary you are planning is committed to a particular cause, the only reason you need any balance at all is to make your own committed position more credible. You will also find that your work carries more conviction if the message emerges from the body of the movie rather than from your superimposed commentary. In other words, *do not say it if you can show it*. This can be done in two principal ways: through the words and actions of the people in the video; and through the power of the visual imagery.

Your equipment needs for a documentary are very similar to those for a film essay.

Adding a commentary

Wherever possible when shooting a documentary you should try to find others to say what you are trying to convey – although there will probably remain quite a few ends to be tied, points to be made and conclusions to be drawn. You will, in fact, need a commentary. Try to keep it as brief as possible and do not fill every frame of film with sound – rather, let the images tell their own story. The best person to record the commentary may well be someone who is utterly indifferent to the issues at stake (for details on writing and recording a commentary, see p. 198).

Recording an interview

Interviews can be conducted in two ways: as a two-way conversation where you would expect to retain the questions as well as the answers after editing, or where you intend to remove all trace of the questions during editing, leaving the final version "clean" of the interviewer's presence. In the latter case, your questions will have to be carefully phrased so that they do not allow a "yes" or "no" answer. In general, a bullying technique should not be adopted. It may well antagonize any non-committed viewer and it will not draw the best response from the interviewee. Also, do not interrupt during the answers, especially if you are not in shot. A friendly nod or encouraging smile is best, and a period of expectant silence often triggers a better response than a hastily put question. It is worth remembering not to overlap your next question over the end of the previous answer – you may want to separate them in editing. If you want to edit, leave periods of silence between answer and question, so you can insert cutaways. Finally, do not be so mesmerized by your next question that you fail to listen to your subject. They are thinking about what they are saying, even if you are not.

A movie about waterways

The shots on this page illustrate one of the ways in which you might go about putting together a documentary to convey a personal point-of-view. In this case, the subject is canals and waterways – the barges and the people who live and work on them, the landscapes, the industrial architecture, and the controversial environmental issues involved. Remember to go for the shots and the juxtapositions that will make your points for you, and do not underestimate the power of the unaided image. Above all, try to avoid relying too heavily on the commentary to get your message across.

Opening shot
Your video might well begin with this kind of image. As an establishing shot, the snow-covered canal boat could be used to lead gradually in to increasingly controversial topics.

The locks (above)
An interesting sequence may be created simply by following a single boat through the lock system. In this case, long shots are intercut with a close-up of the prow of the boat.

Industrial landscape (right)
Shots taken from the boat can illustrate the contrasting environment that the canals encompass – here, the industrial panoramas of warehouses and gas storage tanks.

Cutaways (left)
The architecture alongside waterways can provide rich visual material. Abstract compositions made up from the lock gates, machinery and the waterfront buildings can all be used as cutaways to enrich the overall feel of the movie.

People (right)
These shots portray some of the people working on the canal boats, as well as those in factories on the canalside. If you have recorded wild-track interviews of people talking about the life on the canals, the sound could be used as a voice-over with shots such as these.

Details (below right)
Exploit the bright, strong colors of the traditionally painted barges as far as you can. Powerfully composed, color-saturated shots like these should be allowed to tell their own story

Closing shots (below)
You might decide to end your movie on a strident controversial note. Alternatively, you could go for a quiet, peaceful atmosphere such as that suggested by these shots, recorded in the warm yellow light of early evening.

THE VIDEO ESSAY

This category of filmmaking may sound a little imposing at first, but it is in fact one of the most creative areas of video, and one that is quite accessible to the relative beginner. The video essay should not be confused with a documentary type report, which deals with a given subject or topic in a very literal, factual manner: instead, the subject is, if you like, *the movie itself*. It should be made clear from the beginning that a great deal of this type of filmmaking is "created" at the editing stage. The juxtaposition of one sound with another image is fundamental to this kind of many-layered movie and is responsible for much of the challenge.

The abstract movie

This is a video about an idea – an abstraction. The concept might be grandiose, common-place or even erotic, according to taste. But the concentration on one idea gives you enormous scope to work within a narrowly defined area: you will have to plan it all the way through, and you will almost certainly have to write an outline, if not a proper script. The sources to be drawn upon are innumerable – live action, poetry, music, nature, animation – almost anything that suits your purpose. What you should aim for is some organizing structure that will simplify all this rich but unwieldy material and hold it together and that will give discipline and directness to the movie. For example, you might take the subject of "Time". Though time rules, and eventually ends, our lives, it has the misfortune, from the movie maker's point of view, of being invisible. Your material then is time once removed: the effects of time, the memories of the very old and the indifference of the very young, the seasons, the clocks and the mechanics of time-keeping, the movement of the sun across the sky and the movement of the tides, the prodigious body of poetry and prose on the subject of Time and, of course, music. You could use the progress of one calendar year as your framework: from spring (childhood) through to winter (old age). To illustrate the transitions you could use Shakespeare's sonnets, for example, which are largely about time, as a recurrent theme. Once you have decided on some form of framework, the job of sifting the material becomes much easier.

The types of ideas and examples mentioned here are only intended as a guide. All the crafts of man can be marvellous subjects for your camera and you will soon learn to steer a path between over-literalness on the one hand and wilful irrelevance on the other.

Equipment

An essay of the type we are describing here is often a very personal statement – representing the individual view of its creator – and, as a result, it does not always lend itself to the film-crew approach. This type of movie is therefore ideal for amateur movie makers with compact equipment. A format such as VHS-C will give tapes good enough to be copied for editing. The savings in weight and ease of operation are strong arguments in favor of the smaller format especially S-VHS and Hi-8.

The single-subject video

There are many subjects in the arts and crafts that can be used as the basis for a single-subject video. If, for example, there is a piece of music that excites you, it can be "illustrated" with the images it suggests. The music score can become the script to which you can refer during shooting and editing. Paintings also form the basis of many short movies but they require all the camera movements to be smooth and precise.

A craft process lends itself admirably to a single-subject video. It is always fascinating to watch a person at work, especially when you are able to watch a single object being made from beginning to end. However, the process must be followed very carefully from stage to stage, with a careful eye for detail.

Glass-blowing
Glass-blowing proved to be ideal for the single-subject movie as it deals almost exclusively with one person and their craft. Also, as most of the action is concentrated in quite a small area, it can easily be covered by one camera.

The molten glass
This glass-blowing sequence is typical of the kind of craft process that you might decide to shoot. It offers a wide variety of visual material – the glow of the furnace and the molten glass, the glitter of the finished article – and it also gives you an opportunity to study the character of the glass-blower himself if you wish. In this case you would almost certainly decide to follow one single object – a goblet – from the furnace to the display case.

Forming the glass
One of the difficulties in filming a sequence such as this is that the process is very fast and it cannot be halted in the middle. You will have to move swiftly and keep shooting.

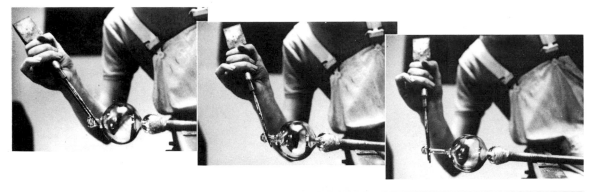

Forming the stem
The likelihood is, however, that you will miss out on some of the action. If possible, choose a subject that you can repeat. Shoot it twice and intercut the two takes in editing. This will also help with the inevitable continuity problems that are involved in any detailed subject. In the shots illustrated here, for example, of the glass stem being formed, images from two different takes have been intercut to form one continuous sequence. This technique will only work if careful attention is paid to camera position and subject lighting. Continuity can also be helped by wide variations of camera angle, and by inserting cutaways.

Attaching the base
Concentrating on a detail can often be more effective than a full-figure shot. Go for all the cutaways you can, so that the time-scale can be compressed without discontinuity or jump cuts.

Also, get all the sound you can, even if you record it "wildtrack". Be certain to shoot an interview with the craftsman talking about his work – it can be used as a voice-over at the dubbing stage, perhaps with a musical track too.

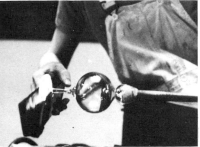

Zooming in
The final sequence of this video essay deals with the finished articles – the glass objects. The reflected light on the glass decanter was the final shot of a slow zoom-in.

Zooming out
A cut to a zoom-out was used to finish the essay. Beginning where the last sequence ended – on a close-up of the decanter – and zooming out to show the setting helps place the objects in their proper perspective.

A FICTIONAL ADAPTATION

To produce a script for your first fictional movie it may be easier to adapt an existing work of fiction rather than originating your own. A novel will almost certainly be too long for your needs, but a short story can easily be condensed into a manageable length. It should not be necessary to change the story too much and you should never change the dialogue if it can be avoided.

If you find a story that you think might suit you, but you intend to enter the video for a competition, or some other form of public showing, then you must consider the question of copyright. If the work is more than fifty years old there may be no problem, but if it is more recent you must get permission from both the author and the publisher. In addition, there is a copyright attached to any new translation, even if the original work is more than fifty years old. If your film is only for local or film-club showing there should be no difficulty in getting permission, and the charge for use should not be too high. Publishers are generally only interested in claiming their due if it looks as if your film may make money.

What to look for in the story

When considering a story for adaptation always consider its suitability for video. For example, it may be easy to imagine concepts such as a twinge of remorse or a shortage of money while reading about them, but it is not so easy to translate them onto tape. Inner thoughts and conflicts *can* be shown, but they must be clearly translated in terms of sound and vision. An amateur filmmaker is therefore better off finding a story with a strong plot, only a few characters, plausible dialogue, and not too much "psychological" action.

Once you have chosen the story, decide what the treatment of it will be. The *treatment* is a synopsis of how the writer "sees" the video. From this, the *storyboard* is drawn up, and with it the *script*. When the locations have been chosen the *shooting schedule* can be drawn up. Choose the locations with as much care as the story itself because they greatly affect the look of the result. They should have adequate light and be free of onlookers, cars, planes and all unwanted noise.

The original story

Henry James' story *The Middle Years* can be used to show how interior life is expressed and visualized on film. It is an account of an ailing but inspired writer, recuperating in Bournemouth, a seaside resort in England. Here he receives a copy of the last book he will ever write. The opening scene is as follows:

"The April day was soft and bright, and poor Dencombe, happy in the conceit of reasserted strength, stood in the garden of the hotel, comparing, with the deliberation in which there was still something of languor, the attractions of easy strolls. He liked the feeling of the south so far as you could have it in the north, he liked the shady cliffs and clustered pines, he liked even the colourless sea. "Bournemouth as a health resort" had sounded like a mere advertisement, but he was thankful now for the commonest conveniences. The sociable country postman, passing through the garden, had just given him a small parcel which he took out with him, leaving the hotel to the right and creeping to a bench he had already haunted, a safe recess in a cliff. It looked to the south, to the tinted walls of the Island, and was protected behind by the sloping shoulder of the down. He was tired enough when he reached it, and for a moment was disappointed; he was better, of course, but better, after all, than what? He should never again, as at one or two great moments of the past, be better than himself ..."

Dencombe stares at the sea, observes a group of figures and opens his parcel.

Plan out the shooting locations with the story in mind. Make a note of the times of day when the light is right, and check with any property or land owners that permission will be granted to record at the times you have in mind. If you intend to work with a tripod in a street you may need to check beforehand.

The treatment

The scriptwriter's task is to rearrange the chronology of the story so that flashbacks, memories and the preoccupations of the characters are comprehensible to the video audience. It is sometimes necessary to add small actions to link scenes, but avoid adding extra dialogue.

It is Bournemouth in the late 1800s. An early spring day. We see the sandy cliffs over the sea, across which a postman is riding, whistling as he goes. He tethers his horse to the gatepost of the hotel, and walks across the garden with his bag of post. As he does so, a gentleman walks out of the hotel, leaning on a cane, and walks unsteadily towards the pines. The postman calls him and tells him that there is a parcel for him. Dencombe takes it, and walks down towards the right of the hotel, to a bench overlooking the sea. He is in his late fifties, but gaunt and clearly in bad health. The effort of reaching the bench has almost exhausted him. He looks closely and with a trace of humor at a group of three people on the beach below – a young man, a young girl, and an older woman – then picks up the packet. We read the address (Bournemouth) and the name. He opens it, and we see the brand new book title, *The Middle Years*, by Dencombe himself. This will act as the main title for the movie. He leafs through the book, then sighs to himself "Ah, for another go, ah for a better chance." (the original dialogue).

This is a more compressed treatment of the opening scene than you would actually have, but it gives some idea of the technique involved. The chronology has been straightened out, and the postman is now first. The name, profession, and location of the writer are now both seen and heard, and his frailty is visible.

Locations
It is a good idea to take polaroid pictures of locations as reference material, both for the script and the storyboard.

The storyboard

The next stage in the production of this adaptation is to convert the treatment into a full script. This is also the stage to look for a location and to produce what is known as a "storyboard". This is a large grid of drawings representing consecutive frames, each of which stands for one shot. In the case of a complex shot, such as a track or a pan, more than one frame can be used. The sketches can be very rough as their only purpose is to help you visualize a shot and to see it in relation to the shots on either side (see below).

1a,b Pan from sea to hotel

2 M.S. over shoulder

3 M.C.U. of Dencombe

4 C.U. of Dencombe

5 M.L.S.

6 M.S. Dencombe

7,8 Dissolve to L.S., becoming M.S.

6 M.S. Dencombe

9 a,b Over-shoulder subjective L.S. Zooms to M.L.S.

10 B.C.U. of Dencombe

11a,b Shot over shoulder. Zoom to C.U. of book

12 Pan from hands to B.C.U.

The shooting script

Scene 1. Exterior. Day. Early morning, early spring. 1893. Location: Hotel Splendide, near Bournemouth, England.

Shot	Action and dialogue	Description
1a,b	Camera pans from the sea onto the land to show the postman on horseback riding along the cliffs. As he comes to the hotel he dismounts and walks in with his satchel.	L.S. pan right to left
2	In over-the-shoulder shot we see the hotel door towards which the postman is walking. Dencombe emerges from the door. He wears a top hat and frock-coat. He looks around and walks right.	M.S.
3	Reverse two-shot with Dencombe in foreground. He walks towards camera, not seeing Postman. Postman calls "Mr. Dencombe, Sir!" Dencombe turns.	
4	Dencombe sees the postman, looks pleased, and exits left.	B.C.U. Dencombe
5	A distant conversation ensues which is heard only as a civilized mutter. The postman hands over a parcel and exits right. Dencombe exits left, parcel under his arm.	M.L.S. two-shot towards gate
6	Dencombe looks around reflectively to decide on the direction for his walk: exits right.	M.S. towards hotel.
7	Dencombe walks towards the sea. Dissolve to:	L.S. towards sea
8	Dencombe now approaches bench, panting heavily, and flops into the seat. The package is on his knee.	L.S. becoming M.S.
9 a,b	Reverse over-the-shoulder shot reveals sea, beach, and three figures. Camera zooms into M.S. of the group – one old woman, one young companion, and a man behind, reading a red book.	L.S. zooms into M.S. three-shot.
10	Dencombe's tired face twitches with a knowing smile, and he looks down at book.	B.C.U. Dencombe
11a,b	Over-shoulder high shot to show book, which Dencombe begins to unwrap. Camera zooms in to show address (Bournemouth) and then, as the book is revealed, the title (*The Middle Years*) and the author (Henry Dencombe).	M.C.U. zooms to B.C.U. of book.
12	He picks up the book, and as he opens it, the camera pans up to his face. He whispers sadly: "Ah for another go, ah for a better chance!"	C.U. book from *in front of* D., panning up to B.C.U. his face.

A SIMPLE SCRIPTED MOVIE

Once you make the jump into fiction, your whole approach to moviemaking will change. You no longer look for shots, you create them. And you are no longer on your own. Even if you write the script, direct, edit and play back the tape yourself, the business of setting it up and shooting it will inevitably involve others. If you are prepared to listen to what they have to contribute, this collaboration can be enormously rewarding.

First, you need an idea. And your choice will depend very much on your reasons for wanting to make a movie in the first place. One person will opt for a thriller, another for a comedy. But all good ideas for a simple fictional movie must fulfil fundamental criteria. The number of actors should not be greater than you can muster, nor should the parts be impossibly demanding for amateurs. The locations should not be inaccessible or expensive. And any stunts, special effects, opticals or graphics should be within your means – both technically and financially. Above all, the characters and the plot should be as *interesting* as you can possibly make them.

Character

For an actor to sustain the illusion of a "real person" on the screen, he or she must have something to go on. It is your job as scriptwriter or director to provide physical mannerisms, an outline of character and, most important of all, a clear and visible motivation for the action the subject is supposed to perform. You must make certain that the human reasons for each stage of the plot are perfectly clear. If one man is trying to kill another, we want to know why. If the motive is not jealousy, greed or mistaken identity, then what is it?

The plot

The conventional wisdom is that the plot should have a distinct beginning, middle and end. But a good plot can just as easily have a slow-fuse opening, two or three successive "middles" and a double-twist ending. The only requirement is that the audience's attention should be held – by guile, mystification, comedy or sheer brute force – from beginning to end. Above all, remember that, if the story is strong, keep it simple.

The treatment

After deciding on the outline of your plot, you should write a treatment of the whole movie. This should contain quite a lot of detail but only a general indication of dialogue. You are not yet concerned with specific shots or camera positions, so concentrate on getting the story itself into shape. This is the point at which you should assess the balance and structure of the movie, and build in all the undercurrents, red herrings, false clues and subtleties of character you need. Ask yourself at every stage of the treatment exactly what is providing the "dynamic" at any given point – is it suspense, curiosity, laughter or the clash of two wills? Make certain that you know what effect you want, so that you can put all your effort into its achievement.

Scripting the movie

A script is essential when dealing with a fictional narrative, even if it is later altered to accommodate the circumstances of shooting. Suppose you have written a simple story in which a boy is kidnapped, driven off and held for ransom. From this idea you can write a treatment, the final sequence of which might run as follows: the boy, bound and gagged, is squirming on the back seat of a car as it races toward a railroad crossing. A train is due and the kidnapper is desperately trying to beat the train as the boy's father, in another car, is catching up. The gates at the crossing close, the father's car screams up, the boy frees himself and the man runs off to avoid capture.

The following film script is one possible treatment. There is no dialogue, only effects, and music if needed.

A simple scripted movie

1	L.S.	Car, low angle, right-to-left. Car passes rapidly through frame. *Sound:* throughout, squealing tires, roaring engines, as appropriate.
2	M.C.U.	Man from passenger's front seat. Man looks around to rear. As he looks, pan to boy on rear seat. His head is on offside.
3	C.U.	Boy's face, gagged, frightened.
4	M.S.	Over man's shoulder. Road ahead.
5	C.U.	Man's eyes. They look down to watch.
6	C.U.	Watch on eyeline. Second-hand moves around. Watch says 10:58.
7	L.S.	Train travels left-to-right.
8	B.C.U.	Man's eyes. Up to mirror.
9	C.U.	Mirror. Other car visible.
10	M.S.	Tracking with other car, M.S. of father in pursuit right-to-left.
11	C.U.	Boy's face, more determined. Pan down to hands as they slowly work loose.
12	C.U.	Gear-change by man. White knuckles.
13	B.C.U.	Man's face, eyes to clock.
14	B.C.U.	Watch 10:59.30.
15	C.U.	Father, anxious.
16	M.S.	Train rushing through frame left-to-right.
17	L.S.	Cars both pass very fast, close together, right-to-left. *Sound:* distant train whistle.
18	B.C.U.	Boys hands finally loose.
19	V.B.C.U.	Massive close-up second-hand 11:00.
20	L.S.	From across *far* side of railway crossing. Gates close just as car arrives. As train wipes the shot *very close* to camera, cut to.... *Sound:* loud train whistle.
21	L.S.	Car stops. Father's just behind. (Camera has now crossed line.)
22	B.C.U.	Man's face. Jumps out. Runs away.
23	M.S.	Boy jumps out. Pan with him to father.

The storyboard

To help you to gauge the cumulative effect of the story as you have conceived it, and to help to communicate this to any other people involved in the production, it is often useful to make rough sketches of the successive images. This process of visualization is known as a *storyboard*. In this particular example, shots 1 to 25, representing the final sequence of the movie, could be laid out as illustrated below. It will be seen that to enhance the suspense, the long shots are intercut rapidly with increasingly large close-ups of the action. Mid shots, wherever possible, have been avoided. The pace of the shots will build up through the sequence.

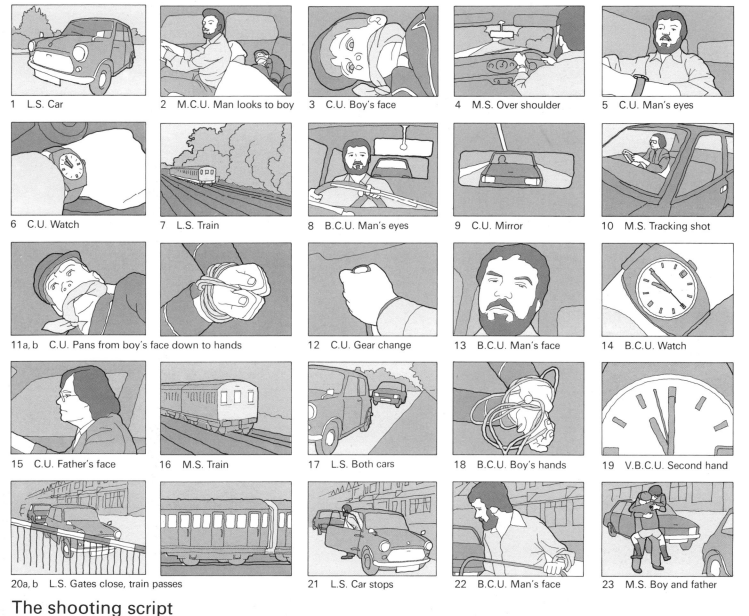

1 L.S. Car

2 M.C.U. Man looks to boy

3 C.U. Boy's face

4 M.S. Over shoulder

5 C.U. Man's eyes

6 C.U. Watch

7 L.S. Train

8 B.C.U. Man's eyes

9 C.U. Mirror

10 M.S. Tracking shot

11a, b C.U. Pans from boy's face down to hands

12 C.U. Gear change

13 B.C.U. Man's face

14 B.C.U. Watch

15 C.U. Father's face

16 M.S. Train

17 L.S. Both cars

18 B.C.U. Boy's hands

19 V.B.C.U. Second hand

20a, b L.S. Gates close, train passes

21 L.S. Car stops

22 B.C.U. Man's face

23 M.S. Boy and father

The shooting script

When you come to shoot, it is not always possible to record each sequence as it will finally appear on the screen. For example, you might have a scene near the beginning of the movie that requires you renting a car. The same car could also be needed briefly near the middle of the movie and again near the end. As your video may be a part-time, week-end production, shoot-ing might be spread over many months. From a planning point of view, it makes more sense to shoot all the scenes involving the car on the same day, rather than hiring the same car on three separate occasions. This principle, of course, applies to making the most economical use of all your resources, including the actors. The order for filming the shots is known as a *shooting script*.

A SIMPLE SCRIPTED MOVIE

1 L.S. Kidnapper's car

2a M.C.U. Kidnapper

2b M.C.U. He turns his head

2c M.C.U. He looks around

2d Pan to C.U. of boy

The chase sequence

The sequence opens with a shot of the kidnapper's car rushing through the frame. We then cut to a shot of the kidnapper from the passenger's seat inside the car. As he turns his head, the camera pans around to reveal the boy bound and gagged on the back seat. Throughout, there are squealing tires and roaring engines on the sound track.

3 C.U. Boy's face

4 M.S. Over kidnapper's shoulder. Road ahead.

5 C.U. Kidnapper looks at his watch

6 C.U. His watch 10:58

7 L.S. Train traveling left to right

8 C.U. Kidnapper's car. He looks up to mirror

Building suspense

The kidnapper knows that he must beat the train to the railroad crossing and that it will arrive at exactly 11:00 He looks at his watch, and we cut to a "parallel action" shot of the train. Meanwhile, a subjective close-up of the kidnapper's car mirror reveals the father's car in close pursuit. Tension increases with the slow pan down to the boy struggling to free his hands.

9 C.U. Father's car in mirror

10 M.S. Tracking shot of father's car in pursuit

11a C.U. Boy's face

11b Pan down to hands

The chase accelerates
In this series of shots, close-ups of the kidnapper (shot 13), the father (shot 15) and the boy's hands (shot 18) are intercut with rapid long shots of the train and of the two cars. The train is seen nearing the railroad crossing, the father's car is gaining on the kidnapper, and the watch shows 10:59,30.

12 C.U. Kidnapper changes gear

13 B.C.U. Kidnapper

14 B.C.U. Watch 10:59.30

15 C.U. Father driving in pursuit

16 M.S. Train, now closer than in shot 7

17 L.S. Both cars pass through frame

18 B.C.U. Boy's hands

19 B.C.U. Watch 11:00

20a L.S. Gates close as cars arrive

20b L.S. Train passes in front of camera, right to left

The escape
From an enormous close-up of the watch showing the time at 11:00, we cut to a shot from the other side of the railroad crossing. The gates close just as the cars pull up. The train hurtles past and wipes the shot close to the camera. The boy, his hands now free of the rope, jumps out and runs to his father. The kidnapper runs away.

21 L.S. Kidnapper's car stops, father's behind

22 M.S. Kidnapper runs away

23a L.S. Boy gets out

23b L.S. He runs towards father

23c L.S. They embrace

THE ROLE OF THE "DIRECTOR"

When applied to home movie-making, the term "director" seems absurdly over-blown. The amateur director, making a home movie on vacation or at a New Year celebration is hardly Cecil B. de Mille. But the curious thing is that the most inept so-called "directors" have left their fingerprints, however awful, on their products, and the reason is that film or video-making is both a very intimate and communal affair, as well as being extremely time-consuming. When you have been working night and day with people, attachments grow that never fade, however unlikely they might at first seem. This is true both of commercial television, where there may be hundreds of people involved, and of a tiny domestic Christmas play.

At the same time this intimacy can be mystifying even to the closest. The present writer has had the privilege and deep pleasure of working with many artists and writers, none more so than a very grand Dame of 90 in the Italian foothills. After a week's slogging through the Dolomites on foot, she asked my assistant: "*Tell* me, my dear, what does that young man *do?*"

The fact is that if you are making a movie with others, you are putting your stamp on it – but only if there is trust, love, understanding, and mutual intent. The director's hand, to anyone with a good eye, is as visible as Rembrandt's brush – and so is a fake. "Technicians" – and they could be your own children – will smell a rat the moment you fumble. The director's job, from that point of view, is to have a clear vision of what he or she wants, and to communicate it to the rest of the team. Early conviction is vastly more important than eventual accuracy. In brief, as on ship, if the crew loses its nerve, you're sunk, and the captain goes down last.

The practicalities

The moment you pick up a camera, you become a "director". And whether you are recording a pet rabbit or a cast of thousands, the job is the same. The skills and strictures are similar whether you are directing for the big screen or making a small family movie. In brief, they involve organizing, planning, controlling the camerawork, and editing.

Organization and planning

First of all, you must have some sort of idea in your mind before you begin. This could be a detailed shooting script, or simply a clear notion of what you want to achieve. Then you should plan all the obvious practical details that will enable you to achieve your aim. This will involve making sure you have all the right equipment, planning the lighting, and providing enough batteries (fully charged) and tape to do the job. And above all, it will involve planning the cast – even if you are casting a pet rabbit.

Camerawork

If you are doing the camerawork yourself, you will clearly know what is in the viewfinder. But if you are lucky or rich enough to have someone else shooting the tape while you direct, you may well wish to preview the exact framing of each shot before the take. This does not apply when you have established a complete mutual understanding with the camera operator. This takes time, and a good deal of restraint on the part of the director. Camera operators usually like to do their work without too much prying from the director; but at the same time you have to be sure that what is being recorded on the tape fits precisely into the scheme that you, and only you, have in mind. The time to intervene is when things are just about to go wrong. But if the camera operator appears to have found something exciting, let the camera run. Above all, do not shout directions, such as "Don't look at the camera!", which will go straight on to a sync soundtrack.

Editing

In many ways this is the most crucial stage for the director, the point at which you can really make your mark. Like shooting, it can be a collaboration and, because it takes longer, it can be even more fruitful. If you are doing the whole thing yourself, ask someone else to look at what you have done. Listen to their first-sight advice even if they seem to be ignorant of the technicalities. In the end, videos and films are designed to be seen by others.

The shooting schedule

No movie is shot in the same order as either the script or the final, edited version. This is inevitable because of the difficulty of coordinating actors, weather, camera and lighting with the actual order of the script. It is common sense to shoot in whatever order is dictated by location, props, and weather. For example, while the camera is in position for the first shot it may be possible to shoot the last scene of the movie as well. Similarly, an actor who has finished one scene may well be able to shoot another, if his or her clothes, the lighting, and the weather are all right.

It is because of this that the *shooting schedule* is drawn up. This is one of the most important parts in the preparation for filming. The shooting schedule simply breaks down the original script into convenient work sessions for the camera. It groups together all the scenes to be shot in one location, all the actors for each scene, the estimated times for each scene, the camera equipment, the props, and the costumes required. It should also note the dates for the scenes, the times the crew and actors should arrive, parking, and possibly accommodation arrangements. Travel and time details may be unnecessary if the cast is your family, but they are essential if you are coordinating a number of people. If one person is late, the whole day's shooting may have to be abandoned. As soon as you have decided on the shooting order, type it out and give a copy to everyone concerned for their comments and suggestions. You are sure to have missed something, and you should be grateful for advice before you actually start shooting.

The final stage of preparation is a *shooting script* which is a kind of breakdown of each day's work. In the shooting script drawn up for the Henry James adaptation (see p. 135), it would obviously be easier to shoot shot 10 and then shot 12, rather than moving the

From film script to shooting script
The film script breaks the action down into scenes and shots. The type of shot is noted, with a brief description of the action. The shooting script organizes these shots into a logical shooting order. It is basically a list for the director, camera operator, actors and crew.

Film script
1a Pan starts from the sea
1b Pan continues to hotel
2 Two-shot over shoulder
3 M.C.U. of Dencombe, turns
4 C.I. of Dencombe
5 M.L.S. of Dencombe
6 Dissolve to L.S.
7 Dissolve to L.S.
8 Dissolve to M.S. of Dencombe
9a Subjective L.S.
9b Zoom into M.L.S.
10 B.C.U. as Dencombe smiles
11a Over shoulder zoom
11b End zoom on book
12 Pan to B.C.U. of Dencombe's face

Shooting script
1a, b Linked by pan
2, 4 Same direction of shooting
5, 6, 3 Same direction of shooting
7, 8 Same location
10, 12 Both C.U. and same location
9a, b, 11a, b Zoom, linked by same location

camera around to the back of the actor in between. The shooting order for the whole sequence would probably be: 1, 2, 4, 3, 5, 6, 7, 8, 10, 12, 9, 11. If this sequence was used you would need an extra dummy book, *The Middle Years*, for shot 12, since the parcel is still closed in shot 9. The costumes would have to be organized as well as permission for the location.

Working with actors

If you are an amateur filmmaker you will probably be working with actors you have known for some time. You will probably have less choice than you would have liked, but if you do have a number of applicants for a part, ask them to audition for you. Give each actor a script and get them to read a section of the text. Then, even if you have enjoyed their reading, ask them to modify it slightly. In this way you can assess their flexibility, their willingness to take direction and their feelings about you as a director. These factors are often as important as their raw acting ability. Another important factor is appearance. If a person looks right on screen you can often disguise their lack of ability, but no amount of acting brilliance can save a miscast face. A great deal of movie directing is in fact a form of typecasting: finding the right person for the right part.

Talk to each person about the part they will play, encourage them to think themselves into the character's state of mind, and then organize a script reading for the whole cast. Afterwards, discuss the characters, the dialogue and the plot. There will almost certainly be things to change in the script as the actors get used to their parts. There may also be some changes in the cast needed, and it is at this stage that these decisions should be made rather than later in production.

Start rehearsals as soon as you have finalized the cast and the script. Try to rehearse at the proposed location, but if this is impossible measure it up and duplicate the equivalent acting space at home or in a hall. Either arrange the furniture to match the layout of the location or stick masking tape to the floor to mark the position of the walls. Whatever you do, you must rehearse the dialogue to establish the identities of the characters before you get to the location for shooting. To guarantee that the camera is accurately focused for the "take" give an actor a mark by sticking a small piece of masking tape on the rehearsal floor. During shooting he will have to stop exactly on that mark, without looking down.

Directing actors is not as autocratic as it sounds. You should always ask actors for their own interpretation before offering your own. It may be helpful for the actor to give his interpretation *only* through movement – for example, by lighting a cigarette or stroking a cat. Use description and analogy to explain how you want them to perform and only demonstrate your own version as a last resort. Make your suggestions as precise and practical as you can and always encourage the actors. Acting can be very depressing when it is not going well, and constant criticism makes matters even worse. You must learn to recognize the point beyond which a performance will not improve (you may also discover that the first of fourteen lengthy takes was the best after all).

Although learning lines is not as difficult for the movies as it is on stage you should insist that the actors know the whole of the scene in which they are involved. Without this you will lose both the flow and the pace of the action. This is particularly true if you use the technique of one master shot plus intercut close-ups (p. 74).

Continuity in shooting

In large productions, people are assigned to look after the script and the continuity of the movie (they were originally referred to as script-girls and continuity-girls). They keep track of the action in relation to the script and make sure that consecutive shots, which may be recorded days or weeks apart, will intercut flawlessly. If you are working out of sequence, or even if you plan to intercut two consecutive, complex actions, you must take similar precautions and this can only be done at the time of shooting. Every time you pass an anticipated cutting shot in the course of a shot, note the relative positions of the cast, their expressions, what they are holding and the clothes they are wearing. A Polaroid camera is handy for taking quick reference shots.

For example, in the storyboard on p. 135 there are two areas in particular where continuity could be a problem. These are between shots 2 and 3, and between shots 11 and 12. In the first case, the postman's position in relation to the gate must be the same in both shots. In the second, Dencombe's hand and the wrapping paper must be the same in relation to the book. Other areas which might cause problems are the weather and pace. Be sure that the sun is not shining in one shot and hidden in the next. Watch out for this in shots 9a and b. Also, when cutting from a long shot to a close-up of a person walking, try to match the pace of the footsteps in the two shots. This would occur between shots 3 and 4.

A *shot list* will also help you keep track of the shooting. This gives details of the tape number, the duration and description of each shot, the comments made at the time relating to each take and any notes on continuity. These notes might be on the weather, time of day, clothes, action, make-up and eyeline. This is obviously a full-time job, so if someone offers to do it for you, accept.

The scene breakdown

Title: The Middle Years

Location: Bournemouth, England. The Hotel Splendide

Time of day: Early morning

Estimated shooting time: 2 hours

Scene sequence number: 5

Characters: Dencombe, postman

Dress: Early twentieth century

Synopsis of the action: M.L.S. (two-shot) of two men talking

Props: Walking cane, postman's bag, parcel

Additional considerations: Crossing the line. Dencombe should enter right of the frame since he left the previous frame from the left.

THE VIDEO FAMILY ALBUM

Video is not only useful for recording the present – it can also be used to recapture the past through a variety of media. You can duplicate old photographs, documents, silent 8 mm movies, slides, and tapes, arranging them either chronologically or thematically into a history of your family or yourself. You can include live footage of subjects such as the place where you were brought up, as it is now, or your first school. And your children, or perhaps grandchildren, can talk about their memories of childhood. The whole can be married into a full account of the family's history, with all its ups and downs, and will amount to the modern equivalent of a Victorian family Bible – except that it can be constantly updated and is always reproducible. There is no limit to the material you can use – except that it should be relevant to your life or your family.

If the tape is to be both effective and authoritative, you will need to plan it carefully. Try to think of all the most evocative symbols of your past, as well as the hard facts. For example, a bunch of dried flowers gathered on a vacation might mean more than a birth certificate. At the same time, try to keep to a sensible chronology, use commentary when necessary, and lace music into the pictures to give your own personal flavor to what is, after all, your life.

Assembling your album
The range of objects, photographs, films, and family records is almost unlimited. You could use slides (which in some cases are dated on the mount), or a passport with some visa stamps (these will also be dated). Other useful materials are old films, sound recordings, and ancient documents.

COPYING TAPE

Having made a video movie you will probably want to show it to your friends, and it may be that the best way to do this is to make a copy. This is quite straightforward, provided that you have access either to two VCRs, or to a VCR and a camcorder. For the sake of clarity, the machine containing the original tape is referred to here as the "source machine", the one containing the tape onto which you are making a copy is called the "record machine".

The main consideration before you begin copying is to make sure that you have the relevant leads to connect the two machines together. When copying video material it is also essential to observe the relevant copyright laws. These laws should not pose a problem if you are copying material you have shot yourself, but they restrict copying other people's tapes.

Copying from one VCR to another

It is usually possible to record from one machine to another by simply connecting the source machine's RF-out socket to the RF-in socket of the record machine. If you use this method, the record machine must be tuned to the source machine, as if the latter was a broadcast channel. The problem with this method is that passing the signal from the original tape through the RF circuitry generally results in a loss of image quality. This can be marked if the original tape is itself a copy – and if you have edited it, the tape may already be several "generations" old.

The alternative method is to connect the video-out and audio-out sockets on the source VCR to the video-in and audio-in sockets on the record machine. The video and audio sockets on both machines may be separate, or in Europe they may be combined in the same 21-pin connector on one or other of the machines. Obtaining the correct leads is therefore vital.

Once you have made the connections, and made sure that the record machine can receive signals from the source, it is simply a matter of switching the source to play and the record machine to record. The process can be monitored by connecting a television receiver to the audio-and-video-out sockets on the record machine.

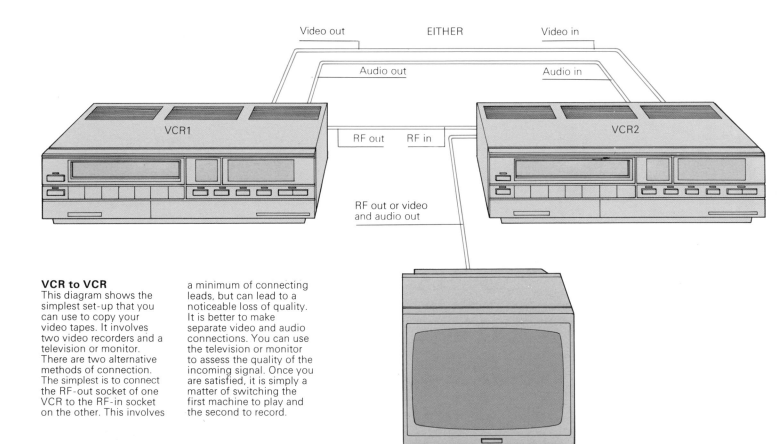

VCR to VCR
This diagram shows the simplest set-up that you can use to copy your video tapes. It involves two video recorders and a television or monitor. There are two alternative methods of connection. The simplest is to connect the RF-out socket of one VCR to the RF-in socket on the other. This involves a minimum of connecting leads, but can lead to a noticeable loss of quality. It is better to make separate video and audio connections. You can use the television or monitor to assess the quality of the incoming signal. Once you are satisfied, it is simply a matter of switching the first machine to play and the second to record.

Television or monitor

Copying from a camcorder to a VCR

You can follow a similar procedure to copy from your camcorder to your VCR. In this case, you will probably have to connect an audio-and-video-out socket on the source camcorder to a comparable audio-and-video-in socket on the VCR. You can monitor the results in the same way.

Camcorder to VCR
This set-up shows how to copy from a camcorder to a VCR. It also shows how you can use some additional equipment – an audio mixer or volume control and a sound source such as a tape recorder or compact disc player – to add extra sound as you carry out the copy. The camcorder acts as the source machine, so the essential connection for copying links the camcorder's AV-out socket to the video-in socket on the VCR. Additional sound is routed in through the VCR's audio-in socket. As with the simpler set-up opposite, a television receiver or monitor is used to view the image.

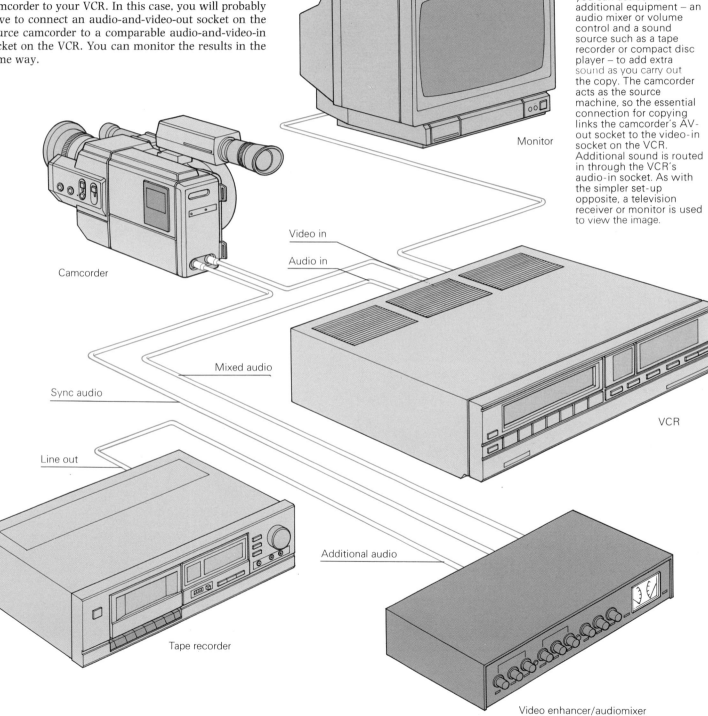

Monitor

Video in

Audio in

Camcorder

Mixed audio

Sync audio

VCR

Line out

Additional audio

Tape recorder

Video enhancer/audiomixer

SPECIAL
TECHNIQUES

UNUSUAL SITUATIONS

Aerial shots are ideal whenever you want to show the layout of a town, landscape, or large building. They are also effective for tracking moving objects – for example, a herd of stampeding animals or cars moving around a race track.

The biggest problem for the amateur moviemaker is the expense of chartering an aircraft. The one you choose will depend on your budget. The helicopter is the movie-industry's vehicle for filming because of its versatility of movement. Fixed-wing airplanes, although more accessible to the amateur, present two problems: they fly too fast and cannot hover. However, they can bank 360° so a subject can be held in the center of a shot while it is filmed on all sides. Only shoot on clear, unturbulent days and try to shoot in the early morning. Shoot into the light to give the image good relief, and to guarantee that the shadow of the aircraft is not visible.

Helmet
A helmet-mounted camcorder is sometimes used in aerial work.

Work with the aircraft door open, so you can look down with an unrestricted view, and secure both yourself and the camera to the plane's body. One difficulty with aerial photography is the vibration caused by the aircraft. The best way to minimize this is to use a vibration isolation mount, which insulates the camera from the operator and the aircraft. The alternative is to hand-hold the camera. When you hand-hold the camera, avoid tele-photo lens settings, which dramatically increase camera shake. Instead, get the aircraft close enough to the subject and use a wide-angle lens.

For a slow, floating but dramatic shot, use a wide-angle lens. Get close to the subject and use the speed of the subject. This is especially effective when the foreground falls away to reveal a vista beyond (as when shooting over the lip of a canyon, or over the top of trees at low altitude).

Hatfield house
For this kind of zoom-out it is essential to mount the camera securely. You will have to zoom in and wait until the helicopter has entered a patch of steady air before zooming out. The effect of such a zoom can be quite dramatic, though less so than moving the aircraft itself to change perspective.

Free-fall (left)
This parachutist is using a helmet-mounted camcorder. Unusual views are possible, and the hands are kept free.

Mount Kenya (right)
Some landscapes are either invisible or inaccessible from the ground. It is essential to brief the pilot and to rehearse before shooting.

Ring of parachutists (left)
Stunning coverage of this team of parachutists was made possible by the helmet-mounted camcorder. Only by free-falling himself could the camcorder-operator get near enough to the others to obtain these effects.

Castle (right)
Flying rules vary, and you will almost certainly need permission to approach buildings closely.

Underwater scenes are ideal for video movies: their ease and fluidity of movement in the most glorious natural environment combines with the body's own buoyancy. To take successful underwater videos, it is necessary to have a waterproof housing for your camcorder and, to take them sub-aqua, you must have professional training in scuba diving techniques. Underwater you must be a diver first and a videomaker second. A good place to begin is to use a snorkel around, say a coral reef. Here, there would be no problem with color temperature, since you are near the surface, and a fixed daylight setting would suffice. For lower depths, lights are essential to capture the colors of the coral, sea anemones, or angel fish. However, you may be surprised by the cost of both the lights and their batteries. Automatic color-balancing will only work if it is through-the-lens. If the overall balance is being assessed through a white diffuser on the top of the camera, it will be blocked by the waterproof housing. If that is the case, the balance must be carefully pre-set before diving.

Underwater equipment

Because of the refractive difference between air and water, you need a very wide-angle lens, preferably with an adaptor such as that known as a "dome-port," specifically designed for underwater use; but an ordinary wide-angle adaptor will do at a pinch and, well rinsed, can be used ashore also. As for sound, all you can expect to hear is your own scuba bubbles.

The duration of the tape is probably less than that of either your air supply or your batteries, especially if you are using lights. So be prepared to surface for a new battery pack, and perhaps a breath of air at the same time.

The best light for underwater filming is the natural light that you get between ten o'clock and two o'clock, when the sun is almost directly overhead. However, the intensity of the light drops off rapidly the deeper you go, and below about 20 ft (6.40 m) some form of artificial light may well be necessary. Battery lights are the most suitable. Always light your subject from the side to prevent any reflections bouncing back and causing a "foggy" effect (like you get if you use full beam when driving in fog). The lights can either be mounted on a wide bar, at an angle to the camera, or they can be held well to one side by an assistant. Artificial lights reveal all the reds and yellows which disappear below about 30 ft (9.15 m). After 100 ft (30.2 m) greens disappear, leaving blue the dominant color.

Filming underwater

When you first get into the water check your housing carefully for any leaks. Next, test that it is neutrally buoyant and that it hangs motionless in the water if you let it go. Guide the camera in front of you in a steady glide to produce the underwater equivalent of a tracking shot. Stick to a wide-angle setting, use plenty of close-ups and mid-shots, and move towards your subject slowly and steadily. You will get the best color by keeping as little water between the camera and the subject as possible.

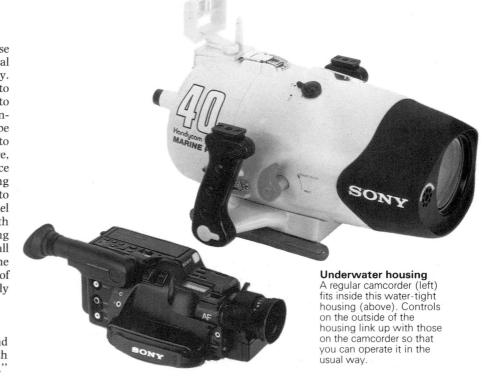

Underwater housing
A regular camcorder (left) fits inside this water-tight housing (above). Controls on the outside of the housing link up with those on the camcorder so that you can operate it in the usual way.

Lionfish
This highly poisonous Lionfish was shot in East Africa. On this occasion you might well prefer a longer lens.

Divers
These divers, on their way to investigate a wreck in the Bahamas, were shot from below with the sun directly above them. This gave the silhouette effect.

MACRO AND MICRO

Macro

"Macro" provides a method of shooting extreme close-ups to produce a magnified image of the subject. Many video cameras have a "macro" setting on their zoom lenses which allows subjects to be recorded at very short distances with high magnification. The exact technique varies from camera to camera, but usually when the zoom lever is placed in a certain position the "macro" setting is engaged. This moves the rear group of lenses inside the camera further away from the chip. The further away they are moved, the greater the magnification. With the lens on "macro" you cannot zoom; the zoom lever is used for focusing.

If your camera does not have a macro lens you can use close-up or *diopter lenses*. The advantage of these is that you can still use the zoom. They screw into the filter threads of the lens and come in varying degrees of magnification (from +1 to +5). Two or more can be used together, with a cumulative magnifying effect. Place the strongest lens nearest the camera, with the convex surface of additional lenses towards the subject. If your camera has an interchangeable lens you can use a *bellows unit* or *extension tube* to produce the same effect. Unscrew the lens and fit the bellows or tube between it and the camera body. At large magnifications the depth of field is very shallow, so you must use the smallest aperture possible and focus very carefully.

Bellows

Diopters

Macro setting

Lily (top left)
A close-up diopter lens was used for this shot.

Butterfly (top right)
Two diopter lenses were used for this shot.

Bee feeding (bottom left)
To reduce the swaying movement of this flower a windbreak was used.

Dewdrop (bottom right)
This leaf, protected by a windbreak, was shot with the camera on macro.

Microscopy

A variety of video cameras can be made to fit onto the eyepiece of a microscope using a specially designed adapter. Alternatively, if the camera has a removable lens, the camera body can be fitted directly to the microscope adapter. In this way it uses the microscope's own optical system. For support, use a copying stand or a tripod with the camera pointing downwards between the legs.

Microscopy
These thyroid sections were stained with fluorescent dye. A copying stand was used to keep the camera completely rigid. The lens, with diopters attached, joined onto the microscope with an adapter. The set-up was lit equally from either side.

How to set up for a macro shot

At large magnifications the movement of a swaying flower or an insect scurrying up a branch will appear unrealistically fast. To correct this you should steady the subject. Steady a flower branch by securing it to a garden cane, positioned out of the shot, or build a clear plastic windbreak around the subject (the shallow depth of field will keep the plastic out of focus). Bear in mind that the depth of field will be reduced because of the larger aperture required by this technique. Set up your camera on a tripod with a cable release to minimize vibration. A minipod or "high hat" is most suitable for extreme close-up work.

Macro set-up
The camera was securely attached to a tripod, and angled down towards the bush. A length of clear plastic was set up around the bush to act as a windbreak.

Bush cricket (left)
Two close-up, or diopter, lenses were used together to shoot this insect. Because these lenses were used, the camera was still able to zoom in on the cricket's head. A small aperture is best used with diopter lenses, since this gives maximum depth of field.

Moth wing (left)
This moth was shot using a +5 diopter lens. This gave a large magnification of the markings and veins on the wing.

Chameleon (right)
The camera, with its macro lens setting, was set up in position on a tripod. A remote control was used to avoid disturbing the animal.

Eye (left)
Close-up lenses were used to shoot this eye. It was shot outside and no additional lighting was needed.

Dragonfly (right)
This dragonfly was shot with the camera on its macro setting. No additional lighting was necessary.

IN-CAMERA EFFECTS

Fades

Many modern camcorders incorporate a fade-in and fade-out control, which manually affects both sound and vision. Most versions fade to black, others, more elegantly, to either black or white. The incoming scene should reproduce the same effect, at the same speed, to create a transition of place or time. The fading speed may be either manually or automatically controlled.

With video, the effective aperture is controlled either electronically or, on more sophisticated models, through a variable iris as well. The advantage of the latter is that you can control not only the exposure, but also the depth of field. It is more elegant if the duration of the fade-out matches that of the fade-in that follows, with a very brief black frame or two between. To mix between fades (in other words, to produce a dissolve) requires a three-machine edit, and is not an in-camera effect – though it is sure to become available soon at the present rate of development.

Fades
A fade-out is often used to signify the end of a scene. The shot starts with a normal exposure. The light is then gradually reduced until the image disappears. A fade-in is often used to convey the change from one scene to another. The image gradually appears as the exposure increases.

Fade-out

Shutter fade

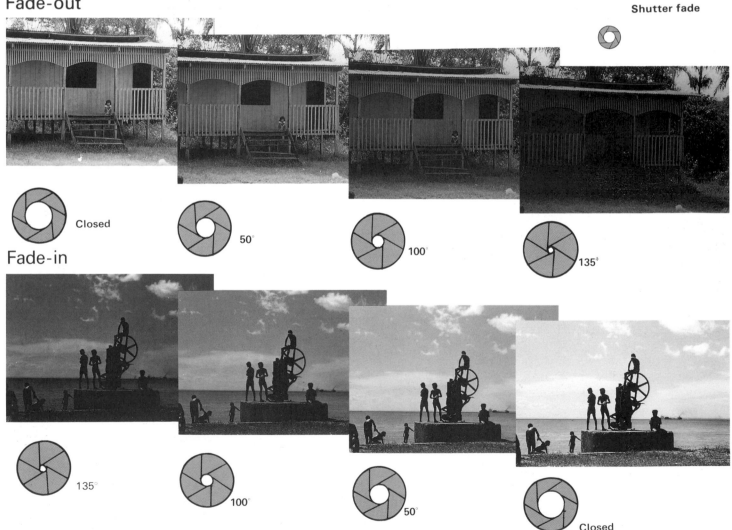

Closed 50° 100° 135°

Fade-in

135° 100° 50° Closed

SPECIAL TECHNIQUES

Matte effects

A *matte* is a kind of mask which is placed in front of the camera lens to screen off part of the action. It enables you to produce simple but dramatic in-camera effects. Mattes are made of black card or metal and come in a variety of shapes. The most common are the keyhole and binocular shapes. You can, however, make your own mattes with black card or sprayed tinfoil which allow you to design your own shapes.

Mattes are usually held in position in front of the camera in a *matte box* or *compendium*. This is usually a bellows-like device which screws onto the filter threads of the lens and has slots at the back or the front for the mattes or lens filters.

To produce a sharp matte image use the smallest aperture you can. This will give you greater depth of field and will guarantee that the edges of the matte are sharp.

Matte box
An extendable matte box has a pair of grooves at the front, into which you slide the matte of your choice. The box also acts as an adjustable lens hood.

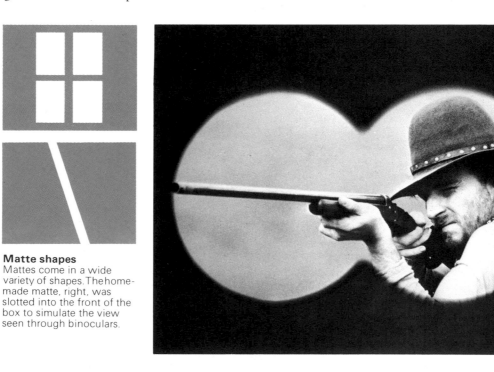

Matte shapes
Mattes come in a wide variety of shapes. The home-made matte, right, was slotted into the front of the box to simulate the view seen through binoculars.

Distortion effects

You may occasionally want to distort the image produced by your camcorder for a particular effect. You can create simple distortion effects with a minimum of additional equipment. Using the wide-angle end of the zoom and coming very close to the subject will create very distorted images. With a wide-angle or fisheye attachment on the lens these effects can be exaggerated even more. Fisheye attachments are available that increase the wide-angle range of the zoom lens by about 2.5 times. They produce a surreal effect that is striking if used very sparingly.

The telephoto end can also create its characteristic sort of image distortion – the compressed perspective of the telephoto is familiar from television shots of traffic jams and urban landscapes.

Another attachment that produces unusual effects is the multiple-image lens. Some designs show the central subject surrounded by repeated images. Turning the attachment makes the repeat images seem to move around the central subject. Again, this is a trick that should be used sparingly, and in an appropriate context, if it is to be effective.

Time lapse and animation

The more elaborate cameras now allow time-lapse sequences. They can be set up on a tripod to record a series of short four-frame bursts at given intervals over a long period. This means that a subject such as a sunset can be compressed into 30 seconds on playback, or an opening flower into 10 seconds. Animation effects are also possible on the most expensive cameras.

SPECIAL FILTER EFFECTS

Many spectacular effects are possible with the aid of gelatin or glass lens filters. In general, gelatin filters are slotted into a holder held in front of the lens with an adapter ring. Glass filters generally screw onto the lens but, like gelatin filters, they can be made to fit a variety of lenses with the use of different sized adapter rings. Filters absorb some of the light passing through them and therefore reduce the amount entering the camera. To compensate for this, the exposure will have to be increased. The degree of increase required is known as the *filter factor*.

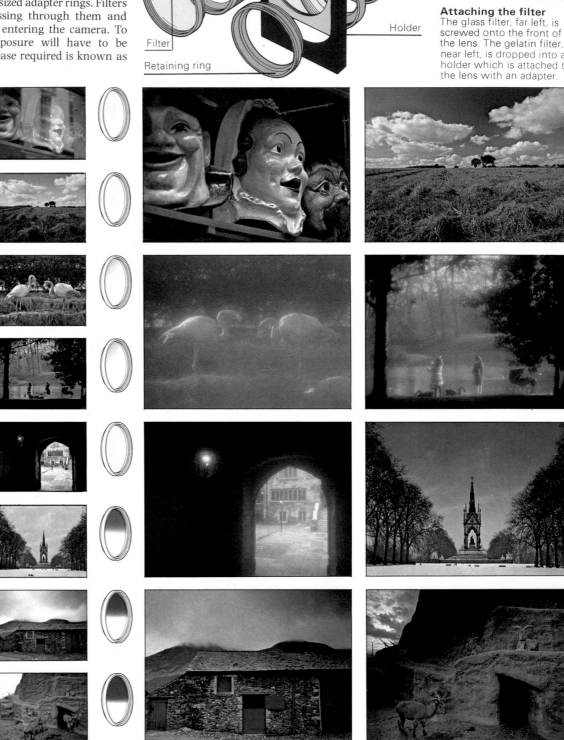

Attaching the filter
The glass filter, far left, is screwed onto the front of the lens. The gelatin filter, near left, is dropped into a holder which is attached to the lens with an adapter.

Polarizing filters
These filters eliminate reflection from non-metallic surfaces such as glass, plastic or water by allowing light to pass through only at a certain angle. They also reduce haze and darken blue skies. Fit the filter and rotate it to the correct position before taking any meter readings. When panning, you will get a variety of effects.

Diffusion filters
These filters give a glamorous effect while maintaining a sharp image. They bleed light from the highlights into the shadow areas and they reduce overall contrast. They are most effective on a glittering, high-contrast backlit subject.

As an alternative, spread petroleum jelly onto an ultra-violet filter until it gives the required effect. Never put jelly on the lens.

Fog filters
These filters give the illusion of fog without destroying definition. The effect is similar to, but more pronounced than, diffusion filters. They are available in different densities and the effect can be controlled by lighting and exposure.

Graduated filters
These filters can be used to produce a dramatic sky without affecting the tone and exposure of the rest of the scene. They have a tinted half which diffuses into clear glass and although the boundary of the two halves is usually placed on the horizon, the filter can be twisted so that it is either vertical or diagonal. The tinted half is usually neutral density gray but may be tinted with dramatic effect.

Color filters

Filters of different colors can be used to alter the natural color balance of the scene. Deep color filters give very interesting results when used on high-contrast or backlit sources. The overall color will be that of the filter, plus an amount of black in certain darker areas. However, pale filters give a subtle overall tint to the scene and thus "warm up" or "cool down" the colors in the frame. With a black-and-white viewfinder, the color can be judged only with a separate portable color monitor – either a regular design or a very small LCD type.

"Day for night"

A blue filter used in bright sunshine with the camera under-exposed two stops produces the effect of night time. Shoot directly into the sun to "rim-light" the subject to give the high-contrast effect of moonlight.

Color spot filters

Color spot filters produce a softly graduated color around the outside of the picture and a clear circle in the center. The best results are gained by using these filters with a wide aperture in conjunction with a high-speed video "shutter". The narrow depth of field throws the hard edge of the filter out of focus.

Dual color filters

These filters, as the name implies, produce a two-colored image. Once fitted to the lens, the filter can be rotated so that the division of colors lies horizontally, vertically or diagonally, according to the effect desired. Generally, the wider the aperture and the longer the focal length, the more graduated the effect of the two colors will be.

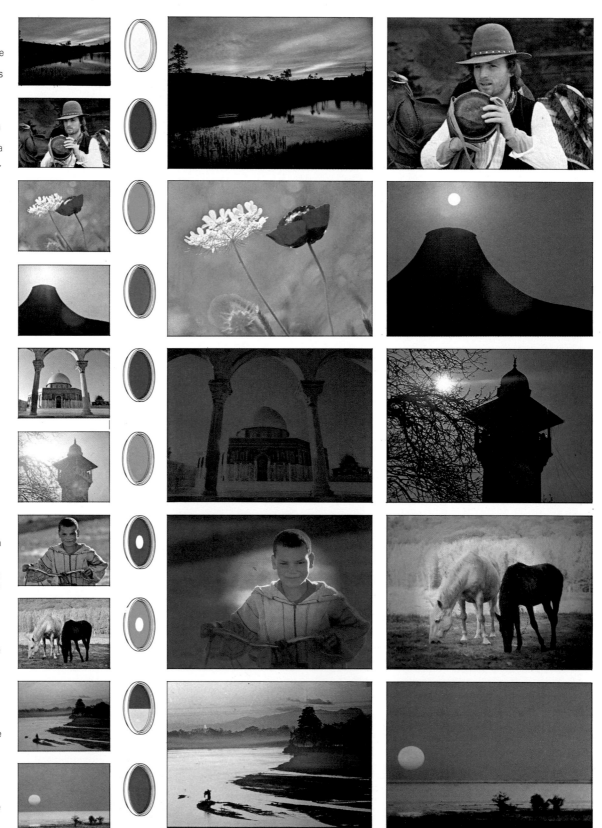

SPECIAL LENSES AND ATTACHMENTS

There are various special lens attachments available, all of which can be used to manipulate the image on the tape. The *prism* lens has a multi-faceted surface and produces two types of pattern – radial and linear (that is surrounding, or parallel to, the central image). The *starburst lens*, as its name implies, produces a starred effect as it picks up highlights of reflected light. A diffraction lens is similar, but the highlights are colored like spectrums.

Split-field diopters allow for focusing on two separate planes at once, thereby overcoming depth-of-field problems. *Ultra wide-angles* and *extreme telephoto* lenses can both produce dramatic effects. Ultra wide-angle lenses and attachments are particularly useful when shooting in restricted spaces, since they greatly increase the angle-of-view of modern zoom lenses.

Adjusting the lens
Rotate the attached lens until you achieve the desired effect.

Attaching and adjusting the special lens

Prism, starburst, attachments and split-field diopter lenses either screw directly onto the front of the lens or screw onto a suitable adapter. They can be used alone or, when there are threads on the front as well as the back, can be used in conjunction with other lens or filter attachments. If you are using a camera with a reflex viewfinder, the effect you see will be the effect that you get on the film. In the case of starburst and diffraction grating lenses the attachment should be rotated as you look through until the desired positioning of the highlights is reached. Extreme wide-angle and telephoto lenses usually interchange with the regular lens of the camera. However, where the camera's lens is not interchangeable, a converter attachment can be used to adapt the existing lens.

Radial prism lens

A radial prism lens produces duplicate images in a circular pattern. The lens may have between three and six faces, each of which produces a separate image. If a colored filter is used with the prism the image will appear tinted. If you want a static image, fit the prism lens into position on the camera and leave it in this position. If you want to produce movement while recording, turn the lens in its mount as you shoot. There is no need to adjust the exposure when using the lens.

Radial prism lens
The faceted surface of this lens produces three images in a radial pattern. The central image is static, but the surrounding images can be made to move by rotating the lens.

Parallel prism lens

Parallel or "repeater" prism lenses produce up to five adjacent duplicate images. One half of the lens is faceted and the other half is plain. The lens can be rotated so that the faceted half lies at any angle, thus giving a horizontal, vertical or diagonal effect. To produce a sharp picture use a short focal length and a small aperture; use a wide aperture for more diffused images. Colored filters can be placed in front of the prism lens to produce tinted images. There is no need to adjust the exposure when using this lens.

Parallel prism lens
The faceted surface of this lens produces three parallel images. The colors, right, are very subtle, but the composition has been given weight by using the multi-image effect.

Split-field diopter lens

A split-field diopter allows you to focus on two subjects at once – one very near the camera and one a long way away. The lens consists of two halves – the curved half of the lens is an ordinary close-up lens, and the other half is made of plain glass. Set the camera up so that the edge of the half lens coincides with an equivalent line in the scene. This way the lens can be used either horizontally or vertically, and the borderline between near and distant focus will be disguised.

Split-field diopter lens
One half of this lens acts as a close-up lens, the other half is plain glass. To keep the houses and tulips in focus the half lens was attached diagonally, covering the tulips.

Starburst lens

A starburst lens produces star shapes of reflected light. The plain glass surface of the lens is engraved with radiating or cross-hatched lines. The number of star points produced by

the lens depends on the number of radiating lines. The lens is particularly effective when it is used to shoot over water and into the sun, or with candlelight. The position of the highlights changes as the attachment is rotated in its mount and their width increases when the aperture is reduced. It is most effective when used on subjects with small, intense highlights against dark backgrounds and the effect varies considerably according to the aperture.

Starburst lens
A five-pointed starburst lens was used on this subject to highlight the reflections from the water. The effect was heightened by shooting directly into the sun, silhouetting the figure of the man.

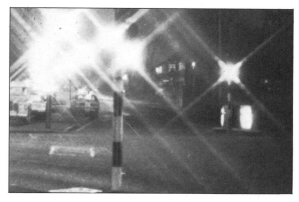

Starburst lens
A simple cross-screen lens was used on this night scene to pick up the highlights from the headlamps and street lights.

Ultra wide and extreme telephoto lenses

An ultra wide-angle lens has a very short focal length and therefore wide angles-of-view, resulting in more of the overall scene fitting into the frame. They can be used on any camera that accepts interchangeable lenses. The weakest aspect of modern video zoom lenses is their wide-angle, which is barely as wide as the still-camera equivalent of even 35 mm focal length. Screw-on adapters are, fortunately, available: they will give you either a wide or telephoto option, but you may not be able to use autofocus when using macro. At the telephoto end, you can extend the range with a tele-extender.

An extreme telephoto lens has a very long focal length and therefore a narrow angle-of-view, resulting in a high magnification of the image. It is possible to use long-focus lenses designed for 35 mm still cameras if your video camera has an interchangeable lens and is fitted with the correct adapter. These give gigantic magnification when used on video cameras. For cameras without interchangeable lenses, telephoto lens converters are available. These screw onto the front of the existing lens and increase the effective focal length by a factor of two or three.

Wide-angle attachment
An ultra-wide lens attachment such as the one shown above was used to record these camels. Perspective is distorted and the front camel appears much nearer than the distant ones.

Telephoto converter
An extreme telephoto attachment was used for this shot.

FILMING STUNTS

The sequence on these pages comes from William Friedkin's film, *The French Connection I* (1971). It is only 13.5 seconds long, yet it has become one of the most justly celebrated car-chase sequences of the recent past. It contains sixteen shots and many of them seem, in the context of the movie, to last a lifetime. Gene Hackman plays the Narcotics Division officer, Popeye, who is chasing a man whom he believes can lead him to the center of a drug-smuggling ring. Popeye snakes through the iron posts of the subway as the suspect edges his way forward through the hijacked train, above, with a gun.

It is essential that each second be carefully scripted and rehearsed. You cannot just put a camera in a car and crash it. The subjective shot from inside the car must match the speed and direction of the exteriors, and the progressively tight close-ups of the cop's face must match, in expression and intensity, the action shots themselves. The complexities of even a very brief sequence like this are such that they are often handed over to a second unit director. He or she will have to clear the police permissions, organize the stunt drivers in their various cars, coordinate the different assistant directors with walkie-talkies, and shoot endless different takes of the same sequence of action.

What lessons are there for the amateur in all of this? First, plan all stunts with great care, preferably with a detailed storyboard (see p. 137). You can get away with outrageous deceits on video if the effect is carefully planned. Next, allow time for lengthy rehearsal before shooting. Finally, use rapid action-cutting and editing tricks to cover those actions which would otherwise be impossible to stage.

Intercutting inserts

This sequence opens with Popeye's subjective point-of-view, shot through the windscreen. It is intercut with a shot of his foot on the gas pedal, then the brake. Needless to say, these would have been shot in the studio. However, shot 3, with the overhead reflections visible in the windscreen, would probably have been shot on location with the camera on the car hood.

1 ⏱ 0.5 sec Popeye's view

2 ⏱ 1 sec Foot on gas pedal

3 ⏱ 1.5 sec Popeye through screen

The car swerves

After Popeye's dead-ahead shot, we again cut to his point-of-view. An orange VW swerves to avoid him and Popeye himself then swerves to avoid another car. These stunts would of course be performed by highly-trained drivers.

4a ⏱ 6 sec He sees the car

4b He avoids the car

5 ⏱ 2 sec Popeye through windscreen

The soundtrack

Throughout this sequence the soundtrack consists of incessant squealing of tires and honking of car horns. In fact, a great deal can, and should, be done with sound to strengthen a stunt-sequence. A perfectly innocuous crash can sound like the end of the world if it has the right sound accompaniment. Good synchronization is vitally important.

6 ⏱ 1 sec He sees the mother

7 ⏱ 0.5 sec Close-up of Popeye

The mother and child

The horrific sight of a mother wheeling her pram across Popeye's path (a fast, subjective tracking shot) is cross-cut to a 180° reverse shot (number 6) in much larger close-up than shot 3. Needless to say, there is no baby in the pram, and the two shots have no physical relation to each other. Indeed, it is doubtful if Gene Hackman ever saw the woman standing-in for the mother.

8 ⏱ **0.5 sec The mother screams**

"Crash zoom"

The camera zooms, not tracks, rapidly in onto the mother's face until it fills the frame. For these nine frames – less than half a second – the zoom is as effective as a rapid track, and far less dangerous. This kind of rapid zoom is generally known as a "crash zoom"

9 ⏱ **0.5 sec Popeye swerves violently**

Hits the garbage

Popeye swerves violently to avoid the mother and pram, and in shot 11 we see that he is veering towards a pile of garbage. This subjective shot cross-cuts to a head-on view of the car careering towards the camera. In these circumstances it is often best to use a remote-control camera.

10 ⏱ **0.5 Popeye's view**

11a ⏱ **1 sec Car hits garbage**

11b Close-up of car

12 ⏱ **0.15 sec Car rushes past**

13a ⏱ **1 sec Car rushes past**

13b The street

The pace increases

Shot 12 is only 3 frames long. At this point in the stunt it is perfectly possible to include a blurred shot such as this which actually cannot be read in its own right. It is there to add to the sense of violent chaos.

Conveying speed

Finally, in shots 13 and 14 the car rushes past the camera very close to the lens and Friedkin cuts back to Popeye. Popeye looks back over his shoulder, then grimly settles down at the wheel.

14a ⏱ **3 sec He looks around**

Summary

These 13.5 seconds of film contain only four basic elements, but with these simple, meticulously timed and planned ingredients, the stunt is created. In all this, only one dangerous event actually occurs, in shots 11–13, and then it may be presumed that the camera, which the car so narrowly misses, was unmanned.

FIGHTS AND EXPLOSIONS

All stunts are potentially dangerous; if misjudged they may be lethal. Always plan the stunts out fully and rehearse them until all your actors understand what is required of them and can perform their parts perfectly. Never take chances or overstep your knowledge.

Staging a fist fight

A fist fight is the stunt most easily performed by the amateur videomaker. First, plot each punch or flying bottle, right down to the collapse of the actors. It is unnecessary to have one sustained master shot taken from one camera angle. Instead, shoot each phase of the fight from a wide range of heights and angles. This allows for the rapid intercutting necessary to produce successful, action-packed fights. To really convey the physical sense of the action, use a hand-held camera and get in close to the actors. Shoot the fight without sound so that you can give directions during the fight. All grunts, crunches and shouts can be added after editing. In a fist fight make sure that the actors just miss each other, and that the chin receiving the punch reels away at the right time. The subsequent sound effect will complete the illusion, especially if there is a change of shot at the moment of impact.

Parts of the set can be constructed so that they break safely on impact; your actors can then break chairs, overturn tables, and smash through windows during the fight. Construct "prop" windows with balsa wood struts, loosely slotted together and held in place with putty, never nails. The glass can either be specially made "soft glass" or previously ripped plastic. As long as you shoot at an angle, or only shoot the window as the actor goes through it, the fact that the glass is already broken will not show up in the finished movie.

Staging a sword fight

The rules for planning and filming sword fights are the same as those for fist fights. However, there is even more reason to plan and execute the fights carefully because of the points on the swords or daggers. "Property" knives with retractable blades should be used. These have parallel sides, short, blunt points and are spring-loaded so that the blade retracts into the handle. If the blade is constructed with a tube down the middle then the handle can be filled with blood. This will squirt out when the blade retracts. It is harder to record a stabbing with a sword or rapier because their blades cannot retract. Shoot the fight from a suitable angle, cutting to the loser just after he receives the final thrust. He will appear to be run-through if two half swords are fitted either side of his body.

It is also possible to fake arrows or knives flying though the air and thudding into their targets, using a whip pan. First, fix a duplicate knife or arrow into the target. Set up the camera so that you shoot the real weapon being thrown, well to one side of the actual target. Whip pan rapidly from the real weapon being thrown and stop when the duplicate weapon and target are in frame. No one will notice that they differ.

Staging a fist fight

1 In preparation for the punch the assailant grabs the victim, pulls back his arm and clenches his fist.

2 As he moves forward the victim tries to pull away from him. He moves back and prepares to recoil.

3 The assailant, careful to miss the victim's jaw, punches past his chin. The victim recoils as if hit.

Props
Props, designed to break easily, are sometimes necessary in fight scenes to protect the actors. Their value can be seen in the shot from *Shane* (below left).

Sword fights
The two shots (below) are from Ridley Scott's *The Duellists*. Apart from the skilful sword work, one of the most important factors in the scene's success is the sound track. This accentuates the noise of the clashing swords and when combined with very atmospheric lighting makes a frighteningly realistic fight.

Arrow trick
This trick relies on camera work to produce its effect. It is simple to produce and can be done with complete safety for the actor, who is positioned with an arrow in place. The camera whip-pans from the arrow being fired and stops when it reaches the second arrow in the target.

Explosions

Regulations concerning the acquisition and use of explosives vary from place to place so you *must* make the relevant inquiries before you begin. The type of explosives an amateur filmmaker will use are the "deflagrating" variety, like gunpowder. When these are ignited they go off with a loud bang. The powder should either be packed into a cardboard tube and sealed to make a "thunderflash," or contained in an open "flash pot" which directs the blast upwards. Gunpowder is fired by a *pyrofuse*, which is a small inflammable charge. The pyrofuse can be triggered electrically with either batteries or magnetos. The amount of explosive needed must be determined before you perform the stunt. This means testing a small amount and gradually increasing it until you have the effect that you want. Always test a blast inside if it is designed for use indoors, and *never* connect up the firing batteries before wiring up the charge, even if you are sure that they are switched off. Finally, never store any powder near the scene of your test explosion. And if you have any doubts at all about using explosives, seek professional advice.

To produce the effect of bullet-hits small plastic-covered charges are placed under the ground or just under the surface of scenery. A string of them, detonated in sequence, produces a machine-gun effect. They should only be placed on an actor's body when absolutely necessary. In these cases special shielding must be worn by the actor to protect him or her from flying debris. Put the bullet-hit between the actor's clothes and a plastic blood bag, and place both of these on top of the actor's protective shield.

Blank bullets can also be used, but they are dangerous. They should never be fired at a closer range than 10 feet (3 m) because small particles of copper and wadding can fly out and hit someone. Even out of this range it is best to aim off to one side of the victim.

Faking explosions

If you do not want to risk using explosives you can quite easily fake them. For example, say you want to show a bottle being hit by a bullet. Take a small mouse trap and tape a strong nail onto the trap bar so that it extends about 1½ in. (3.8 cm) beyond the wooden base. Tie a wire to the trap's release catch and set the assembly carefully behind the bottle. On cue, pull the wire; the nail will swing up and smash the base of the bottle. This is even more effective if the bottle is full of liquid. The explosive "bang" will have to be dubbed in (see p. 192).

An equally easy trick is one frequently used in Western fights – the water butt riddled with bullet holes. Drill two holes in your barrel – one in the front (the cork hole) and one about 1 ft (30.5 cm) higher at the back (the pull hole). Cut a piece of cork to fit the bottom hole snugly, trimming it so that it will be flush with the barrel surface. Screw a picture hook into it and thread this with wire, then pass the wire to another hook positioned opposite the cork hole. This wire should then be passed up and out of the pull hole (you may need another hook to help to guide it upwards). Fill the barrel with water, about half way between the two holes.

Simulating bullet-hits
In these shots from Michael Winner's film, *The Lawman*, a protective plate was placed on the actor's stomach, covered by a blood bag, and the small explosive charge detonated.

Producing explosions
The extremely effective explosions (below) were both performed with stunt men. Unless you have expert advice, it is safer not to attempt any major explosions of this sort.

Simulating explosions
It is quite easy to simulate bullet hits, without risking the use of explosives. A nail, on a carefully positioned mouse trap, can be used to fake bottles being shattered (left). Similarly, a barrel can appear to be riddled with bullets by pulling the wire on cue. If the barrel is full of water it will spurt through the hole when the cork comes out (left).

CREATING COMEDY

Early comedy films were almost exclusively composed of visual gags, but with the coming of sound, the comedy films of the thirties veered largely towards verbal humor – one tends to remember what W. C. Fields or the Marx Brothers *said* rather than what they did. In films such as the famous Ealing comedies that emerged during the fifties, there is more of a balance between the visual and the verbal. You cannot apply general rules to comedy, but in this extract from *The Lady Killers* (1955) certain devices are obvious: the build up of the gag through reversal of our expectations; rapid intercutting; good sound effects; strong images and, above all, clarity and timing.

1 ⏱ 6 sec Professor Marcus and Louis on railway bridge

2 ⏱ 2 sec C. U. Professor prising away ladder

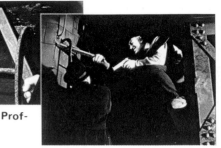

3 ⏱ 2.5 sec Cut to L.S.

Louis: "What are you doing?"
Marcus: "I won't keep you, Louis"

4 ⏱ 1.5 sec C. U. Professor's hand again

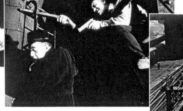

5 ⏱ 2 sec Cut back to L.S.

6 ⏱ 1 sec Train approaching

7 ⏱ 2.5 sec As shot 4

8 ⏱ 1 sec Cut to L.S.

Setting the mood

In this sequence, Louis (Herbert Lom) is hanging onto a ladder above a railroad line. Professor Marcus (played by Alec Guiness) is trying to kill him, as he has killed both his other hopelessly incompetent accomplices – by dropping him from the bridge into the empty wagon of a passing train. In a series of rapid and precise close-ups we see the ladder, the approaching train and the struggle for the gun. The train whistle just precedes the sonorous "clang" as the ladder gives way.

9 ⏱ 1 sec C. U. Louis grabs the gun

10 ⏱ 3 sec The ladder breaks. Louis falls

11 ⏱ 3 sec Reverse angle of Louis falling

12 ⏱ 1 sec Gleeful Professor

13 ⏱ 4.5 sec Ladder begins to return

14 ⏱ 1 sec Professor ready to kick

Rapid intercutting

Shots 10 to 14 show the first of several classic "reversals" – just as we are convinced that Louis is doomed (11), with the train approaching and Professor Marcus triumphant (12), Louis starts to roll back again (13). However, the professor again manages to kick him off (14). Between shots 2 and 17, only one shot is longer than 3 seconds, and most are much less.

Louis' sticky end

There are more comic surprises in store. Louis is doomed (15) but he still has the gun. Professor Marcus has forgotten this. Louis fires (16) and the professor's shock is registered (17). Louis vanishes into the mist, followed by a huge "bong" as he lands in the train. Professor Marcus, who seems unhurt, stands victorious under a signal (19) gazing down to where Louis has fallen (20). He is counting his chickens before they are hatched.

15 ⏱ 2.5 sec Professor Marcus kicks Louis away

16 ⏱ 1 sec Louis fires as he falls away

17a ⏱ 1 sec Reaction shot

17b ⏱ Professor's shock at being fired at

18 ⏱ 4 sec Louis falls

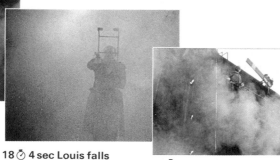

19 ⏱ 4 sec Professor stands

20 ⏱ 5 sec Rail trucks

21 ⏱ 4 sec As shot 19

Just deserts

These last shots complete the series of rapid comic reversals and, indeed, the film. As the music rolls on, the train suddenly starts, and just at the end of shot 23 the music abruptly cuts. The signal falls (24) and hits Professor Marcus on the head (26). He joins poor Louis in the wagon and the train steams away.

22 ⏱ 8 sec Train moves

23 ⏱ 3.5 sec Professor

24 ⏱ 1.5 sec Signal falls

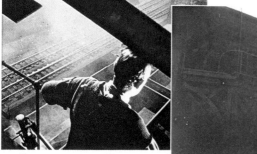

25 ⏱ 0.5 sec Signal hits Professor Marcus

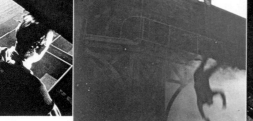

26 ⏱ 1 sec He falls

27 ⏱ 2 sec Body falls into truck

28 ⏱ 5 sec Train pulls away

CREATING SUSPENSE

The melodramatic sequence on these two pages comes from Carol Reed's *The Third Man* (1949). Three separate groups of people have mounted an ambush for the elusive Harry Lime. Reed establishes the scene by intercutting shots of the waiting soldiers and the deserted Vienna streets, and then builds up a carefully controlled atmosphere of suspense. The pacing of the sequence, achieved largely by skilful editing, is masterly. A regular cutting pattern of tighter and tighter close-ups, broken once by a long, continuous shot, is finally brought to a climax, and the tension released, as the shadow is revealed to be not Lime, but a balloon-seller.

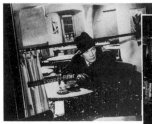

1 ⏱ **3 sec Martins looks left**

2 ⏱ **8.5 sec The street**

3 ⏱ **2.5 sec Martins looks right**

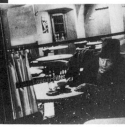

4 ⏱ **3.5 sec The street**

Martins in the café
The sequence begins with Martins (Joseph Cotton) waiting in the Café Marc Aurel. In the background is heard the slow zither music that haunts the film. The shot is tilted. The camera establishes first Martins' view out of the window to his left (shot 2), then to his right (shot 4).

5 ⏱ **3.5 sec Waiting German soldier**

6 ⏱ **1.5 sec The empty street**

7 ⏱ **1.5 sec German officer**

8 ⏱ **2 sec The empty street**

9 ⏱ **2 sec Waiting German soldier**

10 ⏱ **2 sec Alleyway**

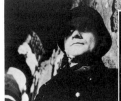

11 ⏱ **2 sec Waiting German soldier**

12 ⏱ **2 sec Empty alleyway**

13 ⏱ **2 sec Close-up of German officer**

14 ⏱ **2 sec Empty street again**

The waiting ambush
Progressively larger static shots of the soldiers waiting for Harry Lime are intercut with point-of-view shots of the empty streets to build an atmosphere of distorted tension.

15 ⏱ **2 sec Martins still waiting in the cafe**

The café (left)
The camera cuts back to another shot through the café window, taken from the same position as shot 1. Martins waits, morosely pondering his coffee.

The shadow appears (right)
The camera shows the soldier, as in shot 5, but from further away. He moves suddenly as if he has noticed something. We cut to his view across the street. A huge shadow appears against the side of a building.

16 ⏱ **2 sec The soldier moves**

17 ⏱ **2 sec Shadow appears**

18a ⏱ **15.5 sec German soldier**

18b Camera tilts slowly down

18c Tilt continues

18d Camera tilts and tracks in

18e Track in to reveal British officer

18f Two British officers wait

Tilt and track (above)
This 15.5 sec shot is the moment when the 2 sec cutting rhythm is broken. A long track reveals the two British officers waiting in the shadows.

Suspense increases
The tension now centers on the growing shadow. Seen from the same camera angle as shot 17, it now advances and spreads menacingly across the wall. The German soldier turns as he spots it, so does Martins from his table in the café. The same music is still playing in the background.

20 ⏱ **1.5 sec Soldier looks around**

19 ⏱ **2 sec The shadow in the street grows**

21 ⏱ **2 sec Martins looks around**

The climax (right)
We cut back to the same camera position as shot 19, the view across the empty square. The suspense reaches a peak as the figure on the wall grows even larger.

22a ⏱ **9 sec The shadow advances**

22b The balloon- seller appears

The dénouement (left)
The built-up tension breaks as the shadow rounds a corner, disappears and is revealed to be an innocent balloon-seller. At the moment he appears, the music changes character and tempo, becoming almost a waltz.

The pace relaxes (left)
The British officers look quizzically at each other, and retire again into the shadows. The German soldier, too, moves back. Martins turns his head away from the window, the music slows down, and the pace of the whole sequence relaxes, in preparation for another climax to come.

23 ⏱ **3.5 sec British officers**

24 ⏱ **1.5 sec German soldier**

25 ⏱ **2 sec Martins turns away**

SPECIAL EFFECTS

A number of different effects are possible with a special effects generator (SEG). These vary greatly in flexibility and complexity and they are generally packaged to include switching systems for two or more cameras which must accept external sync from the SEG and perhaps a "genlock" for connection to a second input VCR. The range of special effects you can then achieve may include: fades, dissolves (or mixes), superimpositions, inlays, overlays, and wipes.

All switchers have separate faders for each camera. These act in the same way as the volume controls on a sound mixer, and regulate the video gain of each input. For example, if camera 1 is selected as the output camera, the image from that camera can be faded up, or down to black, at will, and the effect may be observed on the output monitor. Alternatively, as camera 1 is faded down, Camera 2 may be gradually faded up. The effect here is a *dissolve*, or *mix* between one camera and another. The mix of the two inputs may be held at any given stage so as to produce a sustained *superimposition*. This can be used for a variety of effects including titling. For titling, the titles should be white on a black background, though other colors may be used in certain circumstances.

The input on one of the two channels could equally well be a video recorder, so that, for example, you could cut or mix from live action to tape, and back again. The flexibility of any switcher is circumscribed by the number of buses it contains – buses are complete video and audio in-out circuits. Ideally, you should have one bus for each input source, though in practice it is possible to obtain quite adequate results from two buses only.

Wipes

A *wipe* differs from a mix in that the incoming image occupies an ever-increasing area of the screen, and a hard line separates the incoming from the outgoing image. The wipe may be a straightforward vertical or horizontal line. Alternatively, it may be a square, an iris, or any number of other variations. The direction and speed of the wipe can be controlled through the faders and through the controls on the SEG. If the wipe is left at a half-way position, for instance, the incoming shot may be referred to as an *insert*.

In this way separate shots from two cameras can be combined without mixing. It is not an effect which is particularly suited to realistic shooting, but it can be quite effective in some situations.

Keying

Keying is a system which permits any hard-edged portion of one input (such as the words of a caption) to entirely replace the other input on the screen: for instance, one camera could be on a caption card, while the other was on a face. Unlike a superimposition, this gives a hard white image to the caption, and this effect is

Multi-image
This effect is sometimes used in pop videos, so that two parts of the band are seen at once. The shots may be in sync, or they may be separately edited through an edit controller with special effects. This example has a visible time code for frame-by-frame editing, and a star-burst filter effect.

important if clarity is to be retained. Alternatively, in more sophisticated versions *chroma key* can be used. This replaces all the parts of one scene of a particular color (usually blue) with another image. For instance, if a man is shot on one camera against a pure blue background, and another camera is pointed at a landscape shot, all the blue in camera 1 will be replaced by the landscape of camera 2. The result: a figure in a landscape. This is known as "Color Separation Overlay" and hence the designer's phrase "CSO blue".

Second-generation special effects

Inserts and overlays such as the above techniques are highly sophisticated and correspondingly rather expensive, but they are very primitive when compared with the newest (and most expensive) boxes of tricks such as *Quantel*, in which video images can be stretched, twisted, spun, flung into space, or split into a dozen mosaics. All this can be pre-programmed into one microchip memory, rehearsed, and set. Then you just press a button, roll it, and astonish yourself.

Digitized inlay
If the video image is digitized, it is possible to manipulate it in a number of ways. This example has been broken down into a pattern of squares. A live image of the art master and his student is superimposed as an insert.

TITLES AND TITLING

All films benefit from well-made titles, whether the title is being used to introduce or end the action, or clarify parts of it half way through. Front titles which are well-composed, short and to the point, will give your whole movie a more professional look. The design of the title should suit the subject of the movie – for example, use strong colors and forceful shapes with an action-packed story. Keep the titles simple and unpretentious: *Yosemite* is a more suitable title than *Wonderland of the Sierras*. Make them novel enough to catch the audience's attention, but resist quirky in-jokes. Many camcorders have highly refined titling facilities which are invaluable for tapes you want to show widely.

If you want to keep commentary to a minimum during the film, or if there is no sound, titles and subtitles are an ideal way of identifying a person, date or place. Captions like *Meanwhile*, or *1800* can be shown between action shots, or alternatively they can be superimposed.

The End is an unambiguous way of bringing your movie to a close and is a possible way to finish if you are not planning any credits. However, for any film which goes beyond the simple family record, or for one that you want to enter for public showings, it is important that credit be given to the production team. If the movie is a one-person show the credit is sometimes given at the beginning (*A film by ...*), but normally all credits go at the end. In the interests of democracy, keep the credits the same size and duration, dividing the title cards into the areas of work done – the cast, the writer, the sound recordist and the director.

Lettering

The simplest way to make up titles is to use lettering kits which are produced in a wide variety of styles, shapes and sizes and can be bought from art or photographic stores. Stencil and three-dimensional letters can be re-used; transfer letters can only be used once. In stencil kits the letters are traced with a special pen, using a template. The height and slant of the lettering is often adjustable. Three-dimensional letters are usually made from white plastic and are either stuck to the background with Velcro, magnetized, or clipped into slots. The main alternative to these re-usable systems is dry-transfer sheet lettering. This can be transferred to any flat surface using a burnisher.

Layouts

Whatever method of lettering you choose, an accurate layout of the finished title must be worked out before you start. Always leave sufficient margin around the title. To do this, measure the height of the background which is visible when the camera is in position for shooting. Make your margin at least an eighth of this measurement all around. Align your letters – either with a T-square or with a steel ruler. Space the letters according to what looks good, rather than by measurement (see right), but place them no further apart than the width of the capital N of the type used. If they are spaced out any more than this they will be difficult to read – especially as titles are rarely on screen for more than a few seconds.

Front titles
The obvious background for a movie on New York is the skyline of the city itself and a 35 mm transparency of this was projected on a titling unit. Titles should always be simple, and a bold white typeface was chosen for the lettering in this movie.

New York, New York

Mid-film titles
These titles are sometimes necessary to identify people, places, or dates mid-film. The typeface is the same throughout the movie to maintain consistency.

End titles
If you start with a front title you should really finish with *The End*. If the production team is of any size they should be credited at the end of the movie, along with the director.

Stencil letters
Stencil kits come in a variety of typefaces and can be re-used.

Margins
Always draw up an accurate layout before you place the lettering on the background and position the lettering sensibly within the margin.

Spacing
Fairly tight spacing tends to look better than very wide spacing. Always go by the look of the title, not the actual measurements between the individual letters.

Three-dimensional letters
Always use a ruler to align these letters on the title-board.

Week-End

Correct

Interpol

Correct

Transfer letters
These letters can be transferred to most surfaces, but are not reusable.

Week-End

Incorrect

Interpol

Incorrect

Static or action titles?

Static titles are those in which the lettering is stuck to a background in a fixed position. The camera then records the board. The best way to do this is with a titling stand (see below). The lighting must be even. Set two cross-lit floodlights at 45° to the title board.

Action titles are shot as a continuous part of the movie. For example, you could film a child writing the title in sand on a beach, and then end with the sea washing the title away. Always try to make the end title in the same style as the main title to unify the whole movie.

Echo titles (right)
These titles "zoom" towards the camera followed by visual echoes of themselves. They can be produced using the zoom lens and filming in a series of bursts.

Backgrounds
Whatever the color or texture of the background there must be sufficient contrast between it and the lettering you use. A plain black typeface was chosen to stand out against the plain background.

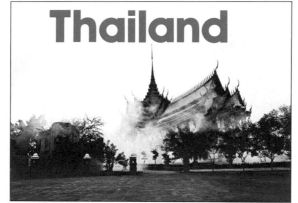

Difficult backgrounds (below)
When superimposing a title onto a gray or pastel background, be careful that the result does not look too "murky" on tape. To make the title more readable, a heavy typeface has been chosen here.

Contrast
Never place light lettering against a light background or it will be illegible. When the lettering was placed on the sky it was illegible; the dark lettering shows up much better.

Correct Incorrect

Pattern and relief
The brick wall was used to form a textured background. Black lettering, with a white outline was used to give relief against the lake background.

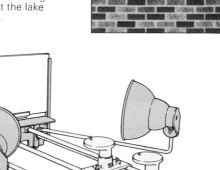

Static titles
This universal titling stand can be used with most video cameras. It can be used both horizontally and vertically and the camera's distance from the title-board can be adjusted.

Animated titles (left)
With some of the more sophisticated camcorders you can create animated titles. In this example the circular shapes were placed randomly on the titling board. They were then moved slightly, and a short burst of four frames was shot, followed by a series of movements and short bursts until the whole title was formed.

EDITING
THE
TAPE

WHY EDIT?

Why should you bother to edit your movies? What is the point of intercutting different shots? Why not simply show the tape as you shot it? After all, many great directors have preferred long, uninterrupted takes to fussy intercutting, and Hitchcock's movie, *Rope*, does not contain a single cut. The answer is that they had at their disposal enormous resources and a highly sophisticated technique: a successful long take is hard to do – since every segment must be interesting.

If you are making movies for the first time, you will realize as soon as you look at your first few tapes, why editing is necessary and why it is the single most important thing you can do to improve your movies. Editing gives you the chance to rectify the inevitable errors of shooting and to create a new order from the raw material. Editing is perhaps the most satisfying part of all movie making. In the quiet of your home, you can run through a whole tape and select inserts and cutaways to combine with other quite different but complementary images. This gives you your first opportunity to weigh one aspect of the material in relation to the other footage you have shot. You can now juxtapose images, intercut different angles of the same scene, begin to build up complex sequences, and establish the pace and mood you want. You may perhaps have visualized such juxtapositions, but only now can they be made to *work* as one combined image.

On the other hand, never edit just for the sake of it. Never overedit or lose confidence in your shot too early when editing. Trust your subject to hold on the screen, and when shooting, try to vary the angles for a sound dramatic purpose rather than for reasons of safety.

Editing procedure
The flow chart below explains how to go about editing your movies. It introduces the stages in the editing procedure which are outlined in more detail in the following pages.

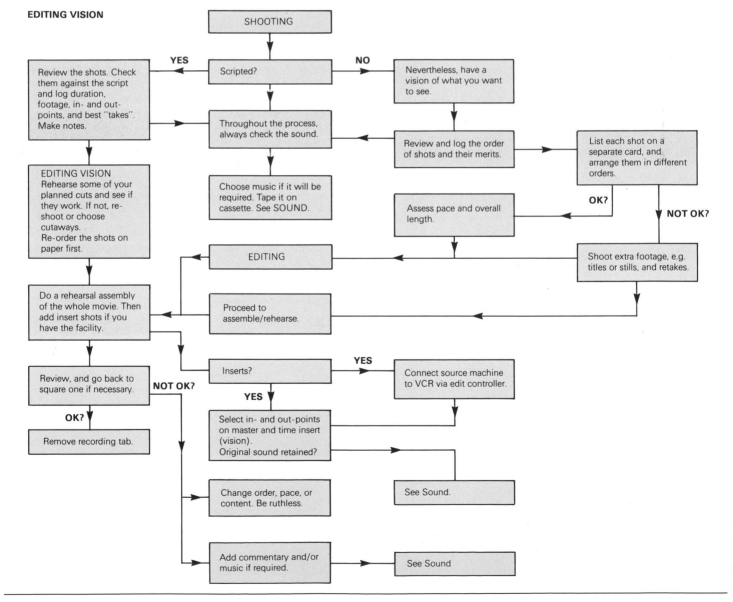

EDITING SOUND

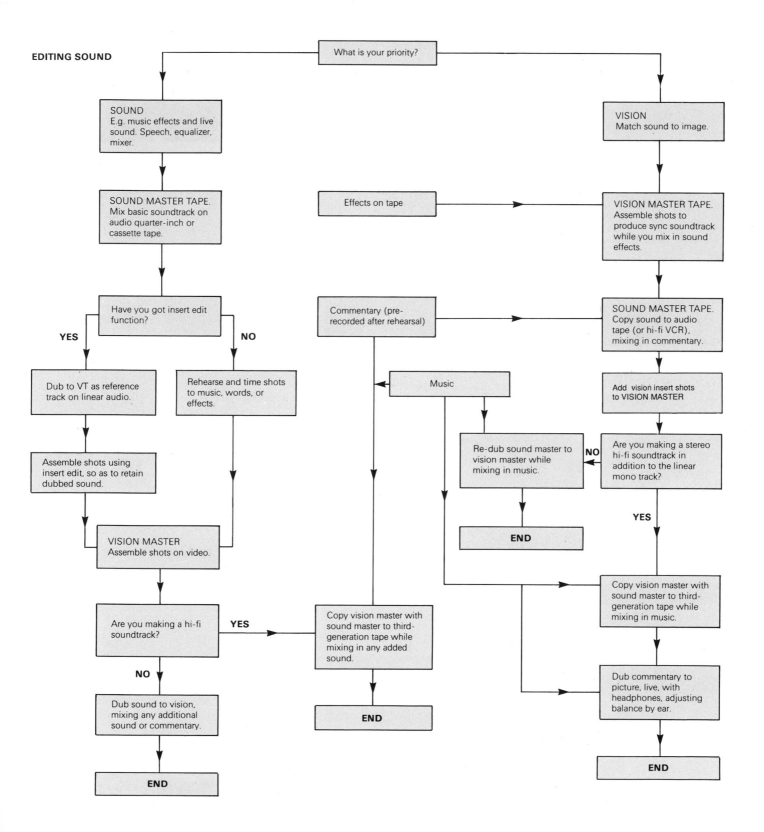

What is your priority?

SOUND
E.g. music effects and live sound. Speech, equalizer, mixer.

VISION
Match sound to image.

SOUND MASTER TAPE.
Mix basic soundtrack on audio quarter-inch or cassette tape.

Effects on tape

VISION MASTER TAPE.
Assemble shots to produce sync soundtrack while you mix in sound effects.

Have you got insert edit function?

Commentary (pre-recorded after rehearsal)

SOUND MASTER TAPE.
Copy sound to audio tape (or hi-fi VCR), mixing in commentary.

YES

NO

Dub to VT as reference track on linear audio.

Rehearse and time shots to music, words, or effects.

Music

Add vision insert shots to VISION MASTER

Assemble shots using insert edit, so as to retain dubbed sound.

Re-dub sound master to vision master while mixing in music.

NO

Are you making a stereo hi-fi soundtrack in addition to the linear mono track?

VISION MASTER
Assemble shots on video.

END

YES

Are you making a hi-fi soundtrack?

YES

Copy vision master with sound master to third-generation tape while mixing in any added sound.

Copy vision master with sound master to third-generation tape while mixing in music.

NO

Dub sound to vision, mixing any additional sound or commentary.

END

Dub commentary to picture, live, with headphones, adjusting balance by ear.

END

END

WHEN NOT TO EDIT

You do not always have to edit. Instead of inter cutting, it is often possible to use one single extended tracking shot to vary the distance between the camera and the subject throughout a take. If the actors, too, are moving, then you are dealing with a very subtle and complex camera movement. The results can be dazzling.

One of the greatest modern masters of this technique is Bernardo Bertolucci. But he is well aware that the technical problems are such that they can threaten to constrain the actors. He said recently that he likes to give his actors freedom to improvise – within certain limits, obviously. But supposing the actor suddenly decided to walk out of shot? That, said Bertolucci, was a matter for intelligent compromise. In extended shots such as these, the camera can itself become an active participant in the drama. And the very need to reconcile the demands of the camera's movement with the freedom of the actors can produce a tension that lends the shot its power or distinction.

An example of how this works in practice can be seen below. This is a selection of frames from the final *third* of a very long tracking shot (the whole shot lasts a full 3 minutes and 4 seconds). The film is *The Spider's Stratagem* (1970). Athos, the young man, has returned to his home town to discover the truth about his father's assassination. He is both confused and seduced by his father's former mistress, who sits at the center of a complex web of lies and deceit.

1a ⏱ 1 min 30 sec. He enters shot from left

1b She removes his jacket

1c He turns and faces her

1d They walk off

Creative camera movement
In the course of this shot, Bertolucci uses the camera movements to enhance the dramatic tension of the scene. The woman removes Athos's jacket, we are in close-up, and she repeats "You can't go away any-more!". At this point she leads him through the door-way. The camera follows them.

Tracking through the corridor
During part of the track through the corridor, the couple actually move out of the frame altogether – this is perhaps what Bertolucci meant by an "intelligent compromise" between spontaneity and formal camera movements. It is as though we, in the shape of the camera, are actually rush-ing after them from room to room. The sudden long shot (1h) provides visual variety and anticipates the long, in-tense close-ups to come.

1e They vanish through door

1f Camera remains on window

1g Camera follows

1h Camera reveals her sitting

1i She walks around him

1j She circles him again

Focusing for a camera tracking shot
One of the major problems encountered when tracking is that the focus varies con-stantly at different points in the track. Normal practice is to rehearse the shot very slowly (a "stagger-through"), checking the focus at each point, and marking the focus points on the lens barrel. The camera assistant (or "focus-puller") then operates the focus during the shot.

1k Still circling him

1l She passes in front of camera

1m She moves behind him

The spider

In these shots, as the woman attempts to persuade Athos to live with her, she circles around him as though she were literally ensnaring him in her web. The camera has now moved into close-up again to match the renewed intensity of this moment in the scene.

1n He walks away, she remains in frame

1o She talks off-screen

1p She follows him

1q Scene through doorway

1r Scene through doorway

1s She turns

Long shot to close-up

In shot 1p Athos again breaks away from the camera, and the next scene (in the bedroom) is glimpsed, and heard, in long shot through the doorway. Between shots 1p and 1t the camera has remained motionless. Now, as she turns, and in shot 1t comes into close-up again, the camera tracks behind her to reveal the long, sun-filled corridor. She is now alone.

1t She walks through doorway, in front of camera

1u Camera tracks with her

1v She looks out of window

Summary

Even in this brief section of the single shot, we have seen three distinct sections of close-ups interposed between long shots and mid shots. Also, the lighting balanced for daylight because of the windows in shot 1w. has remained even; the focus has been accurately maintained; and the movements of both camera and zoom have been perfectly coordinated with the action. This is an outstanding example of unobtrusive technique.

1w She passes through doorway

1x She walks out into sun-filled corridor

1y Camera follows

EDITING VISION

Most subjects benefit from later editing. The way you choose to edit will vary according to your subject, your equipment and, simply, the kind of video movie you want to make. Whether or not you have a shooting script, some initial selection of material will take place at the shooting stage. As you shoot, look for a good "out point". You should also choose shots that run well together. Editing "in the camera", at the time of shooting, is difficult to do well but becomes easier with experience. With plenty of practise, it becomes instinctive. As well as the main body of the movie, any front titles need to be shot in advance, perhaps using a superimpose facility if this is built into the camcorder.

One important fact to bear in mind is that all video machines need to back-space when paused in the record mode, to allow time for the recording head and tape transport to attain the correct speed, and align the tracking for recording the next shot with a clean transition. This means that recording begins a second or two after you press the button. If you are not aware of this, the fine juxtaposition of shots you hoped for will be spoiled by inaccuracy. For this reason, you should always run the camera tape for ten or twenty seconds before the start of the first shot. This allows for "roll-back" time when editing.

You should also shoot more material than you need. This will free you from many constraints when you come to edit.

Creating a structure

A professional approach to editing will make it easier to create the exact kind of video you want. You should begin by making a "shot list" of all the material you have taken. A shot is defined as a section of continuous recording (between operations of the camera's trigger or pause button). Very long takes may need to be subdivided. Interviews, for example, should be transcribed and given tape references. Write down the individual shots in order as they occur on the tape, and give each one a reference number. This can be either the tape counter number at the beginning of the shot or a time code (see p. 179).

Basic editing equipment

The simplest editing set-up consists of your camcorder, VCR, and television receiver or monitor, with the relevant connecting leads. But for more ambitious editing projects, some additional equipment will be invaluable. One attractive solution is to select one of the newer VCRs that offers a range of editing facilities. Alternatively, you may prefer to buy an edit controller that gives you even more flexibility.

Such machines are designed to give you more control over the editing process than a conventional VCR. They are also likely to have the additional advantage of coming from the top of the range and offering excellent sound and picture quality. Look for a machine that offers assemble edit. On these machines, the tape "back-spaces" when you press the pause key, producing a clean break between one shot and the next when they are edited together. Another useful feature is audio dub, which allows you to add sound without removing the original soundtrack.

One of the most useful features on some editing decks is that the sockets for connecting the source machine are on the front of the VCR. Folding down a panel on the front can give access to video and audio sockets for incoming signals, together with sockets for a microphone and headphones.

Another feature available on some VCRs is a split-screen facility which shows you the current picture on the source machine as well as what is happening on the tape in the edit machine. This makes it quite easy to run the two machines until you reach the appropriate points on the tape before starting the edit. Other screen displays that are useful during editing provide a reminder of how much tape you have left and an indication of the record mode (standard or long-play) that you have selected.

Assemble and insert editing

Assemble edits lay down one shot after another in both sound and vision. Insert edits usually lay down vision only and are therefore most often used to insert an illustration or cutaway into a section of continuous synchronized sound and vision. The special thing about insert edits is that they give a clean transition at both ends of the cut by using "flying erase heads" on the recording drum. These delete only the material that is being replaced without disturbing the tape's control track.

To make an edit with added sound from a camcorder (the source machine) to a VCR (the record machine), you begin by connecting the camcorder's audio-out and other sound sources to a sound mixer. Then connect the mixer's output to the VCR's audio-in sockets. At the same time, connect the camcorder's video line-out to the VCR's video line-in. Then connect the recording machine to a television or monitor. The screen will display the picture from whichever machine is in "play" or "play-pause" mode. You can use a second monitor from the source machine if it has a suitable connection, then you can compare the edit points visually. If the source machine has an edit switch, use this to get the best signal.

For an assemble edit, line up the end of the last shot on the record machine, and line up the beginning of the next shot on the source machine. If your machines have a sync edit connector, you will be able to line up the two exactly; pressing the start edit button on the source machine will cause both machines to roll back the tapes by an equal amount before rolling forward to begin playing and recording together at the right time. Without this function you need to allow for the backspacing on the record machine. This is much less accurate than with a sync-edit connector. You play the new shot up to the start point on the source machine and then release the pause button on the record machine.

Insert edits are timed from the end of the insert. This is usually done by setting the record machine's tape-counter to zero at that point. The machine counts down to this point while the edit is being made and then stops recording.

Editing controllers are available to simplify the whole process. They work by means of a vertical interval time code (VITC), which is not visible on-screen but is read from an LCD display on the controller. The controller uses the time code to identify the positions of individual frames on the tapes when carrying out editing programs or manual insert edits.

Three-machine edit

It is also possible to connect a video enhancer (or processor) between the source and record machines. This will allow you to modify the picture signal as it is being copied. The functions offered may include detail enhancement, color saturation, and brightness. Video enhancers also can produce fades to black or white, and sometimes offer a choice of "wipes", or even reverse-color video. In addition, these machines nearly always provide sound-mixing facilities. Video processors with digital special-effect capability can produce mosaics, picture-in-picture, and posterization effects.

The use of a vision mixer with two video sources and a record machine can speed up editing from several source tapes if you are fortunate enough to have access to this equipment. Elaborate techniques such as dissolves are then within your capability.

Connecting an edit controller
The simplest form of editing involves connecting two machines, such as a camcorder and VCR. This more elaborate set-up shows how you can use an edit controller to combine the output of a VCR and camera. You can monitor the resulting output and feed it to a second VCR.

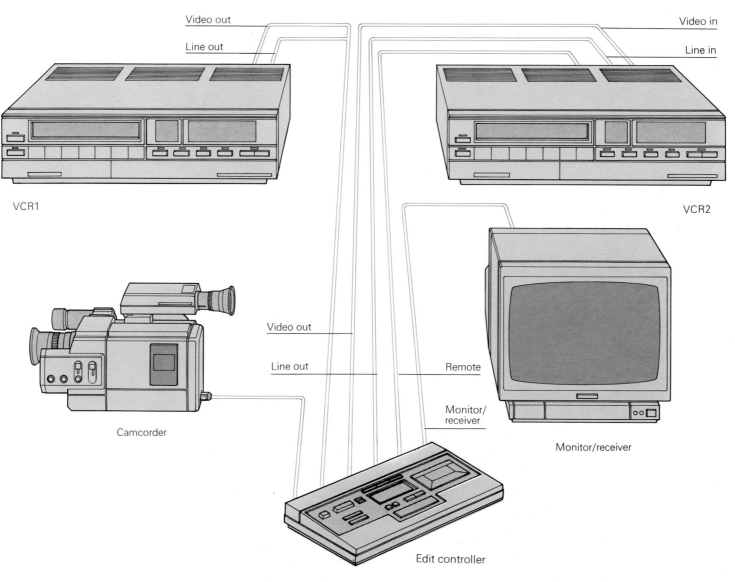

Video out

Line out

Video in

Line in

VCR1

VCR2

Camcorder

Video out

Line out

Remote

Monitor/ receiver

Monitor/receiver

Edit controller

EDITING VISION

Some of the techniques used by more advanced video producers can be instructive for the amateur. The use of an edit controller is one way to make your editing more flexible. Another fruitful approach is the two-stage editing process adopted by professionals.

Edit controllers

Video editing is a lengthy business at the best of times. One device that saves you some time is an edit controller. It also has the advantage of helping you to plan your editing carefully, and of providing clean cuts between shots. For the serious video editor, some form of edit controller is therefore usually an essential.

The edit controller is made possible by microchip technology that allows information to be stored in a memory. To perform an assemble edit, you connect up the edit controller and key in all the "in" and "out" points of the scenes you want to assemble together. Once these are stored in the unit's memory, the edit controller carries out the editing procedure automatically, switch-

ing on and off the source and record machines to produce the required series of shots. It can do this even if the shots are to be in a different order from those on the original tape.

You can also do insert edits with an edit controller. This is especially useful because it ensures accuracy – you reduce to a minimum the risk of erasing something important when you insert a cutaway into a scene.

Another benefit is the ease of producing effects such as dissolves, when one scene visually merges into the next. Only a few video camcorders are able to do dissolves.

But perhaps the greatest advantage of using an edit controller is the amount of time you can save. This is particularly important when making corrections to an edit. It is rare to get an edit exactly right first time – even with an edit controller. When you view the edited tape you may want to extend the length of some scenes, and cut down on others. With a computerized edit controller all you do is key in timings for the relevant shot numbers, then let the machine perform the edit again.

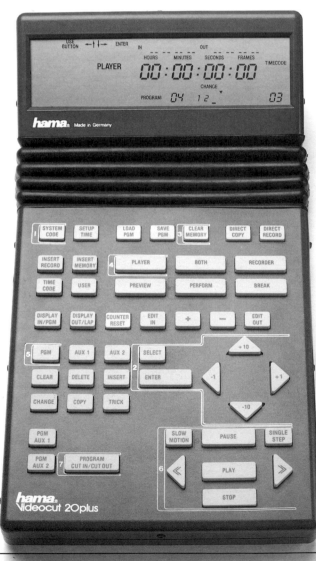

Hama edit controller
This computerized unit allows you to store up to 100 different in and out points at one time. A comprehensive LCD display shows you all the timings and the functions of the machines the unit is controlling.

On-line and off-line editing

The professional broadcast-quality editing suite contains sophisticated equipment that is very expensive indeed. Professional editing is carried out on one-inch reel-to-reel videotape machines. Then the soundtrack is accurately mixed and dubbed, perhaps on two-inch tape carrying as many as 24 separate tracks. Such facilities are very costly to rent and therefore producers arrive at the suite knowing exactly what their finished video should look and sound like. To arrive at this knowledge they rehearse the cut using what is called an "off-line" edit on tapes that have been "time-coded" for reference. All the creative decisions can be made at this point, before the more expensive "on-line" edit takes place.

The original camera tapes are copied onto the off-line tape format (which can be quarter-inch U-matic or half-inch VHS) and at the same time are given a burnt-in time code. This gives each frame a number identifying the source tape, the minutes and seconds into the tape, and the frame number within that second. The codes are displayed on-screen during playback when editing.

During the off-line edit the producer may decide to record some of the sequences that have already been carefully and successfully assembled. To save time, this is simply achieved by copying them onto a new "master" tape. If this is done more than once or twice, the picture quality deteriorates. But for the purpose of off-line editing this does not matter. So long as the time code is still legible, the off-line edit will still be good enough to provide a guide for the on-line edit.

When the off-line edit is completed, the producer can compile a list of the time codes at the beginning and end of each shot, together with details of the sound and vision mixing requirements. These provide a blueprint for the on-line edit.

Although the amateur video enthusiast does not normally have the benefit of a high-quality format on which to make the final edit, this two-stage process still has its advantages. It helps you to achieve a well-paced and structured video, and brings to light any problems before you embark on the final edit. Instead of a time code, you can use the tape counter on your VCR. This is especially useful if it gives a display in minutes and seconds. Unlike the professional time-code system, however, this display only relates to the start of the tape or to when the counter was last reset. But it still provides a useful reference.

Panasonic edit controller
This unit is typical of the sort of edit controller designed to suit a particular VCR. It has a smaller memory than the unit opposite, but is designed for ease of use. A jog dial enables edit points to be located easily.

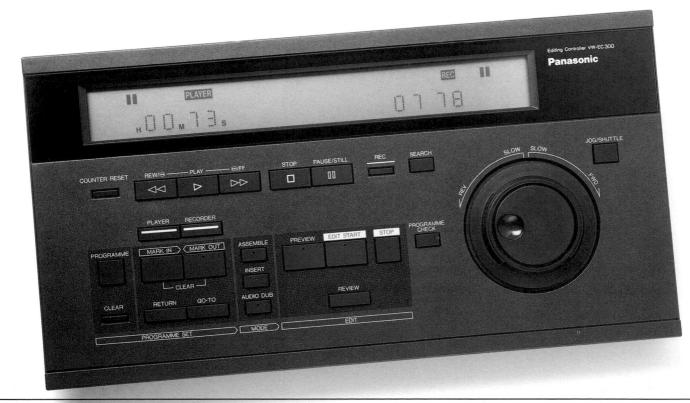

WHERE AND WHEN TO CUT

Editing is largely a matter of experimentation. There are no hard-and-fast rules dictating what you must and must not do. However, just as there are certain useful principles of shooting (discussed earlier in this book, p. 54–79), so there are certain principles of editing which will help you put together coherent sequences. The two most important – cutting for continuity and cutting for the visual action – are explained opposite.

Movies are not always cut for visual reasons. The sound may be more important than the action – especially in music or conversation, for example. And at other times the best cutting points for each medium may conflict. But, in general, the image is paramount. You will find that a very powerful image always tends to have more effect than a crucial piece of commentary. It is therefore the action that you should consider first.

Why cut?

When viewing your unedited footage, the first thing to ask yourself is whether a cut is needed at all. Even though you may have shot an action from different angles, or if you have shot cutaways and reaction shots, you must now decide whether they will strengthen or weaken the main action. Does the master shot stand up on its own? Are the angles and information given by the other shots sufficiently different to enhance the scene, or will they merely complicate the action without strengthening it? Never cut just for the sake of it, or just because you happen to have covered a scene from more than one camera position. This is particularly true when you are shooting a sustained performance or a delicate study of character, where the pauses and imperfections can be more telling than a polished and edited version.

Choosing a cutting point

Suppose that you have recorded a man walking up to a car door, opening it and getting in. You have shot the scene from three angles to give yourself maximum flexibility. Your plan is to cut from the long shot to the mid shot as he reaches the car, and to the close-up as he grasps the handle. Some of the problems and variations inherent in this scheme are shown opposite.

The action
The scene is recorded three times in long shot, in mid shot and as a close-up of the door handle.

L.S. 1

M.S. 1

C.U. 1

L.S. 2

M.S. 2

C.U. 2

L.S. 3

M.S. 3

C.U. 3

L.S. 4

M.S. 4

C.U. 4

L.S. 5

M.S. 5

C.U. 5

L.S. 6

M.S. 6

C.U. 6

L.S. 7

M.S. 7

C.U. 7

Cutting for continuity

When you choose a cutting point for the transition between the long shot and the mid shot, you *must* maintain continuity. In other words, the man must have the same leg extended in both shots and his position relative to the car must be correct. You must watch the movement very carefully and match the action exactly so that when you cut the two shots together they flow smoothly from one to the other. The two things to avoid are the *jump cut* and *double action*.

If you make a cut which omits part of the action, this is known as a jump cut. It may be a small mis-match (in which case the man may appear to "skip"), or it may be a large one (in which case he will suddenly "jump" from one position to another). If you make a cut which repeats part of the action, this is known as double action.

Matching cuts
Cutting from L.S. 4 to M.S. 4 will result in a well-matched, "continuous" shot. The man is picked up in the same position and at the same pace. The transition is smooth and uninterrupted.

L.S. 4

M.S. 4

Jump cut
Cutting from L.S. 2 to M.S. 4 will produce a "jump cut". The man will appear to "jump" suddenly from the end of the car to the side of the door.

L.S. 2

M.S. 4

Double action
Cutting from L.S. 3 to M.S. 1 will produce a double action. The action will be repeated and the man will appear to approach the car twice. The illusion of continuity will therefore be destroyed.

L.S. 3 **M.S. 1** **M.S. 2** **M.S. 3**

Cutting for visual action

Try to choose a cutting point from the mid shot to the close-up just as the man makes the first suggestion of a move towards the door handle – that is, just as he *begins* to extend his arm. It is a general rule that *an action cut is best placed a fraction after the beginning of a movement*. The cut is then visibly motivated, and the action will carry the viewer's eye effortlessly over any breaks or flaws in the continuity. If the cut comes half-way through the action (for instance, just *after* the man's hand reaches the door handle), the cut will tend to be slack.

There are other possibilities within this whole sequence, of course. If you wanted to compress the scene, you could cut directly from the long shot to the close-up, leaving the door handle alone in the frame for a second or so before the man's hand came into the shot.

Cutting on the action
If you cut from M.S. 6 to C.U. 6 just after the man has started to move, the action in the close-up will pick up on the action in the mid shot and the movement will appear to be continuous.

M.S. 6

C.U. 6

Cutting in mid-action
If you cut after the action has begun, say from M.S. 7 to C.U. 7, there will not be such a strong visual movement to carry over the change of camera angle.

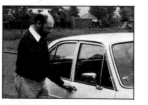

M.S. 7

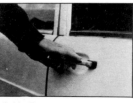

C.U. 7

Compressing time
It is possible to manipulate the action so that it still makes sense visually and yet "real time" is compressed on the screen. L.S. 1 establishes that the man is walking towards the car. You can then cut to the door handle (as a "buffer shot") just before the man's hand grasps it.

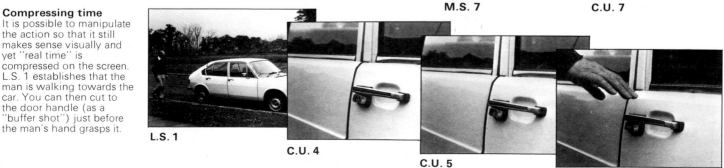

L.S. 1 **C.U. 4** **C.U. 5** **C.U. 6**

SHOT LENGTH

So far we have dealt only with cutting between shots of the same scene. However, not all action cuts are concerned with intercutting different camera angles of the same event. In any form of documentary film – from the family movie upwards – you will often be cutting together shots from different times and places that you have linked purely thematically. Each single shot will have its own rhythm, and probably a continuous series of separate actions throughout its length. The task is therefore to find a good "in-point" and also a satisfactory "out-point" in each case.

There are generally quite a number of possible ins and outs in any shot. Put the tape in the VCR, run it through a few times and look for some decisive action, such as the sweeping gesture of a hand or the departure of a person from the edge of the frame, to carry your eye into the new shot or out of an old one. Note the in-point, and then run the shot through the VCR – at the correct speed – until you feel you have located the exact moment where the shot should end. Make a note of it. Then consider it in relation to the shot that is to follow: very often, a right-to-left movement out of one shot which is effective in isolation can look wrong if the shot that follows is in the opposite direction. (Note that this is not a matter of continuity – since in this case the shots are of different subjects – but a question of visual effect.)

Choosing an in- and out-point
In this example, the movement of the girl across the frame is allowed to dictate the length of the shot.

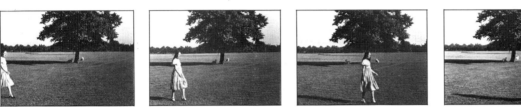

Cutting static shots

Finding a moment of decisive action may be one way of deciding on a cutting point, but it is not the sole criterion for the length of a shot. Even more important is the length of time that the shot can "hold" on the screen. This will depend partly on the overall rhythm of the sequence (see pp. 184–5). Judging the duration of a shot is particularly difficult if you are editing a series of static takes or cutaways. First, since nothing is actually "happening" in a static shot, it gives you no assistance in the way of action towards making your decision. Second, the tendency is to use fast-forward when viewing the tape, instead of looking at the movie at the correct speed. Even if you are familiar with the material and the shot is a static one, you should look at it using the right tape speed, otherwise you will not be able to judge its effect.

Remember that the more information you are compressing into a single static shot, the longer it must be held. If the shot has been seen before, it can be quite short; but if it is a surprise, or packed with detail, it may need to be held longer on the screen. There is always a danger that as you edit you become over-familiar with the footage, and consequently cut the shots too short.

Shot duration
These two shots of a formal garden can be used to illustrate the difference between the various static shots. The close-up of a single flower (left) is a much "simpler" image than the wide-angle, long shot (right). You may find, therefore, that it will not need to be held on the screen for so long in order for the audience to assimilate it.

ASSEMBLING SHOTS

Establishing geography

There is a convention in movie photobraphy that each new location or time-span in any film is introduced by an *establishing shot*. This is generally a fairly wide-angle, long or mid shot which shows the audience the relative position of the people or things that are seen in the subsequent shots. It tells the audience where the action is happening, which way the camera is facing in relation to the scene, and perhaps also that some time has elapsed since the previous scene. This convention therefore has a solid practical basis: it establishes the scene and then allows you to cut in closer – although in a long sequence it will probably be necessary to return to the wider shot from time to time. However, the formula can be varied for a particular effect. For example, it is a classic technique for building suspense to open with a series of mysterious and unexplained close-ups which are only made clear by a final wide-angle establishing shot.

The problems of "crossing the line" have already been explained in an earlier chapter (see p. 68), and it is crucial that the guidelines you used while shooting should be carried through in editing the movie. Continuity of direction must be maintained when you cut shots together or the audience will become confused about what is happening where.

Matching and contrasting shots

When putting together shots, you will find that the succession of images you choose will dictate the "feel" of the sequence. For example, it is possible to improve the flow of a sequence, and in some way to suggest a harmonious connection between quite different objects, if there is a similarity between the neighboring shots. This similarity may be one of composition, or even of color. On the other hand, if the composition is contradictory, or if the colors clash, the effect is of drama and contrast. This fact can be a valuable tool in the establishment of pace and atmosphere.

Just as the "look" of consecutive shots should be considered, so you should also be aware of the effect of joining together too many moving or static shots. The relation of movement to stillness in a video movie is a delicate one, and it has a great effect on the final result. At one extreme, the action might take place in front of a single, static camera; at the other, the camera may be continually zooming, panning and tracking in a restless, frenetic fashion. The chances are that you will want an effect somewhere in between. Unless you are aiming at a restless mood, avoid following one zoom or pan with another. Space out the moving shots – especially if they are in the same direction – with static shots, and in any case let the movements come to halt on a "holding shot" before cutting them.

Finally, bear in mind the different effects which can be created by varying the shot size and angle (see *Choosing the Right Shot*, p. 60, and *Editing Errors*, p. 188). A large change from, say, a long shot to a big close-up is likely to look very dramatic on the screen. If this is the effect you want to achieve, it can be used very tellingly. But if it is unplanned it may appear clumsy and inappropriate, and may disrupt the flow of the sequence.

B.C.U. Man's eyes

C.U. Razor

Creating suspense
Begin with the sinister close-up and end with the establishing shot.

M.S. Man shaving

M.S. Man shaving

Cutting-in
Begin with the mid shot to establish the scene.

C.U. Razor

B.C.U. Man's eyes

Editing a chase
In this sequence from *The Third Man* (1949), the drama of the chase is conveyed by intercutting rapid long shots with static close-ups. High contrast, low key lighting is combined with powerful and matching compositions.

1

2

3

4

5

6

7

8

BUILDING A SEQUENCE

When you begin to assemble your shots, you should remember that the *rhythm* of a sequence is determined by the duration and frequency of the shots – and also by the amount of movement within each shot. Try to develop the habit of looking at your sequences, not just from the point of view of the developing action, but also with an eye for the pace and rhythm. The principal point to remember is that fast intercutting does not on its own produce either tension or excitement. What matters is the *variation* of cutting-tempo, not its average speed between two points. A slow build-up, followed by a rapid explosion of fast, strong single shots is far more dramatic than a monotonous and unmotivated fast-cutting sequence. If a sequence has to be fast, then the length of the shots can still be varied by including one longer shot which derives its pace not from its brevity but from the speed of the action contained within the shot.

By contrast, you may be aiming for a mood of slow, dreamy contentment. In this case, you would tend to cut the shots at a rather regular pace – so that the variations in composition, duration and the frequency of the shots are just sufficient to maintain interest but not so great as to disturb the smooth flow of the images.

To build suspense, some form of compromise between the two rhythms can be used: for example, a series of slow long shots, followed by one or two very quick jolts, then another few long shots, and a few really violent jolts. Here, as elsewhere, film and video dramatic techniques are identical.

Action cutting

In this sequence, which comes from Joseph Losey's film, *The Servant* (1963), the cutting points are determined primarily by the action. Tony (James Fox) and Barratt (Dirk Bogarde) are engaged in a bizarre and sinister game with a tennis ball. However, the "game" turns nasty, and the latent aggression between the two men explodes. In a series of short, fast cuts of mounting speed and power, the scene comes to a climax. Each shot begins and ends with a fast motion on the screen – in other words. all the cuts are action cuts.

Opening shots
The cut from shot 1 to shot 2 is from a long shot to a mid shot – the camera is still high. Barratt bends around to retrieve the ball. The cut to the close-up (shot 3) is made on the visual action – just as his head *begins* to turn.

Barratt: "Take your ball"

1 ⏱ **47 sec Long shot**

Tony: "Take it yourself"

2 ⏱ **24.5 sec Mid shot**

3a ⏱ **1.5 sec Close-up Barratt**

3b Barratt throws ball at Tony

Subjective shot of Tony
The cut from shot 3 to shot 4 is made just as Barratt throws the ball back to him. It is the movement of the ball itself which dictates the cutting pace. During shot 4 Tony picks up the ball and hurls it violently back at Barratt.

4a ⏱ **2 sec Tony picks up ball**

4b Tony throws ball at Barratt

4c Ball approaches

4d Ball hits camera

Barratt is hit
Because shot 4 is a subjective shot from Barratt's point of view, the ball comes directly at the camera. The cut to shot 5 is made a split-second before the ball, which virtually fills the frame, actually hits the camera lens. We see the impact in a cut back to the same camera position as for shot 3.

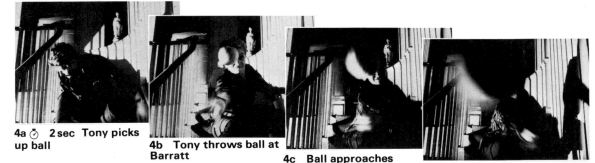

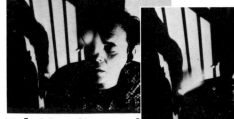

5a ⏱ **1.5 sec Close-up of ball hitting Barratt**

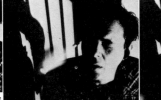

5b Ball bounces off

5c Barratt recoils

5d He turns away

Thematic editing

The shots that build up a sequence may also be selected for reasons that have nothing to do with the requirements of clear action. They may be designed for purely symbolic effect, as in the famous opening sequence to *Citizen Kane* (1941). The whole film proceeds in a series of flashbacks and opens with the death of Kane. After a slow track up to his insane Gothic castle, we find ourselves in his death chamber. In a series of dissolves, snow is mysteriously superimposed on the interior, then a snowy cabin appears, revealed as a glass "snowstorm". Kane whispers "Rosebud", drops the snowstorm, and dies. It is revealed at the end of the film that "Rosebud" was the name of Kane's boyhood sled, and that the cabin was a childhood memory.

1 ⏱ **8 sec Kane in bed in front of window**

1a Snow drifts across screen. Dissolve.

Kane's death bed
The sequence opens with a shot of an enormous window through which the dawn light is beginning to shine. In front of the window, in a huge bed, lies the dying Kane. Just as we decipher the image, however, it blurs, and the screen fills with snow. This is of course an optical effect. The scene eventually dissolves to shot 2.

Snow-covered house
The scene with the dying Kane dissolves into this extraordinary shot of a snow-covered house in front of which there are mysterious, shadowy figures. The snow still drifts across the screen and at first there is no sense of scale. There is a subtle dissolve to shot 3.

2 ⏱ **6 sec B.C.U. of "snowstorm"**

3 ⏱ **2 sec Kane's hand holding globe**

The glass globe
The dissolve from shot 2 to shot 3 reveals that the tiny house and figures are contained inside a water-filled glass globe, a "snowstorm". The camera tracks out and we see that the globe is lying in Kane's outstretched hand – though at this stage we have not seen Kane. In fact we do not see his eyes at all.

Kane: "Rosebud"

4 ⏱ **2 sec Kane's lips**

5 ⏱ **3.5 sec The globe falls**

The globe breaks
There is a shock cut to an extreme close-up of Kane's lips. The lips move, and he hoarsely whispers the word "Rosebud". In a new shot (actually a reverse cut from shot 3), the globe falls out of his hand. It is picked up in a 1 second low-angle shot, rolling towards the camera. It bounces down the stairs and smashes on the floor.

6 ⏱ **1 sec The globe rolls down steps**

6a The globe smashes

The nurse
Following the explosion of the glass globe, there is a cut to a distorted view of the bedroom door. It opens and a nurse enters. There is a cut to the same scene in long shot, seen through the curved glass of the smashed globe. She walks across to the bed and covers the face. Kane is dead. Fade to black.

7 ⏱ **1 sec Bedroom door opens**

7a Nurse enters

8 ⏱ **6.5 sec Nurse comes forward**

SYMBOLIC EDITING

All the guidelines included in the previous pages are merely ways to produce a smooth narrative. You can equally well decide to aim for a movie that works on a symbolic level, bypassing the logical demands of narrative. In this kind of video you are not setting out to reproduce a recognizable version of ordinary reality, but creating a new and purely cinematic reality from a precisely controled succession of images. In fact, of course, all films do this to some extent, but the process can be carried to great lengths. It is seen at its most extreme in a large number of modern experimental films which have no narrative structure, no time-scale and no pretence of continuity. Ironically, this is, in a sense, the logical end to the great Russian tradition of silent film making, "editing is the creative force of filmic reality, and ... nature provides only the raw material from which it works" (V. I. Pudovkin, 1929). Symbolic editing is in fact a technique of pure visual imagery, and as such it is well suited to the amateur filmmaker who wishes to experiment with film in its most free and expressive form.

There is still no better illustration of the technique than the early Russian cinema, since the tradition did not survive the birth of the Talkies in the 1930s. In Pudovkin's case, the dramatic situation was still dominant. In his film *Mother* (1926), he juxtaposes images in a purely cinematic way to produce a poetic evocation of a prisoner's joy at his forthcoming release. "I tried to affect the spectators not by the psychological performance of an actor, but by plastic synthesis through editing ... The problem was the expression of his joy".

"Mother" (1926)
From the first subjective shot as the prisoner reads of his impending release, Pudovkin begins to build up the imagery of joy. We have already been told that "outside it is spring", and throughout the whole film the image of a frozen river melting has been used to express political liberation. Shot 4 in fact contains no less than five separate shots of rushing water cut together within 64 frames.

1 ⏱ 14.5 sec The letter

2 ⏱ 1.5 sec B.C.U. Hero's eyes

3 ⏱ 1.5 sec Hero in cell

4 ⏱ 2.5 sec Water

5 ⏱ 1 sec Hero's hand

The power of imagery
As the sequence builds up, shots of rushing water and a laughing child are rapidly and lengthily intercut with the hero sitting in his cell, and close-ups of his hand gripping the chair and of his beating heart. The crescendo of shots is at last resolved in shot 12, as the hero too is seen laughing with joy. The sequence ends with a fade to black.

6 ⏱ 2 sec Heart beating

7 ⏱ 2.5 sec Sunlight on water

8 ⏱ 2 sec Laughing child

9 ⏱ 1.5 sec Water

10 ⏱ 1.5 sec Laughing child

11 ⏱ 2 sec Water

12 ⏱ 4 sec Hero laughing. Fade-out

Editing for shock effect

Eisenstein, even in his early film, *Battleship Potemkin* (1925) was developing theories of intellectual symbolism to the point where, at times, the narrative was almost completely abandoned. The battleship "Potemkin" has mutinied against Tsarist rule, and has sailed out to meet the main body of the Russian fleet. There is a good deal of uncertainty as to whether the fleet will join her or sink her. The anxiety of the sailors builds up throughout the sequence until at last it is clear that the rest of the fleet has joined the mutiny. Eisenstein believed, with Pudovkin, that a film should proceed by a series of *shocks*. Each shot should add a new element to the drama. He despised the technique of master shot plus inserts and cut-ins. In Eisenstein's case, each composition derived its power from the contrast with the shots on either side.

"Will they open fire?"
Four rapid and dramatically contrasted shots lead up to another massive close-up of the gun barrel. Shots 8 to 12 build up the tension still further by strongly contrasting compositions of the battleship, the gun-loaders, the shells, and finally a sailor's face breaking into a delighted grin (which prefaces the caption "Brothers!").

1 ⏱ 3.5 sec "Potemkin"

"Battleship Potemkin" (1925)
The sequence opens with a shot of "Potemkin", in the hands of the revolutionaries sailing out to the fleet.

2 ⏱ 0.5 sec B.C.U. of gun barrel

3 ⏱ 1.5 sec Anxious sailor. Fade-out

Rapid intercutting
A sequence of seven shots of guns, gunmouths and preparations to fire culminate in the big close-up of the gun barrel.

4 ⏱ 1 sec B.C.U. of sailor

5 ⏱ 1 sec Sailor's hand on firing lanyard of gun

6 ⏱ 1.5 sec B.C.U. of gun barrel

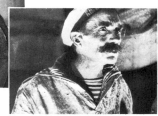

7 ⏱ 1 sec Sailor

8 ⏱ 2.5 sec The battleship "Potemkin"

9 ⏱ 1 sec Sailors holding shells

10 ⏱ 1 sec Pile of shells

11 ⏱ 1.5 sec Sailors training a gun

12 ⏱ 2 sec Sailor breaks into smile

13 ⏱ 0.5 sec Sailor cheers

14 ⏱ 2 sec "Potemkin"

The culmination
After the avalanche of rapid close-ups, the tension is released, and we pass from the big close-up of the sailor's face to this giant, liberating top-shot of the bow of the boat, as the cheering sailors rush to the rails.
Throughout, the sequence derives its force by contrast: contrasting angles, shot sizes, subjects, speed and composition.

EDITING ERRORS

The shots on these two pages are designed to illustrate some of the most common errors that are made when editing. Together, they combine to form a kind of "Chamber of Horrors" of mistakes that you should try to avoid when you edit your own movies. Some of them will be glaringly obvious to almost any audience; others may be noticed only by other filmmakers. But it is good practice to edit your movies as carefully as you can, to cut together your shots as smoothly as possible and to build up sequences that "read" logically.

Reverse cut
In between these two separate shots of a girl roller-skating, the camera has accidently crossed the line. In the first shot, the girl is moving from left to right; in the second shot, she has inexplicably changed direction. For guidance on how to cross the line successfully, see p. 68.

Jump cut
A jump cut is any cut which appears to "jump" badly on the screen. In the example here, the camera stopped and then started again after the man had moved to a different position.

1 2 3

4 Jump cut

Double action
When editing together shots of the same action recorded from different camera angles, take care to choose the right cutting point (see p. 180). In the example here, the in-point for the close-up has been made too early: as a result, shot 4 repeats shot 2.

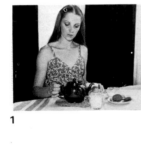
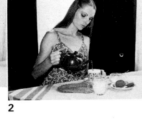
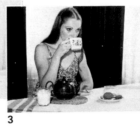
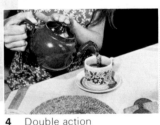
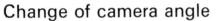
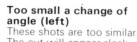

1 2 3

4 Double action

Change of camera angle
Any change in camera angle should be great enough to mark a distinct change in shot but not so great as to be shocking or disrupting to the audience.

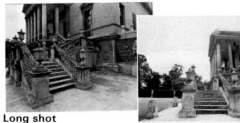

Long shot

Long shot

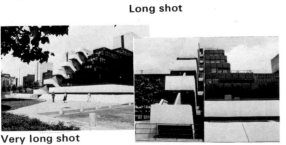

Very long shot

Long shot

Too small a change of angle (left)
These shots are too similar. The cut will appear slack on the screen.

Too small a change of image size (right)
The difference between these two shots is too slight for a good cut.

Too great a change of angle (left)
These two shots are so different that geography becomes confused.

Too great a change of image size (right)
The statue is so small in the long shot that the cut-in to the close-up is unrecognizable.

Change of image size
Any change of image size should be great enough to make a noticeable difference but not so great as to interrupt the mood or flow of a sequence.

Mid shot

Medium close-up

Long shot

Big close-up

Incompatible eyelines

When shooting a scene containing more than one person, you must strive to maintain a clear sense of geography. The audience will only be absolutely certain where everyone is in relation to everybody else when they are all in the shot together. Therefore, as soon as you cut in to close-ups, you should see that your subjects look and speak in the right direction – that is, towards the point outside the shot in which the other characters are thought to be located (see p. 61).

Mis-matched eyelines
If you are filming a conversation by intercutting between single close-ups, take care that your subjects are facing in the right direction. Although the two girls in these shots are talking to one another, the camera angles make them appear to be back-to-back.

Inappropriate cutaways

A cutaway is a shot inserted into a sequence to show something other than the main action. It is often used to disguise a bad continuity cut or to introduce another aspect of a scene – a flashback, a subjective reaction or parallel action, for example. Obviously, the cutaway should appear to be related to the action. It should also – unless it is your intention to do otherwise – match the mood of the sequence. It is pointless trying to enrich a scene by introducing cutaways which disrupt the pace, interrupt the flow, confuse the action, or which are plainly inappropriate. Be ruthless, and judge each shot in relation to the ones that surround it.

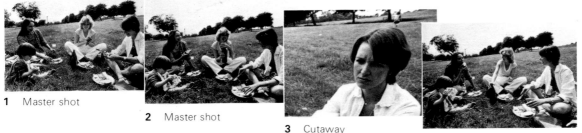

1 Master shot

2 Master shot

3 Cutaway

4 Master shot

Mis-matched cutaways
When inserting a cutaway into the main action, take care to match the mood of the overall sequence. The atmosphere of the picnic in the shots on the left has been disrupted by the cutaway of one of the girls frowning.

Continuity

Errors of continuity are probably the most common of all editing mistakes. The very nature of editing – the running together of different shots, often recorded at different times and in different places, to create a convincing impression of real events – means that a video editor will always be faced with continuity problems. Many of the most serious and most obvious mistakes can only be prevented at the time of shooting, so you should take a careful note of all the details of each shot – either mentally, or on paper with an instant-picture camera. But bear in mind that when you join any two shots together continuity must be maintained, not only in appearance (dress, color, weather, etc.), but also in action, pace, and sound.

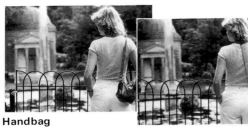

Handbag

Different handbag

Continuity errors
This series of shots illustrates some of the most commonly made continuity errors. If you are shooting more than one take of the same scene, or two consecutive scenes in which the same subject appears, it is all too easy to overlook consistency between small details such as clothing, lighting, furniture or time of day. In these shots, the girl appears with different handbags, with the clock showing different times, with a new and a burnt-down candle, and with and without earrings.

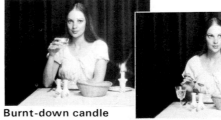

Burnt-down candle

New candle

11:45

12:10

Earring

No earring

EDITING TRICKS

Cutaways

The cutaway, a shot of something outside the flow of the main action, is one of the principle tools of all editing (see p. 75). It can be used to introduce variety and an added dimension to a sequence; it can be used to divert the audience's attention away from continuity errors; to disguise unintentional jump cuts; or to conceal the fact that real time has been compressed on the screen. Thus, two shots which will not cut together can be linked by inserting a cutaway lifted from somewhere else. The cutaway itself need not be shot at the same time.

1a
1b

2a
2b

2c

1c
1d

Inserting a cutaway
In this sequence a shot from a series of crowd reactions has been inserted into the main action.

2d
2e

Jump cutting

In the case of a cutaway, you can manipulate screen time by *inserting* extra footage into a sequence. But this is also possible by *removing* footage. For instance, if an interview contains a zoom-in from a mid shot to a close-up, the zoom itself can be removed, giving a straight cut from the mid shot to the close-up. The eyeline and expression should, however, match in both shots. This is one reason why interviews, on TV for example, usually contain several different shot sizes.

Jump cuts used to manipulate screen time in this way should not be confused with accidental jump cuts (see p. 188). If you take care to maintain continuity, then the cut will appear smooth; if you do not, then there will be an ugly and glaring jump on the screen.

1a

1e

Cheating the action
This sequence of a man shearing a sheep was shot as a long, slow zoom-in. You can "cheat the action" and compress screen-time by removing part of the footage in the middle of the zoom.

1b
1c

1d

The jump cut
In the example shown here, the middle three shots (1b to 1d) have been edited out. The sequence now cuts directly from the mid shot (1a) to the close-up (1e).

Dissolves

If it proves impossible to avoid a jump cut or a bad continuity cut, you can resort to a fast dissolve (see p. 77). This softens the cut sufficiently to cover the break in continuity. Unfortunately, however, it is an effect which is only available at the editing stage.

A cut covered with a four-frame dissolve
This rather abrupt cut between a mid shot of the clown laughing and a close-up of him looking sad has been softened by a quick dissolve.

Strong action-cuts

If you are faced with a scene filmed from two positions on opposite sides of the "line" (see p. 68), it may be possible to join the two shots together despite the fact that you will have made a "reverse cut". If you choose your cutting point carefully so that it coincides with some dramatic action, then the momentum of the action itself will carry the audience over the reverse cut and the apparent break in continuity will almost certainly pass unnoticed on the screen.

The reverse cut
Here, the mid shot of a man about to deliver a karate blow has been shot from one side of the "line". The close-up of his hand has been shot from the opposite side.

The cut covered by a strong action
In order to cut the two shots together without too glaring a break in continuity, choose your cutting point just as the man's hand reaches the brick. The downward movement will cover the cut.

Buffer shots

An alternative answer to the problem of disguising a reverse cut is to use what is sometimes known as a "buffer shot" (see p. 68). If you begin with a shot in which your subject is seen walking in one direction, and you then wanted to follow it with another shot in which he or she is walking in the opposite direction, you might well be able to avoid the break in continuity by using a buffer shot. Typically, the second shot would begin with the camera focused on some portion of the scene which did not reveal the main action. It might then zoom out or pan across to reveal the reverse action. Provided the action is clearly the same as before the cut (though in a new screen-direction), the buffer shot will blunt the force of the reverse cut by distracting the viewer's attention from the break in continuity. The buffer shot acts as a "neutral" image to smooth the cut.

The buffer shot
In the first shot, the boy is walking through the frame from left to right; in the second, he is walking from right to left. The change of direction was disguised by cutting to a close-up of the sign post (the "buffer shot"), then zooming out just before the boy walks into the frame.

BUILDING A SOUNDTRACK

There are many reasons why you might wish to add to or change the sound recorded with your pictures. You might want to add a commentary, to smooth over the sound jumps between cuts, or simply to replace sound that was inappropriate or badly recorded when the image itself was satisfactory.

Simple sound dubbing

Many camcorders allow you to dub sound directly onto an existing picture. This is not possible on 8 mm formats, except on the few machines that feature the "PCM" method of stereo audio recording.

On mono machines, all the live sound is replaced in the dubbed section of the tape. On hi-fi machines, when hi-fi sound has been laid down on the helically-scanned tracks alongside the picture, the hi-fi sound will remain. You will hear it on playback alongside the dubbed sound unless you choose "mono only" from the machine's sound mix selector. When the live sound is good and you simply want to add a commentary or music this can be an advantage.

You carry out the dub using the "audio dub" mode button on the camcorder. Sound input to the camcorder may be through the machine's built-in microphone, an external microphone socket, or a "line in" socket if the camcorder has one. If you want to use an audio source but have only a microphone socket, beware. Line audio source voltages are much higher than those of microphones, so you should use an attenuation lead to connect an audio source to a microphone socket without damage.

If you are dubbing from a recorded source, make sure that it is long enough to cover the whole section required. The end of a section of music, for example, often provides the best end to a sequence of vision, and the start of the dub therefore needs to be carefully backtimed. Some recorders feature real-time reverse play, to help you to do this.

To make the dub, find the point on the video tape where you want the dub to start, hold the camcorder in "pause play", and press the "audio dub" button. Play the sound source, checking the levels through headphones if possible. Release the "pause" button at the exact moment and continue dubbing up to the point where you want to finish. Then press "pause" again, being careful not to overrun and erase the sound from the next section of the tape.

Dubbing to a VCR
Although dubbing sound onto original camera tapes retains picture quality, which is progressively lost in copying, in general it is best to work with copies. There is no danger then of ruining irreplaceable material. There is also scope for experimenting. Copying to a VCR also allows you to change formats.

A very useful bonus when using copies is that you can dub sound from anywhere on the camera tape to some other picture sequence from the same tape. Good ambient (or "wild track") sound from the same location can be used to cover bad sound; or the voice of an interviewee or other speaker can be dubbed over illustrative vision sequences. A more flexible method is the "insert edit", in which new visual material is inserted alongside existing edge-track sound. Many VHS machines now have this facility. Whereas few camcorders have video/audio-in sockets, these are common on VCRs, allowing the copying or dubbing of separate sound and vision sources.

Building a mixed soundtrack
You may want to create a soundtrack made up of a number of different original sound sources. Sound effects, music, or commentary can all be added later – or you may wish to replace the original synchronized sound completely. The exact method will vary according to whether you are using conventional tape, on which the sound is carried on an edge-track, or hi-fi, on which the sound is encoded with the video tracks themselves.

Sound dubbing connections
When recording more than one sound source you should pass the sources through an audio mixer. This will allow you to adjust the volumes of the different sources, and to fade them in and out easily.

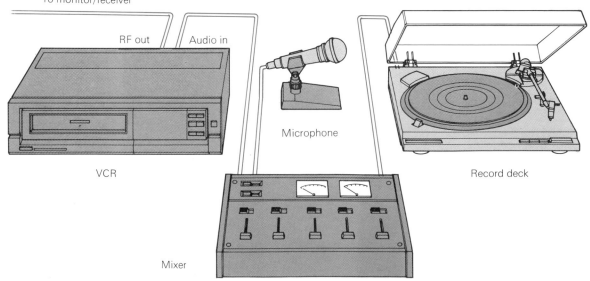

To monitor/receiver

RF out | Audio in

VCR

Microphone

Record deck

Mixer

Edge-track dubbing

An audio mixer is essential to combine several sound sources smoothly and professionally. Many models are battery powered and are suitable for mixing microphone inputs when shooting on location. You should plan the proposed sound mix carefully in advance. You can compile a chart (called a "dope sheet"), to plan the alignment of the various sound and picture elements second by second.

You can build up a complex soundtrack progressively on audio tape. You do this by mixing tracks in pairs and re-recording the result while mixing in another track. This simplifies matters, since you end up with one soundtrack for final dubbing onto the edited images.

Like video, sound quality tends to deteriorate progressively the more you re-record. You should therefore keep the number of stages to a minimum. Using sound-on-sound recording systems helps you to do this.

Another problem can be poor synchronization with the picture. This is especially noticeable in speech, and comes about because of slight inconsistencies of speed in audio equipment. This may not be noticeable in short sections of video, and one solution to the problem is simply to keep the sections short. Alternatively, you can use an isochronous tape recorder. Some of these are controlled by a quartz crystal for general-purpose use. Others, designed for video, are kept in time by pulses from the control track of a recorded video tape.

Creating the soundtrack

Begin by editing the video tape, passing the audio channels through a sound mixer as you do so. You use the sound mixer to boost or fade the live sound or to replace it or mix it with pre-recorded sound effects. The aim at this stage is to assemble the live synchronous sound in the right order.

The master tape that you have created in this way can then be copied onto an audio or video tape while mixing-in another sound element, such as a pre-recorded commentary. It is best to record the commentary with a very small interval between each section, so that when you are dubbing it is only necessary to release the tape recorder's pause button to start dubbing the next section at the right time.

The resulting tape containing sync sound, special effects, and commentary, can now be copied back onto the master tape. Do this using the audio-dub facility. You can also mix in another sound element at this stage, pre-recorded "mood" music, for example.

When you are dubbing in this way, one of the biggest problems is keeping the sound and vision synchronized. The sound tape and the vision master must be accurately aligned at the start of dubbing. Some sort of marker must therefore be provided on both. The traditional device is the clapper-board, which provides a clear reference point on both sound and vision and which has to be edited in as the first shot. Another method is to use a shot of a clock with a sweep seconds-hand to give a countdown. The reference point on the audio tape depends on whether you are using a reel-to-reel or cassette machine. On reel-to-reel, you can mark

the beginning of the sound section on the tape itself with a chinagraph pencil. On cassette, you should wind the tape by hand so that the end of the leader is directly in line with the middle of the slot.

Another difficulty is controlling the levels of the incoming sound. Some VCRs allow you to regulate one or two sound-input channels manually. Others have automatic recording level and gain control (AGC), which tends to amplify tape noise in quiet sections and reduces the dynamic range. If you cannot override this feature on your machines, you may have to avoid quiet passages altogether. Otherwise, you can buy a device that feeds an ultrasonic signal through the mixer to satisfy the AGC that the sound level is adequate.

Advanced sound editing set-up
This set-up includes an edit controller, to operate both video machines automatically, and a unit that combines the functions of audio mixer and video enhancer. Pre-mixed sound comes in via a reel-to-reel tape recorder, although you can also mix in additional sound from other sources, such as a microphone.

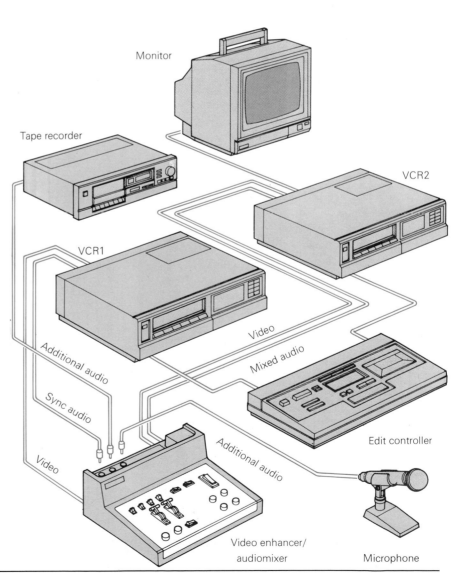

Monitor

Tape recorder

VCR2

VCR1

Video

Additional audio

Mixed audio

Sync audio

Video

Additional audio

Edit controller

Video enhancer/ audiomixer

Microphone

HI-FI SOUND DUBBING

Hi-fi camcorders and VCRs have added a new dimension to home video. Their excellent sound recording quality is achieved by placing the sound heads on the helical recording drum alongside the video heads. This means that both the audio and video information is recorded in tracks that run diagonally across the tape. The effective tape speed at which the soundtrack is recorded is much faster than on regular VHS, giving improved quality. The disadvantage is that sound dubbing is not so straightforward, since you cannot dub directly to the diagonal audio tracks.

On hi-fi equipment, all changes to the tape need to be performed during the process of copying. You need a hi-fi VCR, a hi-fi camcorder, and one other VCR. You use one tape to assemble an image sequence and another to make a synchronized hi-fi soundtrack by copying and remixing between machines. Finally, you copy the master vision tape and the finished sound tape at the same time onto a third-generation tape which is the finished product. Although the hi-fi soundtrack is achieved at the expense of an extra generation of copying, the quality should be quite adequate, especially on S-VHS or Hi-8 formats.

Future developments in hi-fi sound editing will include the possibility of dubbing directly to the helical AV tracks. An extra set of heads on the recording drum will be capable of lifting sound and vision in advance of the main heads. The signals can then be modified by audio or video mixing, dubbing, or replacement, before being re-recorded in the same position on the tape.

Additional resources

Sophisticated sound-mixing equipment is now available at reasonable prices. The self-contained "Portastudios" used by many amateur musicians have high-specification multi-track recording facilities, combining the roles of mixer and audio tape recorder. Some, expressly intended for video work, include a synchronizing device to allow frame-accurate dubbing over long sequences of vision.

Although it can be fun to create and record your own sound effects, there are many records of copyright-free sound effects and music that you can use to enhance your videos. Sound-effects records usually offer a selection of effects – from parties to rail accidents, summer countryside noises to blood-curdling screams. You can copy these onto tape for dubbing to video. If an effects track is not long enough for a given sequence it can be doubled by re-copying. If you overlap the effect using two separate tracks, the join will be seamless.

Reel-to-reel
A good reel-to-reel audio tape recorder like this eight-track model is capable of producing soundtracks of the highest quality. This unit has the advantage of a remote-control

Multi-track mixer
Professionals use mixers with as many as 16 tracks to put together a complex soundtrack. Each track has a slider control to fade the sound in and out, together with a host of controls to vary the tone of the incoming sound. Less costly versions, with fewer tracks, are also available.

The protable studio
Units like this, combining a four-track mixer with a cassette tape recorder, are increasingly popular with amateur musicians. They can produce results of quite high quality and have noise-reduction circuitry to reduce tape hiss.

MIDI-studio
At the top end of the ''compact studio'' range, this device combines a ten-track mixer with a high-quality cassette recorder. It is compatible with the MIDI system, meaning that a wide range of electronic musical equipment can be connected to it.

ADDED AND DUBBED SOUND

The techniques you can use to add sound to your video tapes vary from the simple dubbing in of one sound source to the complex multi-track mix. But whichever method you use, it is essential that you choose your additional sound material carefully. Pay attention to the best method of delivery when speaking your commentary and, if you are adding music, devote some thought to what is the best accompaniment to your images. You should also try to be restrained about added sound. A continuous commentary can distract the viewer from the visual images and become boring, so learn when to let the pictures speak for themselves.

Adding a commentary

Commentary may be added, either with or without music, to any film that you find does not tell its story by purely visual means, or where sync sound needs some further explanation. At its crudest, a commentary for a very short film can be recorded and played "wild" as an accompaniment but video offers great opportunities for sound editing, so you will probably want to record your commentary on the video tape itself.

In a commentary, your role is to guide the audience into the movie: you are subtly placing your own personality between the video and the audience, which is why so many filmmakers prefer to write and read their own scripts.

Writing a commentary

The fundamental problem when writing a commentary to accompany a film is that the information you give should add to the movie without duplicating what is already on the screen. The writing should not, in general, be too jokey or too solemn, because after two or three showings you may well regret the intrusive style. It is best not to combine the moment of maximum verbal information with the strongest visual images as they tend to compete for the viewer's attention. Both are weakened as a result. It is most important, when writing a commentary, to time the delivery of the words so that those which are crucial to the new shot are spoken *as the new shot begins*. To illustrate this point, we can use a simple example. You may have used two different locations in a movie – a woodland setting and a coastal area. When writing the commentary to cover the transition between these locations, you should aim to hit the word "sea" just as the shot cuts from one scene to the other (see right).

This particular example may seem pretty obvious, but if carelessness of this kind is carried across the whole film the effect on the audience can be one of unease; they will be jarred every time the spoken word and picture clash. If the commentary is well presented, the audience will absorb the information without being aware of it.

The commentary should be written and recorded so that key words in each sentence hit the cuts or events precisely as the relevant piece of tape is viewed. In this way, *the sound will appear to motivate the cut*, not the other way round.

Choosing the music

By far the most common form of added sound is music. For a private movie that you have no intention of exhibiting in public, you can choose from the vast range of recorded classical and popular disks or cassettes. Alternatively, you can make a choice from the various, but somewhat anonymous, "mood music" recordings.

The best solution of all to finding a musical accompaniment to your movie is a piece that is specially composed. If, for instance, you have a friend who can improvise on the guitar or piano, let him or her view the tape a few times until it is familiar. Then, when they are confident, record the improvisation onto audio tape, which you can dub in later.

Recording a commentary

The quality of any voice is not easily changed, so you should be honest with yourself when deciding if your voice is the best available. Set up the microphone a foot or so away, check for the sound level, make the recording and then play it back to check the result. You should aim for a cool, conversational delivery with neither histrionics nor flatness. The method you use to match sound to picture will vary according to which of the main dubbing systems are in use. In any case, make sure the timing is satisfactory. If your commentary is too long, you will either have to re-record or consider cutting the vision. Careful rehearsal should help you keep your commentary to the right length.

Cue for music
You can often heighten the atmosphere of a landscape shot by dubbing in some music on the soundtrack. This must be something that conveys the mood you want. For a shot like this, Hawaiian music might set the scene if it is part of a travelogue – but you might use something more menacing if the shot was to form part of a suspense movie.

Correct

"... after so many days in the forest we began to long for the sea (cut) ..."

Incorrect

"... the sea occupied our thoughts during those days in the forest (cut) ..."

Steady descent
An unusual subject like the cable ladder on Half Dome in the Yosemite National Park, California, may need some explanation in the commentary. But do not let your words distract the viewer from the sheer visual drama of the descent.

TITLE.	Gone With The Wind – 50th Anniversary Edition
CATEGORY.	Romantic Adventure
STARS.	Clark Gable, Vivien Leigh
DIRECTOR.	Victor Fleming
YEAR OF PRODUCTION.	1939
RUNNING TIME.	220 mins approx.

SYNOPSIS.

A celebration of the 50th anniversary of Hollywood's greatest screen classic.

To mark its 50th anniversary, "Gone With The Wind" is brought to video as never before seen, capturing the visual impact experienced by the audience of 1939, in a specially packaged limited edition.

This epic masterpiece has been painstakingly restored to its former brilliant colour and the soundtrack has been carefully enhanced.

Set in the turbulent period of the American Civil War, this timeless spectacle of passion and adventure based on the Pulitzer prize-winning novel, has won ten academy awards and continues to inspire an audience of millions with its unforgettable performances.

CATALOGUE N
RELEASE DAT
BBFC CERTIFI
T.V. HOLDBAC
DEALER PRIC

MARKETING A

- The 50
 the leg
- A newly
 original
 video.
- The am
 soundt
- A huge
 created
 be sust
- A fabu
 design
- A rema
 remark
 makes
- One go

EDITING TO SPEECH

There is one major problem when editing vision on tape, as a vision insert edit to match a pre-recorded commentary – when should you cut to the object or event being referred to? First, you should rarely cut to it after the end of the word in question, and certainly not after the whole sentence used to describe it. A better alternative is to cut to an illustration of what is being described just as the relevant word begins, *or slightly before it*. This should not, however, be repeated too often or an impression of overliteralness may be created. The timing is similar to the technique used when dubbing commentary onto a pre-cut sequence, though here the priorities are reversed – the sound is the master, and the vision cut to match. The only problems that are likely to arise involve moving shots, which have a fixed beginning and end. Try to adopt a flexible and varied approach to visual illustration of a commentary so that the audience is kept informed, sometimes surprised and never kept waiting for a point to be made. Avoid the temptation to overdo the commentary: where possible, let the images speak for themselves. Better still, add the commentary last; having edited vision first.

Overlapping dialogue

When you are intercutting between two or more people who are engaged in conversation, the obvious thing to do is to cut to each person as they begin to speak. This was, in fact, the way the early filmmakers used to edit dialogues. However, it will soon become clear that very often the most compelling shot will not be of the person speaking but rather the reaction shot of the listener.

In the example used here, a man is talking to a woman. He suspects she has been out with someone else, and is clearly jealous. As the dialogue progresses, his suspicion hardens into certainty, just as the woman's evasion turns into outright resentment. The cutting of this could perfectly well follow the pattern of speech, but the reactions would then be lost. Instead, a pattern such as the one suggested on the right might be adopted. We begin with one straight line from each of the participants involved in the conversation.

Then, after "Is your phone out of order?" we cut to the woman to catch the first ripple of apprehension before the man says "I phoned twice". Similarly, we cut back to the man after she says "I suppose it must be", so as to record his visible disbelief, and back to her once more as the word "Ritz" gives the game away for good. This is, of course, only one of the many possible ways of editing the sequence, and much would depend on the action – a vigorous hand movement, for instance, might well provide a better cutting point than the dialogue.

When editing an interview, you should always favor the subject, reserving your reaction shots for key moments or for cutaways to be used in editing.

Where to cut
When editing a tape to match a pre-recorded commentary, make certain that you listen carefully to the words *before* making the cut. The example on the right shows both the wrong and the right way to make a cut. Although the example may seem obvious, a cutting mistake like this could destroy the atmosphere you are trying to create as the audience dissolves into laughter.

Correct

The children went to the zoo and admired the camels

Incorrect

Man:	"Did you enjoy the evening?"	
Woman:	"I didn't go out."	
Man:	"Is your phone out of order?"	"I phoned twice . . ."
Woman:	"I suppose it must be."	"I must have it checked."
Man:	". . . and I could have sworn I saw you coming out of the Ritz."	"I must have been mistaken."
Woman:	"Yes you must."	

Man: "Did you enjoy the evening?"

Woman: "I didn't go out."

Man: "Is your phone out of order?"

Man: I phoned twice . . ."

Woman: "I suppose it must be."

Woman: "I must have it checked." **Man:** ". . . and I could have sworn I saw you coming out of the Ritz."

Man: "I must have been mistaken." **Woman:** "Yes, you must."

APPENDICES

VHS · UMV 10284

10th October 1989

PG

–

T.B.A.

OTIONAL SUPPORT.

sary of Hollywood's greatest screen classic starring
ARK GABLE and VIVIEN LEIGH.
35mm print displays the brilliant colour seen by the
es of 1939 and is now available for the first time on

toration also includes a carefully enhanced

f publicity in national press, on radio and on TV has
ed public awareness and interest in the film which will
the video release.
emorative sleeve and quad posters have been
rate the 50th anniversary.
ce level has been sustained for this
– along with the anticipated consumer demand this
must for all libraries.
token available per copy.

INTERNATIONAL TELEVISION STANDARDS

There are three different, incompatible systems for encoding video signals. These three "standards" are used in different parts of the world, which means that tapes made in one country will not necessarily play back on equipment used in another part of the globe.

The three standards

The first system to be invented is still used in America, Japan, and some other countries. It is known as NTSC after the National Television Systems Committee of 1953. Unfortunately, the early system suffered – and still does – from a poor tolerance of phase distortion at every stage of the process, leading to the unkind nickname Never Twice Same Color.

In the PAL system (Phase Alternation Line), which is the European standard (except for France), one of the two color-difference signals is changed in phase every alternate line, while the other is not. By comparison of the phases in the receiver, any transmission distortions or errors can be canceled out, and the hue of the colors accurately maintained. PAL is, however, only a minor variation – though a very significant improvement – on NTSC. A further complication is that the PAL system used in the UK (shown as PAL 1 on the chart) is not compatible with the PAL system used on the European mainland.

SECAM (Séquential Couleur à Mémoire), the French system also adopted in the USSR and eastern Europe, is a far more radical departure. The R-Y signals is transmitted on one line, and the B-Y on the next. A memory circuit in the receiver compares the two, and the resulting color stability enables total control of the color at the point of transmission. The receivers are slightly more expensive than PAL or NTSC.

The three systems transmit on different line standards: NTSC, 525; PAL, 625; and SECAM, also, now, 625. All the systems can be viewed in monochrome on a black and white receiver.

The chart on this page shows which standard are used in which countries. Some manufacturers offer video recorders that are switchable from one standard to another for purposes of playback only.

Television standards chart
The chart shows a list of the world's major nations and which of the three standards they use. Countries that use non-standard versions of PAL are also indicated.

Country	Standard
Albania	SECAM
Algeria	PAL
Argentina	PAL
Australia	PAL
Austria	PAL
Bahamas	NTSC
Bahrein	PAL
Bangladesh	PAL
Barbados	NTSC
Belgium	PAL
Bermuda	NTSC
Bolivia	NTSC
Brazil	PAL M
Bulgaria	SECAM
Burma	NTSC
Canada	NTSC
Canary Islands	PAL
Chile	NTSC
Channel Islands	PAL I
China	PAL
Colombia	NTSC
Cuba	NTSC
Cyprus	PAL
Czechosolvakia	SECAM
Denmark	PAL
Dubai	PAL
Ecuador	NTSC
Egypt	SECAM
El Salvador	NTSC
Finland	PAL
France	SECAM
Germany (East)	SECAM
Germany (West)	PAL
Ghana	PAL
Gibraltar	PAL
Greece	PAL
Greenland	NTSC

Country	Standard	Country	Standard
Guam	NTSC	Pakistan	PAL
Haiti	NTSC	Panama	NTSC
Hawaii	NTSC	Paraguay	PAL
Honduras	NTSC	Peru	NTSC
Hong Kong	PAL I	Philippines	NTSC
Hungary	SECAM	Poland	SECAM
Iceland	PAL	Portugal	PAL
India	PAL	Puerto Rico	NTSC
Indonesia	PAL	Romania	SECAM
Iran	SECAM	Saudi Arabia	SECAM
Iraq	SECAM	Singapore	PAL
Ireland (Eire)	PAL I	South Africa	PAL I
Israel	PAL	Spain	PAL
Italy	PAL	Sri Lanka	PAL
Jamaica	NTSC	Sudan	PAL
Japan	NTSC	Sweden	PAL
Kenya	PAL	Switzerland	PAL
Korea (South)	NTSC	Taiwan	NTSC
Kuwait	PAL	Tanzania	PAL I
Laos	SECAM	Thailand	PAL
Lebanon	SECAM	Tibet	PAL
Liberia	PAL	Tunisia	SECAM
Liechtenstein	PAL	Turkey	PAL
Madagascar	SECAM	Uganda	PAL
Madeira	PAL	UAE	PAL
Malaysia	PAL	UK	PAL I
Malta	PAL	Uruguay	PAL
Mexico	NTSC	USA	NTSC
Monaco	SECAM	USSR	SECAM
Mongolia	SECAM	Venezuela	NTSC
Morocco	SECAM	Yemen	PAL
Mozambique	PAL I	Yugoslavia	PAL
Netherlands	PAL	Zaire	SECAM
New Zealand	PAL	Zambia	PAL
Nicaragua	NTSC	Zimbabwe	PAL
Nigeria	PAL		
Norway	PAL		

FUTURE DEVELOPMENTS

The world of video is developing with alarming speed. The specifications of televisions, VCRs, and camcorders are improving almost week by week, making it often difficult to decide whether to buy the latest piece of equipment or to wait for the next technical breakthrough. Many of the features offered on VCRs are already beyond the needs of most people. For example, timers frequently offer the possibility of recording more programs than will fit on a single tape.

But there are useful new features appearing on VCRs. Index search, for example, provides a way of locating different programs on the same tape. A cue signal is placed on the control track of the tape and the machine can find this signal. Some systems offer instant replay of the first section of the chosen recording, or numbering of the various index points on a tape, so that you can easily find the program you want.

Another feature that will become increasingly common is digital tracking. This automatically finds the best tape position for accurate tracking and optimum reproducing of sound and picture. It is one of many refinements that are less obvious from the outside of the machine but which give improved performance. Such features can be more useful than a host of controls.

Tapes

Manufacturers are continuously researching ways of making tapes longer. One of the main problems is that a longer tape inside a cassette of any existing format inevitably means thinner tape. Nevertheless, longer-playing tapes in both standard VHS and VHS-C formats are on the way. No doubt those extending the playing time in the compact format will be particularly welcomed.

Camcorders

Perhaps the greatest limitation of current camcorders is the fact the electronic viewfinder only shows you the subject in black and white. But color viewfinders are just around the corner. This will be a boon to video makers everywhere. While the small size of the viewfinder will still mean that a monitor will be needed for checking color in really critical work, a good-quality colour viewfinder will remove many of the anxieties about color rendition that amateur video makers often face.

The other developments in camcorders will also be aimed at reducing operator anxiety. Exposure measurement and autofocus will continue to become more accurate. But it is to be hoped that manual settings will not disappear altogether from camcorders. No amount of technology will take away the occasional need to override the automatic settings.

Video printer
One of the most revolutionary developments in home video, the video printer allows you to look through a recording frame by frame and print out the frames of your choice. The images are in high-quality color, and a zoom lens enables you to make selective enlargements.

Still video

One of the most exciting developments in recent years has been still video. In this system, a special camera can record up to 50 still images on a floppy disk. The camera can then be connected to a television via a variety of leads and the images can be viewed on the screen.

The system is portable, easy to use, and has many advantages over conventional still photography. There is no film, so loading the camera is simply a matter of inserting a floppy disk. The developing stage is eliminated completely and the results can be viewed instantly if there is a television screen to hand. Picture quality, while not yet up to the resolving power of a top-quality 35 mm camera, is good; each frame is made of 40,000 individual elements (or "pixels"), giving a sharper image than regular broadcast TV pictures. The floppy disks can be erased and re-used, just like video tape, so you avoid the repeated expense of film and the feeling of waste that comes with shots that do not come out as you hoped. The cameras have sophisticated exposure meters and many of the features, such as autofocus, automatic exposure, and backlight compensation, that you often find on conventional still cameras.

In the future a printer will become available, enabling you to obtain hard copies. In fact, one company is already producing a home video printer, although this is not being supplied in conjunction with a still video camera. It is designed to allow you to play through your video tapes and capture favorite moments. These can then be printed out. The printer has its own zoom lens,

Still video camera
This still video camera can record up to 50 images on a single two-inch floppy disk. The pictures can be played back by connecting the camera to a television or monitor. The sensitivity of the imaging chip is similar to that of 100 ASA/ISO film, which means that the camera can be used in quite a wide range of lighting conditions with its shutter speeds of between 1/500 and 1/30 sec.

FUTURE DEVELOPMENTS

which allows you to print a section of your chosen frame. There is also a built-in character generator, to allow you to label the pictures and print the data and time on them. A piece of equipment like this could be as useful for the movie maker as the still photographer. It shows how, in the future, the television will become the heart of an entire video system, offering facilities for moving and still images, the reception of both satellite and conventional broadcasts, and hi-fi sound.

For the moment, the image quality is not high enough for still video to replace conventional photography. But for snapshots and other areas where on-screen viewing is desirable, still video should soon become popular – especially when the prices of this new technology come down. The rapid-replay ability of still video should also mean that it will replace instant-picture cameras.

Video disks

Disks containing pre-recorded video material have been available for some years now, although they have not been widely used. But recent developments make it more likely that video disks will become more popular.

Video disks work in a similar way to the familiar audio compact disks. Sound and picture information is encoded on the disk in digital form. The disks are then "read" by a laser pickup and the results can be viewed on screen or listened to on an audio system.

There are several advantages over ordinary video tape. First, because there is no physical contact between the laser pickup and the disk, wear is reduced to a minimum. Second, the information on the disk can be read in any order, without laboriously winding or rewinding the tape. Third, the digital technology involved gives superb sound and picture quality. On the other hand, disks can only be used for playback.

The possibility of accessing any section of the disk instantly makes this medium suitable for storing reference information containing both words and pictures. It would be an ideal place to store the pages of an encyclopedia, for example, with the added extra of accompanying digital sound.

There are various different sizes of disks. The larger 30 cm and 20 cm disks (usually known as laserdisks) offer up to 72 minutes and 32 minutes of play time respectively. The smaller disks are 12 cm in diameter, the same size as audio CDs – they are therefore known as CDVs, and they provide up to 6 minutes of color video with digital sound, plus an additional 20 minutes of digital audio.

Digital audio tape

One of the most interesting developments in audio in recent years has been digital audio tape (DAT). This type of tape allows much higher quality reproduction than conventional analog tape, because the digital code in which the sound information is stored is not prone to distortion. In other words, it offers the advantages of compact disk, with the added bonus that DAT is also a recording medium.

DAT will accept any digital information – pictures as well as sound. There is already one DAT recorder that can be adapted for the recording of still video pictures. This is yet another hint that video and audio equipment will become increasingly integrated as time goes on.

CD video player
Players like this use a laser pickup to read the billions of microscopic pits on the surface of the disk. The machine then translates this digital information into pictures and sound. The result – superb picture quality and lifelike sound.

Large and small
Miniaturization has led to some remarkable feats of compression in electronics. Notable in video have been smaller and smaller camcorders, tiny color monitors, and portable VCRs (top right). More dramatic still are the developments in larger screens (top left), with high-definition wide-screen television promising to recreate the effect of the cinema. Even for people unable to afford the cost or space needed for the largest receivers, the benefits in image quality will be felt in smaller sets.

Developments in television

There is little point in the improvements to the quality of audio and video if the television screen does not also improve in quality. Without a large, good quality screen, video still cannot approach the experience of watching a film in a modern cinema. Until recently there was a major problem with increasing the size of television screens: because of the design of the tube, any increase in screen size had to be matched by an increase in the depth of the receiver. Wide screens meant very large boxes indeed.

Modern technology has overcome these problems to a certain extent, with screen sizes of up to 37 ins (1.1 m) possible. Projection televisions come even larger, but they are also very costly. Improvements in large-screen pictures are already possible with improved displays that effectively double the number of scan lines on the screen. Receivers with this ability also incorporate circuits to remove flicker and clean up the picture.

But the real leap forward will come when new transmitting systems are introduced, to provide true high-definition television (HDTV). The first type of HDTV is already being used in Japan. An extra signal is transmitted containing an element that enhances the picture. This means that ordinary receivers can pick up the broadcasts – they simply ignore the extra signal. A similar system known as PAL Plus is being developed in Europe and another system in the USA.

The final phase aims at a more radical improvement. Known as HD-MAC, it will increase the number of scanning lines to 1,250. Its pictures will contain so much detail that they will require a broader bandwidth than conventional TV pictures. For this reason they will have to be broadcast via fiber-optic cables or satellites rather than conventional ground-based transmitters. Film-like picture definition will be possible.

Smaller screens

If recent trends are anything to go by, televisions will not only get larger in years to come. Improvements in image definition will also make smaller screens a better proposition. Pocket LCD televisions are already available, of course. They are starting to show their usefulness to the video maker because they allow portable, on-the-spot monitoring of video images in situations where larger monitors are not available. But their role is limited because the image quality is poor. Improvements in LCD and flat-screen technology should soon make smaller televisions more useful – and easier on the eyes.

Communications

The technology is now available for video telephones, allowing your picture as well as your voice to be sent to the person at the other end of the line. The problem here is that the amount of information needed to transmit both the voice and the picture is simply too great to be sent over most telephone lines. Ingenious methods have been tried to break up the picture and voice signals – sending the pictures during the gaps between words in the conversation, for example. Another system allows the receiver to memorize static elements in the picture so that only information about image movement needs to be sent down the line. The Japanese have had some success, but none of these systems has yet proved satisfactory on European or American telephone lines. It seems that, for most of us, videophones must remain a dream of the future.

CABLE AND SATELLITE TV

These two alternatives to conventional broadcasting offer the possibility of a much wider selection of programs. They are also useful in areas where reception is poor. Both systems have existed for some time in the USA; they are now gaining ground in Europe too.

Cable companies are fed their various channels via a network of satellites, which beam literally hundreds of channels to earth-stations for distribution through cable. It is highly likely that in future, to cope with the huge bandwidths required for multi-channel broadcasting, optic fiber cable will be used rather than the current coaxial high-loss cable.

Satellites transmit in the microwave band (3700–4200 MHz) from geo-stationary orbits over 32,000 kilometres (24,000 miles) above the earth. Modern satellites have much larger solar panels than their earlier counterparts. They therefore transmit more powerfully, and over a larger "footprint" on the earth's surface, than their predecessors. A circular or square dish is needed to intercept their transmissions. Originally these were 10 ft (3 m) in diameter, but with the higher-power satellites now entering service, 2 ft (60 cm) dishes are now the norm. They must be very precisely aligned since microwaves are extremely directional. Then a low noise amplifier at the antenna will also be needed, and a receiver to convert the high-frequency microwave FM signal to a lower frequency AM signal that the TV can use. Some systems offer a remote control to swivel and tilt the dish from indoors.

In order to receive satellite broadcasts, you require one of the now-familiar dish antennae. This needs to be mounted on the outside of your house and aligned correctly so that it picks up the signals from the satellite itself. In the USA, where there are many different satellite broadcast sources, this often entails a dish that allows motorized adjustment, so that you can line it up with different sources. In the system most commonly used in Europe, there is also an amplifier, which is positioned on a boom in front of the dish. This amplifies the weak signals that the dish receives from the satellite and passes them to a receiver inside the house. This unit is in turn connected to the television.

The receiver has a series of buttons for the selection of preset television channels, and these are duplicated on an infrared remote control unit. Once the receiver has been tuned manually, choosing a channel is simply a matter of pressing one of these buttons.

Satellite receivers in Europe also have a SCART socket, allowing you to send stereo sound signals to your audio system. The result is a vast choice of programs, superb, studio-standard reception, and the potential for excellent sound quality. But the usefulness of equipment such as this depends on whether you actually want to watch the programs offered by the satellite companies.

Satellite reception
A dish and a receiver are the requirements for satellite reception. The dish must be attached to the outside of the house (inset) in a position that allows alignment with the incoming signals. In some countries you need an adjustable bracket to receive signals from the different satellites broadcasting in the area.

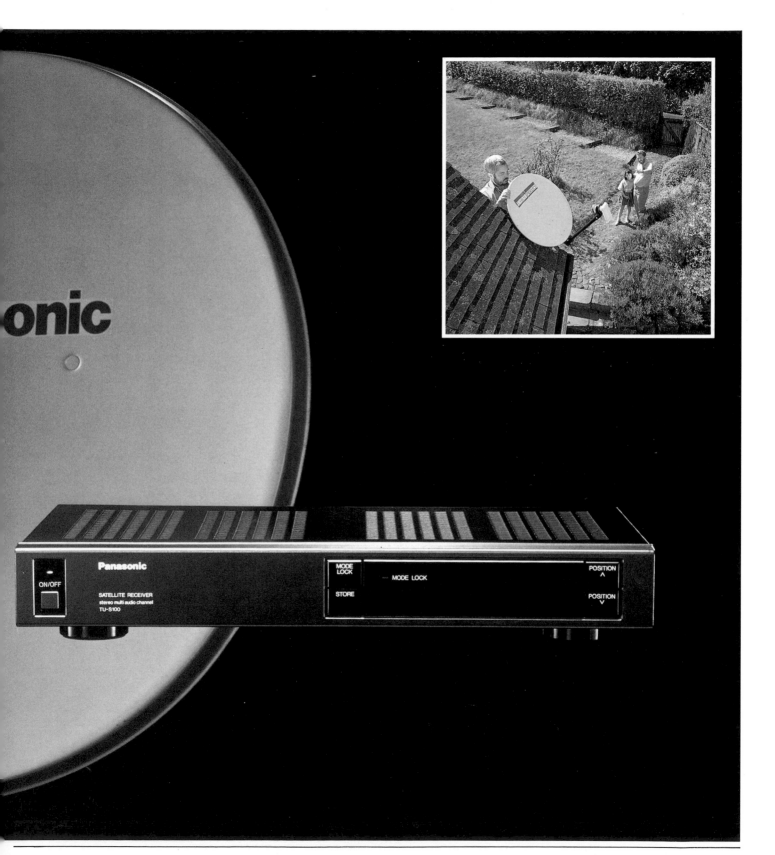

PRE-RECORDED TAPES

Pre-recorded tapes are widely available. The best choice of material is in the VHS format. Feature films are the most popular choice, although many are pirated. But the latest releases are expensive, especially when compared to video disks or the cost of a blank tape, and you might prefer to confine your purchases to those tapes which you will want to watch repeatedly, or on which you could profitably use the freeze-frame facility – instructional tapes, coaching courses, educational programs, do-it-yourself lessons, even video instruction manuals.

The reproduction quality of pre-recorded tapes varies wildly: at best, it is excellent; at worst, in a third-generation pirated tape, it is virtually unwatchable. Fortunately, as the cost of tape and technology has come down, pirating has become less profitable and less of a problem. Now many rental videos are hi-fi stereo.

Nevertheless, rental services and video clubs are clearly more economical, and the modest weekend rental for a 2-hour feature is certainly less than the cost of taking even a small family to the cinema. These facilities are likely to grow rapidly in the future, and if laserdisks (which are virtually immune to wear) take a hold it may be expected that video-disk libraries will also spring up.

Video and the law

The law in almost all countries has not kept pace with technology, and the situation is often unclear where video material is concerned. A prerecorded tape is usually covered by the copyright of the original program-maker, unless this has expired. If the tape is copyrighted, you may legally watch it, rent it to others, resell it, give it away, or show it to family or friends. It is illegal to copy it or charge an entrance fee for the viewing.

The same applies in theory to all taping off air as well as to cable-vision, though the virtual impossibility of enforcing the law even in cases of major piracy, let alone for the small-time "thief", has brought it into some contempt.

The major manufacturers, however, especially in the USA, have found a system to defeat home copying. This consists of an anti-piracy signal placed on the control track of pre-recorded tape. It weakens the vertical sync signal so that the tape can, in theory, be played, but cannot be copied onto another recorder without loss of vertical sync. Unfortunately, even playing such tapes on many receivers causes frame-roll, and not all receivers have accessible vertical-hold controls. To make matters worse, some recorders may be used quite successfully as record machines. Finally, devices are available which, placed between replay and record machines, defeat the anti-piracy system entirely. It is plainly illegal to *use* such devices but not, apparently, to sell them.

Video games

Video games generally come as a separate piece of hardware which you plug into the antenna socket of your television. This is then tuned to receive the RF frequency transmitted by the game's modulator. Games may be conveniently divided into three types: simple "dedicated" games; semi-programmable; and fully programmable.

Dedicated games

These cheap and cheerful machines originally used transistors to play just one simple "ball and paddle" game such as table tennis. The later models use an integrated chip: this might, for instance, give tennis, soccer, squash, and a rifle target game on one chip, with joy sticks and a target rifle as possible accessories. More sophisticated developments include color, variable speeds, and variable sizes, but all such dedicated units are incapable of expansion beyond their original pre-programmed games.

Semi-programmable games

Semi-programmable games are in essence a hybrid – they are an attempt to widen the possibilities of the dedicated game without the major expense of fully programmable games. Here, the custom-built integrated chip (IC) is housed in a small plug-in cartridge, which may be replaced at any stage in the machine's life with additional cartridges that in turn contain a whole range of new games. However, the extra cartridges are comparatively expensive to produce and the range of software in these games is likely to be limited. In view of this it seems likely that semi-programmable games will in the long run be entirely replaced with the much more flexible fully programmable types.

Fully programmable games

In fully programmable games a central console is essentially a simple computer, which reads and responds to the computer language on the plug-in cartridge. These cartridges are much cheaper to produce than the custom ICs used on semi-programmable machines, and altogether vastly more flexibility is possible. Some of the more advanced machines in fact offer computer facilities, with keyboards, thus providing a bridge to the home user between games and the true home computer. These accept a wide range of different games cartridges.

The logical extension of this trend is to use a home computer to play the video games. Such a machine can offer not only very advanced graphics, with three-dimensional games and highly realistic movements that virtually amount to animation, but also the ability to run other types of computer programs. Video disks give vastly better interactive graphics than tape.

Movies on tape
The range of movies now available on pre-recorded tape is enormous. From classics like *Gone with the Wind* to films released only recently in the cinema, there is material to suit all tastes. The vast majority of pre-recorded tapes are on the standard VHS format.

MAINTENANCE AND TAPE STORAGE

Treat your equipment carefully and it should give years of trouble-free service. Keep camcorders and accessories in their cases when they are not in use. Metal cases with foam inserts will protect equipment from dust and help to cushion it from any impact. Keep VCRs in an environment that is as free as possible from dust.

Lenses should never be cleaned with a cloth, and even lens tissues or special lens cloths should only be used for really stubborn smears that cannot be removed with a blower brush or compressed air, nor brushed away with a squirrel's-hair brush. If you do use them, be careful not to grind dirt into the delicate coating on the lens. *Never* touch the glass surface of a lens, and use the lens cap when the camera is not in use.

Head cleaning

All VCRs tend to accumulate deposits of dirt on the spinning video heads, the static heads, and the rollers. The dirt is an amalgam of oxide, dust, and grease, which passes into the machine with cool air, and after about thirty hours of play this will produce a noticeable degradation in the picture – drop-outs, streaking, and video noise. Quite a wide variety of so-called cleaning cassettes is available, but they should be chosen and used with great care since they are all, to a greater or

Head cleaner
Special cassettes are available which clean harmful oxides and other residues from the heads of your VCR. This type comes with a cleaning solution which you add to the cassette before inserting it into the VCR and pressing the play button. It cleans the whole tape path, including the rollers and capstan.

lesser degree, abrasive, and in the process of cleaning the heads the eventual life is always shortened. The cassette is inserted into the machine, and played for a few seconds only. Some cleaning cassettes are absorbent, and they can be soaked in a solvent (usually called TCTFE) which is highly effective at gently removing deposits.

A manual method of cleaning needs to be used with reel-to-reel machines (VTRs), and you can also use this procedure for VCRs. It is not really recommended at all, but if you have to clean a VCR using the manual methods, always disconnect the machine from the electricity supply, be careful not to drop screws into the works, and if in any doubt, have the job done professionally. Suffice it to say that the top cover must be removed to gain access to the heads – to be more specific is impossible in view of the wide variety of machines. However, the following is a likely procedure: remove the Tracking knob; press Eject; unscrew all the Philips screws from the top cover, and carefully lift it clear. You should now have access to the heads, and from here on the principles are the same as for VTRs, in which the heads are always accessible. (When cleaning VTRS, however, the function lever should be placed in the REW or FF mode.)

Dip the swab into the cleaning solution, and very gently wipe it *horizontally only*, to and fro across the heads. This movement must only be in the same plane as the tape travel. The video erase, audio, and control track heads may be cleaned in the same way, as may the capstan and tape guides. If, in the case of a VCR, the top cover has been removed, take care not to drop any screws when replacing it.

Tape storage

It will not be long before you have a collection of video tapes. These will probably include pre-recorded tapes, tapes off air, and home movies. In all cases, it is good practice to adopt a sensible yet not too complex indexing system from the very start, even if at first you do not expect to amass a large collection. Tape collections have a habit of growing, and can rapidly get to the point when you begin wiping important tapes by mistake. Pre-recorded tapes are very straightforward, and so, up to a point, are family tapes: they can be simply identified according to the subject, tape counter, and duration, and numbered for easy retrieval. Remember, though, that tape counters vary, and if a tape has been recorded on a portable machine or camcorder it will almost certainly not correspond to a domestic recorder's counter at a later date. Store tapes upright, in cases, in a dust-free area.

Recording off air

Before the question of cataloging can begin to arise, the recording itself must be guaranteed. If the timer is in use, always check before leaving the house that the recorder is switched to Timer and, if applicable, to Record. The tape should have been rewound, zeroed, then wound on to the recording position if you are not starting at the beginning of the tape. Make a note of the

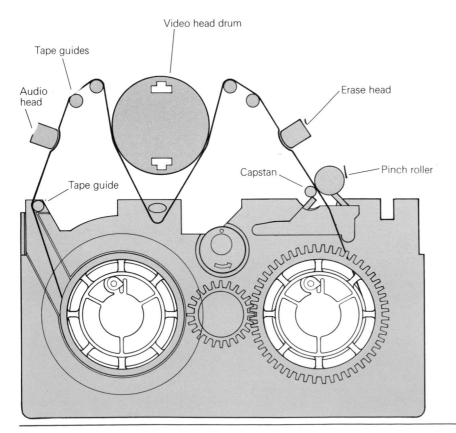

Tape guides

Audio head

Video head drum

Erase head

Tape guide

Capstan

Pinch roller

counter reading for the beginning of the recording. You will then be able to log this into your filing system from the very start. Allow plenty of leeway for off-air programs, since they often begin, and therefore end, late.

Conversely, if you are recording a program on a commercial channel while monitoring it yourself to edit out commercials, remember that less time will be needed on the tape than the total advertised duration. This consideration is particularly useful in the USA, where commercials may make up 20 percent of the total air-time.

Cataloging and indexing

The tape counters on many VHS machines do not operate in real time or in footage: in order words, "100" at the beginning of a 3-hour tape does not correspond in time to "100" at the end. However, your machine may offer a valuable time readout. Therefore it is vital that in making all counter notes, the tape should have been accurately zeroed at the start, and that the end of the recording should have been noted. Time/counter calculators, at various tape speeds, have been marketed in the USA, and they have their uses in optimizing the use of blank tape. They are not, of course, applicable to European tape speeds, being purely mechanical card-calculators or charts.

Make a separate card for each numbered tape, noting the counter numbers or start time, duration, and title of each item, with recording speed if appropriate. On another card, list each title, with a cross-reference to the tape number. This may be one large card if you have fairly few tapes, or you could use a small box-file with a separate card for each item, filed alphabetically, for a larger library. Finally, on the stick-on labels that come with the blank tape, list the contents, with footages. This will need updating and replacement if the tape is used a lot, as will that on the spine of the cassette and cover.

Repairing tape

Joining video tape should only be considered as a last resort. Even then, you should only use proper video splicing tape – anything else will damage the video heads and you will have an even worse problem on your hands. To avoid damage to tape in the first place, buy only top-quality brands, never touch the tape itself, and use the pause button sparingly.

If you do have to repair a tape, proceed as follows. With a narrow Philips screwdriver, remove the screws on the underside of the cassette. Press the front panel release catch and open the front panel. Now carefully lift off the top panel, exposing the tape. Cut out all the damaged tape, and overlap the two ends in parallel. Hold them firmly together, and cut them with scissors, butt-jointing them with the splicing tape; it must not go on the oxide side of the tape. Lastly, trim the splicing tape of all overlap, rewind it into the cassette, and, having made sure the tape is correctly threaded through the tape guides, replace the top lid.

Types of tape

Tape formulation is one of the most rapidly developing areas of video technology. Video tape manufacturers are constantly improving their ranges, with the aim of producing tapes that give better quality on both vision and sound. The best tapes currently available, when used in the right conditions with high-quality equipment, can provide results of almost broadcast quality.

But this constant changing and upgrading shows itself in a confusion of different descriptions on tape packaging – both in names such as "Hi-Grade" and "Pro-Grade", which are meant to describe different levels of a manufacturer's range, and in phrases like "metal powder" and "metal evaporated", which describe the tape formulation itself. How can you sort through this variety of different descriptions and select the tape which is best for your needs?

The main way in which tapes vary is in the chemical make-up of the magnetic particles on the front surface. Standard tapes use particles of finely powdered gamma ferric oxide, Hi-grade tapes add other substances, such as cobalt or titanium oxide, and S-VHS tapes use cobalt-modified gamma ferric oxide, which has a very small grain size that can cope well with the very short wavelengths this tape is designed to handle. Some tapes use chromium dioxide, which is claimed to give a much longer tape life than the standard formulations. Tapes meant for hi-fi recording have a thicker magnetic coating. "Metal evaporated" tape is designed to give high quality, but is much thinner, meaning that more tape can be crammed into a smaller cassette.

What this means in practical terms is that buying a higher-grade tape will give a better picture, with an improved signal-to-noise ratio in both picture and sound. The more editing and copying you do, producing recordings several "generations" old, the more important this will be. But any recording, from the first generation onwards, will be improved with better quality tape, and it is pointless to sacrifice this for a little extra cost.

The other major consideration when buying tapes is the manufacturer. You should only buy those that are produced by a recognized maker of tapes or of VCRs and camcorders. Beware of apparent "bargains" in the shape of cheap tapes from unknown manufacturers. At best, they might yield substandard recordings; at worst they might break and clog up your VCR or camcorder.

FAULT-FINDING

Video recorder troubleshooting

Symptom	Cause	Remedy
No power	Power cord not connected, blown fuse or jumped circuit breaker	Check cord, fuse or circuit breakers, and plug in or connect
TV programs do not record	Timer record set to "On"	Set timer record to "off"
	Antenna disconnected	Connect antenna
	Reception channel not properly tuned	Tune reception channel
	Input signal selector not set correctly	Set input signal to "tuner"
Timer recording does not work	Timings set incorrectly	Set times correctly
	Timer record function not selected	Select timer record function
	Clock shows incorrect time	Set clock correctly
	Input signal selector not set correctly	Set input signal to "tuner"
Cassette ejects when inserted	Erasure prevention tab on cassette has come out	Cover tab hole with adhesive tape
Playback picture not in color; or with large amounts of snow	Reception channel not adjusted correctly	Readjust reception channel
	TV set not properly tuned to VCR	Properly tune TV set to video playback channel of VCR
	Video heads are dirty	Consult service engineer
	Video heads are worn	Consult service engineer
	Tape is old or defective	Use new tape
Remote control does not work	Distance too far	Move nearer VCR
	Unit not pointed accurately at VCR	Point unit directly at IR window on VCR
	Batteries exhausted	Use new batteries

Camcorder troubleshooting

Symptom	Cause	Remedy
Color inaccurate	White balance incorrectly set	Set the white balance to match the subject or switch to automatic
Picture snowy or "noisy"	Tracking set incorrectly	Reset tracking controls or restart camcorder
Picture blurred	Dust may have built up on record and playback heads	Consult service engineer
Main subject too dark	Exposure meter misled by backlighting	Use backlighting compensation control or manual exposure to open iris and allow more light to reach the chip
No sound on playback	External microphone not properly connected	Reconnect microphone
	On some models: television system switch not set correctly	Reset system switch
No recording on cassette	Safety tab on cassette removed	Cover the slot on the cassette with adhesive tape
No power	Battery not charged	Remove and recharge battery
Tape runs, but no picture on playback	Correct television channel not selected	Switch television to AV or equivalent channel

Glossary

A

AC (alternating current) box An adaptor enabling the *camcorder* to be powered from wall current; also used to charge the battery.

Acoustic The environment that surrounds and affects any given sound, particularly when making a recording

Acutance The sharpness of the boundary between dark and light areas of an image.

Additive principle Creation of other colors of light within the spectrum by combining the primary colors – red, blue and green.

AFC Automatic frequency control. Circuit that keeps a television receiver tuned to the correct signal

AGC Automatic gain control.

A-lens Anamorphic lens.

Alternating current or line voltage This may be at a frequency of 50 Hz (Europe) or 60 Hz (USA, Japan, and certain other countries).

AM Amplitude modulation. The earliest type of broadcast signal. The strength (or amplitude) of the carrier varies with the changing voltage of the signal.

Amplifier Electrical circuit which increases the power of a signal without affecting its quality.

Angle-of-view A measure of the proportion of the subject and its surroundings which can be included in the image. This depends on both the focal length of the lens and the size of the camcorder chip. A shorter focal length or wider film gives a greater angle-of-view.

Aperture Opening which controls the amount of light transmitted by a lens. its size can be varied to control the amount of light passing into the camera.

Aspect ratio The ratio of width to height of the image.

Assembly editing Method of electronic editing in which shots are re-recorded one after the other to form a coherent sequence.

Audio dub An editing feature which enables the sound track to be re-recorded without affecting the picture. Useful for adding commentary, background music, etc.

Audio head A head which records or plays back sound.

Audio-out The audio output jack or socket.

Autofocus (AF) A system which automatically keeps the image sharp. There are several AF systems. Most camcorders offer manual focus as well.

Automatic gain control Facility on most sound recorders which automatically maintains a steady level of sound input.

Auto iris An automatic aperture or exposure control.

Auto white balance A camcorder feature that automatically makes adjustments for different lighting conditions so avoiding odd colour casts when moving from one type of lighting to another. Many camcorders have a manual override option.

Auxiliary-in (Aux) An audio line input.

Auxiliary-out An audio line output.

AV Stands for audio/video.

Azimuth The angle of a given recording head in relation to the video or audio track.

B

Background light Artificial light used to give a lighter background behind the principal subject.

Back light Light placed behind and slightly to one side of the principal subject in order to produce highlights which "lift" the figure from its background.

Back projection Method of projecting a photographic image onto a translucent screen so that it is viewed from the side opposite to the projector. This is especially useful for effects such as faking a moving background.

Backspace editing Occurs when a recorder or camcorder is put in the record/pause mode. The tape is rewound a little to give clean breaks between sequences.

Balancing Adjusting the relative volume of the different components of the soundtrack to give a balanced composition to each part of the movie.

Bar code programming An innovative system devised by Panasonic. A VCR can be programmed by running a scanner, built into the remote handset, across the black and white bar code. Codes can be read off a special sheet.

Barndoors Metal screens fitted in front of a lamp. They can be opened or closed to give selected areas of the subject extra illumination.

Behind the lens (BTL) Any metering system which views through the taking lens itself. cf. "through the lens" (TTL).

Betacam The professional format based on the obsolete Betamax system.

Betamax The Sony ½-inch video cassette format, also known as Beta format. Now obsolete.

Black level That portion of a video signal which determines pure black in the video image.

Blanking That period of time during the TV scanning of the raster when the beam is shut off as it returns to scan the next line on either camera tube or receiver.

Blue Lamp filter used to bring artificial light to the color temperature of daylight. May be gelatin or dichroic glass.

Boom Pole used to suspend a microphone over the sound source but out of sight of the camera.

Bounced light Light which is not cast directly on the subject but reflected off a white surface such as a wall or ceiling.

BTL Behind the lens metering.

Buffer shot Shot inserted between two others to disguise a break in continuity, or, occasionally, a shot which itself begins or ends in such a way as to disguise a jump-cut.

Bus One complete channel of a video or audio system. Frequently used of switchers and special effects generators.

C

Camcorder A consumer device consisting of a camera and *VCR* packaged in one compact housing.

Cannon connector A high-quality secure audio jack also known as an XLR plug.

Capstan The roller in the VTR that governs the speed of the tape transport.

Cardioid microphone Microphone which is more responsive to sound sources which are in front of it than to those behind or to the side. The pattern of response is heart-shaped.

CCU Camera Control Unit.

CdS Cadmium sulfide, a compound used in light-senstive cells. The electrical resistance varies in inverse proportion to the light received.

Center-weighted metering Through-the-lens metering system which reads the amount of light received by the whole frame but is biased towards the central portion.

Character generator A computer specifically designed to produce electronic screen writing.

Charge-Coupled Device (CCD) A solid-state electronic silicon chip which performs similar functions to the vidicon tube but which is much smaller.

Chroma The color element in a composite video signal.

Chroma key The electronic replacement of one color in a given scene by another video input – the color is usually blue.

Cinéma vérité A filmic technique which portrays, or intends to portray, a candid realism.

Close-up Shot which concentrates on one detail such as a face.

C-mount A standard screw thread for 16 mm movie cameras, also found on video cameras with interchangeable lenses.

Coaxial cable A single-ground one-conductor cable frequently used for video connections. It has a resistance of 75 ohms.

Color burst A very accurately phased burst of high frequency at the beginning of each scanning line. This determines the color of the signal.

Color compensation, see color correction

Color conversion Use of a filter control which compensates for color temperature of the existing light.

Color correction Use of a lens filter which makes up for slight differences between the color temperature of different light sources.

Color separation overlay (CSO) A system of electronically *matte*-ing two video images together by *keying*. The technique works by losing one color (usually cyan) from the original *shot* and placing the second *shot* in the blank area. Obviously, the color areas of the first *shot* must be scrupulously planned in advance.

Color spot filter A special effect filter that produces a clear picture in the center surrounded by graduated color.

Color temperature A scale in degrees Kelvin (°K) which measures the color balance of light. Artificial lighting, for example, contains less blue than daylight and has a lower color temperature.

Complementary colors The colors which combine with each of the primaries to produce white light. They are cyan, magenta and yellow, for red, green and blue respectively.

Composite sync The complete sync containing both horizontal and vertical sync signals.

Compressor Recording device used to narrow the range of volume of sound without producing noticeable distortion.

Condenser Arrangement of lenses which focuses light into a parallel beam.

Confrontation A stage in the development of a *narrative*, the essence of the dramatic in Western culture.

Continuity Correspondence in details such as props, costume, lighting, sound level and direction of movement across the screen between successive shots of the same piece of action.

Contrast ratio The range of brightness between the lightest and darkest objects in a given scene.

Contrast The range of brightness from highlight to shadow in a given subject or image.

Contre-jour Shooting into the light.

Control track The track along the length of tape which contains speed control pulses.

Control track head The stationary head which lays the control track during recording.

Cookie, see Cukaloris.

Copyguard One of several patent systems to prevent a pre-recorded tape being copied.

Crane shot Shot during which the camera is raised or lowered vertically

Cue An electronic signal placed on a tape to indicate an editing point or the beginning of a recording.

Cue sheet List referred to when mixing the master sound track. It is intended to give an indication of timings for particular shots and sections of sound track.

Cukaloris Studio accessory fitted on the front of a lamp and used to project mottled shadows onto a background.

Cut Transition from one shot to another which results from editing the two together.

Cutaway Shot of something not covered by the master shot, but in some way relevant to the main action.

Cutting height Level at which the human figure is conventionally cut by the frame without giving a displeasing composition.

Day-for-night Technique of under-exposing footage shot in daylight to give an impression of night time.

DC Direct current. In batteries for use on portables this is commonly 12 volts.

DC restoration A circuit, sometimes known as black level clamp, which ensures a full tonal range.

dB see Decibel.

Dead acoustic Environment with very low reverberations, in which sound is absorbed and "deadened" by surfaces such as carpets.

Decibel (dB) A logarithmic unit which expresses ratios of powers, voltages, and currents. The scale is logarithmic. It is commonly used for signal-to-noise ratios and for the evaluation of sound volume.

Depth of field The range of distances within which a subject is in acceptably sharp focus at any given aperture and focal length.

Diaphragm The device in the lens which allows the aperture to be varied.

Dichroic glass filter Optical color filter without absorption dyes. Can be made to filter out heat rays.

Dichroic mirrors Mirrors commonly used in cameras which allow some colors to pass, while others are reflected.

Diffraction lens Special effect lens which produces rainbow-colored highlights.

Diffusion filter Filter placed over the lens to give a soft-focus effect.

Digital A way of representing light or sound values as a series of pulses.

Digital counter Accessory on most VCRs and sound recorders which "clocks up" the length of tape that has been played. If it is always set to zero at the start of a tape, the numbers can be used as reference points.

Digital effects VCR A video recorder that uses computer memory chips to create special effects.

Digital tracking A system which automatically adjusts the tape tracking for optimum picture quality.

Diopter Unit of measurement for the light-bending power of lenses. The diopter value of a lens, multiplied by its focal length in meters, equals one.

Diopter lens Magnifying lens used in close-up work. It is placed in front of the main lens and the power is rated in diopters.

Dipole The simplest form of primitive aerial.

Direct metering System in which the intensity of the light is measured by a light-sensitive cell placed alongside the lens.

Dissolve Vision-mixing effect in which one image slowly appears as another fades out.

Dolby Noise-reduction system incorporated in many tape recorders to reduce the hiss inherent in the tape itself. Dolby recordings and recorders must be used in conjunction.

Dolby stereo A cinema surround sound system.

Dolby surround A domestic version of Dolby stereo.

Dolly A wheeled platform on which the camera can be mounted for tracking shots.

Dope sheet Shooting script, for animation. Also, sound-mixing plan for editing.

Double action A cut in which part of an action is erroneously overlapped from another angle.

Dropout Momentary losses of the sound in a recording caused by dust or imperfections in the tape.

Dubbing Combining several sound tracks onto one final track. Also, the transfer of one tape to another.

Earth-station A dish for reception of satellite communication.

Echo chamber System for increasing the reverberative resonance of recorded sound. It may be mechanical or electronic.

Editing Process in which the raw material of the tape as originally shot is reordered to create a coherent and satisfying whole.

Edit switch A control which helps to improve the picture quality of dubbed material.

EFP see Electronic Field Production.

EIAJ Electronic Industries Association of Japan. They established the standard $\frac{1}{2}$-inch helical scan reel-to-reel format in both color and black and white.

Eight-pin connector A standard connecting plug between VTRs and monitors providing full in-out audio-video connections.

85 filter An orange color conversion filter which reduces daylight to the color temperature of tungsten lighting.

Electron gun The device inside a camera or receiver which fires electrons at the surface of the cathode ray tube.

Electronic Field Production The use of small, high-quality recording equipment for purposes other than news gathering.

Electronic shutter Camcorder circuit which controls the scan rate of the tube or chip, producing effects analogous to a photographic shutter.

Electronic viewfinder A camera viewfinder in which the image is generated by a cathode ray tube rather than optically.

Encoding Electronic circuitry which combines three color signals into one composite video signal.

ENG Electronic News Gathering.

Equalization Process of filtering recorded sound in order to produce an improved balance between the range of frequencies.

Erase head The head on a recorder (either static or rotating) which erases a previous signal on a tape during recording.

Establishing shot Shot used to introduce a new location or time span. It is frequently a wide-angle.

Euroconnector, see **Scart socket.**

Exposure The process of exposing a camera chip to light. The degree of exposure is a product of the time for which each frame is exposed and the aperture setting of the lens. In video the time element is determined by the scan rate, which is controlled electronically (see Electronic

shutter).

Exposure lock Device which overrides automatic metering by holding the aperture at a selected stop.

Extension tube Rigid metal tube inserted between the lens and the body of the camera in order to lengthen the distance from lens to camera chip. It is used for close-up filming.

External microphone A microphone which plugs into a socket on the side of a camcorder. External mics usually give better sound quality than built-in microphones.

Eye light Lamp arranged to produce an attractive glitter in the subject's eyes.

Eyeline The direction in which a subject is looking relative to the camera. It involves consideration not only of left-to-right orientation but also of height.

Fade In-camera or laboratory effect in which the image slowly appears or disappears into darkness.

Fast shutter Also known as a high speed or electronic shutter. Camcorders normally record 50 pictures per second – equivalent to a shutter speed of 1/50 sec. Fast shutters electronically increase the shutter speed (sometimes up to 1/10,000 sec) to allow fast moving objects to be recorded without blur. However, the benefits of fast shutters can only be seen on video recorders equipped with good slow motion or frame advance facilities.

F/C Mechanism (Full/Compact) A VCR loading mechanism that accepts both full size VHS and VHS-C cassettes without the need for an adaptor.

Field Half of a complete TV picture. Two fields when interlaced combine to make one frame.

Filler A light used to relieve the shadows cast by the principal light source.

Filter Disk of colored glass or gelatin which fits over the lens. It is used to cut down particular wavelengths in the light entering the camera or to create special effects.

Filter factor An indication of the amount of light that a filter absorbs, given in terms of the adjustment that must be made to the aperture in compensation.

Fisheye lens Extreme wide-angle lens, giving a circular image.

Flare Light deflected from any bright highlight into a darker area of the frame. It may be caused by mechanical or optical defects, but

usually it is generated by the sun shining onto the front element of the lens.

FL Mechanism A miniature Video 8 tape drive mechanism which makes it possible to produce very small camcorders and VCRs.

Flood Full diffusion. Also, a lamp with a parabolic reflector. This gives a broad parallel beam of light which is used for overall illumination. "Full flood" is the term used when a variable lamp is fully diffused.

Flutter A fault in recorded sound producing a gurgling effect on speech, usually caused by unsteadiness in the sound recorder or reproducer.

Flyback The period during scanning when the electron beam returns rapidly to the beginning of the next line.

Flying erase head An erase head which is incorporated in the rotating disk of a recorder. Essential for perfect electronic editing.

FM Frequency modulation. The type of signal normally used by television channels and VCRs. The frequency of the carrier varies with the original vision signals.

f number Number which indicates the relative aperture of a lens at different diaphragm settings. It is calculated by dividing the focal lengths of the lens by the effective diameter of the diaphragm. As the aperture narrows, reducing the amount of light reaching the film, the f number increases.

Focal length The distance between the lens and the camcorder chip when a very distant object is brought into focus. Different lenses are usually described by their focal lengths; a greater focal length will give a larger image of the same object.

Focusing Altering the distance between the lens and the chip until a sharp image is obtained.

Focus zone Camcorder autofocus systems usually focus on whatever is at the center of the picture. This is the focus zone. Some models have two zone systems for greater accuracy and to minimize "hunting" in awkward situations.

Fog filter Special effect filter which diffuses the image while retaining sharpness.

Following focus The technique of keeping a moving subject constantly in focus.

Foot-candles The illumination from one candle power falling on an area of one square foot at a distance of one foot.

Footprint The area of the earth over which a given satellite signal can be received.

Frame A complete TV picture, made up of two fields interlaced.

Frame advance A feature which enables a sequence to be analysed frame by frame. Useful for editing.

Freeze-frame An effect in which the action is arrested.

French flag Opaque panel which is used to deflect direct light from the camera lens or to shade part of the action.

Frequency A measure applied to wave-motion, in units of cycles per seconds (Hertz). In sound, this indicates pitch (a low note has a low frequency).

Frequency response The ability of a recording system to record or reproduce the full range of sound frequencies.

Fresnel lens A stepped-surface condenser lens which, though thin and light, performs the same function as a thicker normal lens when attached to lights.

Front porch Period of time in the video signal which precedes the line sync pulse.

FST (Flatter Squarer Tube) A TV screen that gives a flatter display than conventional TV picture tubes.

F-stop Number which indicates the relative aperture of a lens at different iris settings. The higher the f-number the smaller the iris setting.

G

Gaffer tape Very strong thick, wide adhesive tape used in rigging lighting equipment.

Gain The degree of amplification of an electrical signal.

Gamma Contrast gradient.

Genlock The locking or enslaving of one or more recording systems to the sync of a master recorder or Special Effects Generator.

Glass shot Scene in which part of the set is created by a picture carried on a sheet of glass. The glass is placed between the camera and the rest of the set.

Graduated filter This has a tinted half, which diffuses into clear glass.

Guard bands The gaps between video tracks on a tape which prevent "cross-talk".

Gun mike, see Shotgun microphone.

H

HDTV (High Definition TV) A new generation of TV broadcast systems for greatly improved picture quality. HDTV will probably arrive in the 1990s.

Head Part of a VCR or camcorder that converts the electrical impulses from the chip and

microphone into a varying magnetic field. This leaves a record on the tape by rearranging the metal oxide particles which coat the tape. When the tape is played, the playback head responds to the pattern on the tape and sends an electrical impulse via the amplifier to the loudspeakers. The erase head removes any previous recording on the tape.

Head drum A fast spinning drum which carries video (and sometimes audio and flying erase) heads.

Helical scan The recording system common to all except 2-inch Quad machines in which a rotating drum records a long diagonal series of tracks from the video heads on a laterally moving tape.

Hertz (Hz) The frequency per second of any waveform, such as an electrical signal.

Hide Construction used to camouflage the camera operator while filming wildlife.

Hi-8 (Hi-Band 8 mm Video) An enhanced version of the Video 8 format.

Hi-fi High fidelity. Unlike stereo, a hi-fi signal is encoded onto a deep layer of video track, reducing hiss.

High angle shot Shot from a camera placed above the subject and pointing down.

High-band (or Hi-Band) A video recording system with very high-frequency response and consequently excellent quality.

High-definition television (HDTV) A television system designed to match the resolution of 35 mm film by having around 1200 lines per *frame*. The system is currently in the development phase.

High key Lighting in which the overall level is bright. This kind of Hollywood "look" is also conventionally associated with glamorous backlighting.

Horizontal resolution The number of vertical lines that can be distinguished by camera or receiver in a horizontal direction on a test chart.

Horizontal sync The sync pulses that control the line-by-line scanning of the target.

Hyperfocal distance The distance between the camera and the nearest point of the subject which is sharp, when the lens is focused on infinity at any given aperture.

I

Iconoscope The trade name of the earliest RCA television cameras.

Ident An identification mark on

the head of a *videotape*.

Ident clock A studio clock used when putting *idents* on tapes.

Image enhancer An accessory for sharpening the video image.

Image-processing The electronic manipulation of a video signal by either analog or digital methods.

Impedance The total resistance of an electrical system, measured in Ohms. (Ω). Components such as microphones, tape-recorders and speakers must be matched in impedance to operate correctly together.

Infrared Rays that occur beyond the red end of the electro-magnetic spectrum and which are invisible to the human eye.

Incident meter Instrument for measuring the amount of light falling onto the subject.

In phase If stereo recordings are to be correctly reproduced, the two loudspeakers must be "in phase". In other words, each positive terminal on the speaker must be connected to a positive output on the amplifier.

In-point Frame selected during editing to be the beginning of a shot.

Insert The replacement of part of one video image by another.

Insert edit The introduction by electronic editing of one scene into the middle of an existing recording.

Interval recording A camcorder feature which records shots at timed intervals, eg every 60 seconds.

Inverse square law This law of physics states that the intensity of light is inversely proportional to the square of the distance from its source. This means that at twice the distance from the source, the amount of light falling on an object will be quartered, while at three times the distance, only one ninth as much light will be received.

Ips Inches per second. Unit measuring the speed at which magnetic tape runs.

Iris Type of diaphragm consisting of interlocking blades producing a near-circular aperture.

J

Jog shuttle dial An editing control that varies the tape speed from frame by frame advance (jog) to high speed picture search (shuttle).

Jump cut Cut in which a portion of the action is omitted. This may cause a jarring break in continuity, but can also be used as a technique for compressing time.

K

Kelvin (°K) Unit of color temperature of light.
Keying The matteing of one video image over another.
Key light The light which principally illuminates a given scene.
Kilohertz (kHz) A thousand cycles.

L

Lag Image retention on a camera tube when shooting at low levels of illumination.
Lap dissolve A special visual effect in which a second image gradually replaces the first image by increasing in amplitude or brightness.
Lavalier A term used for a microphone worn hung around the neck.
Leader The length of tape at the head and tail ends of a reel, used to protect the tape from damage.
L.E.D. Light emitting diode used in viewfinder.
Lens One or more pieces of precisely curved glass arranged in a tube to direct light rays from the subject into the camera. The rays are bent by the lens so that they converge on the chip, forming a focused, inverted image.
Lighting ratio Ratio of the power of the keylight to that of the filler light.
Line An imaginary line used as a reference for positioning the camera when taking different shots of the same scene. It may be the subject's eyeline or direction of movement or some other line of interest. Filming from the same side of the line preserves continuity.
Line Crossing Moving the camera from one side of the action to the other. This may be for creative motive, but more often it makes the spatial narrative incoherent to the audience.
Linear sound A soundtrack which is recorded by a fixed audio head. Linear soundtracks take the form of a thin strip running along the tape edge. Sound quality is poorer than hi-fi stereo recordings.
Line frequency The number of horizontal lines scanned in one second: 15.625 kHz in UK and Europe, 15.75 kHz in USA.
Line input A socket which accepts a video signal. Found on all VCRs but on few camcorders.
Lip Sync The precise synchronization of lip movements and speech sounds.
Live acoustic A resonant recording environment.

Live on tape A recording system in which a program is transferred to tape without breaks or edits, to be shown later as if it were being transmitted live.
Locking-off A special effect technique whereby the camera is locked in position half way through a shot. After a period of time, the camera is restarted, for a trick effect.
Long shot Shot taken from a distance to include the overall scene.
Low angle shot Shot taken from a camera placed close to the ground and pointing upwards.
Low-band A low-frequency color recording technique commonly used on $\frac{1}{2}$-inch machines.
Low key Low-level, but possibly high contrast lighting which emphasizes dark tones and shadows, creating a dramatic or sinister atmosphere.
LP (long play) A feature which runs the tape at a slower speed to increase playing time. Sometimes called Half Speed.
Lumen A standard unit of luminous flux.
Lux One lumen per square metre (1 foot-candle equals 10.76 lux).

M

MAC Multiplexed analog components. A television system based on digital sound and FM analog picture transmission. It is designed to be compatible with future developments such as wide screen and high definition. Variations include D-MAC and D2-MAC.
Macro The technique of filming in extreme close-up to give a highly magnified image.
Macro lens A close-up lens capable of very high magnification.
Magnetic sound The most common method of sound recording, in which magnetic variations are made on a tape coated with a magnetic substance. The recording head produces these variations by converting the electrical signal from the microphone into a fluctuating magnetic field. The playback head reverses the process: it monitors the tape signal and feeds the information to the amplifier.
Master shot Main shot of a scene, filmed continuously from one camera. Other shots of the scene may be cut in to the master shot during editing.
Matrix Electronic circuit that combines several electronic signals.
Matte An opaque piece of metal, card, or film which masks off part of the image in either a camera or

printer.
Matte box Accessory which fits in front of the camera to provide both a sun-shade and a holder for filters and mattes.
Megahertz (MHz) A million Hertz.
Microphone Device which converts sound airwaves into mechanical, then electrical energy
Mid shot Shot of part of a scene, from a sufficient distance to include most of the body of an actor or a group of people.
Mini-brute Set of small quartz lamps used together to provide powerful illumination.
Mistracking Incorrect tape-to-head contact or tape-path contact causing picture distortion as bursts of noise on replay.
Mixer A device for combining several audio or video inputs.
Modulation The process of adding video and audio signals to a pre-determined carrier frequency.
Monitor A TV used to assess video output; in strict terms, a TV set without sound, often directly connected to the camera.
Montage A rapidly cut sequence which produces a generalized visual effect even though it may be made up of dissolves or superimpositions.
MOS "Mit-out sound". i.e. silent, or mute shooting.
Movielight Small quartz light mounted on top of the camera.
Multi-track Professional recording system in which eight or even sixteen separate sound tracks may be recorded simultaneously. They are then mixed to produce a balance between the components of the sound or to add special effects.

N

Neutral density filter A filter which reduces the brightness of a scene without affecting its color balance.
Ni-Cad Nickel cadmium rechargeable batteries.
Nicam (Near Instantaneously Companded Audio Multiplex). A digital stereo TV sound system.
N.G. take Shot rejected during editing ("No good").
Ninelight Set of small quartz lights which provides powerful studio illumination.
Nodal point Theoretical optical center of a lens
Noise Any interference to video or audio signals, electrical as well as acoustic.
NTSC National Television System Committee of the Federal Communications Commission. Commonly used to describe the USA/Japanese color system.

O

Octopus cable A multi-plug cable with a number of jacks at one or both ends for interfacing video equipment.
Omnidirectional microphone Microphone which responds equally to sound received from all directions.
Oscilloscope Cathode ray tube connected to electronic test device for aligning video equipment.
Out-of-phase The condition in which two loudspeakers are wrongly connected to the amplifier so that their cones vibrate in opposite polarity. The stereo effect will be lost if the speakers are "out of phase" in this way.
Out-point Frame selected during editing to end a particular shot.
Outtake Shot rejected during editing.
Overall metering Built-in camera system which measures the light received by the whole frame area.
Over-exposure Allowing too much light onto each frame, giving a pale, washed-out effect.
Overrun To use a bulb at a power higher than its nominal wattage.
Oxide The magnetic particles that record sound and vision on conventional tape. Now being replaced by metal and metal-evaporated formulations.

P

PAL Phase Alternation Line. The European standard color system except for France.
Pan To rotate the camera so that the field of view sweeps round in a horizontal panorama.
Pan head Mount which supports the camera on the tripod while allowing it to be panned and tilted smoothly.
PAR Quartz light with a built-in parabolic aluminized reflector.
Parabolic reflector Lamp fitting which produces a broad, parallel, directed beam.
Parallel action Sequence intercut with the master shot. It is usually a simultaneous and related scene which does not occur in the same place as the main action. It may also be a flashback or an imagined future event.
Parallel prism lens Adaptor producing up to five parallel images. One half of the lens is split into several parallel lenses.
Passive filter Part of a sound system which removes some of the low or high frequencies in a signal.
Personal mike A chest microphone worn by a speaker which leaves the hands free.

Perspective "Sense of depth" in a two-dimensional image created by the relative size, position and shape of the ojects that appear.

Photoflood Lightbulb with standard screw fitting but very high power output and color temperature of either 3,200°K or 3,400°K.

Picture-search The rapid scanning in vision only of a recorded tape.

Piezo system This is a focusing system that reduces "hunting", where the lens moves back and forth searching for the focal point

PIP (Picture-in-Picture) A digital special effect which puts a small picture in the corner of the main TV display.

Pixel The smallest sensitized unit of a video screen picture or *CCD*.

Playback deck A *deck* used for playing prerecorded video *inserts* into a program. Also the *source deck* in an editing set-up.

Plumbicon tube A high-quality lead-oxide tube much used in professional broadcasting.

Polarizing filter Filter which cuts down glare and reflected light of a given polarity. It also reduces haze and darkens blue skies at 90° to the sun. The filter should be rotated and the effect gauged through the lens.

Power zoom A zoom lens in which the change of focal length is motor-driven. This is now a standard feature. Some zooms have variable speeds.

Pre-roll The process of running two tapes in sync in preparation for an electronic edit.

Primary colors The three colors which can be combined additively to produce any other color on projection. For light (rather than pigments), these are red, green and blue.

Prime lens Lens with a fixed focal length.

Pulling focus Changing focus to follow a moving subject.

Q

Quadruplex (Quad) A video recording system on 2-inch tape using four rotating video heads at right angles to the direction of tape travel.

Quartz lighting High-intensity lighting using quartz halogen bulbs with near-daylight color temperature.

R

Radial prism lens Special effect lens which gives a multiple image.
Radio microphone Small portable transmitter and receiver linked to a microphone.

Raster The pattern formed by the scanning spot of a TV system.

Real time counter A tape counter which displays the time in hours, minutes and seconds. Used for finding sequences and handy for seeing how much recording time is left on a tape.

Reaction shot Shot of subject's response to some part of the action, often filmed as a cutaway after the master shot.

Record review Used for checking camcorder shots. When the camcorder is put in record/pause, it rewinds and replays the several seconds of the last shot.

Reflected light meter Device which uses a light-sensitive cell to measure the amount of light reflected by the subject.

Reflector Lamp fitting used to control and direct the light, or reflective sheet used to balance light levels in day-light shooting.

Reflector flood Photoflood with a silver coating on the inside of the bulb to form a built-in reflector.

Refraction The bending of a ray of light at the point where it passes obliquely from one transparent medium to another.

Relief The degree to which texture is brought out in the form of shadows and high-lights. Hard, directional lighting produces high relief.

Resolution The degree to which fine detail in the image can be distinguished.

Reverb Short for reverberation (echo).

Reverse cut Editing cut in which the change of camera angle makes the subject appear to be moving in opposite directions at the end of the first shot and the beginning of the second.

Reverse play A trick feature which runs the picture backwards.

RF Radio Frequency.

RF adaptor A modulator for converting direct video and audio signals into radio frequency for replay on a conventional receiver.

RGB (Red Green Blue). 1. The primary colors from which all other colors are derived. 2. A type of connector used on some video equipment.

Rim-lighting Rear-lighting which highlights the outlines of objects.

Rotary erase head *see* Flying erase head.

Rumble or "hum" filter Sound filter which cuts out low frequencies.

S

Saticon tube An arsenic tellurium tube offering improved lag performance over conventional vidicon tubes and greater sensitivity.

Saturation The intensity of color in an image.

SCART 21-way connector used in Europe for both audio and video connections. Also known as Peritel and Euroconnector.

Scenic projection Method of creating a set by projecting a filmed or photographed image behind the actors.

Scratch filter Sound filter which cuts out high frequencies.

Scrim Translucent wire screen placed in front of a lamp to cut down its brightness.

SECAM Séquentiel Couleur à Mémoire. French color TV system also adopted in Russia.

Separation light Back light,
Sequence A semi-autonomous *segment* of a *narrative*, often a scene so that the sequence therefore ends with a change of location. In documentary programs, a series of *shots* linked thematically or logically.

Set Arrangement of scenery, whether real or simulated, within which the filmed action takes place.

Shadow mask Screen inside conventional TV tubes through which electrons are passed to hit correctly colored phosphors.

Shooting schedule Timetable prepared from the filmscript in which the scenes are arranged in appropriate groups for shooting, with details of location, actors and props required, and so on.

Shooting script Detailed list of shots in the order that they are to be filmed.

Shot Part of a film recorded in one continuous run of the camera.

Shotgun microphone Highly directional microphone which responds only faintly to sounds from more than 20° on either side of the direction in which it is pointed.

Shoulder pod Support for a camera, allowing it to be carried or braced against the shoulder.

Shuttle-search Facility allowing frame-by-frame playback of a tape, either forward or backward, for editing purposes.

Signal-to-noise ratio (S/N) The ratio between the video or audio signal and noise or interference. The higher the signal-to-noise ratio the better the quality.

Skew Tape tension. Incorrect skew results in distortion at the top or bottom of the picture.

Snoot Open-ended cone which fits in front of a lamp to give a narrow circle of light.

Solarization Reversal or partial reversal of the image by extreme over-exposure. It is an electronic effect.

SOT Sound on tape: video *inserts* complete with sound track. Also often termed sound on video (SOV).

Sound-on-Sound superimposition (SOS) Facility in some tape recorders for recording one sound on top of another.

Special Effects Generator (SEG) Unit in video production to mix, switch, or process video signals.

Speed (lens) The f number of the lens aperture when it is fully open. A "fast" lens is suitable for shooting in low-level lighting. The lower the f-number, the faster the lens.

Spider Device which holds the legs of a tripod in fixed relative positions on a slippery floor.

Split-field diopter lens A close-up lens which has been divided into two halves. The lower half usually has greater magnification.

Split-screen Technique in which the two halves of the frame are separately exposed, giving a split, composite picture when screened.

SP (Standard Play) Normal tape speed.

Spotlight Lamp designed to give a very powerful and narrow beam of hard light.

Spot meter This exposure meter gives an extremely accurate measurement of the light reflected by a very small area of the subject.

Spun glass Material clipped on the front of a lamp to diffuse the light.

Squeeze lens, see Anamorphic lens.

S-Terminal (Separate Video) Also known as a Y/C connector. A connector used by high quality picture formats (such as S-VHS), which keeps the chroma (C) and luminance (Y) signals separate for improved picture quality.

Starburst filter Special effect lens which dramatizes highlights by creating star-shaped flares of light.

Still video An electronic version of the conventional camera. Still video pictures are recorded onto a magnetic disk or chip and can be replayed on a TV set or printed out like a photograph.

Stop Any of the range of fixed aperture settings. Opening the aperture by one stop allows twice the amount of light into the camera as the previous stop. The stops are in a logarithmic progression. Thus, the standard stops correspond to f numbers of 1.4, 2, 2.8, 4, 5.6, 8, 11, 16, 22

and so on.
Stop-pull Technique of altering the aperture by hand during the course of a shot.
Storyboard An ordered collection of sketches representing consecutive shots as they are visualized by the moviemaker while planning the production.
Stripe filter A single-camera tube that can produce three-color output.
Subcarrier The frequency on which color information is modulated in a color TV system: 4.43 MHz in UK/Europe, 3.58 MHz in USA/Japan.
Subjective track Tracking shot in which the camera moves in place of a character in a movie and reveals what is supposed to be the scene through their eyes.
Sungun Hand-held rechargeable battery light.
Super VHS (Super Video Home System – S-VHS) An enhanced version of the VHS format. Also the name of a full-sized camcorder format.
Super VHS-C (Super Video Home System Compact – S-VHS-C) A miniature camcorder format that offers Super VHS picture quality.
Switcher A device for cutting from one video input to another.
Sync Synchronization, i.e. accurate correspondence between sound track and vision.
Synchro edit An editing feature which enables two pieces of video equipment to be linked together (eg VCR and camcorder) and controlled by a single machine.
Sync plop One frame of sound placed at the beginning of a sound track to establish sync during the mix of multiple tracks.

T

Tally light The light on a camera which indicates to the subject that it is in use at a given moment.
Tape synchronizer Device used during editing and viewing to keep a tape recorder and VCR locked together, adjusting the speed of one to match the other.
Target The face of a camera pick-up tube or chip.
Tearing A distortion caused when horizontal sync is lost or distorted.
Telecine (film chain) The total system for transferring film on to video tape or on to a live-output video system.
Telephoto Lens with long focal length, giving a narrow angle-of-view.
Thirds rule Principle of composition which states that strong horizontal or vertical lines should cut the picture in thirds

rather than in halves.
Three-shot Mid or long shot in which three people appear.
Through-the-lens A variety of meter in which some of the light passing through the lens is diverted to a light-sensitive cell. This measures the intensity of the light that will reach the chip, and in some cameras controls the automatic adjustment of the aperture.
Tilt Pan in a vertical direction.
Time-base corrector A device that corrects mechanical and electronic errors in a video system for purposes of transmission.
Time code A frame-by-frame time reference recorded on the spare track of a video tape.
Time lapse Technique of exposing in short bursts at regular intervals so that the event filmed appears greatly speeded up when played back as normal.
Tracking Moving the camera horizontally across the ground while filming a shot.
Transmission stops T stops.
Treatment Written reinterpretation of a story, an idea or a theme in terms of video.
Tripod Adjustable three-legged stand on which the camera is held steady.
TTL Through-the-lens metering.
Tube The cathode ray tube consists of three electron ''guns'' that fire electrons at the surface of the tube separating color.
Tungsten Metal used for the filaments of light bulbs.
Two-shot Shot in which two people appear.

U

UHF Ultra-High Frequency (300 to 3000 MHz). Also used to refer to coaxial cable connectors.
Ultra-violet filter Filter designed to cut down ultra-violet light, which, while invisible to the human eye, produces a blue haze on reproduction.
U-Matic Sony trade name referring to $\frac{3}{4}$-inch video cassette format.
Uni-directional microphone A microphone that records sound from one direction.
Under-exposure The effect of allowing too little light into the camcorder; giving an excessively dark image.

V

Variable shutter Video cameras do not have mechanical shutters, but some models can vary the duration of the individual scan

down to thousandths of a second and beyond.
VCR A video cassette recorder.
Vertical sync The sync pulse which controls the field-by-field scanning of the target area.
VHF Very High Frequency. Commonly referred to as 30 to 300 MHz.
VHS Video Home System, the $\frac{1}{2}$-inch cassette format developed by JVC.
VHS-C This is the video home system compact cassette, which runs for up to 45 minutes at standard play on $\frac{1}{2}$ inch tape.
Video Picture information. Also generic term for all matters televisual.
Videocassette The container in which small gauge videotape is both recorded and replayed. There are several standards.
Video disk Replay system for pre-recorded video information on high-speed rotating disk. It is scanned optically by laser.
Video dub An editing feature which replaces the picture but leaves the original soundtrack intact.
Video 8 The smallest currently available tape formats – only 8 mm wide with a running time of 90 minutes at standard speed, or three hours at long play settings.
Video heads Heads which record and play back the video signal. Home VCRs have two or four video heads mounted on a head drum.
Vidicon tube Pick-up tube used in TV cameras. Increasingly being replaced by CCD chips.
Viewfinder The system through which the subject is viewed by the camera operator.
Vignetting Fading of the image towards the corners of the frame. It is sometimes produced by an aberration or fault in the lens, but it can also be introduced as an optical special effect.
VTR A videotape recorder.
V2000 (Video 2000) Philips $\frac{1}{2}$-inch video cassette system now obsolete.
VU meter Instrument for monitoring sound level.

W

Warming filter Filter which reduces the proportion of blue in the light entering the lens.
Whip pan Very rapid pan which completely blurs the subject and the background.
White balance The system for calibrating color balance on a domestic color camera.
Wide-angle lens Lens with a short focal length which provides a wide angle-of-view.

Wildtrack Separate sound recording made at the time of recording.
Wipe An effect in which one shot appears physically to displace another on the screen. It may be created as an optical laboratory effect or in the camera with mattes. Wipes may be vertical or horizontal.

Z

Zoom-in Reducing the angle-of-view by increasing the focal length of a zoom lens during the course of a shot. The result is that the subject becomes larger in the frame.
Zooming ratio The ratio of the longest to the shortest available focal length of a zoom lens. For example, a 10 mm to 50 mm lens is said to have a zooming ratio of 5:1.
Zoom lens Lens of variable focal length. This means that an object can be held in focus while the angle-of-view and magnification of the image is varied during a shot.
Zoom-out Widening the angle-of-view by shortening the focal length of a zoom lens during the course of a shot. The result is that the subject becomes smaller in the frame.

INDEX

ACKNOWLEDGEMENTS

PHOTO CREDITS
Aerofilms Ltd: 148 cr, br. Ardea: 124 t, c. Aspect: 125; 150 tl, tr, cl, cr; 151 t, cl, cr, br. Jon Bouchier: 1; 16–7; 18–9; 22–3; 26–7; 28–9, 30–1 (except insert); 34–5; 36–7; 39; 46 l; 48–9; 53; 89; 110–1. David Bruton: 82 cr; 122 tr; 168 t, cl, br. John Bulmer: 157 cbr. J. Allan Cash: 114 bc. Brian Castledine: 43 cl; 60 t; 130; 131; 143 c; 169 br. David Cheshire: 38 t; 42 t; 43 r; 44–5; 47 tl, tr; 50–1; 59 br; 80–1; 82 cl; 83; 112–3; 122 tl; 123 tl, tr, cl, cr; 126; 142; 166–7; 169c, br; 196. Chusak: 43 cc; 58 t; 59 cr; 82 t; 154 ctl, ctr, cbr, bl, br; 155 bl, br; 156; 168 tcl. Colorsport: 114 cbl, cbr. John Couzins: 41 br; 60 b. Leo Dickinson: 148 cl, bl. Zoe Dominic: 96–7. Peter Gardiner: 108–9; 143; 146–7. Bob Gordon: 54–5; 85; 152. Robert Harding Picture Library: 2–3; 170–1; 199. Chris Harvey: 188 tr, btl, btr; 189 tr, c, btl. Hutton Picture Library: 101, r; 11; 12 t, b; 13 t, b. Carolyn Johns: 120; 121. Michael Joyce: 209 t. The Kobol Collection: 84 cb; 92 t; 160 c, bl, br; 161 t, tr, cl, cr. Roger Perry: 41 tr; 43 tl; 46 cr; 66; 67; 84 t, ct, b. Paul Popper Ltd: 15 tr. Science Museum: 8. Seaphot: 149. Tony Stone Worldwide: 64–65; 197. Syndication International: 94–5; 114 t. Mathieu Thomas: 199; 211. Malcolm Warrington: 122 bl; 123 tc, cb, cl, br.

FILMS
Artificial Eye Film Company
62–3 PADRE PADRONE (Dir: Paolo & Vittorio Taviani) 1977
93t THE RED DESERT (Dir: Michelangelo Antonioni) 1964
174–5 THE SPIDER'S STRATEGEM (Dir: Bernardo Bertolucci) 1970
Connoisseur Films
78–9 LE BOUCHER (Dir: Claude Chabrol) 1968
Contemporary Films
186 MOTHER (Dir: V. Pudovkin) 1926
187 BATTLESHIP POTEMKIN (Dir: Sergei Eisenstein) 1925
EMI Elstree Studios
162–3 THE LADY KILLERS (Dir: Michel Balcon) 1955
164–5, 183b THE THIRD MAN (Dir: Carol Reed) 1949
184 THE SERVANT (Dir: Joseph Losey) 1963
RKO General Pictures
185 CITIZEN KANE (Dir: Orson Welles) 1941
Twentieth Century Fox
158–9 THE FRENCH CONNECTION (Dir: William Friedkin) 1971
Visual Programme Systems Ltd
90–1 MAHLER (Dir: Ken Russell) 1973

ILLUSTRATIONS
RON HAYWARD AND ANTHONY DUKE

Carroll & Brown want to thank Mike Trier for his research and the following for the loan of equipment for photography: AICO International Limited, Canon Photo Division, Casio Electronics Limited, Ferguson Limited, Johnsons Photopia, Panasonic Consumer Electronics (UK) Limited, Sanyo Limited, Sharp Electronics Limited; and for pictures of electronic equipment: Michael Joyce, NEC (UK) Limited, Panasonic Consumer Electronics (UK) Limited, Philips Consumer Electronics, Pioneer High Fidelity (GB) Limited, Sony (UK) Limited, Teak/Tascam.

David Cheshire wants to thank Peter Gardiner for the time and effort he put into researching material for the book.